SIGHT UNSEEN

SIGHT UNSEEN

WHITENESS AND AMERICAN VISUAL CULTURE

MARTIN A. BERGER

UNIVERSITY OF CALIFORNIA PRESS

BERKELEY LOS ANGELES LONDON

SIGHT UNSEEN

WHITENESS AND AMERICAN VISUAL CULTURE

MARTIN A. BERGER

UNIVERSITY OF CALIFORNIA PRESS
BERKELEY LOS ANGELES LONDON

The publisher gratefully acknowledges the generous contribution to this book provided by the Art Endowment Fund of the University of California Press Foundation.

University of California Press
Berkeley and Los Angeles, California

University of California Press, Ltd.
London, England

Library of Congress Cataloging-in-Publication Data

Berger, Martin A.
 Sight unseen : whiteness and American visual culture / Martin A. Berger.
 p. cm.
 Includes bibliographical references and index.
 ISBN 0-520-24459-1 (cloth : alk. paper)
 1. Race awareness in art. 2. Art and race. 3. Whites—Race identity—United States. 4. Arts, American—19th century. I. Title.
NX650.R34B47 2005
701'.03—dc22 2005008042

Manufactured in Canada

14 13 12 11 10 09 08 07 06 05
10 9 8 7 6 5 4 3 2 1

The paper used in this publication meets the minimum requirements of ANSI/NISO Z39.48-1992 (R 1997) (*Permanence of Paper*).

FOR VICKY

CONTENTS

ILLUSTRATIONS

ACKNOWLEDGMENTS

If this book succeeds in articulating meaningful connections between visual culture and its real-world effects, much of the credit is due to Vicky Gwiasda. For nearly a decade, Vicky has challenged me to make my scholarship relevant to non–art historians by focusing on the practical implications of visual arts in day-to-day life. Through the example she sets personally and professionally, and through her careful reading of my work, she pushes me to keep the links between social products and power always within sight.

For insightful feedback on draft versions of the manuscript and related talks, I am indebted to Chris Castiglia, Jill Gordon, Julie Hansen, Ena Harris, Sharon Ann Holt, Cynthia Mills, Alex Nemerov, and Jack Quinan. Sharon's comments in particular were remarkable for their thoroughness and detail. The Press's two readers, Frances Pohl and Bruce Robertson, each provided thoughtful, meticulous, and generous assessments of the manuscript that helped me refine my thesis. Jolene Rickard's help was indispensable to me as I thought through my arguments on Native American representation, and I thank her. To Mark Aronson, Ron Gaczewski, Karl Kusserow, and Jack Quinan, I express appreciation for aid in locating, acquiring, and reproducing a number of my illustrations.

The Press's fine arts editor Stephanie Fay does a wonderful job with ideas, words, and psyches. Consequently, there is no editor with whom I would rather work. I am grateful for the diligent and responsive efforts of her assistants, Erin Marietta and Sigi Nacson. Thanks also to Susan Ecklund, who copyedited the book with precision.

Much of the research and writing of this book took place at the Smithsonian Amer-

ican Art Museum, where I had the privilege of being a fellow in 2002–3. I thank Virginia Mecklenburg, Cynthia Mills, and Bill Truettner for fostering a warm and intellectual environment in which to write, and also SAAM and Congress for seeing the value in continuing to fund research in the humanities during this era of social cuts. Among the many fellows who enriched my experience in Washington, I wish to single out Isabel Taube and Catherine Whalen for particular thanks.

WHITE LIKE ME

Race has become metaphorical—a way of referring to and disguising forces, events, classes, and expressions of social decay and economic division far more threatening to the body politic than biological "race" ever was. Expensively kept, economically unsound, a spurious and useless political asset in election campaigns, racism is as healthy today as it was during the Enlightenment. It seems that it has a utility far beyond economy, beyond the sequestering of classes from one another, and has assumed a metaphorical life so completely embedded in daily discourse that it is perhaps more necessary and more on display than ever before.

TONY MORRISON, *PLAYING IN THE DARK: WHITENESS AND THE LITERARY IMAGINATION*, 1992

Sight Unseen explores the links between racial identification and vision. It probes the role of European-American whiteness in guiding both the form and the meaning of the visual arts during the late nineteenth and early twentieth centuries. Without claiming that all whites see the world through an identical lens, *Sight Unseen* maintains that shared ideologies rooted in race provide a consistent and detectable structure that guides their interpretation of the visual world. This book analyzes the discursive contexts in which selected paintings, photographs, buildings, and early motion pictures were produced and received, tracing how European-Americans internalized historically specific ideologies linked to whiteness, how such ideologies were both expressed by and impressed on visual texts, and how these texts worked in conjunction with social structures and practices to produce real-life material implications for both white and nonwhite peoples.[1]

Sight Unseen differs from many previous studies of race in that its focus on the visual arts does not reflect the importance of visual evidence per se in constructing racial identities. Despite the human propensity to privilege sight, and the long-standing Western tendency to root racial designations in observable traits, images do not persuade us to internalize racial values embedded within them, so much as they confirm meanings for which the discourses and structures of our society have predisposed us. Instead of selling us on racial systems we do not already own, the visual field powerfully confirms previously internalized beliefs.

Because the narratives and meanings visible to us in artworks are supported by forces

external to the works themselves, *Sight Unseen* expends considerable energy explicating what is *unseen*. The unseen is at work in the discourses and structures that guide and delimit the significance of art but extends as well to the evidence selected for examination and the properties of whiteness itself. In my effort to illustrate the power and ubiquity of race in conditioning the meaning of American visual culture, I have selected the primary texts scrutinized here for their conspicuous distance from the politics of race. This book not only shuns artworks containing obvious racial themes or tropes, but also avoids analyzing images that include nonwhites. In illuminating the value systems that informed the meaning of genre paintings and adventure films populated exclusively with white characters, and landscape photographs and fine arts museums containing no human beings at all, *Sight Unseen* argues that a decidedly racialized perspective animated even those cultural products most removed from racial concerns.[2]

The focus on works that exclude nonwhite characters both helps to deflate the common assumption that racial minorities catalyze otherwise race-neutral texts into treatises on race and expands the range of evidence used to elucidate whiteness. But perhaps more important, it also mitigates the dangers associated with white scholars' making a subject of racial others. Since the late 1960s a host of antiracist whites across a range of disciplines have produced sophisticated and sensitive studies of nonwhite racial identities, convinced that their analyses might serve as catalysts for social change. In critiquing the dominant construction of black, brown, or red identity, such studies have had an undeniable impact on the material conditions of nonwhite peoples. Yet in light of the pernicious legacy of whites' taking both vicarious and physical pleasure in the bodies of nonwhites, it seems prudent to consider the investment of whites in producing even the most progressive analyses of nonwhite representations.

Until quite recently, I explained my own investment in teaching and writing on people of color as a natural by-product of my ethnic identity. My concern with racial justice struck me as a reasonable outgrowth of my cultural identification as a Jew. As the son of a refugee from Hitler's Germany, and the nephew of a survivor of Dachau and Bergen-Belsen, I grew up with family narratives of anti-Semitism, arrest, deportation, and death, which offered vivid reminders of the dangers inherent in racial classification. Concern for disempowered peoples seemed a logical extension of my identity politics. But despite the ways in which I believed myself politically aligned with nonwhite peoples, my identification as a Jew did nothing to dismantle my whiteness.[3] As a host of scholars have shown, American Jews worked hard throughout the twentieth century at losing those traits, outlooks, and affiliations that marked them as racially distinct. In contrast to my father's childhood in Berlin, mine in Toronto was characterized by the possibility of being both Jewish and white. I will have more to say in later chapters on the utility of reading nineteenth-century and early twentieth-century American Jews (or, for that matter, Irish Catholics and Italians) as nonwhite, but for now it is enough to appreciate

that widely held perceptions of the racial inferiority of Jews in the 1930s complicated my father's relation to the dominant ideal of whiteness in ways that were not true for me in the 1960s.[4] From time to time I may be made to feel racially insecure based on comments and actions that target my ethnic background, but most of the time I comfortably pass as white.

I continue to believe that my slightly outsider status has much to do with my interest in racial questions, though I am now more attuned to the ways in which my whiteness must necessarily complicate this interest. Being Jewish or, for that matter, being female, gay, or working class may well increase one's potential for sensitivity to societal inequities—even as it sadly offers no guarantee—but since those of us who are Jewish and white, or female and white, were nonetheless formed by a perspective on the world that owes much to our racial identification, it is important to acknowledge what is at stake in our desire to make a subject of racial others. My concern is that white academics who focus on representations of nonwhite peoples—no less than members of the general public who "love" black athletes, comedians, and musicians—may use the mantle of "racial justice" as a respectable cover for indulging in our long-standing fascination with the other.[5]

There is a way in which the public and academic attraction of whites to images depicting blacks might constitute a twenty-first-century incarnation of the minstrel show.[6] The claim is less fantastic than it may seem, given the insatiable white desire for racial others, as well as the complex cultural functions of minstrel performance. As historians from Eric Lott to Michael Rogin have cogently explained, minstrelsy has long provided an outlet for the conflicted racial impulses of whites, expressing both the denigration and the celebration of black American life. Instead of creating satirical skits that only lampooned African Americans, and so solidified northern support for the slave system, or later, segregation, minstrelsy expressed both fear and desire, disavowal and identification. In presenting minstrelsy as ambivalent and conflicted, contemporary scholars have sought not to defend it as positive or even benign but to explore its complex cultural functions for nineteenth- and twentieth-century Americans, and to allow modern readers to see beyond what we take today as its unmitigated racism. This revisionist account helps explain how both abolitionist and proslavery Americans could attend and appreciate the same performances by drawing on those elements of the spectacle that resonated with their own views.[7]

Once we acknowledge the contradictory cultural meanings that minstrelsy embodied, we can appreciate how the performances necessarily promoted views that segments of their audience did not consciously embrace. White abolitionists who enjoyed minstrel shows may have believed that the performances celebrated African American life, but it should be obvious that their financial and moral investment in the genre promoted collateral meanings they were unable to control. Minstrelsy did not promote either pos-

itive or negative images of African Americans depending on the politics of a given audience member; to varying degrees, it advanced both simultaneously. The cultural work that minstrelsy performed for even racially progressive whites remained ambiguous, even if some audiences judged its impact as beneficial to blacks. Given that most blacks in nineteenth-century America deplored minstrelsy while such racially progressive whites as Walt Whitman and Abraham Lincoln attended minstrel performances, and considering that as powerful an antiracist as Mark Twain expressed unequivocal love for minstrelsy, it seems appropriate for whites today to consider how our modern interest in the black image may express a cultural complexity—a multivalence—of which we are similarly unaware.

Knowing of the long-standing white need for black others should make us skeptical of claims that well-meaning whites can transcend their race's investment in depictions of nonwhites. Because even progressive whites are still white, I am convinced that those of us motivated by a vision of racial justice should begin an analysis of race by assessing how white identity affects the lives of both white and nonwhite peoples. This process might start with European-American scholars shifting their *primary* evidence of race from black to white representations. To suggest such a shift is not to say that people of color approach images of nonwhites objectively, but simply to acknowledge the markedly different stakes for each group. Nonwhites (not whites) pay the cultural and material price for any analysis of racial minorities that inadvertently reinforces cultural stereotypes or feeds the white need for racial others. Given the stakes for minority peoples, our understanding that the "problem" of race lies primarily with the group that holds most of the power, and considering the growing number of studies on African American, Latino, Native American, and Asian American depictions produced today by nonwhite peoples, we might ask, why would whites concerned with racial justice *not* begin their examinations with their own racial representations? As bell hooks urges, it is time "for concerned folks, for righteous white people, to begin to fully explore the way white supremacy determines how they see the world, even as their actions are not informed by the type of racial prejudice that promotes overt discrimination and separation."[8]

For hooks and contemporary scholars of race, whiteness is clearly not a natural identity rooted in our genes but a malleable social product. Notwithstanding how the many historians of whiteness choose to define it—through its effects (as a kind of violence, blindness, or entitlement), through its secondary characteristics (as self-regulation, control, or rigidity), or as a coherent entity (such as a form of property or a self-perpetuating discourse or structure)—all share a belief in its artificiality.[9] Virtually every study of whiteness opens with the academic commonplace that there are no significant genetic distinctions between the races, and that our system of racial classification is an invention of the West. The melanin concentrations that Americans read as signs of racial belonging may be genetically grounded, but as academics routinely point out, there is

no *biological* reason to group human populations according to skin color. While color is a culturally significant sign for separating various human populations, researchers have long maintained that there is no more logic to this demarcation of race than there would be in fixing a racial order based on other genetic patterns, such as eye color, balding patterns, or lactose intolerance. Americans who trace their earliest-known ancestors to Kenya are likely to be darker than those whose origins are in Norway, but we know that there is as much genetic variation within the "black" and "white" races as between them.[10] As James Baldwin famously remarked, "Color is not a human or a personal reality; it is a political reality."[11]

Politically progressive scientists and historians have embraced the concept of race as a social product, in part, because it so effectively discredits group claims for racial superiority. Even casual students of history will appreciate the racial impetus behind some of the twentieth century's most infamous acts of genocide—against Armenians in Turkey (1915–18, 1920–23), Jews in Europe (1941–45), ethnic Vietnamese and Chinese in Cambodia (1975–79), Kurds in Iraq (1988), Tutsis in Rwanda (1994), Muslims in Srebrenica (1995), and black Africans in Darfur, Sudan (2004–). Given the frequent rationalization of laws, policies, prejudices, and crimes by reference to "innate" and "natural" differences between human groups, it is no wonder that we are attracted to imagining that all begin life with an identical biological base. But those who argue for our social construction, finding the evidence for human equality in genetic sameness, ironically ally themselves with those who support racial hierarchies, to the extent that each group adheres to identity models grounded in biological determinism. For social constructivists, genetic homogeneity ensures racial equality, while for biological determinists, genetic difference produces racial hierarchy.[12] In both cases, genes are the base dictating the shape of racial superstructures. The stance of social constructivists has the added effect of leaving their arguments vulnerable to advances in genetic analysis, for should improved technology allow scientists to discover consistent genetic signatures separating racial groups, the rationale for racial equality would appear open to attack. Such concerns are more than hypothetical, given that recent progress in genomic research has begun to chip away at the orthodoxy that genes are unconnected to racial divisions.

In 2002 a group of American, French, and Russian researchers developed a technique for accurately determining an individual's place of genetic origin, reliably grouping their test subjects into one of five geographic regions based on an examination of correspondences in their genomes. While the researchers were careful not to invoke the loaded label of "race" in their published report, their geographic zones closely correspond to popular racial categories, dividing the world's population by descent into African, Eurasian (European and Middle Eastern), East Asian, Oceanic, and American.[13] Their work is complemented by that of Steven Pinker, a psychologist of language, who argues that academics have consistently suppressed evidence of how genes shape human be-

havior, for fear of undermining cherished principles of equality under law. For Pinker, scientific analysis of the links between certain social behaviors, innate abilities, and biology need not bring about conflict with our moral value system. Committed to legal equality, and unconvinced by the sensationalistic arguments of Richard Hernstein and Charles Murray that the IQ "gap" between various races has a genetic component, Pinker nonetheless argues that particular elements of our makeup are hardwired into our genes.[14] Pinker's work focuses on general social behaviors (our drive for dominance, ethnocentrism, and moral sensibility) and abilities (our intuitive physics, spatial sense, and propensity for language), which he sees as innate in human beings, even as he leaves open the possibility that minor genetic distinctions between races might play a role in predisposing the individuals in racial groups to other subtle behaviors or abilities.[15]

To conclude that populations closed to outside groups for tens of thousands of years share a detectable genetic signature, or that some social behaviors and abilities might have a genetic tie, is a long way from declaring that Jews are genetically programmed for avarice or that blacks are naturally slothful. To acknowledge minor racial differences does not mean asserting racial superiority any more than accepting the existence of major genetic differences between the sexes necessarily entails an argument for the superiority of either females or males. To be sure, innate differences are routinely noted in support of claims for the supremacy of one sex over the other, but corresponding assertions are also made for various races, despite forty-odd years of academic rhetoric stressing the social nature of racial divisions. Whether human beings are ultimately shaped by society, biology, or some combination of the two, racial justice is a moral imperative that must not hinge on the vicissitudes of popular or scientific identity theories. As Pinker writes, "The case against bigotry is not a factual claim that humans are biologically indistinguishable. It is a moral stance that condemns judging an *individual* according to the average traits of certain *groups* to which the individual belongs."[16]

Whether or not our racial divisions are linked to biology, it is inarguable that our experience of race is shaped predominantly in the social field. Academics in recent decades have produced an impressive corpus of research detailing the fluid borders of whiteness during the past three hundred years. We know from the work of historians that Protestant European-Americans deemed Irish Catholics racially inferior into the final third of the nineteenth century and that they rejected Jews as their racial equals up through the middle of the twentieth.[17] From legal scholars we have learned that, beginning in the last two decades of the nineteenth century, numerous immigrants went to court asking to be designated white so that they might become naturalized citizens of the United States. Between 1790, when naturalization was limited to "free white persons," and 1952, when overtly racial criteria for citizenship were dropped, scores of immigrants turned to the courts in the hope of being declared white. Citing a bewildering array of contradictory rationales, including scientific evidence, common knowledge, congressional in-

tent, and legal precedent, federal and even Supreme Court judges shifted racial borders by extending white identity to individuals from Mexico and Armenia, and at times to those from Syria, India, and Arabia.[18] In opinions that show no awareness of the ways in which their collective efforts shaped race as a social and legal fiction, U.S. judges worked diligently to secure what they took as the natural borders of race.

Given both the potential dangers of linking moral claims for equality to social definitions of race and our understanding that socially produced criteria have historically guided American racial thought and policy, it makes little sense for scholars in the humanities and social sciences to wade into debates on correspondences between genetic markers and modern racial definitions. Biology should concern historians only to the extent that *perceptions* of biological makeup have consistently produced social definitions of race. Biology in early twentieth-century America was wedded to race by ethnic (and at times religious and even political) ties, taken as signs of an individual's immutable biology and so determining who could be classified white. As we shall see, the discourses and structures of American society encouraged both whites and nonwhites to embrace a white perspective on the world (that naturalized the perquisites of European-Americans), even as fluctuating perceptions of biological identity severely restricted who might and might not enjoy the benefits of being labeled white.

The chapters that follow take seriously the importance of situating racial identities in social context. Each analyzes how the borders of whiteness have expanded and contracted over time and outlines the structural and discursive forces that made such changes possible. Each considers how shifting definitions of whiteness presented opportunities and perils for Native American, African American, and European-American peoples. Yet, the chapters are more concerned to illustrate the material consequences that result from being white than to trace the fluid boundaries of whiteness. I claim that acceptance of whiteness conditions the sight, beliefs, and actions of European-Americans, thus naturalizing their sense of entitlement, but more significant, I argue that this racialized value system led European-Americans to interpret their art in decidedly racial terms. By the end of the nineteenth century, the perspective that came with being white was sufficiently ingrained in the European-American mind that it consistently structured whites' interpretations of the visual world.

I claim that racial thinking has long infected how European-Americans view and respond to their environments, but do not insist that everything in America is always about race. The distinction is significant. In analyzing visual texts that contain no links to racial subjects (and often no sign of human beings), I illustrate how whites used the logic of race as a powerful, comforting mold for casting both human products and the natural environment into recognizable forms. As my chapters demonstrate, genre paintings depicting white farmers, landscape photographs of the western frontier, fine arts museums, and early action films were made intelligible in part through racialized viewing prac-

tices of which European-Americans were utterly unaware. Although whites did not see race as an issue in any of my primary texts, they nevertheless responded to the works in ways that betrayed their investment in being white.

Sight Unseen radically shifts the boundary of what counts as "racial" by refusing to confine its inquiry to texts containing obvious racial themes. Politically progressive studies of art that expose European-American investment in racial hierarchies center on the depictions of white and nonwhite peoples, aiming to end their unequal treatment in art. Over time, such analyses have had the unintended effect of equating the narratives of art with identity formation, racial symptoms with the illness itself. Since altering how whites and nonwhites are represented cannot by itself cause (or cure) racial inequalities rooted in structural and discursive systems, it is essential that racial studies probe beneath the narrative surface of images. Only by unearthing both the operational logic of race and its manner of guiding the interpretation of our visual world may we come to comprehend, and potentially dislodge, its power in American culture.

Somewhat uneasily, I refer throughout the text to those Americans classified as white as European-American. I do this to distinguish whites in the Americas from those in Europe but also to produce a term that parallels the terms "African American," "Asian American," and "Native American." To disrupt the apparent self-evidence of what the term "white" signifies, I elect to employ a clunky alternative that embodies the messy and contradictory ways in which modern racial divisions are produced. This decision presents some obvious difficulties, given that all people from Europe residing in the United States were not accorded equal claim to status as white. But even such a difficulty presents certain advantages, for in those cases where I am forced to distinguish between, say, Protestant and Jewish European-Americans, the needed adjectives compel readers to confront the inconsistent and historically contingent nature of racial definition. Because the term "white" occludes contradictions that are unavoidable in the phrase "Catholic European-American," it is ultimately less useful to my project. Its neatness is something of a liability in a study devoted to exploring how race works. The picture of whiteness that emerges in this book reflects, in part, the legal definitions mandated by Congress and policed by the nation's courts. But it is primarily a representation of cultural understandings of who is and who is not white, and of the shifting hierarchy that exists within the white race. The apparent clarity with which legal definitions purport to divide black from white flattens the lived reality of many Americans, given that the legal designation "white" has never guaranteed equal treatment under the law, never mind social or economic equality, for those whose whiteness is less culturally secure.

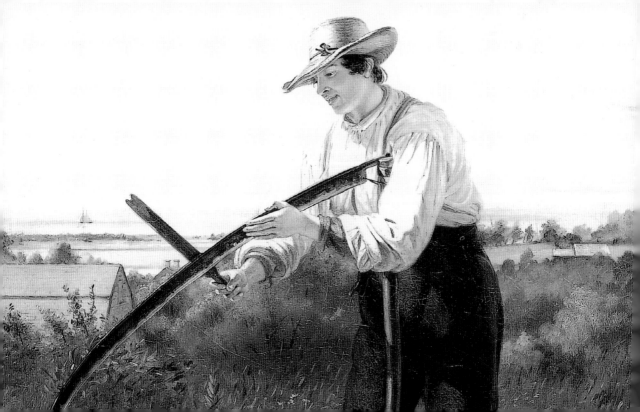

GENRE PAINTING AND THE FOUNDATIONS OF MODERN RACE

I n a lengthy tribute to William Sidney Mount (1807–68) in 1851, the critic Alfred Jones lauded the painter's honest treatment of American racial types. Jones showed considerable interest in exploring both black and white identity in Mount's works, though, revealingly, he found racial themes at play only in those canvases that included blacks. For Jones and his European-American contemporaries, an African American presence was required to think through the racial identity of those categorized as black, but it was also necessary for considering the racial designation of those deemed white. As period responses to the European-American laborers in *Farmers' Nooning* (1836; fig. 1) make clear, the protagonists owed their whiteness to the presence of a black. For Jones, the scene provided a "perfect transcript" of life, documenting "how lazily lolls the sleeping Negro on the hay [while] the white farmers are naturally disposed about with their farming implements."[1] The nonwhite figure cued the critic to invoke a series of binaries (lazy and industrious, asleep and awake, black and white), which gave to whiteness tangible, visible traits. In European-American culture, nonwhites have historically functioned as racial catalysts, transforming whites from individual human figures into symbols of an otherwise unmarked race.[2]

Mount's *Boys Caught Napping in a Field* (1848; fig. 2) depicts a similar rural scene of midday ease, yet lacking a nonwhite figure, it had nothing overt to say about race. Whereas the African American of *Farmers' Nooning* is entitled to rest during his lunchtime break, the white youths in *Boys Caught Napping* are clearly shirking their responsibilities. Even without the aid of its title, the canvas's visual evidence presents us with

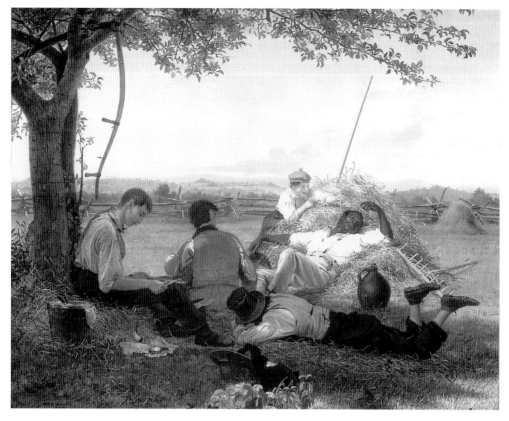

FIGURE 1 William Sidney Mount, *Farmers' Nooning*, 1836. Oil on canvas, 51.44 × 62.23 cm. The Long Island Museum of American Art, History & Carriages, Stony Brook, NY. Gift of Frederick Sturges Jr., 1954.

obvious signs of their failings. A discarded pitchfork is displayed prominently in the center foreground, and a deck of cards—long a symbol of gambling and, hence, vice—spills from the cap of the central youth. Despite these signs of dereliction, European-American audiences were not led to reflect on the racial fitness of the boys. The same viewers who saw the African American protagonist of *Farmers' Nooning* as a sign for an inferior race took the white miscreants of *Boys Caught Napping* as individuals, who apparently revealed little about their racial group. An anonymous critic describing the scene's allure to European-American viewers in 1848 noted how "we . . . look with feelings of regret somewhat akin to envy at the delicious indolence of the boys *Caught Napping* who bask under the shady trees and are troubled by no care or anxiety."[3] Far from

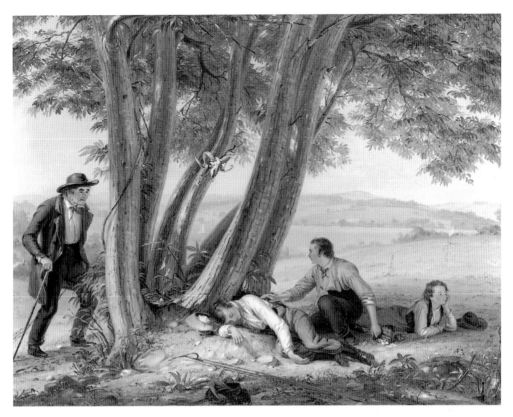

FIGURE 2 William Sidney Mount, *Boys Caught Napping in a Field*, 1848. Oil on canvas, 73.66 × 91.44 cm. The Brooklyn Museum of Art. Dick S. Ramsey Fund 39.608.

offering an exposé of white idleness, the canvas presented viewers with a nostalgic ode on the pleasures of (white) boyhood.

European-Americans overwhelmingly accepted the existence of a racial opposition between black sloth and white industry, yet they were nonetheless able to view the white youths' "delicious indolence" in *Boys Caught Napping* as an appealing trait. This suggested no paradox to European-American audiences. Without an African American presence to activate racial binaries or to transform whites into symbols of their race, viewers interpreted the youths as lazy individuals who just happened to be white. Because no ideological context existed then to taint European-Americans' perceptions of their race, the social or economic implications of whites who acted in seemingly unwhite ways were limited. It was not simply that European-Americans overlooked the indolence of the youths, but that they viewed their laziness in positive terms. Virtually identical actions

confirmed both the innate "laziness" of blacks and the "delicious" quality of white boyhood. So ingrained was this racial asymmetry that the obviously European-American laborer lounging in the right foreground of *Farmers' Nooning* did nothing to disrupt the racialized binary of indolence and industry that critics saw as central to the work.

The historical inability of European-Americans to see whiteness at work entails considerable costs. These are evident in the economic, political, and judicial inequities suffered by nonwhite peoples—already touched on in the introduction and to be detailed in the chapters that follow—and in less-often-remarked-upon biases that impair our ability to account for the lived complexity of race. Prior to analyzing the racial investment of European-Americans in late nineteenth-century painting, this chapter accounts for how current art historical biases necessarily skew the analysis of whiteness; it then proffers a three-step formula for analyzing race that takes into account the historically contingent processes by which we read meaning from visual texts. Convinced that discourses circulating outside art objects circumscribe their significance, I begin my study by analyzing the dominant discourses that established the parameters for what visual texts might mean, before attending to the visual evidence of the art. Since acknowledgment of the social utility in examining whiteness is some distance from developing a practical model for its analysis, this chapter lays out a legible road map for approaching race in the visual arts, establishing the route for the chapters that follow.

It should come as no surprise that a culture blind to whiteness developed similarly oblivious art historical methods.[4] All methods are fashioned from distinct perspectives and priorities, each with an internal logic. Such logic ensures that methods have built-in blind spots, at times because various issues are deemed extraneous to the central inquiry, but also because they may not even register as issues: empiricist approaches tend to miss the cultural relativism of truths; Marxist methods, the dynamics of gender; and structuralist inquiries, the notion of agency. Because the off-the-shelf methods available to Americanists were forged in a culture unattuned to whiteness, they all possess deficiencies for the analysis of race. At their best, our standard methods serve as a blunt tool for examining race; at their worst, they simply confirm the impression of most Americans that nothing new or remarkable can be learned about individuals labeled white.

Our methods impede the study of race by internalizing the racial blindness characteristic of our society; they then compound the problem through their visual determinacy. Because virtually all methods root their inquiries in the visual evidence of artworks, they participate in an endless feedback loop: methods that privilege visual evidence combine with our cultural blindness to whiteness to ensure that texts containing only white people—or those containing no figures at all—have nothing to say about race. This visual determinacy is endemic to our methodological landscape, for although Americanists today employ a range of approaches, virtually every one is anchored first in the visual

register. Even approaches typically taken as polar opposites in American art history—formal and contextual methods—support my claim.

Formalists believe in the autonomy and primacy in art of line, color, texture, and, in some instances, representation. Contextualists, in turn, see art as inextricably linked to culture; they believe that no understanding of the fine arts is possible without a thorough grounding in the economic, political, philosophical, and religious underpinnings of a society. If these are the strict definitions, the practice of Americanists is considerably less clear-cut, for the boundaries between camps frequently blur, and formal and contextual approaches both continually evolve in response to ongoing disciplinary debates. Claims made for the supposed primacy of form are frequently used by formalists to support broader claims for other artworks and American culture. Similarly, contextualists routinely promote the sociology of art—that is, while paying attention to the context provided by external social forces, use art to understand society. They explain how social forces guide what art gets made and how and consider what that art, in turn, says about our values. To my mind, the most politically responsible scholarship produced by members of each camp seizes on the potential of art to illuminate culture, with formalists focused on the art itself, and contextualists more concerned with factors external to the art object.

The formalists' privileging of visual evidence offers many advantages for the study of visual culture, including attention to the materiality of art and a corresponding insistence on not reflexively subordinating visual to text-based evidence. It also presents serious drawbacks. To ground the meaning of an artifact in its visual evidence exaggerates the power of art objects, limits our ability to see the range of cultural work performed by art, and in the case of racial inquiries, predisposes us to overlook whiteness by ensuring that we root our analysis in what is readily seen. Certainly the artifacts of a given society constitute a material residue of that culture's past, but an investment in the object, coupled with a general reticence to see any art as simply a mirror of social values, leads many formalist scholars to overstate the cultural impact of artifacts. Studies that stress the primacy of visual evidence make it difficult to read an artwork as an intellectual dead end or a mere reflection of dominant norms. The tendency is always to interpret artworks as proactive, counterhegemonic, and anticipating future trends. The investment in close looking—and, hence, in a privileged object—enshrines each work as a rare and singular artifact.

Reliance on "visual evidence" entails other risks as well. In many such studies there is an underlying assumption that what we see in an artwork as "obvious," "significant," or "strange," or even what we take to be the work's primary narrative, was read in a similar way by the work's original viewers. Close looking helps us understand the original culture only if we can accept vision as a self-evident and unchanging route to knowledge; but as a number of scholars—from art historians to neurobiologists—have con-

vincingly argued, human vision is contingent on historical context.[5] We cannot approximate the viewing experience of a canvas's original audience in the nineteenth century, because of how our historical moment conditions our sight. Frederic Edwin Church, working in nineteenth-century America, and Fan K'uan, painting in eleventh-century China, each impressed his countrymen with his "truthful" depictions of the natural world (figs. 3, 4). Notwithstanding the penchant of these artists for selectively combining natural forms in their compositions and for using subjective representational systems, these paintings were taken as veritable transcripts of nature. Readers will instantly appreciate the futility of debating the relative truthfulness of the depictions, given the dissimilar value systems informing the creation of these two works. Whereas Fan's contemporaries valued his ability to conjure up the internal essence of nature, Church's audiences prized his photograph-like replication of external forms. If one considers "truthful" those scenes rendered in parallel perspective, with objects viewed frontally from a constantly shifting rather than a fixed vantage, and with light eliminated as an external organizing principle, then Fan's work is clearly superior. If, in contrast, one values linear perspective, with additive forms organized by an external light source, and photographic rendering of detail, then Church's work is more satisfying.[6] One's evaluation of the landscapes' veracity indicates reasonably well the cultural system that dominates one's worldview.

The differences in culture and vision between eleventh-century China and twenty-first-century America make it impossible for us to ground arguments about Fan's art and society in the *visible* evidence of his painting; we cannot see what the artist and his contemporaries saw. Without claiming that it is impossible to learn a new way of seeing more in keeping with Fan's, I nonetheless believe that a study rooted in the formal elements of a canvas will lead mostly to insights on the modern critics who do the looking. If the gulf between us and the Victorian era is less than that between us and the Sung dynasty, still the cultural divide remains significant. Since realist novels and sentimental paintings are still produced today, our conversancy with the artistic forms of the Gilded Age masks the significance of the altered social context in which such forms are read. The problem is only exacerbated by the long-standing American penchant for naturalistic art. Because the art of Victorian America minutely reproduces our modern sense of sight, it is easy to downplay the changes separating us from the Gilded Age. Familiar genres and naturalistic renderings serve to cloak more than a century of change. Although the best formalist studies are always careful to move beyond the visual evidence of an isolated artwork—taking into account an eclectic array of historical evidence in their analyses— the bedrock insistence that visual evidence establish the direction of inquiry diminishes the likelihood of producing readings that counter what our modern eyes can "see."

On one level, our experience of nineteenth-century art differs from that of Victorian Americans because of the cultural work that the texts themselves performed. In *Hard Facts: Setting and Form in the American Novel*, Philip Fisher argues that the experience

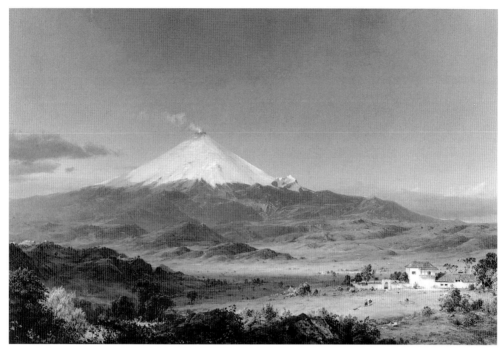

FIGURE 3 Frederic Edwin Church, *Cotopaxi*, 1855. Oil on canvas, 71.1 × 106.8 cm. Smithsonian American Art Museum, Washington, DC. Gift of Mrs. Frank R. McCoy.

of modern-day audiences reading *Uncle Tom's Cabin* (1852) cannot replicate that of readers in the 1850s because of the ways in which the novel has altered American culture. By leading white readers to experience the emotion of black characters, and thus perceive their humanity, *Uncle Tom's Cabin* counterbalanced the indifference and cruelty to which blacks were subject in antebellum society. But, as Fisher notes, the triumph of the novel's humanizing strategy has meant that present-day readers confront the sentimental ethos of a text that no longer has anything to balance. The novel (in conjunction with a host of other period texts) has done its work so well—obliterating that which it was created to refute—that we can no longer experience it as an antidote to a poisonous ideology. We can and do recognize the dehumanizing context in which the novel first circulated, but it is difficult to conceive how we might ground our understanding of it in the formal properties of the text and yet experience *Uncle Tom's Cabin* in a manner approaching that of antebellum audiences.[7]

On a more elemental level, cultural trends having little to do with artworks per se distort our modern experience of nineteenth-century texts. Broad cultural shifts unrelated

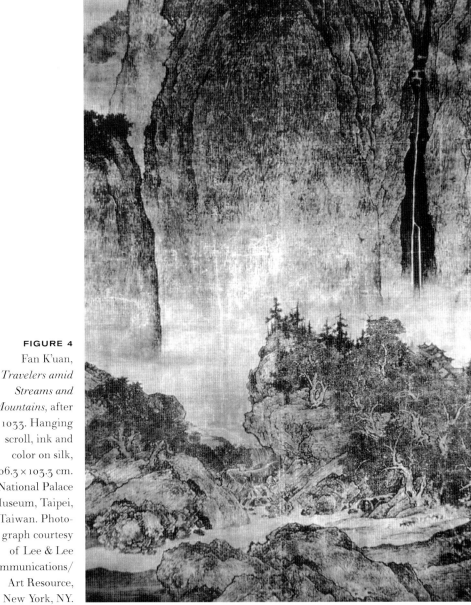

FIGURE 4
Fan K'uan,
*Travelers amid
Streams and
Mountains*, after
1033. Hanging
scroll, ink and
color on silk,
206.3 × 103.3 cm.
National Palace
Museum, Taipei,
Taiwan. Photo-
graph courtesy
of Lee & Lee
Communications/
Art Resource,
New York, NY.

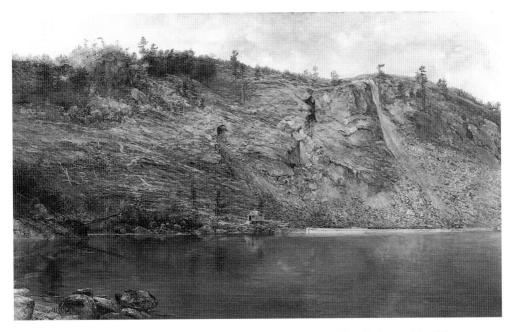

FIGURE 5 Homer Dodge Martin, *The Iron Mine, Port Henry, New York*, ca. 1862. Oil on canvas, 76.5 × 127 cm. Smithsonian American Art Museum, Washington, DC. Gift of William T. Evans.

to the history of art couple with close looking to encourage the overlay of contemporary narratives on historical artifacts. Cultural determinacy leads formalist viewers of Homer Dodge Martin's *Iron Mine, Port Henry, New York* (ca. 1862; fig. 5), for example, to see the painting through the lens of contemporary environmentalism. Audiences today, molded by decades of modern conservationist rhetoric—from Rachel Carson's *Silent Spring* (1962) to Al Gore's *Earth in the Balance* (1992)—doubtless focus on deforestation and erosion as evidence of industry's degradation of the land, though Martin's contemporaries most likely saw a very different scene.[8] Midcentury Americans overwhelmingly shared an optimistic attitude toward development, believing in the potential compatibility of industry and nature and in the resilience of the natural world. Many of the nineteenth-century painters and photographers who are taken today as advocates of wilderness protection also produced canvases that championed the development of the land. As the art historian Nicolai Cikovsky Jr. reminds us, George Inness saw no inconsistency in creating scenes of untrammeled nature at the same time that he celebrated the railroad's transformation of the Lackawanna Valley (fig. 6).[9]

In a posthumous tribute to Martin after his sudden death in 1897, the art historian John C. Van Dyke noted critics' universal appreciation of Martin's "landscapes . . . deserted

of man, that were silent, forsaken places," before praising the painter's unique ability to capture nature's "normal condition [of] repose." Pointing to disruptions of nature caused by storms, volcanoes, and earthquakes, and to those precipitated by human beings, Van Dyke characterized such disturbances as "mere accidents from which nature straightway recovers. . . . After they have passed, nature once more returns to herself. She is ruffled for a moment and then only in a small localized area."[10] Whereas to modern audiences the scraggly trees at the borders of Martin's denuded hillside represent the pathos of the land's destruction, for Van Dyke and his contemporaries they surely signaled nature's reclamation of a landscape seemingly abandoned by human beings. What we are conditioned to see as a scene of ruin, Victorians could appreciate as an image of rebirth.

In significant ways, the problems with formalist art historical methods I have enumerated might seem to be overcome by the contextualists' distinctive approach. By emphasizing the context surrounding the production of artworks and by downplaying the centrality of visual evidence, contextual art historians reduce the risk of projecting personal or cultural biases on historical artifacts. But the approach of contextualists is strangely menaced by visual determinism, for although their theoretical position may downplay the role of formal properties, their practice of art history is surprisingly attentive to visual evidence. Contextualists rarely ignore the formal attributes of an artwork that contribute to its narrative, subject matter, style, and color, considering only its history of production and reception, or its medium. In determining which contexts are

worthy of analysis, contextual historians necessarily consider what artworks depict. Thus, at an early stage of analysis, contextualists buy into the representational systems of art, taking the subjects of illusionary scenes as meaningful to their inquiries. This investment in the primacy of vision may strike some readers as a rather strained link between formalists and contextualists, but I want to make a case for its significance in circumscribing the meanings contextual studies of art produce.

It is less consequential that contextual inquiries quickly move beyond formal properties than that they start there, for by acknowledging form researchers delimit the range of social factors deemed "appropriate" for discussion. The analyses of patronage, academic training, and markets will always be relevant, but I am interested in scholars' decisions to select additional contextual frames invariably based on visual information and that, in studies of nineteenth-century American art, almost always involve some consideration of narrative. Although it seems reasonable that a landscape painting encourages a contextualist's analysis of environmental issues, or a film about shoppers raises issues of consumerism, these connections by their very obviousness, which suggest themselves to every scholar and member of the public who but glances at the artwork, preclude the consideration of other, less obvious, contexts.

Late twentieth-century scholarship on Mount exemplifies the contextualists' de facto reliance on visual evidence. Since the 1970s social historical readings that argue for the works' bold assertions of the artist's party politics have supplanted the standard interpretations of his images as sleepy vignettes of country life. Art historians, to recuperate allegorical readings that were widely understood during the artist's lifetime, have concentrated on the works' pictorialization of contemporary slang, market philosophies, and political slogans. Beginning with Joseph Hudson's trailblazing study of *Cider Making* (1841; fig. 7) as an allegory of William Henry Harrison's successful "log cabin and hard cider" presidential campaign of 1840, through Elizabeth Johns's influential analysis of *Farmers' Nooning* (see fig. 1) as a cautionary note on foreign-born agitators "tickling the ears" of African Americans, and thus providing them with unrealistic expectations of abolition's benefits, contextual art historians have grounded elaborate readings of Mount's works on the paintings' visual cues.[11]

Allegorical interpretations serve important cultural functions for contemporary art historians. By rooting meaning in coded signs consciously crafted by the artist, the readings both express a firmly held belief in artistic agency and affirm meaning as singular, lucid, and recoverable with sufficient research. But an allegorical approach entails significant drawbacks: it disregards the reception of art by heterogeneous audiences who may or may not have known the artist's overt design; it slights the works' complexity and play; it creates a static picture of the paintings, downplaying the ways in which meanings change over time; and, most significant, it ignores the most elemental meanings, which have nothing to do with conscious intent.

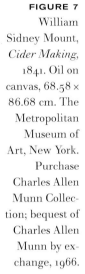

FIGURE 7
William
Sidney Mount,
Cider Making,
1841. Oil on
canvas, 68.58 ×
86.68 cm. The
Metropolitan
Museum of
Art, New York.
Purchase
Charles Allen
Munn Collec-
tion; bequest of
Charles Allen
Munn by ex-
change, 1966.

Even scholars who resist explicating allegories display the tendency to read into paint-
ings the most frequently voiced concerns of the decade in which they were produced.
Scholars are inclined to characterize any image produced between 1861 and 1865, how-
ever an artist's patrons or public received it, as at least an unselfconscious reference to
the Civil War. On one hand, this makes perfect sense, for how could cultural products
created during a national trauma *not* relate to the conflict on some level? On the other
hand, surely there is something too pat about our reflexive conclusion that if it is the
1860s, the issue must be the Civil War; if the 1830s, Andrew Jackson's bank war; if the
1890s, the Jim Crow era, or at least the closing of the western frontier.

Although methods privileging visual evidence are sure to uncover narratives prompted
by an artwork's formal properties, they are destined to overlook more basic meanings
generated by invisible discourses circulating in the common culture. These shared dis-
courses help animate the meaning of art, because those of us who produce and inter-
pret art have our vision partially structured by discourses whose cultural work precedes—
and need not be activated by—individual artworks. As counterintuitive as it might sound,
these invisible discourses are more revealing of a culture than its artworks, given their
unobtrusive work in establishing limits on the range of meanings that a text, and a cul-
ture, might produce. To reconstruct the meanings of visual artifacts for their original

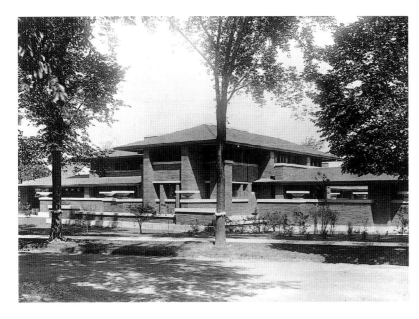

FIGURE 8
Frank Lloyd
Wright, Dar-
win Martin
House, 1904–6.
Buffalo, NY.
University
Archives
Collection,
SUNY Buffalo.

audiences, then, we must ask what the works were *not* about, focusing on unseen dis-
courses that no amount of looking can tease out. I do not recommend that if the dom-
inant discourses Mount's contemporaries sensed in *Farmers' Nooning* relate to abolition,
agrarianism, or labor politics, we now arbitrarily tie the canvas to gender relations, merely
for the sake of producing a counterreading. But once we have acknowledged that power-
ful unseen discourses circulating in society play a significant role in determining how an
artwork gets seen, it is imperative to visualize the discourses these artworks fail to depict.

Although discourse is popularly conceived as a coherent set of beliefs on a subject or
theme, it is understood herein in Foucauldian terms—as a well-defined body of social
knowledge. The discourse of race, for example, is composed of many ideologically ir-
reconcilable beliefs, unified only by our acceptance of arbitrary boundaries on the state-
ments and the debates that may proceed under its rubric. Powerful yet seldom-remarked-
upon discursive boundaries allow me to refer to Frank Lloyd Wright's Darwin Martin
House (fig. 8) as "a successful example of the architect's mature prairie house style, with
his signature cantilevered roof" and to contend that it "makes appropriate use of such
modern materials as concrete, glass, and steel in ways that exemplify the modern era,"
but also to claim that "it is a spacious six-bedroom home on a generous corner lot, con-
taining original woodwork, updated kitchen, and a new roof." It is easy to distinguish
the passage in the academic style of an architectural critic from that in the commercial
language of a sales agent, for each description adheres to the disciplinary rules of its

profession. In each example, a discursive logic establishes the parameters for appropri-
ate thought and speech long before the first descriptive phrase is uttered.[12]

My approach to visual analysis sees meaning shaped by the complex interaction of
discourses—those that circulate invisibly in the common culture, others prompted by
general themes of an artwork, and those arising from the unique formal properties of
the work. Dominant cultural discourses residing in viewers interact with a range of sec-
ondary discourses suggested by the work's subject matter and media to establish the out-
side boundaries for what the artwork might mean. This initial discursive interaction de-
marcates the range of possible meaning, without dictating the specific interpretations
at which audiences will arrive. Once outside limits of potential meaning are established,
discourses prompted by particular narrative and material attributes of a singular object
further narrow the range of meaning. To put this another way, free-floating invisible
discourses (flowing through socialized human beings) interact with thematic discourses
(arising from the artwork's medium, general subject, and display venue) to demarcate
the parameters of potential meaning; then specific discourses arising from formal evi-
dence (stylistic and narrative qualities specific to a unique material object) constrict pos-
sible meanings down to a limited menu, which gives off the illusion of having sprung
organically from the artwork. My method for recovering the significance artworks held
for period audiences is based on this model of meaning's production in the visual arts.

While my selection of race as the significant external discourse guiding the mean-
ing of my chosen artworks may be interpreted as no less subjective than a structuralist's
discovery of racial binaries in the syntax of the image or a social historian's recovery of
racial allegory in its narrative, my approach differs from theirs in telling ways. Instead
of analyzing racial themes in images whose narratives suggest race, I apply whiteness
as a category of analysis to artifacts (paintings, as well as photographs, buildings, and
films) with no *visible* links to race. Concerned about the ways in which visual evidence
typically sets the trajectory of art historical inquiries, thus diminishing analyses by pre-
cluding those readings that do not jibe with what is currently seen, I have selected a cat-
egory of undeniable concern to nineteenth-century and early twentieth-century Amer-
icans, and then handpicked artifacts that appear removed from such concerns. My analysis
of art is not more sophisticated than that of other art historians, though it is undoubt-
edly more attuned to the investment of European-American audiences in racial patterns
of thought. In reading artworks against the grain of their visual evidence, *Sight Unseen*
concerns itself less with what artifacts mean than with how their meanings get produced.

To illuminate the complex philosophical and racial discourses that animated late nine-
teenth-century conceptions of race, and to make concrete my method of reading visual
evidence, consider what Mount's *Fair Exchange, No Robbery* (1865; fig. 9) meant to post-
bellum audiences. Completed toward the close of Mount's career, when his contempo-

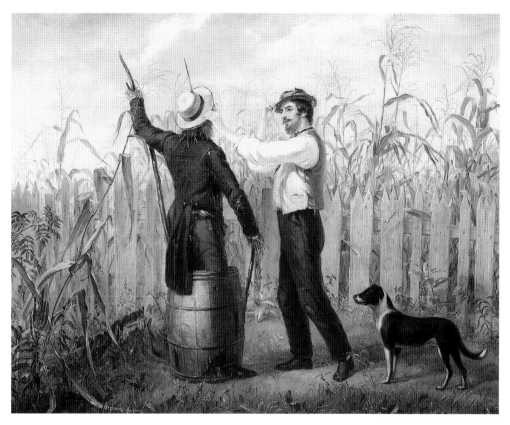

FIGURE 9 William Sidney Mount, *Fair Exchange, No Robbery*, 1865. Oil on panel, 64.77 × 83.82 cm. The Long Island Museum of American Art, History & Carriages, Stony Brook, NY. Gift of Mr. and Mrs. Ward Melville, 1958.

raries were increasingly convinced of his irrelevance to modern American art, the image follows in a long line of amusing genre scenes of country life that the artist had consistently turned out since the early 1830s. Against a backdrop of ripening corn, the mustachioed and goateed man at the center of the painting grips a hat in each hand, evidently in the process of swapping his own ragged hat for the scarecrow's more serviceable headgear (fig. 10). Because the exchange seems so obviously *unfair* by present-day standards—with the man simply taking what he desires—modern scholars have read the title as ironic. The historian Charles Colbert, writing in the late twentieth century, terms the canvas's exchange "decidedly unequal," claiming that the work offers a sardonic commentary on the relative value of the man's and the scarecrow's labor. According to Col-

bert, the scene contrasts the industry of the scarecrow, which successfully protects the cornfield from hungry birds, with the idleness of the man, whom he takes to be a feckless vagabond.[13]

The extent to which the exchange was deemed "fair" during the nineteenth century is suggested by an anonymous review of the work published in the *New York Herald* in 1871. For this critic, who refers to the work as *Swapping Hats* and *Exchange Is No Robbery*, it "represents a country man, who, while crossing a field of corn, finds—as is often the case in this world—that a blessing has alighted on a head which cannot appreciate it: he hastens to exchange his own well worn chapeau for the more presentable Panama of the scarecrow. The gratification occasioned by this piece of unlooked for good fortune is well depicted in the face of the young man."[14] Intertwined with the critic's assertion that the world is unfair, with "blessings" often going to those unable to appreciate them, is an understanding that the man's ability to value good fortune legitimates his swap of the hats. The exchange is fair not because the hats are equal in value, or even because the respective parties have freely agreed to the trade, but simply because the man getting the best deal appreciates his good fortune in a way that is obviously impossible for the scarecrow.

Merely by describing the exchange of hats in positive terms, the critic for the *Herald* reveals his unspoken belief in the protagonist's whiteness, for such appreciation and appropriation of material resources were then commonly understood as exclusively white prerogatives; the entitlement of whites has long been naturalized as a central principle of European-American culture. This interpretation may strike some readers as a heavy interpretive burden to place on a simple genre painting, with its illustration of an innocent swap of hats, but I claim not that the painting is *about* white entitlement but that the worldview of European-Americans ensured that the reception of the image was *structured* in such racialized terms. Whatever the subject of the painting for its creator or audience, European-Americans viewed it through the lens of white privilege. For nineteenth-century viewers, the exchange at the heart of the narrative tapped into a racialized discourse on property that legitimated fictional confiscations as trivial as that of a scarecrow's hat or, alternatively, real-world appropriations as consequential as those of Native Americans' land. At either extreme, the logic of whiteness rationalizes appropriating what belonged to those unprotected by a designation as "white."

When contemporary scholars address the historical eagerness of European-Americans to dispossess native peoples of their land, they often explain it as a consequence of the perceived failings of Native Americans. Because native populations were understood by European-Americans to lack Christian, democratic, capitalistic, and individualistic values, whites readily justified confiscating Indian property. Given the many native groups that accepted all the supposed trappings of European-American culture but were nonetheless dispossessed of their lands—the most obvious example being the Cherokee

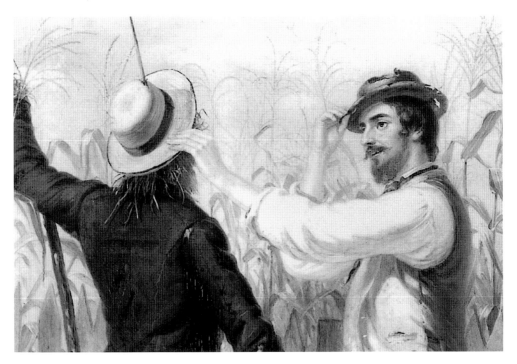

FIGURE 10 William Sidney Mount, detail of figure 9.

Nation, forced by the Indian Removal Act of 1830 to relocate west of the Mississippi River, despite the community's embrace of agriculture, Christianity, and Western-based systems of law and governance—such historians' explanations must be seen as merely partial. The Cherokees' fate was sealed not by their inability or unwillingness to acquire particular values or traits but by their designation as racially "other."

As the historian Ronald Sanders points out, Europeans and colonial Americans made sense of Indian identity by assigning Indians a nonwhite position along a racial axis that ran from "European" to "African." Having scant interest in understanding the value systems of indigenous peoples, European-Americans supplied them with an identity largely prefashioned out of old-world encounters with racial and religious others. The racial binaries that Europeans used to distinguish themselves from Africans (including industrious/lazy, controlled/wild, Christian/heathen, culture/nature, and white/black) gave them a framework for cementing the identities of indigenous peoples in the New World. Although the legal status of Indians fluctuated over the first century after contact, the immutability of racial categories fixed their initial designation as racially other. When it came to peoples designated as nonwhite, Europeans conveniently ignored how

the dominant signs of civilization and race were obviously cultural.[15] Americans stripped them of their land, even though the Cherokees adopted Western values and institutions, because perceptions of their difference ensured that Indians were viewed through a racialized frame that took for granted their inability to make proper use of, or appreciate, material resources.

Rationalizations for the confiscation of Indian land invariably focused on native failings. The justification John Winthrop, the first governor of the Massachusetts Bay Colony, laid out during the colonial era for appropriating native lands resonated with European-Americans for the next two and a half centuries: "That which lies common, and hath never beene replenished or subdued is free to any that possess and improve it." Winthrop argued that as for "the Natives in New England, they inclose no land, neither have they setled habytation, nor any tame Cattle to improve land by, and soe have no other but a Naturall Right to those Countries, soe as if we leave them sufficient for their use, we may lawfully take the rest."[16] Up through the end of the nineteenth century, most European-Americans accepted the prerogative of whites to seize unenclosed land, provided they fenced it and exploited its resources. As Theodore Roosevelt claimed, surveying American history at the turn of the twentieth century, "The settler and pioneer have at bottom had justice on their side; this great continent could not have been kept as nothing but a game preserve for squalid savages."[17]

European-American observers sympathetic to native claims seemed equally unable to separate themselves from the logic of white entitlement. Speaking to his Senate colleagues in 1830, during the fierce debate over the Indian removal bill, Senator Theodore Frelinghuysen of New Jersey roundly condemned President Jackson's legislation, yet he conceded that "when the increase of [white] population and the wants of mankind demand cultivation of the earth, a duty is thereby devolved upon the proprietors of large uncultivated regions, of devoting them to such useful purposes. But such appropriations are to be obtained by fair contract, and for reasonable compensation."[18] Despite being one of the Cherokee people's greatest advocates in the Senate, Frelinghuysen had internalized the racialized belief that whites had a right to appropriate land that they would make "useful." As the contemporary legal scholar Cheryl Harris notes in her analysis of whiteness, Indians and blacks were oppressed not by abstract definitions of race but by the material effect of such definitions interacting with conceptions of property.[19]

The general subject of *Fair Exchange, No Robbery* cued European-American viewers to tap into a discourse of property, so establishing the parameters for the significance of the work. But as we begin to see, the painting's meanings were produced by the interaction of the visible discourse of property and the invisible discourse of race. One discourse suggested by the image's subject matter was shaped by a second discourse, which was at issue simply because it resided in a broad cross section of Americans conditioned to privilege the values associated with whites. Modern readers can readily interpret as

an expression of white privilege the *Herald* critic's commentary on who can and cannot appreciate "blessings," for the issue of white entitlement continues to be relevant to contemporary European-Americans. To account for the conditioning of the nineteenth-century reception of the painting by other strands of racial discourse that no longer resonate with us today proves more difficult.

If nineteenth-century texts are to possess meanings that are not reducible to modern value systems, we need to recover discursive strands long since faded from view. Period commentary that strikes us as ambiguous, confused, or even banal must be analyzed for what it reveals of narratives that have lost their currency rather than dismissed as an insignificant idiosyncrasy of a critic or a culture. Consider, for instance, that the *Herald* critic who drew our attention to entitlement noted his belief that Mount's scarecrow was "quite equal to Hawthorne's *Feathertop*."[20] Invoking the title character of Nathaniel Hawthorne's short story "Feathertop: A Moralized Legend" (1852), the anonymous reviewer linked the painting to the most famous scarecrow in American fiction before L. Frank Baum's *Wonderful Wizard of Oz* (1900). While it is easy to gloss over the statement as a prosaic observation that both painter and writer depicted scarecrows, the cultural relevance of the assertion is rooted in what this "equality" meant for audiences in the early 1870s.

Hawthorne recounts the tale of a scarecrow, named Feathertop, created out of a pumpkin, broken wooden tools, straw, feathers, and threadbare clothes; he is filled with hundreds of empty stock phrases and is given life by a New England witch. Sent by his creator to court the daughter of a prominent judge in a nearby town, Feathertop projects an image of refinement, convincing nearly everyone he encounters of his aristocratic lineage. Despite his initial social success, the story closes with a distraught Feathertop taking his own life, having caught sight of his "true" reflection in a mirror and recognizing, as he explains to the witch, "the wretched, ragged, empty thing I am" (257). Readers today may be predisposed to accept a scarecrow built of straw, broken tools, and a pumpkin as a symbol for a "hollow man," with a pleasing surface but no depth, but Feathertop confounds such expectations by emerging as the story's deepest character in the author's most powerful *anti*allegorical tale.[21]

We learn that despite his motley makeup, the scarecrow has "more real substance" than ninety-nine out of a hundred men (249). Yet neither the townspeople who first encounter Feathertop nor the scarecrow himself can see beyond appearances to judge his real worth. In Hawthorne's short story perceptions are always misleading.[22] Just as the townspeople mistakenly judge the scarecrow as noble based on their "false" view of his finery and manners, so the scarecrow errs in finding himself worthless after glimpsing his "true" visage. Perhaps appropriately, then, we learn that Feathertop comes closest to "vindicating his claims to be . . . human" (257) at the moment he apprehends his reflection and misjudges his value. He is most human, then, *not* when he realizes his actual

worth but when he relies on a human value system that reads appearance as an index of worth. Harboring feelings "too tender [and] sensibilities too deep" (258) for this world, he takes his life only after *accepting* that a hollow scarecrow stands for a hollow man. He dies because of an investment in allegory that readers are meant to question.[23] Much as with Mount, Hawthorne's appellation as an allegorical artist promotes a narrow, restrictive understanding of his work.

It is intriguing that the *Herald* critic links the works, given that twenty-first-century audiences are likely to note significant contrasts between short story and painting. Whereas "Feathertop" conjures up a messy, fluid universe where external signs stand in a complex relation to inner worth, modern scholars consistently read *Fair Exchange, No Robbery* as depicting a stable, positivistic world.[24] Recently scholars have explained the painting as a period allegory of President Andrew Johnson's political jockeying during Reconstruction and as a pictorial jibe at a much-mocked community of Long Island anarchists; both readings assume that the painting conveyed a straightforward message, readily decoded by the artist's contemporaries.[25] But such positivistic interpretations of Mount's work bring us no closer to understanding how the nineteenth-century critic linked it to Hawthorne's inscrutable tale.

The critic saw the "equality" of graphic and literary scarecrows because of the philosophical and racial context through which the depictions were filtered in the 1870s—not the similarities in narrative or subject matter, shared use of allegorical conceits, or political views common to the artists. Despite being the products of distinctive ideological contexts, painting and story were drawn together and framed by anxious metaphysical debates then gripping postbellum society. The philosophical ascendancy of idealism over older empiricist paradigms, and the adjustments in racial definition that the emergent worldview fostered, combined with the internal evidence of the works to argue for more equality than difference in the scarecrows. To appreciate how such debates transformed *Fair Exchange, No Robbery*, consider first the intellectual and racial ground out of which Mount's art developed. Born in 1807 into the early republic, Mount came of age at a time when empiricist thought retained a strong grip on American political and social culture. Driven by a core belief in human rationality and in the possibility of free choice, empiricist thinkers—such as Locke, Voltaire, Hume, Paine, and Jefferson—provided the intellectual foundations for the new democracy. They articulated both the rights of man and a cogent rationale for rebellion against a tyrannical regime.[26] But more relevant to a study of American race is the common view that the egalitarian impulses of empiricist thinkers that nurtured democratic political reforms also played a sizable role in improving the racial climate in the West. According to a host of scholars, empiricism helped break down rationalizations for both slavery and the essentialist concepts of race that supported its imposition.[27]

Scholars advancing this thesis turn naturally to the writings of John Locke, one of

empiricism's most eloquent advocates, who famously wrote in his *Two Treatises of Government* (1690), "Slavery is so vile and miserable an Estate of Man, and so directly opposed to the generous Temper and Courage of our Nation; that 'tis hardly to be conceived that an *Englishman*, much less a *Gentleman*, should plead for't." Not only did Locke argue against the institution of slavery, but, as his many admirers suggest, his philosophy helped lay the foundation for racial classifications uncoupled from physiognomy. Rejecting older philosophical systems that accepted the concept of innate ideas, Locke maintained that human beings begin life as a blank slate to be filled by experience, not biology. Historically, liberals have read Locke's concept of the blank slate to support a behaviorist notion of identity, seen to support human equality and individual freedom.[28] The philosopher Kay Squadrito, for example, claims that "Locke's *tabula rasa* hastened acceptance of the view that blacks are not congenitally inferior to whites." She argues that "the empiricist polemic against innatism resulted in stress being placed on environmental factors which contribute to differences between races as opposed to purported congenital differences."[29]

But given the insights of revisionist scholars over the past few decades, we cannot simply link empiricism, and Locke's philosophy in particular, to egalitarian reforms. The man who labeled slavery "vile and miserable," oddly enough, also invested in slaving companies, authored the colonial Carolina charter enshrining the rights of slave owners, and reasoned that the European ability to make productive, agricultural use of Indian "waste" land allowed for the dismissal of native titles.[30] Those wishing to shield Locke from the taint of racism tend to interpret the philosopher's ties to slavery either as ideologically inconsistent or as a tortured application of his philosophy.[31]

The philosopher Harry Bracken, however, takes a different, more pragmatic approach to Locke. Noting the rise of modern theories of race during the seventeenth and eighteenth centuries, Locke's own complicity in the slave trade, and the "remarkable" acceptance and popularity of empiricism over the past several centuries, Bracken suggests that empiricism helped lay the foundations for modern conceptions of race.[32] Although some of the world's oldest written texts illustrate the human tendency to make distinctions based on physical appearance, only in the seventeenth and eighteenth centuries were phenotypical differences established as *the* markers of identity, signaling biological differences that offered unproblematic signs of intellectual and cultural worth. Even academics who argue that race is a meaningful division of human populations must acknowledge that the significance of particular physical traits has altered over time, and that our modern formulation of race is unique to the past three hundred years.

Bracken points to four elements of Locke's doctrines that combine to enable racist thought to flourish: antiessentialism, the tally model for determining (nominal) essences, choice preference of items in the tally, and the blank tablet. Locke began by accepting the Aristotelian position that material objects have a particular substance (an inner con-

stitution), which might be classified into sorts or species. But his antiessentialism held that while real substances might potentially exist, human beings have no basis for knowing them. This is because we base our understanding of substance on our sense perception of its external qualities, which are secondary to its "real essence." Our sense perceptions, unable to uncover a thing's "real essence," provide us what Locke termed "nominal essence," a collection of qualities serving imperfectly for our idea of a substance. As Locke points out, we may take qualities such as the color yellow, shiny appearance, and malleability as the real essence of gold, but we cannot find any necessary connection between these qualities and the substance itself. According to Locke, the choice preference with which we ascribe various qualities to gold, or to human beings, is grounded not in substances' real essences but in our subjective interests. In this context the blank slate, for many liberals an empowering component of Locke's philosophy, by thwarting efforts to pin down what is common to all human beings may actually push us to accept racial classifications rooted in biology.

Bracken points out how the Cartesian mind/body dualism, which empiricism displaced, offered a "modest conceptual barrier" to racist ideologies by separating human identity from external characteristics. Because the Cartesians rooted human identity in thought—with external characteristics such as skin pigmentation and sex merely accidental, and unreflective of identity—the Cartesian worldview resisted racial theories grounded in physiognomy. Bracken explores how it is possible in Locke's empirical philosophy, however, for skin color (and other physical and cultural markers) to become the "essential" human property. It is not that Locke argued for the pertinence of skin color in determining identity (if anything, he argued against it) but that he promoted a philosophical system that, unlike Cartesian thought, did nothing to *prevent* adherents' taking pigmentation as an essential attribute of human beings. Locke's philosophical worldview ultimately made it easier to conclude that human beings were those who were white, rather than those who thought.[33] This is not to argue that empiricism necessarily produced race any more than it created democracy, for philosophical systems do not invent social structures, but only provide an ideological ground conducive to their development. Instead of giving birth to race, Locke's empiricism simply made the acceptance of slavery, and of modern racial theories, more likely.

Given Bracken's care not to attribute the invention of race to either Locke or empiricism, one is left to wonder what led Europeans and European-Americans to embrace racialized patterns of thought from the seventeenth century onward. To say that empiricism laid the foundations for race, by making it a conceptual possibility, is not to explain why race turned into the dominant social structure of the West. To appreciate why European-American culture seized on race, we need to consider what the sociologist Albert Memmi has argued is our inborn tendency to differentiate: "Racism is the generalized and final assignment of values to real or imaginary differences, to the accuser's

benefit and at his victim's expense, in order to justify the former's own privileges or aggression." Despite the utility of racism, Memmi cautions against searching for an overarching logic or consistency to racist discourse, for as he makes clear, racism is driven by something outside itself. He makes the controversial claim that racism is "a lived experience . . . inherent in the human condition [whereby] each time one finds oneself in contact with an individual or group that is different and only poorly understood, one can react in a way that would signify racism."[34]

Memmi contends that we exhibit a universal tendency to articulate differences when confronted with an alien group—a tendency heightened when we feel our privileges or well-being threatened. For Memmi, it is the articulation of difference, not racism, that is innate to human beings. Merely to observe "differences" is not a racist act, but it is rarely a neutral exercise either, for to articulate difference would be largely meaningless if it did not illustrate qualitative disparities. According to Memmi, the human predisposition to differentiate produces a racist discourse once it combines with *interpretations* of those differences that serve to consolidate or promote the power of a given group. Memmi argues not that our perception of race is grounded in our biological makeup but that a propensity to differentiate is hardwired into our systems, and that such a proclivity, *in our particular social context*, has produced the modern concept of race.[35]

Locke's legitimating of an inborn predisposition to evaluate human beings according to observable traits at once weakened the power of innate ideas (which at least potentially could check experiential biases) and helped produce a social and intellectual context in which modern racial theories might flourish. Just as empiricism did not prevent skin color from being taken as a sign of identity, nor did it bar selective prejudices that might appear verifiable through "scientific" analysis. Thus it allowed the invention of modern ideas of race from a diverse array of preexisting biases: religious prejudices, climactic theories of development, belief in the hereditary nature of human traits, ancient predispositions related to physical appearance, anthropomorphism, long-standing xenophobia, and even philological readings of languages as a reflection of natural character, all of which influenced what would be understood as the scientific discovery of race.[36]

This Lockean context establishes the antebellum racial conditions out of which the formal qualities of *Fair Exchange, No Robbery* were born and suggested how the old-fashioned and increasingly marginalized artist may have conceived of his work. Since by the 1870s, when the *Herald* critic described *Fair Exchange, No Robbery* for his readers, the empiricist paradigms of Mount's youth had been largely supplanted by American idealism, my discussion also illuminates the significant intellectual foil against which the emergent philosophy rebelled. Having surfaced in America in the 1830s as transcendentalism, idealism attained philosophical dominance in the decades following the Civil War. Called Absolute Idealism and drawn from Hegelian and contemporary British idealist thought, American idealism offered a pointed critique of empiricism, finding its route to

knowledge through experience inadequate because it limited one's ability to arrive at larger, overarching truths. The idealists argued that all truths (and all that exists) stem from one spiritual reality, which human beings might know. Postbellum Americans embraced a metaphysical system that assured them that a master plan existed at a time when empiricist thought no longer assuaged their doubt. Period Americans were troubled by the human costs associated with industrialization and urbanization; concerned about geological science and Darwinian theories of evolution, which weakened traditional religious beliefs; deeply unsettled by the carnage and destruction of the Civil War. For a nation traumatized by experiential knowledge—overloaded with sensory perceptions and scientific discoveries that fostered disillusionment and doubt—idealism held out an appealing promise of an ultimate meaning that transcended everyday experience.[37]

Idealism proffered a compromise. Instead of promoting the outright rejection of experience and science, as many conservative theologians desired, idealism argued that such routes to knowledge were partial, not that they were invalid. As Josiah Royce, America's most famous proponent of Absolute Idealism, urged in *Religious Aspects of Philosophy* (1885), "Let us overcome all our difficulties by declaring that all the many Beyonds, which single significant judgements seem vaguely and separately to postulate, are present as fully realized intended objects to the unity of an all-inclusive, absolutely clear, universal, and conscious thought, of which all judgements, true or false, are but fragments, the whole being at once Absolute Truth and Absolute Knowledge."[38] Here, effectively, was a new religion that appeared compatible with the modern world.[39]

The triumph of a philosophical system that questioned sensory experience meant the redefinition of racial types, which had been predicated in part on experiential knowledge. Without suggesting that Americans in the aftermath of the Civil War were suddenly unable to judge racial categories according to an individual's appearance, I contend that the shift away from experiential knowledge unsettled long-standing views of race and then-current racial definitions. The growing appeal of idealist philosophies prepared the ground for realignments in racial thought at the close of the century. The shifting racial outlook is evident in both the increasingly broad acceptance in the South of the "one-drop rule" as the arbiter of black identity and in the first lawsuits various racial minorities brought seeking legal designation as "white" and the consequent conferral of citizenship that status made possible.

The consolidation of the one-drop rule in the years following the Civil War is sometimes seen to buttress, rather than diminish, the American tradition of defining race on the basis of physical appearance. After all, the rule undermined a long-standing practice of consigning mulattoes to a separate racial category, neither white nor black. Because the rule stipulated that individuals with even a single black ancestor be classified as black, light-skinned mulattoes were folded into the black race.[40] But just as the rule simplified racial categorization by reinforcing a white/black division, it also complicated

understandings of race by downplaying physical differences that had long stood as immutable signs of identity. Under the new system it was possible for individuals whose communities categorized them as black to pass as white, just as a portion of those deemed white were unknowingly black. The one-drop rule both built upon and consolidated racial definitions that transcended physiognomy, leaving whites to fear what came to be known as "invisible blackness."[41]

Similarly, the lawsuits filed by racial minorities to gain citizenship during the final decades of the nineteenth century must be seen in this context to provide further evidence of the loosening tie between racial categories and physical traits. Although a congressional act of 1790 restricted citizenship to any alien deemed to be a "free white person," not until 1878—almost ninety years later—did a visible minority ask the courts to declare him white. The legal scholar Ian F. Haney López argues that such court challenges began only in the late 1870s because of the increased importance of national versus state citizenship in the years following passage of the Fourteenth Amendment, and the concomitant rise in immigration from Asian nations, which produced a critical mass of people who were not obviously white or black.[42] But given that a number of early litigants were Hispanic or Native American—two groups that had long boasted significant populations in the United States—it seems evident that other factors explain why such lawsuits were attempted only in the final decades of the nineteenth century.

Even the increased importance of national citizenship at the century's close does not fully account for the number of such suits. They could not be initiated or proceed to court until a conceptual framework developed to allow for the *possibility* of non-European-Americans' being declared white. If the Fourteenth Amendment and rising Asian immigration encouraged the challenges, the suits were conceivable only after the fluidity of period racial models allowed the *consideration* of such claims. In the 1870s and 1880s, blacks could be legally black notwithstanding their physical appearance as white, just as Asians, Native Americans, and Hispanics could sue for citizenship based on a legal possibility of their being determined white. Although many blacks had been subjected to the one-drop rule over the course of American history, and members of various racial minorities had long agitated for equal rights, the rise of idealism ushered in an ideological context wherein identity models that were only marginally embraced in the antebellum era now rose to dominance.

With this picture of shifting racial formation in mind, I turn again to *Fair Exchange, No Robbery* to ask how its meaning was produced and how the painted and literary scarecrows might have seemed equal to audiences in the 1870s. As we shall see, various strands of external evidence (including the visible discourse of property and the invisible discourses of whiteness and metaphysics) were shaped by the painting's internal, formal evidence to produce a meaning specific to this particular visual artifact. Because the sub-

ject matter of thousands of pastoral artworks in various media suggested the visible dis-
courses analyzed in this chapter, and because the invisible discourses resided in virtu-
ally all Americans of the period, it is essential to consider the unique formal properties
of Mount's painting to have any hope of understanding the contemporaneous responses
of gallery audiences.

The narrative elements of Mount's composition are relatively spare. The swap of hats
between man and scarecrow takes place in a shallow foreground space blanketed with
short grass and scattered weeds. The figures are bracketed on the right by a small black-
and-white dog and on the left by a large cornstalk and stump. The middle distance is
bisected horizontally by a rickety picket fence, with missing and broken boards, that sep-
arates the figures from a field of ripening corn. Anyone familiar with the art of Mount
is likely to place the scene in rural Long Island, where the artist spent his working life,
but Gilded Age Americans would have recognized a more precise location based on a
common knowledge of fence types—a sort of iconography of enclosure.

Americans traditionally used fences to keep animals away from crops and as barriers
to contain and exclude human beings, and, just as significant, to symbolically demarcate
the use of exterior spaces. The type of picket fence illustrated in Mount's painting was
never erected to protect the boundaries of large commercial farms but was placed around
houses to signal a domestic space. The standard use of picket fences strongly suggests that
the enclosed field in Mount's image was a modest corn patch attached to a private home.
As the architectural historian Philip Dole explains, on nineteenth-century American farms
"a trinity of fences—rail, horizontal board, picket, one within the other—described three
different but concentric zones. Split rails surrounded the distant pastures; board fences
bounded barnyards or backyards; at the house stood the picket fence . . . [which] marked
the operational center of most farm acreages—the farmhouse itself, home."[43] This
"trinity" of fencing types is apparent in Mount's *Long Island Farmhouses* (begun 1862;
fig. 11), where a rail fence runs across the foreground, a short section of horizontal board
fence appears just to the left of the central structure in the middle distance, and a picket
fence is evident in the background on the far side of the main farmhouse.

Given the construction and orientation of the picket fence in *Fair Exchange, No Rob-
bery*, we can be fairly certain it encloses the cornfield rather than encircling the fictive
space in which the protagonist and viewers stand. By a convention, fences are built so
that the posts and rails are exposed on their interior sides; since the fence pickets cover
both posts and rails, audiences would have understood the fence to surround the back-
ground cornfield and not the foreground space. This arrangement is significant. Read-
ers should appreciate that the protagonist's whiteness was overdetermined for nineteenth-
century audiences—produced by the light coloration of his skin, a tendency to read titles
as literal rather than ironic, and period understandings of the appropriate roles and char-
acteristics of white and nonwhite peoples, but also by the man's evident placement out-

FIGURE 11 William Sidney Mount, *Long Island Farmhouses,* begun 1862. Oil on canvas, 55.88 × 76.2 cm. The Metropolitan Museum of Art, New York, NY. Gift of Louise F. Wickham in memory of her father, William H. Wickham, 1928.

side the fenced field of corn. That placement encouraged viewers to read the title literally because of the long-standing association of open land with fair appropriation. Because settlers perceived Indian property as unfenced and unimproved, they concluded that it was free for the taking; for European-Americans, the enclosure of land was the key sign of ownership. Placing the scarecrow outside the fence further diminished the likelihood that the man's appropriation of its hat might be seen as theft.

The low picket fences surrounding nineteenth-century homesteads and urban dwellings were symbols of a domestic realm, not intended to safeguard property or crops from animals or people. The poor condition of the rickety fence in Mount's painting did not, then, pose any practical danger to the corn. Even if intended as a protective barrier, such picket fences were as often as not enclosed by rail and horizontal board fences, which were designed to keep animals and humans in their places. The dilapidation of the scene

is reinforced by the poor condition of the clothing on both scarecrow and man and the unruly tangle of plants threatening to overrun the scene. An errant corn stalk in the left foreground has taken root outside the fence—it leans curiously toward the man—and a jumble of foreground weeds have made their way into the field. Contrast the image with that presented in Mount's *Farmer Whetting His Scythe* (1848; fig. 12). Framed by tidy barns and houses and distant cleared fields, the neatly dressed farmer stands sharpening his scythe on a patch of newly mown grass. Surrounded by signs of a world kept under tight rein by human beings, he labors to bring order to a patch of unrestrained nature, evident in the foreground tangle of wildflowers and grass. Unlike most of Mount's orderly scenes of Long Island farming life, *Fair Exchange, No Robbery* gave viewers a clear sense of disorder and decay—of a world that was fundamentally unstable.

The instability at the heart of the scene was manifest in the central exchange. Whether or not we deem the trade as fair, we appreciate that the condition of its hat has nothing to do with the scarecrow's ability to perform its role. A scarecrow need only look human and lifelike to hungry birds. Since a human appearance might be achieved with a multitude of poses, bodily shapes, and sizes, and by a range of clothing styles in varying conditions, it was not difficult for the scarecrow to meet the minimum requirements of its job. The imminent swap may leave the scarecrow materially diminished, but it will not prevent it from looking sufficiently human to ward off birds. Even as long-standing artistic conventions predisposed viewers to read the canvas's decay as an allegory of broader social or political malaise, the decay portrayed in the painting had scant narrative significance, for the physical condition of the scarecrow is unconnected to its identity.

The critic for the *Herald* who found the scarecrows of Hawthorne and Mount "quite equal" may well have appreciated the novel separation in each work of physical appearance from social identity. In both short story and painting, the scarecrow's appearance points to nothing more than our *inability* to read larger truths from surface appearance. The *Herald* critic based his understanding of the works not on an "objective" reading of the texts but on the dominant philosophical and racial systems of the 1870s. The positivistic worldview informing the creation of Mount's painting, tying the visible world to inner truths, had been replaced by a perspective that doubted one's ability to accurately interpret the material world. In the final third of the century, Americans still held to the importance of racial categories, even as they acknowledged the inadequacy of using visual cues to determine identity. As the literary and painted scarecrows demonstrated to viewers, it not only was difficult to "correctly" interpret visual evidence in determining an individual's identity but also was impossible to know if vision was even capable of leading one to truths. In the exciting and unsettling world of late nineteenth-century America, individuals could be either black or white without ever looking it.

That Mount's positivist canvas might conjure up the unstable world of Hawthorne's

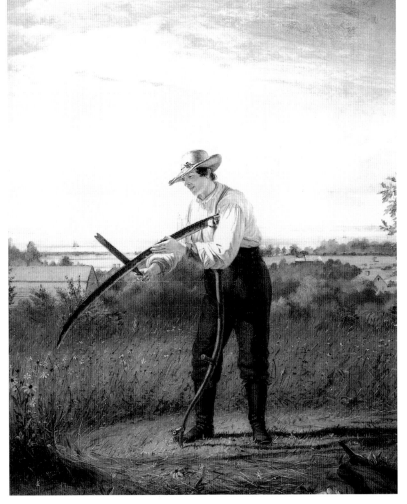

FIGURE 12
William Sidney
Mount, *Farmer
Whetting His
Scythe*, 1848.
Oil on canvas,
60.96 × 50.8 cm.
The Long Island
Museum of
American Art,
History &
Carriages, Stony
Brook, NY. Gift
of Mr. and Mrs.
Ward Melville,
1955.

"Feathertop" testifies to substantive changes in identity formation. Just as the "laziness" of the African American figure in *Farmers' Nooning* had more to do with the ideology through which the work was seen than with an objective reading of the painting's visual evidence, the ambiguity of Mount's *Fair Exchange, No Robbery* was similarly produced by period concerns. The evolving racial definitions of late nineteenth-century America restricted and expanded the categories that defined people and also raised the anxiety of European-Americans, whose unearned privileges depended on a racialized worldview in which appearance (produced by genetic heritage and cultural norms) was

everything. The changes in identity formation that idealism encouraged did not dismantle the privilege of white Americans; they simply fostered a period of transition—between older and newer conceptions of identity—during which racial definition was unusually malleable.

Had Mount's painting been an allegory about debates on white identity (or, for that matter, on Johnson's presidency, or anarchist Long Islanders), it would have carried a certain power, expressing the artist's beliefs and potentially affecting the beliefs of those who viewed the exhibited canvas. The work's true potency, however, lies in its very distance from such debates. Though it says nothing about race, *Fair Exchange, No Robbery* nonetheless shows the centrality of racial discourse in structuring how European-Americans thought about themselves and their nation.

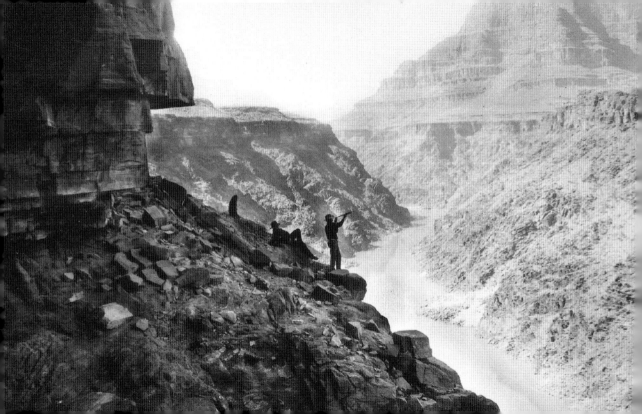

CHAPTER TWO

LANDSCAPE PHOTOGRAPHY AND THE WHITE GAZE

n the late summer of 1858, the landscape photographer Carleton Watkins (1829–1916) took the stand in a California courtroom to defend the accuracy of his work. Watkins answered questions on his panoramic image of the Guadalupe quicksilver mine, commissioned to help resolve a boundary dispute that the court was adjudicating. Asked to explain his selection of the vantage from which the image was taken, the photographer recounted that he had chosen a location "which would give the best view." He assured the court that the resulting panorama was "accurate."[1]

Although modern scholars of photography are quick to note the subjective, culturally determined nature of representational systems, they often perpetuate the assumption that nineteenth-century Americans accepted photographs as straightforward transcripts of reality. Abigail Solomon-Godeau, in a chapter of her influential book *Photography at the Dock*, argues that the term "documentary photography" came into regular use during the late 1920s, as Americans began to appreciate just how easily photographs could be manipulated. According to Solomon-Godeau, only when a photograph could be conceived as something other than reality did the modifier "documentary" become necessary. With the public realization of the medium's susceptibility to mechanical manipulation, a new category emerged to label those images that would continue to circulate as authentic. "To nineteenth-century minds," she concludes, "the very notion of documentary photography would have seemed tautological."[2] If many Victorians took photographs as unassailable snippets of reality—and there is considerable ev-

idence that they did—there is also no shortage of evidence that many twenty-first-century Americans continue to do so.

The court, by calling on Watkins to explain the verity of his image, revealed an awareness of distinctions between photography and the real: photographs were not equal to firsthand visual experience, though under certain controlled conditions they might be an acceptable substitute. They were believed to offer potentially more objective depictions of the material world than competing modes of representation. In the words of Ferdinand Hayden, who led one of the important western survey parties in the 1860s, photographs were "the nearest approach to a truthful delineation of nature."[3] Thus although nineteenth-century audiences—like viewers today—wanted to believe in the reality of photographs, they nonetheless saw them generating fragile fictions. Photographs appeared less real when viewers perceived a disjunction between their own beliefs and those apparent in the photographs and more real when they reflected ideologies that accorded with the viewers' own. Thus the images a society accepts as true possess unique potential to reveal its values.

Bearing in mind both the fragility of photographic fictions and their potential to reveal social values, I consider in this chapter what the reception of landscape photographs—those lacking any human figures and any sign of their activity—reveals about American racial norms during the late 1860s and 1870s. My focus is on how Watkins's images of the Yosemite Valley consolidated and promoted the identity of whites. While some readers may find it implausible to implicate pure landscape photographs in the racial politics of their era, the same cultural values that condition the production and reception of narrative genre paintings operate in landscape photographs. We shall see that a construct as central to American national identity as race does not confine itself to conventionally "appropriate" subject matter, genres, or media.

During the summer of 1866, as his geological survey team meandered through the Yosemite Valley, Josiah Dwight Whitney recorded his obvious pride in the achievements of his survey photographer, Carleton Watkins. Singling out one photograph (fig. 13) for special praise, Whitney claimed that Watkins "has taken many fine pictures, some of these I think will surpass anything he has ever had—especially the trail views from the Mariposa Trail & a spectacle from a spot two-thirds of the way down which we all think gives the best general view of the valley."[4] Repeating Whitney's boast, Watkins titled the published print *The Yosemite Valley from the Best General View*. At a time when the valley was crawling with photographers eager to turn their views of Yosemite into commodities for eastern patrons—many of whom would never venture west—the title of Watkins's photograph assured customers of the superiority of his overview.[5] But it also made a tacit claim for the valley itself, for the photograph purports to provide not simply the *best* view but the *best general view*. Modern viewers may question what it means to produce the

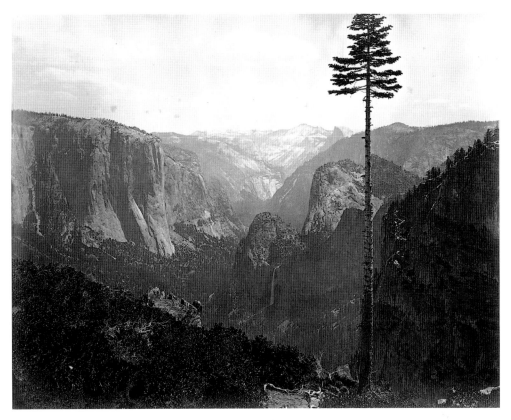

FIGURE 13 Carleton Watkins, *The Yosemite Valley from the Best General View*, 1866. Albumen print, 19.4 × 29.5 cm. J. Paul Getty Museum, Los Angeles, CA. © The J. Paul Getty Museum.

best *general* view of something as amorphous as an irregularly shaped valley, more than seven miles long, one to two miles wide, and in places more than three thousand feet deep, yet, tellingly, the claim seemed not to trouble the photographer's clientele.

The shared belief in a "best general view" presupposes that the valley can be—and has been—quantified, either through the efforts of previous observers or through the creation of the photograph itself. This assertion is borne out by consistent photographic, literary, and cartographic depictions of Yosemite produced during the second half of the nineteenth century. Despite the difficulty of quantifying such a massive and heterogeneous formation, almost all European-American descriptions of the valley focus on an identical set of traits, implicitly claiming that these features embody the unique quality of the region.[6]

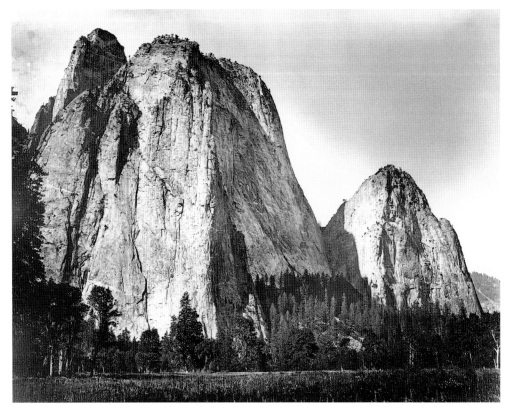

FIGURE 14 Carleton Watkins, *Cathedral Rock, Yosemite*, ca. 1865 or 1866. Albumen print, 40 × 52 cm. Prints and Photographs Division, Library of Congress, Washington, DC.

Present-day viewers of Watkins's photograph are likely to pick out at least a few of the distinguishing geological formations taken today as hallmarks of the region: the distinctive profile of Half Dome (on the horizon just to the left of the foreground pine tree's trunk), Sentinel Dome (on the horizon to the pine's right), Cathedral Rocks (in the right middle distance), Bridal Veil Falls (just below the Cathedral Rocks), and El Capitan (in the left middle distance) are clearly evident in the photograph. That these particular geological features were not merely incidental elements of the landscape that happen to attract twenty-first-century eyes is suggested by the two types of photographs that Watkins produced in the valley: tightly focused close-ups of monumental geological features and distant overview shots, of the kind typified by *The Yosemite Valley from the Best General View*. The close-ups include *Cathedral Rock, Yosemite* (ca. 1865 or 1866;

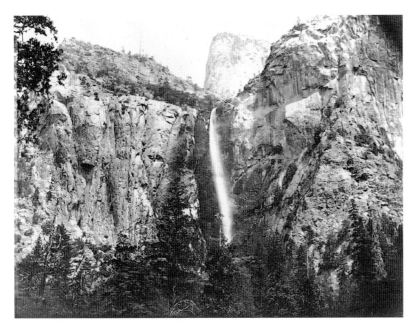

FIGURE 15
Carleton
Watkins, *Bridal
Veil, Yosemite,*
ca. 1865–66.
Albumen print,
12 × 9.2 cm.
Prints and
Photographs
Division, Library
of Congress,
Washington, DC.

fig. 14), *Bridal Veil, Yosemite* (ca. 1865–66; fig. 15), *Mirror View of El Capitan* (ca. 1872), and *The Half Dome from Glacier Point* (1878–81; fig. 16) and all the other famous forms gathered in the photographer's *Best General View.*

These two photographic types worked in tandem to convey the distinctive character of the region, with many dozens of tightly focused images of rocks and waterfalls offering "specific" views, which provided the visual and ideological building blocks out of which the "general" vistas were created. The 1868 report of the Yosemite Valley Commissioners confirms that period Americans consciously appreciated these distinct manners of apprehending the natural world. Outlining options for a tourist to experience the valley, the commissioners wrote, "If he wishes to have the grandeur of the Yosemite revealed to him at once, he will enter the valley on the Mariposa side [from the outlook at Inspiration Point]; if, on the other hand, he prefers to see various points in succession, one after another, and then finally, as he leaves the Valley, to have these glorious general views as a kind of summing up of the whole, he will enter by the Coulterville and depart by the Mariposa side."[7]

Watkins's commercial displays during the 1860s and 1870s both encouraged and reinforced the tendency of Victorians to engage in these two types of viewing. In the stereoscopic card *At the Mechanics' Institute* (1869; fig. 17), we see what scholars know to be Watkins's preference for dense hangings of photographs rising high up a gallery's walls.

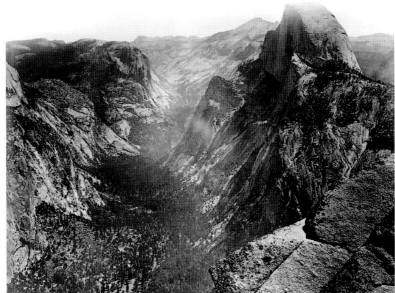

FIGURE 16
Carleton
Watkins, *The
Half Dome from
Glacier
Point*, 1878–81.
Albumen print,
40 × 52 cm.
Prints and
Photographs
Division,
Library of
Congress,
Washington, DC.

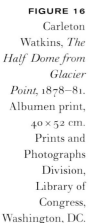

In such a setting, individual framed photographs offered "specific" views of natural objects that joined together in a "wall" of images to form another kind of "general" view. For both Watkins's contemporaries and modern Americans, a finite set of monumental rocks and waterfalls helped shape the meanings of the photographer's more sweeping scenes of nature.[8]

Watkins was neither the first nor the last European-American to see Yosemite through this lens. Long before Yosemite became a popular subject for European-American audiences, the adventurer James Mason Hutchings was captivated by the same formations that would intrigue the photographer. Hutchings, recording his experiences leading the first party of tourists through the valley in 1855, marveled at the view from a spot near where Watkins would take his *Best General View* a decade later: "on the north side stands one bold, perpendicular mountain of granite, shaped like an immense tower [El Capitan]. . . . Just opposite this, on the south side of the valley, our attention was first attracted by a magnificent waterfall, *about seven hundred feet in height* [Bridal Veil Falls]. . . . passing farther up the valley, one is struck with the awful grandeur of the immense mountains on either side." Nearly two decades later J. H. Beadle recounted his impressions of Yosemite as a tourist while resting on the porch of his hotel on the floor of the valley after an exhausting day of sightseeing. Beadle, lying in near darkness, described his

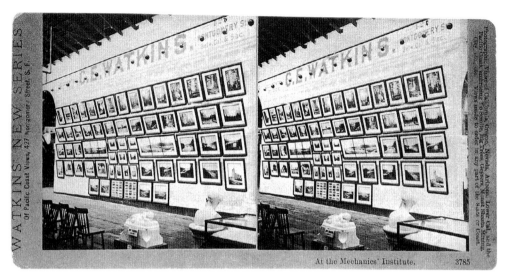

FIGURE 17 *At the Mechanics' Institute,* 1869. Albumen stereograph, 8.9 × 17.5 cm. University of California at Berkeley, Bancroft Library.

surroundings: "to the northwest is El Capitan, glorified in the soft moonlight; opposite Yosemite Fall, to the right the Royal Arches, over all this wondrous sky, and all around us monster battlements." Finally, the California promoter John Hittell offered tourists his own condensed summary of the valley's highlights: "At Yosemite there are eight cataracts, fives domes, a dozen cliffs, several lakes and caverns, and numerous minor wonders, besides the big-tree groves near by, and a score of mountains that reach an elevation varying from 13,000 to 15,000 feet."[9]

Maps of the valley produced during these decades display an identical value system. They consistently include names for trails, bridges, and hotels along with bodies of water and the tallest, most massive, and most unusual rock formations, while leaving much of the valley unlabeled. The dearth of names is striking, given that mapmakers might have drawn on thousands of ancient Indian names, as well as labels developed more recently by Spanish explorers, American military parties, early tourist groups, geological surveys, shepherds, and cattlemen.[10] The selective naming of the valley's features is evident both in the large-scale scientific map drawn for J. D. Whitney's massive *Geological Survey of California* (1868; fig. 18) and in more commercial maps created for tourists, such as that reproduced in Mary Cone's diminutive guide, *Two Years in California* (1876; fig. 19). What is named in each case reveals that artificial additions to the landscape and the "biggest" natural features were of greatest interest to European-Americans.

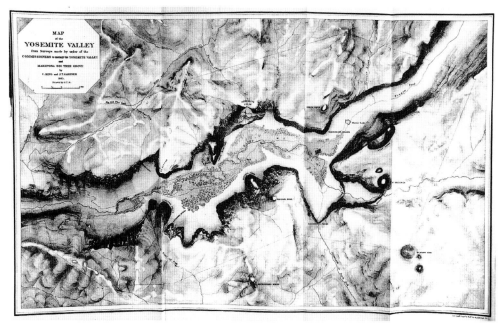

FIGURE 18 C. King and J. T. Gardner, *Map of the Yosemite Valley*, 1868. Plate from *Geological Survey of California*, 45.4 × 40.1 cm. Courtesy the Newberry Library, Chicago, IL.

The Yosemite Valley from the Best General View did indeed offer a good "general" view, but only because it brought together so many of the monumental features that nineteenth-century Americans unquestioningly took to be the most important of the region. While twenty-first-century viewers probably agree with Watkins's evaluation of the valley—who could fail to be impressed by such an assortment of natural wonders?—our present-day assessment reveals more about the continuing sway of an entrenched European-American value system than about the objective importance of the formations themselves for establishing the character of the area. Despite the "naturalness" of late nineteenth-century photographic, literary, and cartographic representations of the valley for readers today, descriptions that focus on massive rocks and waterfalls do not exhaust the conceptual possibilities for characterizing the valley.[11]

We can gain a sense of the visual and cultural bias of Watkins and his white contemporaries by considering how indigenous peoples viewed their environment. The original inhabitants of the region now known as Yosemite were the Ahwahneechee, a branch of the Southern Sierra Miwok tribe, first driven from the region by federal troops in 1851 to allow European-American farming, mining, and lumber interests to expand.[12]

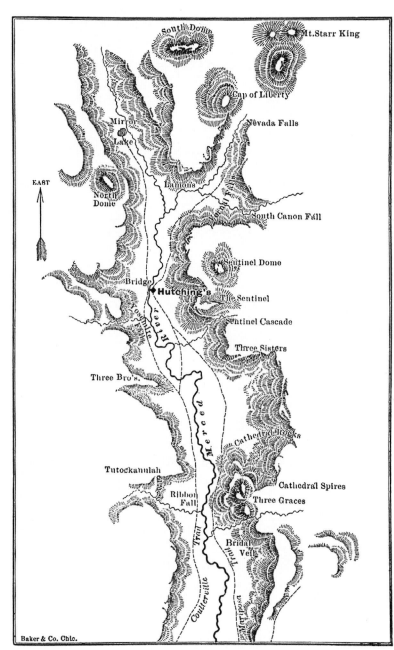

PLAN OF THE YOSEMITE VALLEY. PAGE 215.

FIGURE 19
Baker and
Company, *Plan
of Yosemite
Valley*, 1876.
Plate from *Two
Years in Cali-
fornia*, 15.6 ×
12 cm. Courtesy
the Newberry
Library,
Chicago, IL.

Although the precontact Ahwahneechee left no records of their views on Yosemite's natural features, in the second half of the nineteenth century a number of European-Americans preserved the tribe's nomenclature. Skewed as the records invariably are when one group attempts to comprehend the language or culture of another, the Native American place-names recorded by European-Americans hint at a value system in conflict with that of the white explorers, settlers, and promoters.

Stephen Powers, frustrated by studies of Native American culture that relied solely on white informants, set out in the 1870s to create a more authoritative account of indigenous languages and cultures by interviewing the Indians themselves. While collecting Indian artifacts for the upcoming Centennial International Exhibition of Industry in Philadelphia, Powers engaged a knowledgeable native guide at Yosemite who pointed out and named, in Powers's words, "all the places." Powers's *Tribes of California* (1877) devotes a chapter to Yosemite, listing Indian names for various natural formations, translating them, and giving the corresponding European-American term, if one existed. As we might expect, Powers devotes considerable attention to the now-famous features Half Dome and El Capitan but also lists a host of natural formations European-Americans had not named and some for which they had no term. To explain the term Kai-al'-a-wa, Powers could offer only the phrase "mountains just west of El Capitan," as no European-American had thought the peaks significant enough to label. And at times he could give only a negative definition, as when he defined Tol'-leh as "the soil or surface of the valley wherever not occupied by a village."[13]

Indians' unique conception of the land is evident in their principles of naming and also communicated in the distinctive visual records they continued to make during the early contact period. Long before the arrival of Europeans, Native Americans had created a range of maps, recording the locations of mythological and religious spaces, communities, and hunting and trading routes, usually made to facilitate travel and the exploitation of resources, themes very much on the minds of Europeans. Nonetheless, these maps embodied a perspective on land and space radically different from that of European models. In about 1840 two Ojibwa or Algonquin travelers in Upper Canada affixed an incised birch-bark map to a tree, recording their route along the Ottawa River for members of their party who were a day's travel behind them (fig. 20). The map depicts a tiny canoe propelled by two figures, whose route and previous night's campsite are indicated by a series of short vertical hatch marks, which form a horizontal band traversing the map. Collected in 1841 by Captain Bainbrigge of the Royal Engineers, the map was mounted on stiff paper, copied, and annotated by the British surveyor before being sent back to England.

For early European explorers, who frequently relied on the knowledge of indigenous peoples to make their way around North America, such maps possessed severe limitations. Instead of charting large areas of terrain, Indian maps tended to record the narrow

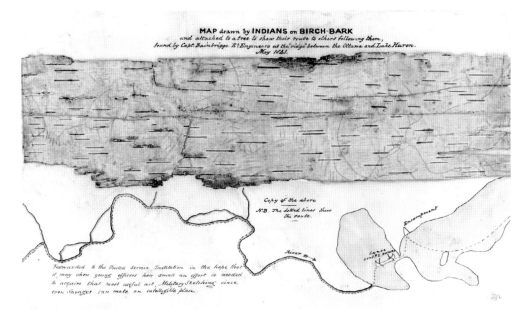

FIGURE 20 Ojibwa or Algonquin maker, *Map Drawn by Indians on Birch-Bark*, ca. 1841. Incised birch bark, 8.8 × 38 cm. Map Library, British Library, London, United Kingdom. By permission of the British Library.

path of a journey, without differentiating waterways, portages, and trails.[14] Rather than demarcate what Europeans would have understood as the region's characteristic features, the map displays a thin band of territory, illustrating little more than the immediate area experienced by the travelers. The map gives little indication whether the travelers' route had taken them through mountainous terrain or a marshy flat. Major and minor tributaries of the river along which they paddled are treated alike, being important merely for their ability to signify the number of branches passed. The map offered none of the consistency of scale a European would expect. The Indian penchant was to alter the form and size of natural features to accommodate the shape and size of the object on which a map was drawn.[15] Two renditions of the same trading route were unlikely to be depicted in an identical manner if they were drawn on surfaces as distinctive as birch bark and buffalo hide.

 The very scarcity of surviving Indian maps (and the unfortunate absence of any produced by the original Ahwahneechee of the Yosemite region) in and of itself testifies to their characteristic use. For native populations, maps were transient things drawn on the earth or on snow as often as they were scratched into bark, rock, or hide. As Mark

Warhus, a historian of native mapmaking, explains, whereas European maps are concerned primarily with objective and verifiable spatial relationships, those of Native Americans record only geographic features related to a larger context established by personal experience. A mountain range was interesting, for example, only to the extent that it entered into stories of community history and relations to spirits, ancestors, and needed natural resources. Native American maps never purported to represent topography objectively but instead sought to provide a partial record of the events associated with the natural world that gave the land its meaning.[16] Unconcerned with the "scientific" objectivity Europeans considered crucial, Native Americans created maps that responded to both a human context and material limitations.

Readers will appreciate that European maps, of course, were not more objective. Maps are selective, reproducing particular elements of the landscape to communicate specialized information.[17] A single map containing data on a region's climate, topography, land use, aquifers, transportation networks, congressional districts, mineral deposits, waterways, political boundaries, and population density would be scarcely intelligible. Maps are useful because they exclude information. Yet there is no denying that maps produced with Western mapping techniques do *appear* more objective to modern Western eyes. The scientific method of Western mapmakers does not ensure a more truthful end product, but it fosters the impression of objectivity through standardization. Standardized, innumerably repeated maps ensure our thorough familiarity with Western mapmaking conventions, and our belief in objectivity is rooted in this familiarity. Conversant with the various mapping genres—subway, climactic, or topographic—we adjust nearly instantaneously to the subjective logic of the mapping system. Such maps appear objective, then, because of our facility in rapidly employing their particular logic. The birchbark map that Bainbrigge shipped back to England seemed less objective to the surveyor (and seems so to many present-day Americans) because its guiding logic was not one to which he had better access than most European-Americans have today.

Scholars have long appreciated how the linguistic, mythological, and pictorial tools by which a society orders its environment actually help to guide that society's understanding of the material world. Instead of offering transparent media by which to represent the external world objectively, human representational systems contribute to shaping that world. Thus one's experience of Yosemite would vary according to the values embedded in systems of signification one possessed to think about the region. It should come as little surprise that contemporaneous European-American photographs, maps, and guidebooks embody their culture's dominant value system—the biggest natural features are the most noteworthy and, consequently, are taken to establish the unique character of the region. After all, nineteenth-century European-American photographers, cartographers, and explorers were indelibly impressed with their society's cultural norms. A shared value system allowed the valley's first European-American visitors to "see"

Yosemite's most salient features, encouraged Watkins to locate the vantage from which such features might be brought together for reproduction, and allowed viewers of the images—who may or may not have recognized features by name—to pick them out as the images' most significant. Long before western explorers and tourists reached the valley, their culture had conditioned them to appreciate, in highly specific ways, the area that came to be known as Yosemite.

Putting aside Native Americans' distinctive way of conceptualizing the natural world, there exists a temptation to argue that the Ahwahneechees' extensive naming of Yosemite's features relates more to their long-term residency in the region than to their unique worldview. It seems plausible that European-Americans named so few of the valley's features simply because they had occupied the region for a comparatively brief period. The point, however, is not that European-Americans possessed fewer terms for the valley's features but that they showed consistent interest in specific objects, which they named in particular ways. European-Americans would in time label thousands of the region's geological forms, but the most monumental of these would always hold the greatest interest. Moreover, it is clear from nineteenth-century European-American guidebooks and maps of the Adirondacks—a region of the continent that whites had known for nearly three hundred years—that the same value system informs descriptions of both America's most familiar wilderness regions and the new wonders of the west.

Consider E. R. Wallace's *Descriptive Guide to the Adirondacks* (1875), which focuses on the area's grandest falls, gorges, waterways, and mountains, recommending various routes to tourists. Wallace describes in detail what travelers can expect: "Entering the colossal portals of the Pass we are filled with amazement and awe by its utter wildness and savage grandeur. Here the Ausable [River], compressed to a few feet in breadth, bursts through the mountain obstruction and thunders onward in its furious career. On the right, Whiteface, with almost perpendicular ascent, towers in awful majesty 2,000 ft. above its bed; upon the opposite side another precipitous mass attains an altitude of nearly equal sublimity. Thus for 2 m[iles] does this terrific gorge extend." Similarly, the full-page map of the Adirondacks appearing in *The Tourist's Guide Book to the United States and Canada* (1883; fig. 21) labels just two categories of objects—monumental natural forms and human additions to the landscape. Period discussions of Yosemite and the Adirondacks employ descriptive systems so similar that guidebook readers would be hard-pressed to distinguish one region from the other without the aid of site-specific place-names.[18]

The dominant European-American view of the valley is evident in the fixation on geological wonders but also in the naming of those forms. Whereas Native Americans' names for the valley's features consistently referred to legendary events, to activities specific to a region, and to the location of native plants and animals,[19] European-Americans' names commemorated people, anthropomorphized the landscape, or likened geological formations to architectural structures. Representative names devised by European-Americans

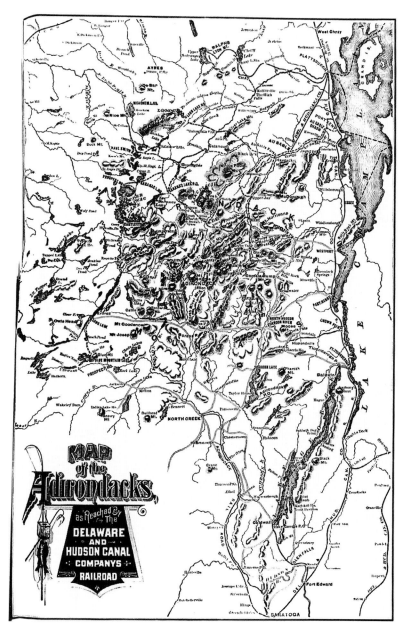

for Yosemite's formations include sentinels, brothers, and captains, on the one hand, and cathedrals, spires, domes, and columns, on the other. The prevalence of European-American names associating the natural landscape with human beings and their artificial products is notable. European-Americans labeled the most impressive features of the region in a manner that anthropomorphized the landscape and thus suggested human agency.

Both the associations of the natural formations and the labels chosen for them spoke less of a general human agency, however, than of what white men took to be their primacy over Native Americans, European-American women, and even Europeans.[20] Whites often believed that their appreciation of nature's monumental forms showed their superiority to indigenous peoples, who seemed to European-Americans indifferent to or fearful of the geological formations whites thought the continent's grandest.[21] While European-American women tended to admire gigantic rocks and waterfalls as much as their male contemporaries, the names given such prized features of the valley placed white women at a symbolic remove. Frequently, the most valued rocks were associated with male actors—sentinels, brothers, and captains—whose forms evoked stereotypically masculine adjectives like "massive," "solid," and "powerful."

For European-Americans, whiteness was not a stand-alone construct but one produced by a confluence of other dominant markers of identity. Objects were coded white to the extent that they exhibited (valued) traits associated with their essential nature. In other words, the whitest objects possessed positive cultural resonance and also expressed valued secondary traits that epitomized what was seen as the intrinsic nature of those objects. The uniquely masculine geological forms at Yosemite—powerful, singular, and civilized—came to be considered paradigmatically white. Whiteness is thus a metalabel of identity, in play when other dominant indicators valued by European-Americans are appropriately attached to an object or person.

While various geological forms at Yosemite suggest that the link between "whiteness" and "masculinity" was exclusive, the link was instead contextually specific. Because the ideal mountain is masculine in the European-American mind, only its masculinity could contribute to its coding as white. The whiteness of objects or people associated with feminine ideals, however, was rooted in a different set of attributes. Many of the rivers, lakes, and waterfalls of the region—Virgin's Tears Creek, Mirror Lake, Ribbon Fall, and Bridal Veil Fall—were linked to whiteness by their appropriate expression of feminine qualities. Although European-American men epitomized the ideal of whiteness during the nineteenth century, in the proper context the whiteness of European-American women could exceed that of men. The strong period identification of white womanhood with chastity, morality, and culture ensured that both men and women intuitively understood that no one was more white than a European-American woman threatened with real or imagined sexual violation at the hands of nonwhites. As this ex-

ample suggests, it is dangerous to make pronouncements on what constitutes the paradigmatic white person (or landscape), given the degree to which ideals of whiteness metamorphose according to the social and historical context.

Although Native American men and women and European-American women suffered materially for their distance from ideals associated with the valley, the devaluation of femininity did less to limit women's access to Yosemite than the corresponding devaluation of redness worked to exclude native populations. In the end, the valley's coding as masculine disadvantaged women (and enabled men) less than its coding as white disempowered Native Americans (and empowered whites). In the symbolic system applied to Yosemite, race always trumped gender and class. There are obvious social and political drawbacks inherent in any attempt to establish a hierarchy of suffering, but it remains important to appreciate how individuals who depart from religious, gendered, racial, sexual, political, or class norms pay unequal prices for their outsider status. European-American women did not reap the same financial rewards as white men in the valley, nor did they enjoy men's unlimited freedom of movement. But women participated in Hutchings's first tourist party to the valley, returned to explore the region in ever-greater numbers year after year, and wrote many reports for guidebooks and newspapers on their experiences in Yosemite (frequently adopting the masculine voice of their male peers)—evidence that the price they paid for their symbolic remove from masculine norms was less than that paid by Native Americans for their distance from racial ideals.[22]

While European culture had provided the architectural forms that lent characteristic names to Yosemite's features, white Americans interpreted their older, and more monumental, geological "domes" and "arches" as signs of their cultural ascendancy over old-world society. This jingoistic assessment is communicated by a sizable percentage of the reports on the valley. For example, John Hittell's Yosemite guidebook boasts that "the largest and highest works of human art dwindle into insignificance when compared in bulk or elevation with the tremendous precipices of Yosemite. The elevation of Cheops Pyramid is four hundred and ninety-eight feet, and the highest cathedral spires are those of Strasbourg, four hundred and sixty-six feet, Vienna, four hundred and thirty-two feet. They would be lost in the unnoticed talus of Tutucanula [El Capitan], which rises to 3,300 feet, or of Sentinel Rock, which ascends to 3,000."[23] As the environmental historian Chris Magoc has noted, even though the West was indelibly marked with the nomenclature of European architecture, white Americans consistently read continental architecture as little more than a reminder of fallen civilizations.[24]

On one level, nineteenth-century Americans could imagine their natural architecture rivaling the built architecture of Europe, based on an expansive notion of what constituted national identity. From the time of the early republic, European-Americans understood their distinctive heritage to include the products of both nature and culture—mastodon bones, rock formations, and waterfalls, along with Indian artifacts, European-

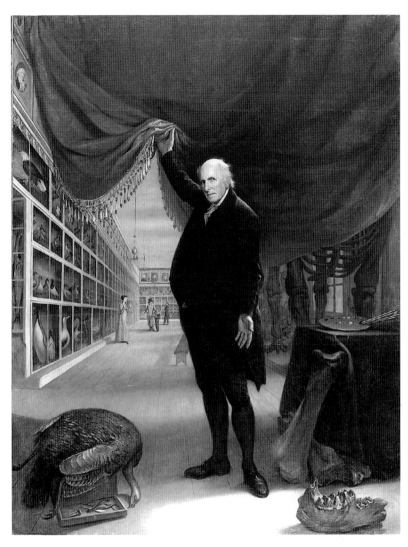

FIGURE 22

Charles Willson Peale, *The Artist in His Museum*, 1822. Oil on canvas, 262.9 × 203.2 cm. Courtesy of the Pennsylvania Academy of the Fine Arts, Philadelphia, PA. Gift of Mrs. Sarah Harrison (the Joseph Harrison, Jr., Collection).

American arts, machinery, and scientific discoveries, all combined to signal the richness of American history. In his Philadelphia Museum, the impresario Charles Willson Peale offered museumgoers just such an eclectic assortment of American products. Peale's self-portrait of 1822, *The Artist in His Museum* (fig. 22), shows the elderly Peale pulling back a curtain to reveal the mysteries of nature and ushering visitors into his famous museum, with extensive displays of what modern viewers see as natural and cultural

products: dinosaur bones, gilt-framed oil portraits, and geological samples. All attested to the greatness of American culture.

But in addition to recording the ancient history of the Americas, the geological record also suggested the potential of American society for future accomplishments. Photographic historians are invariably careful to point out that Watkins did not subscribe to any one of the competing theories explaining the creation of the west's natural wonders, yet there is little doubt that viewers' interpretations of his scenes were guided by dominant geological hypotheses, discussed widely at the time in both the popular and the scientific press. During the final decades of the century, a growing number of Americans accepted the scientifically backed uniformitarian theory first put forth by the English geologist Charles Lyell in the 1830s. This theory held that the earth's appearance evolved gradually in response to the action of fire, water, and ice. Whereas older models of creation claimed that an essentially static earth assumed its present form through sudden, cataclysmic events, Lyell believed that the earth's formation was ongoing, its geology and topography experiencing slow but constant change.[25] Given this model of the earth as a work in progress, natural architecture not only signaled past achievements but also mapped the potential heights to which America's cultural products might aspire.

The architectural historian James O'Gorman sees the expression of nineteenth-century America's association of geological architecture with nationalism primarily in distinctive East Coast building forms. In O'Gorman's estimation, pride in nature's architecture, as exemplified in Yosemite, and the powerful influences of such thinkers as Ralph Waldo Emerson, John Ruskin, Owen Jones, and Frederick Law Olmsted, who embraced natural models for the creation of cultural products, encouraged architectural styles that referenced geological formations. Examining the designs of the 1870s and 1880s by Frederick Law Olmsted and H. H. Richardson—including Richardson's Ames Memorial (Albany County, Wyoming; 1879–82), Ames Gate Lodge (North Easton, Massachusetts; 1880–81; fig. 23), R. T. Paine House (Waltham, Massachusetts; 1884–87), and E. W. Gurney House (1884–86)—O'Gorman explores how geological formations that appeared artificial inspired the creation of architectural structures that strove to be natural.[26]

The images of natural architecture that helped shape building trends in distant East Coast cities had an even greater impact on the development of the west. Watkins's photographs helped to convince Congress to set Yosemite aside as a federally protected area in 1864, but his images also encouraged capital investments in mining, lumber, railroad, and real estate.[27] Watkins may be best known today for breathtaking scenes of nature, but the photographer also created images for European-American corporate and industrial patrons that celebrate their transformation of the land. Rather than representing a distinct category of his work, Watkins's numerous photographs of factories, urbanization, clear-cutting, and hydraulic mining (fig. 24) were consistently displayed and sold

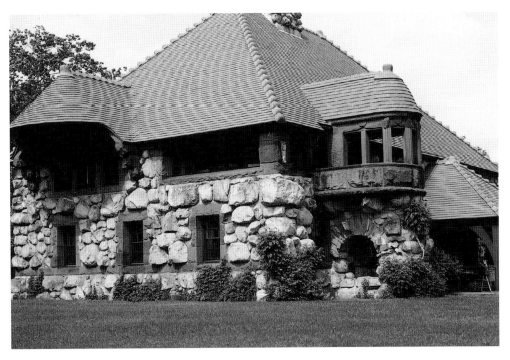

FIGURE 23 H. H. Richardson, Ames Gate Lodge, North Easton, MA, 1880–81. Photograph courtesy of Jack Quinan.

alongside his images of unsullied wilderness. An advertisement Watkins placed at the back of an 1871 tourist guidebook to Yosemite suggests the normalcy of displaying and selling images of nature and industry together. In bold capital letters, the full-page advertisement promises potential customers "photographic views of Yosemite Valley, the Big Trees, the mines, [and] the splendid scenery of the Central Pacific Railroad."[28] What we see today as the ideological inconsistencies of Watkins's work, which seems to celebrate both nature and industry, are in fact products of twentieth-century values.[29]

Most late nineteenth-century Americans defined nature so that they could esteem the natural world and, at the same time, celebrate industry's transformation of the land. This era valued nature not as a realm of untouched wilderness but as one that could foster an aesthetic sensibility. As the historian Alfred Runte reminds us, when Congress designated Yosemite "reserved forest land," it was not to protect the area in any modern sense but to permit for the "controlled exploitation of natural resources"—allowing development, but maintaining the aesthetic features deemed significant.[30] Providing that the largest and most monumental geological forms of a region were preserved—along

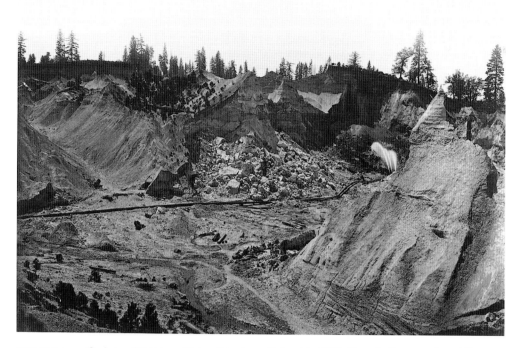

FIGURE 24 Carleton Watkins, *Union Diggings, Columbia Hill, Nevada County*, 1871. Albumen print, 40.3 × 54.9 cm. Smithsonian American Art Museum, Washington, DC. Museum purchase from the Charles Isaacs Collection made possible in part by the Luisita L. and Franz H. Denghausen Endowment.

with the vistas that allowed them to be visually consumed at a glance—most Americans had no objection to that area's subsequent development. As long as industry did not disturb the elements of the landscape that confirmed European-American cultural values, development of even the most singular sites was rarely a problem.

Accounts of the west by European-American scientists, explorers, tourists, and developers during the second half of the century provide abundant evidence that the development of nature was seen as both inevitable and propitious. Period accounts routinely argue that the natural world was actually improved when it was transformed by European-Americans. A promoter of western tourism and development, scanning the wild valleys of northern California in the early 1860s, claimed that "in the course of ten or fifteen years, when ornamented with thorough cultivation, [the coastal valleys] will be as pretty

as any places in the world." He goes on to note that "Napa . . . is now the most beautiful of these valleys, because most thickly settled and most thoroughly cultivated."[31]

From our twenty-first-century vantage Gilded Age land development seems obviously driven by the self-interest of European-Americans. Development made sense for those who saw nature as a resource to be exploited. European-Americans, from their nineteenth-century perspective, however, read a more organic justification for their exploitation of nature: the landscape itself offered direction and legitimation for their actions. The promoter I quoted in the preceding paragraph, describing the rich veins to be mined in California, recounts how "beds of lava, which after filling up the beds of antediluvian rivers, were left, by the washing away of the banks and adjacent plains, to stand as mountains, marking the position of great treasures beneath."[32] Another proponent of the state's development, writing in the following decade, claimed that "ordinarily the rock in which gold is found crops out, or rises above the surface of the ground and gives indication of the riches it contains."[33] Thus human intervention improved the landscape, which guides its own development, with mountains serving as little more than "markers" and "indicators" of where European-Americans should start their digs. Through frequent reference to the wilderness as a "testimony," a "sermon," or, most commonly, a "map," late-century explorers and industrialists expressed the conviction that nature might serve as a resource—providing both the raw material and the plan—for the nation's development.[34] During this era, untouched natural tracts—be they famous gorges or unsung coastal valleys—served as natural maps, recording the past but also laying out the direction of future growth.

It is tempting to assume that only those with a clear economic stake in developing natural resources would read in the land justification for agricultural or mining endeavors, but those who argued for the preservation of wilderness tracts were similarly convinced of the links between natural formations and development. During the summer of 1870 Nathaniel Pitt Langford—a key player in securing political support for Yellowstone's preservation and the park's first superintendent—participated in the first European-American survey of the territory that would become Yellowstone National Park. His published account of that survey reveals how those who advocated wilderness protection viewed the natural world. Convinced that the region contains "nature's greatest novelties," Langford lavished attention on Yellowstone's "majestic . . . natural architecture" and looked forward to the day when it would be "crowded by happy gazers from all portions of our country." In recounting the natural attractions encountered on his journey around Yellowstone Lake, he predicted it would soon "be adorned with villas and . . . ornaments of civilized life." He went on to boast that the region "possesses adaptabilities for the highest display of artificial culture, amid the greatest wonders of Nature that the world affords. . . . Not many years can elapse before the march of civil improvement will reclaim this delightful solitude, and garnish it with all the attractions of cultivated taste and refinement."[35]

Langford was not arguing for the inevitable development of land that stood in the path of urban growth or contained valuable mineral or timber resources. Acknowledging both the utter remoteness of the region and its worthlessness to industry, Langford was nonetheless convinced that the very logic of the landscape required that this geologically singular area be developed.[36] By a process of reasoning that would be lost on modern conservationists, Langford held that the presence of majestic "natural" architecture made a compelling case for development. Natural wonders needed development to realize the potential of their whiteness. Rather than simply legitimating existing European-American culture, grand geological formations established a model to guide the future growth of the nation.

Langford was not an environmentalist in any modern sense. His views on development and his long-standing association with the Northern Pacific Railroad (which pushed for the creation of Yellowstone National Park to encourage tourist traffic along its routes) must temper any such conclusion. But the point is not to judge whether Langford's outlook fits neatly with our contemporary definitions of environmentalism but to emphasize that even Gilded Age European-Americans who espoused preservationist sentiments that were radical in their day could simultaneously believe that the landscape called out for its own exploitation. During the late nineteenth century, Langford's desire to preserve America's most singular wilderness tracts did not necessarily conflict with his hope for their controlled development. Even John Muir, a man frequently invoked today as the most prescient of Gilded Age preservationists, advocated development in our national parks that would, if proposed today, send alarmed Sierra Club members racing in protest to their congressional representatives.

These characteristics of the European-American view of the landscape help explain both Watkins's celebration of nature and industry in his photographs and the extensive development of America's national parks during the late nineteenth and early twentieth centuries. The example of Yosemite is not atypical, with its permanent villages (and their attendant power plants, sewage systems, water treatment plants, parking lots, and roads) as well as a zoo, museum, racetrack, golf course, agricultural lands, grazing pastures, lumber operations, and even a massive dam all springing up within the boundaries of the park. Zeal for the development of Yosemite reached its height in 1929, when a co-founder of the National Park Service, Horace Albright, lobbied to bring the 1932 Winter Olympics to the valley.[37] With some of the strongest supporters of national parks, like Langford and Albright, actively promoting their development, we might more usefully relate that development to a racialized worldview than to Americans' failure to protect their natural heritage.

To claim that this particular, racialized view of nature dominated European-American thinking during the late nineteenth century is not to assert that view as the only one in play when whites looked at the natural world. A few vocal dissenters in the period

held views of the land diametrically opposed to those of the developers and preserva-
tionists I have cited, yet these divergent views were rarely less white. The vast majority of
European-Americans who criticized the dominant manner of comprehending nature ad-
vanced competing models firmly wedded to their racial self-interests. As a number of
scholars of whiteness have suggested, the power of the construct lies in its fluidity—it
can adopt and discard attributes and outlooks, all the while promoting the interests (eco-
nomic, political, cultural, etc.) of those categorized as white. Although the social pro-
duction of vision held out the potential for Protestant European-Americans from west-
ern Europe to adopt modes of looking that were not white, it was rarely realized. More
often than not, the malleability of sight worked in one direction—with nonwhites adopt-
ing modes of vision that worked against their racial self-interests.

At the time when Watkins's landscape photographs promoted the dominant European-
American gaze, Frederic Law Olmsted's writings and speeches forcefully advanced a com-
peting view of nature. In the 1890s Olmsted advised that Yosemite's worth not be based
on "the greatness of its walls . . . [the] length of its little early summer cascades; the
height of certain trees, the reflections in its pools, and other such matters as can be en-
tered in statistics tables . . . [or] pointed out by guides and represented within picture
frames." As early as 1865, he spoke out against what he took as the public's harmful in-
clination to see the region as a mere "wonder or curiosity."[38] For him nature's significance
did not lie in its largest geological forms, nor did he read such forms as legitimating de-
velopment of the land. While most preservationists of the period hoped to save a hand-
ful of vistas and gigantic rocks, he promoted a novel agenda to shield nature from
commercialization and the grossest intrusions of industrial development.

Though his vision of nature conflicted with mainstream European-American views,
Olmsted shared his contemporaries' ideal of a landscape devoid of Native Americans.
Several of his texts lamenting the narrow and destructive attitudes of his white con-
temporaries toward the natural environment referred frequently to the "problem" of
Indians. For Olmsted an Indian was "a prodigious nuisance and an enormous super-
stition. . . . I call him a savage, and I call a savage a something highly desirable to be
civilized off the face of the earth. . . . He is a savage—cruel, false, thievish, murderous;
addicted more or less to grease, entrails, and beastly customs; a wild animal with the
questionable gift of boasting; a conceited, tiresome, blood-thirsty, monotonous hum-
bug."[39] Although Olmsted shared with Native Americans an interest in the interconnec-
tion of animals, plants, and geological forms in the natural world and distanced himself
from what might be termed the spectacular gaze of his European-American contem-
poraries, he held uncompromisingly to a worldview that precluded nonwhite peoples
from sharing equally in resources. Remarkable for his perspective on nature, Olmsted
was altogether conventional in his racial outlook, holding with many of his contempo-
raries the hope that Indians would be "civilized off the face of the earth."

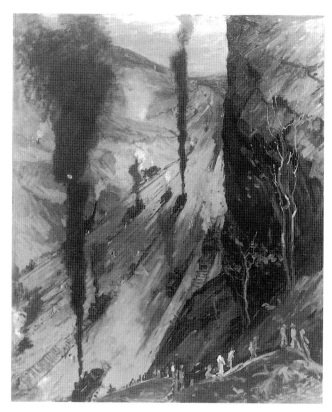

FIGURE 25
Jonas Lie, *The Conquerors (Culebra Cut, Panama Canal)*, 1913. Oil on canvas, 151.8 × 126.7 cm. The Metropolitan Museum of Art, New York, NY. George A. Hearn Fund, 1914.

Readers might question the usefulness of categorizing as white the works of Watkins and Olmsted when they promote such obviously dissimilar agendas for the natural world. If anything links the disparate texts, it would appear to be their shared focus on nature, rather than their connections to racial politics. But hesitation about positing the racial link probably has more to do with our unfamiliarity (and perhaps even discomfort) with whiteness as a category of analysis than with a judgment on the usefulness of seeing the racial connections. Distinct outlooks toward nature are also evident in *The Conquerors*, by Jonas Lie, and *Lake and Mountains*, by Lawren Harris (figs. 25, 26), but our culture's growing comfort with gender as a category of analysis allows us to see the works united in their promotion of a masculinist gaze. Although in Lie's work nature is an obstacle to be overcome and in Harris's a pristine backdrop to be visually consumed, both men demonstrate a clear interest in the masculine tropes of their eras. In *The Conquerors* conventions of narrative gender the work by depicting man-made engines of steel tearing a massive cut through land that will form the Panama Canal; in *Lake and Moun-*

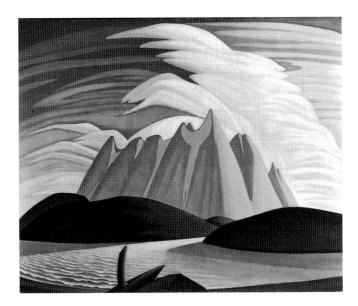

FIGURE 26 Lawren S. Harris, *Lake and Mountains*, 1928. Oil on canvas, 130.8 × 160.7 cm. Collection of the Art Gallery of Ontario, Toronto, Canada. Gift from the Fund of the T. Eaton Company, Limited, for Canadian Works of Art, 1948.

tains the symbolism of the barren North and phallic peaks presents a distinctly masculine aesthetic. During the late nineteenth century pro-development rhetoric was white because it took for granted the right of European-Americans to expropriate the land of nonwhites and develop it to support exclusively European-American cultural values, and much preservationist sentiment was similarly white because it failed to reconcile the protection of nature with the rights of Native Americans to remain connected to the land. Even though Watkins's photographs and Olmsted's writings espouse significantly different views of nature, their (admittedly varying) promotion of a white perspective links photographs and treatises on a continuum of white desire.

That men such as Watkins and Olmsted might hold contrasting views of nature suggests that if a white gaze might usefully be said to exist, it constitutes a common interest, stemming from often distinct ways of looking, rather than a shared view of—in this case—the landscape. Notwithstanding my reading of the racial coding of Watkins's images, I do not wish to suggest that all "white" landscapes must take a side in the preservation-development debate, or even that they need necessarily focus on the most monumental forms in nature. Along the same lines, I do not want to reinforce the long-standing contrast between Indians as environmental guardians of the land and European-Americans as its exploiters, for every human society exploits the environment—that is how we survive and develop our cultures.[40] The manifestations of that exploitation and its ramifications for people designated as racially other, however, are formulated differ-

ently by each race. Without claiming that certain discourses circulate exclusively within a given racial group, I wish to highlight how the discourse of development helped structure the beliefs and actions of European-Americans during the Gilded Age. Formal arrangement and focus evident in Watkins's work follow a pattern common in depictions of the nineteenth-century American landscape, though that pattern represents only one element of the complex relations that produced the racialized meaning of the images. Landscapes advancing a white perspective promote the varied interests of whites rather than depict particular forms in regularized arrangements or advocate specific policies.

In the photographs of Watkins and the writings of Langford and Olmsted, meanings are circumscribed by the invisible discourse of whiteness (residing in viewers), then particularized by the visible discourse of nature (suggested by the subject matter of the works), and ultimately refined (as I will explore shortly) by formal evidence. To clarify how visible discourses suggested by the works can produce radically diffferent meanings, I want to briefly consider an image by the Hudson River school painter Frederic Edwin Church. Church's canvas, though it has many superficial affinities with Watkins's renditions of the natural world, says nothing about the debate on preservation and development and ultimately uses whiteness to advance a political agenda that relates only tangentially to nonwhite peoples.

During the decades when Watkins established a national reputation for his dramatic scenes of the western United States, Church too gained fame, for his depictions of the Far North and South of the Americas. In Church's *Aurora Borealis* (1865; fig. 27), we glimpse an arctic scene of rock and ice, with the tiny schooner of the explorer Isaac Hayes illuminated by the ghostly glow of the northern lights. Between the lights and Hayes's icebound craft is the silhouette of a shadowy mountain called Church's Peak, which Hayes named in honor of his artist friend. The peak does not jump out at modern viewers, but readers will now appreciate the ways in which nineteenth-century European-American eyes were conditioned to read its significance in its placement at the center of the composition, towering above the surrounding mountains, and in its unusual shape, a seemingly artificial, triangular form. Having never ventured to the region, Church produced his rendition of the mountain from a sketch Hayes had given him, from which a print was also made (fig. 28). In the finished canvas, the base of the peak is hidden from view (fig. 29), a strategy that downplays the gradual and irregular foundation on which it rests and emphasizes the artificial qualities that would have attracted midcentury eyes.

Twentieth-century scholarship considered the painting as it relates to polar explorations, the artist's fascination with the American wilderness, geology, astronomy, and nationalism, but the dominant reading has linked *Aurora Borealis* to the impending end of the American Civil War. The art historian David Huntington and others, citing Herman Melville's belief that a particularly brilliant display of the northern lights in December 1864 heralded the Union's coming victory in the war, have argued that Church's

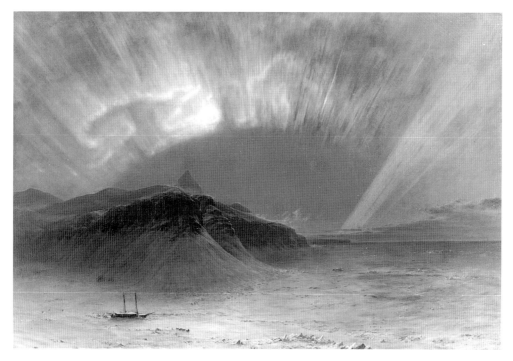

FIGURE 27 Frederic Edwin Church, *Aurora Borealis*, 1865. Oil on canvas, 142.3 × 212.2 cm. Smithsonian American Art Museum, Washington, DC. Gift of Eleanor Blodgett.

contemporaries understood the work primarily as a parable of God's support for the Northern cause.[41] The Civil War context ensured that viewers read the artificial peak as evidence of Northern white culture fulfilling God's master plan, not as a call for the development of the Far North. Bathed in red, white, and blue light, at the farthest reaches of the globe, Hayes and his crew stumbled on evidence that the highest architectural and cultural aspirations of Northern whites were a natural part of God's order. If the transient phenomenon of the aurora borealis foretold the Union's military victory, the singular peak manifested the cultural triumph of Northern whites.

Readers may see difficulties in my effort to tie the painting to the perceived "whiteness" of the North when the Civil War was fought by opposing forces that were largely white. These exist, however, only if we accept the fixity and self-evidence of the racial category. Because the whiteness of individuals is more usefully understood as a contested ideological position than as a shared genetic code, there is nothing intrinsically odd about the North's efforts to "outwhite" the South. In many ways this is precisely what the South had been doing for years, questioning the racial fitness (and, not incidentally,

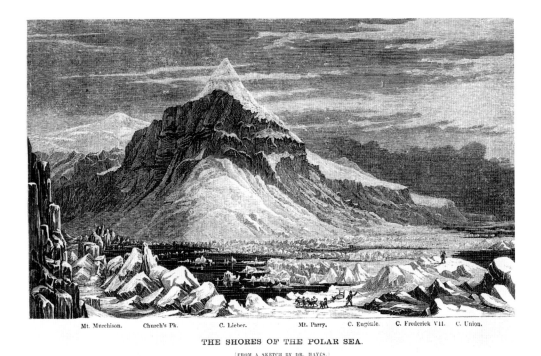

Mt. Murchison.　　Church's Pk.　　　C. Lieber.　　　Mt. Parry.　C. Eugénie.　C. Frederick VII.　C. Union.

THE SHORES OF THE POLAR SEA.

[FROM A SKETCH BY DR. HAYES.]

FIGURE 28　　Isaac Hayes, *The Shores of the Polar Sea*, 1867. Plate from *The Open Polar Sea: A Narrative of a Voyage of Discovery towards the North Pole*, 9.3 × 13 cm. Lockwood Memorial Library, SUNY Buffalo.

the manhood) of Northerners, in reaction to what Southerners took as Lincoln's attack on their racial and economic foundations. As implausible as it sounds today, Confederates in the early 1860s could write of how the "antagonisms existing between the North and the South" were a "necessary consequence of their radical difference in race." Believing that northern European-Americans descended from "Anglo-Saxons," and that their southern counterparts traced their ancestry to the "Normans," many whites in the South took these groups as separate races possessing distinctive and often incompatible traits.[42] In 1860 the editors of the Richmond-based *Southern Literary Messenger* published an article entitled "The Difference of Race between the Northern and Southern People," which extended the racial logic typically used to justify the enslavement of blacks to argue for the efficacy of Southern rule over Northern whites. Noting that the northern and southern European-Americans were "equal" in no biological sense, but merely treated as such by the "peculiar form" of government in the United States, the author observed approvingly that Southerners "come of that race to whom

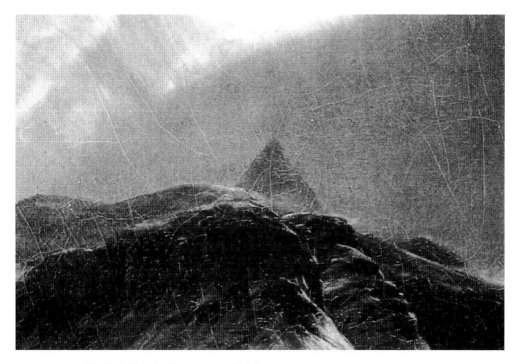

FIGURE 29 Frederic Edwin Church, detail of figure 27.

law and order, obedience and command, are convertible terms, and who *do* command, the world over, whether the subject be African or Caucasian, Celt or Saxon."[43]

No one would argue that the "command" that Southerners exercised over "Africans" and "Saxons" had any correspondence to real life, but how fascinating that the writer could forge a rhetorical link between groups that modern readers take as self-evidently "black" and "white," and see them standing together in racial opposition to the purity of Southern whites. We typically relate the malleability of race to the alterations, over time, of the traits associated with a given racial group or to the possibility that racially marginal groups can work toward becoming more securely white or black. Race in this example, however, emerges as fluid even for those most securely raced. The two chapters that follow say more about this characteristic of race, but for now it is enough to appreciate the power of abolitionist politics to cast doubt on the racial designation of European-Americans in the minds of proslavery whites. The writer for the *Literary Messenger*, who would never have confused Americans of African and European descent on the street, could nonetheless designate "Saxons" as racially other in a political, social, and military context where their interests and beliefs were seen to ally with those of blacks.

Aurora Borealis made its claim for white cultural superiority at the very moment when white economic and social dominance appeared most threatened—by the passage and ratification of the Thirteenth Amendment to the U.S. Constitution, which abolished the institution of slavery. The Civil War context out of which *Aurora Borealis* was born encouraged European-Americans in the North to favorably imagine their cultural products in relation to those of Southern whites but also ensured that Northerners consider their relationship to blacks, given the debates on emancipation then gripping the nation. Hailed today as a corrective to a democratic nation founded on both liberty and slavery, the amendment was greeted with ambivalence when first introduced. It quickly passed the Senate by a sizable margin but failed to garner enough votes to pass the House in 1864; it barely attained the two-thirds majority (by a 119–56 vote) required for passage in 1865, after Lincoln made it a political priority. Its narrow passage in the House is all the more remarkable when we consider that in 1865, Southern representatives, not yet readmitted to the Union, were still not voting in the chamber.

The endemic racism of the era may explain the Thirteenth Amendment's difficult journey to ratification, but the label "racist" sheds little light on the cultural workings of postbellum society. Consider the gap that exists even today between the number of Americans who claim to favor "equal" treatment of all and those who would support legislation to address specific structural inequalities in our society. In postbellum society as today, Americans tacitly appreciated that racial justice can be a zero-sum game; the expansion of economic and political opportunities for traditionally disempowered groups necessarily comes at the expense of more advantaged groups. In the aftermath of the Civil War, legislators and their white constituents understood that if blacks competed freely in the marketplace, or advanced their interests through the electoral system, the environment would be less well tailored to the desires of whites. Equal protection and opportunity effectively mean less protection and opportunity for those who have traditionally profited from the preferential treatment that is the cornerstone of any discriminatory system. Although many European-Americans at the close of the Civil War may have embraced emancipation intellectually, their sense of the justness of the cause did not make them drop emotional objections to a postbellum society in which white power would be diminished.

Aurora Borealis permitted European-Americans (whether regressive or progressive on questions of racial justice) to counter the reality of postbellum political and social gains for blacks with a fantasy of white cultural supremacy. Works by photographers and painters helped smooth over ideological inconsistencies, allowing many Northern whites to fight militarily for the liberty of African Americans during the very years when they battled symbolically (and at times legislatively) for the supremacy of whites. Given that white identity is predicated on a shared sense of superiority, any disruption to this sense of power undercuts the identity of whites. Because whites supporting emancipa-

tion and black rights were effectively engaging in an act of identity destruction, un-
dermining the very inequalities on which their racial identity rested, many of them dis-
played a psychic need for symbolic and material reinforcement of their racial preroga-
tives. European-Americans contending with contradictory beliefs in emancipation and
whiteness found solace in visual products offering assurance of the God-given privileged
place of white Americans in the world.

To explore how nineteenth-century audiences interpreted *The Yosemite Valley from
the Best General View,* I have discussed a series of dominant narratives on nature, de-
velopment, and race that conditioned period responses. Up to this point, I have not dis-
tinguished the image from literary and cartographic depictions of the Yosemite Valley,
because I wish to illustrate how the photograph's meaning was produced foremost by
existing visual and literary currents, not to claim that the image forged a unique state-
ment on Victorian culture. Given my belief that images contain no inherent meanings—
that the meanings attributed to them are created solely by a society's shared invest-
ment in them—I anchored the work in significant cultural narratives. But because
creation and interpretation in the same cultural context do not ensure that the era's de-
pictions of Yosemite possess interchangeable meanings, I now want to consider how Wat-
kins's photographic image—with its distinct and recognizable narrative properties—
differentiates itself from other visual depictions of the valley. *The Yosemite Valley from
the Best General View* is surely given its cultural significance by the concerns of the so-
ciety in which it was produced, but it is important not to conflate its meaning summar-
ily with that of either Whitney's survey map or Hittell's literary descriptions. Given the
critical and commercial success of Watkins's images, and the often minor elements that
separate his work from that of his less-renowned contemporaries, the formal and narra-
tive specificity of his photographs must have played a role in separating their ideologi-
cal work from that performed by other artifacts of the Gilded Age. Watkins's images of
Yosemite allowed European-Americans to read meanings that apparently were unavail-
able to them in less-celebrated depictions of the valley.

There can be little doubt that Watkins's works had special resonance for European-
American viewers in the late nineteenth century. Although Watkins himself displayed
noted weaknesses as a businessman and a disinclination to promote his work, his pho-
tographs of the west were among the most highly praised of any produced during the
1860s and 1870s.[44] The photographer Charles Roscoe Savage assured readers of the
Philadelphia Photographer in 1867 that "among the most advanced in the photographic
art, none stands higher than Mr. C. E. Watkins, who has produced, with his camera, re-
sults second to none in either eastern or western hemisphere." For Oliver Wendell Holmes
Watkins's subjects were "among the most interesting to be found in the realm of Na-
ture," and the photographs were "a perfection of art which compares with the finest
European work." Writing in 1863, Ralph Waldo Emerson went so far as to claim that

Watkins's photographs of the giant sequoia reversed Emerson's doubt regarding their existence and "made the tree possible."[45]

Watkins's images were both immensely popular and profoundly effective in shaping nineteenth-century viewers' experiences of the natural world. Looking back on a trip to Yosemite in 1863, the adventurer Fitz Hugh Ludlow recalled his keen anticipation of entering the valley for the first time. As he waited for morning light to begin his descent into Yosemite, he recalled Watkins's work. Ludlow fantasized about the moment when he and his traveling companion, the landscape painter Albert Bierstadt, might venture into "the vale whose giant domes and battlements had months before thrown their photographic shadow through Watkins's camera across the mysterious wide Continent, causing exclamations of awe at Goupil's window, and ecstasy in Dr. [Oliver Wendell] Holmes' study." When he reached the valley floor and glimpsed the North Dome, Ludlow explained, he "immediately recognized [it] through Watkins's photographs."[46]

Ludlow's excitement stemmed less from his anticipation of seeing the famous valley firsthand than from his eagerness to experience the scenes memorialized in Watkins's photographs. Such enthusiasm is noteworthy, given what present-day viewers might take as the fine distinctions between Watkins's Yosemite photographs and those of his numerous competitors. In hauling his equipment through dense brush to the edge of Mount Beatitude for the creation of *The Yosemite Valley from the Best General View*, for example, Watkins followed in the footsteps of Charles Leander Weed, whose image *Yo-semite Valley from the Mariposa Trail / Mariposa County, Cal.* (1863–64; fig. 30) clearly served as a prototype.[47] Centered on the same monumental geology and taken from an almost identical vantage, the two photographs are similar in arrangement and subject matter. But their differences, if subtle, are also significant. Watkins positioned his camera closer to the canyon's rim and directed its lens more sharply downward toward the valley floor to offer viewers a more comprehensive view of Yosemite's interior. The resulting image reveals the uninterrupted height of the towering canyon walls and offers a more complete overview of the valley's sprawling floor, stressing both Yosemite's depth and the size of its individual geological forms. Watkins's treatment of the foreground tree further enhanced depth. By moving the pine to the right of his composition and by cropping its crown, Watkins transformed it from a freestanding tree in a landscape to an abstract prop pressed up against the picture plane. As a visual marker of foreground space, the tree accentuates the distance separating us from the valley floor—an effect greatly heightened in stereoscopic versions of the image. In contrast to Weed's rendition, which presents Yosemite as a comparatively flat and static backdrop, Watkins's image suggests the distance from rim to floor and encourages visual movement down into the fictive space.

Significant narrative departures in Watkins's version are evident in his elimination of the trail that meanders to the edge of the gorge and the removal of two diminutive figures—a man leaning against the trunk of the pine tree in the foreground and, to his

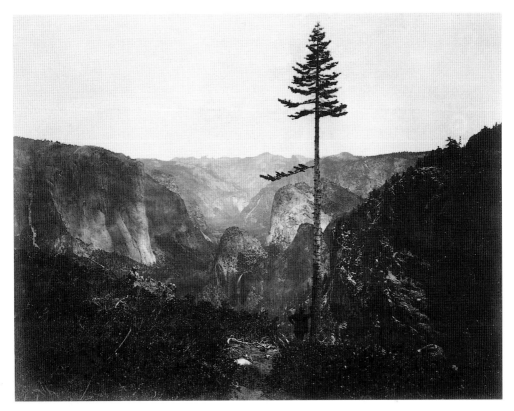

FIGURE 30 Charles Leander Weed, *Yo-semite Valley, from the Mariposa Trail / Mariposa County, Cal.*, 1863–64. Albumen print, 39.6 × 51.6 cm. J. Paul Getty Museum, Los Angeles, CA. © The J. Paul Getty Museum.

left, a bonnet-clad woman seated with a book on a rock outcropping at the canyon rim. In creating a best general view that effaced human beings and any sign of their activities, Watkins produced an image consistent with his standard practice for depicting geological wonders. Critics as early as the 1860s noted his proclivity to exclude signs of a human presence in Yosemite, which subtly distinguished his landscapes from those of his most prominent competitors, Weed, Timothy O'Sullivan (fig. 31), and William Henry Jackson (fig. 32).[48]

Art historians tend to read figures in painted or photographic landscapes as surrogate viewers who signal human power over the natural world. Albert Boime, in his analysis of American landscape painting, argues that Hudson River, Luminist, and Rocky Mountain school scenes are unified by a "magisterial gaze." According to Boime, landscapes

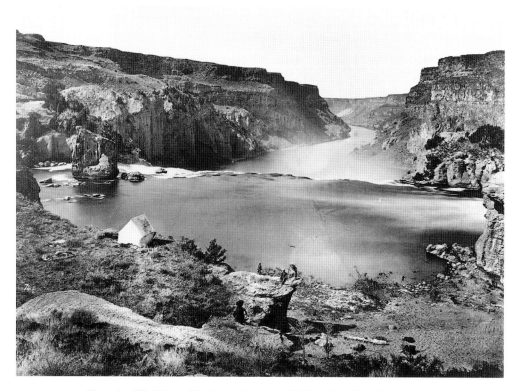

FIGURE 31 Timothy O'Sullivan, *Shoshone Canon and Falls*, 1868. Plate from *Geological Explora-tion of the Fortieth Parallel*, 20.3 × 26.7 cm. Prints and Photographs Division, Library of Congress, Washington, DC.

from the middle third of the century consistently position viewers at a height in the image from which they can survey a vast terrain spread out beneath them. Boime reads this built-in vantage as a metaphor for the audience's power and as a cultural paradigm revealing the "ideology of expansionist thought."[49] While Boime argues that the spectators' power is communicated by the angle from which they view the scene and not by surrogate figures included in the artwork, he appreciates how such figures allow audiences to believe in their power over the canvas's fictive space and, by extension, over the natural world.

Boime concludes that western landscape photographers appropriated the magisterial gaze from the tradition of landscape painting—a contention borne out by the reception of Watkins's images.[50] An editor of the *Philadelphia Photographer* who scanned one of

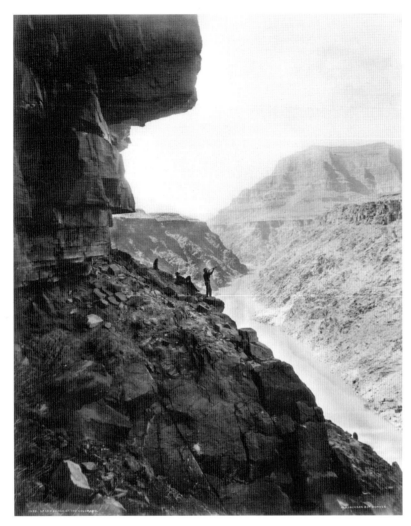

FIGURE 32
William Henry Jackson, *Grand Cañon of the Colorado*, ca. 1880. Albumen print on paper, 53.7 × 42.8 cm. Smithsonian American Art Museum, Washington, DC. Museum purchase from the Charles Isaacs Collection made possible in part by the Luisita L. and Franz H. Denghausen Endowment.

Watkins's depictions of Lower Cathedral in 1866 noted that "the whole world might be viewed from it, and from there ruled and commanded."[51] But while the ideological function of the gaze may have been similar in painted and photographic scenes, the meaning of surrogate figures was transformed by the change in media, ultimately weakening the case for white racial entitlement in photographic renditions. If, as I have argued, depictions of natural architecture helped legitimate European-American development by providing a natural affirmation of white culture, I suspect that those photographs

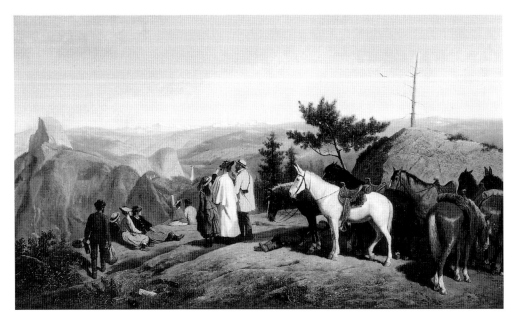

FIGURE 33 William Hahn, *Yosemite Valley from Glacier Point*, 1874. Oil on canvas, 69.22 × 116.84 cm. California Historical Society, San Francisco. Gift of Albert M. Bender.

that in any way lessened the "naturalness" of the scene may have diluted arguments for white dominance. Photographs containing figures or other signs of human activity did not refute European-American claims for racial superiority but made a slightly less compelling case. The inclusion of figures in a photographic landscape linked the work to a long-standing art historical tradition that was necessarily seen as artificial. Because the artificial and subjective nature of photographs was already understood, stylistic or narrative links to genres perceived as less objective could only further undermine photography's ties to the real. To be sure, even without signs of a human presence, the formal arrangement of Watkins's photograph signals its contrivance by relying on the conventions of landscape established by Claude Lorraine. My point here is certainly not that Watkins's work is more true than Weed's, only that the elimination of an obvious human presence allowed period viewers to read it as such.

The potential for figures to disrupt the "naturalness" of landscape photographs operates on a more potent level as well, given Americans' cultural, rather than natural, justification of European-American domination in the latter half of the nineteenth century. Consider William Hahn's *Yosemite Valley from Glacier Point* (1874; fig. 33). The sightseers in his canvas, dressed in fine attire and occupying much of the foreground,

are arrayed before the diminutive profile of Half Dome, which appears in the upper-left distance. Despite a literary and visual context that celebrated the power of Yosemite's unparalleled geology, Hahn's work reduces Half Dome to a studio backdrop, allowing the human actors to dominate the scene through their size, placement, and coloration. In this work raw natural architecture is subordinated to cultured, leisure-class tourists. Such a model of European American power contrasts starkly to that of Watkins's Yosemite photographs, where power is not oppositional—people over nature—but flows naturally from the land itself. Watkins's photographs affirm the dominance of European-American culture by seamlessly allying it with nature.[52] Watkins's pristine landscapes, with their focus on natural architecture, signal the logic and inevitability of white cultural dominance without displaying overt signs of human activity. Both canvas and photograph may be said to picture European-American ascendance, though Watkins's naturalized model of pure landscape is considerably more potent.

European-Americans read the works of Watkins and Weed (and, for that matter, those of O'Sullivan, Jackson, Church, and Hahn) as advancing the interests of whites. What separates Watkins's works from those of his contemporaries is his ability to draw into his photographs those strands of discourse on nature, development, and race that resonated most profoundly with his contemporaries' perceptions of their self-interest. European-Americans who gazed at Watkins's photographs had little difficulty interpreting the images of the Yosemite Valley before them. Secure in their entitlement and surrounded by what they took as obvious signs of white civilization, they saw in the images affirmation of their history and ambitions. *The Yosemite Valley from the Best General View*, produced and viewed through the lens of whiteness, proffered a template for the development of the west, legitimating the extension of European-American society into the very environment whites would irrevocably transform.

CHAPTER THREE

MUSEUM ARCHITECTURE AND THE IMPERIALISM OF WHITENESS

While studying architecture in Paris, Charles McKim received periodic reports from his father on the architectural practice of Frank Furness (1839–1912), a partner in the rising Philadelphia firm of Fraser, Furness and Hewitt. Impressed with the design of Rodeph Shalom Synagogue (1869–70; fig. 34), the elder McKim commented in an 1869 letter to his son that "Frank Furness is building a costly Jewish Temple. It is of course in the saracenic style."[1] For McKim and his contemporaries, "Saracenic" or "Moorish" architecture was a Western style adapted from the designs of medieval Muslim builders in North Africa and southern Spain.[2] Near Eastern styles, popularized by such nineteenth-century European and American artists as Samuel Taylor Coleridge, Eugène Delacroix, and Washington Irving, reached a broad architectural audience through the mid-nineteenth-century publications of the Welsh architect and designer Owen Jones, whose books contained lush illustrations of the Alhambra palaces built by the Moors at Granada between the thirteenth and fifteenth centuries. In *Plans, Elevations, Sections and Details of the Alhambra* (1842–45) and *Grammar of Ornament* (1856), Jones provided rich primary sources for the brilliant color schemes, intricate decorative patterns, slender columns, bulbous domes, and horseshoe and trefoil arches that emerged as signature elements of the style in the West.[3]

Though popular, nineteenth-century Saracenic design was neither as ubiquitous in the United States as either neoclassical or Gothic Revival architecture nor as indiscriminately applied to a range of building types. By the end of the century, for example, the seemingly limitless range of structures with neoclassical designs included private homes,

FIGURE 34
Fraser, Furness
and Hewitt,
Rodeph Shalom
Synagogue,
Philadelphia,
1869–70. Grams-
torff Collection,
National Gallery
of Art, Library
Image Collections,
Washington, DC.

apartment houses, banks, libraries, statehouses, court buildings, department stores, churches, city halls, museums, clubs, railroad stations, and office buildings. As an architectural critic observed wearily in 1868, "The country was studded with [neoclassical] 'temples,' from court-houses down to bird-boxes."[4] In contrast, Saracenic designs were applied more narrowly to a particular category of buildings that included synagogues, clubs (fig. 35), department stores, restaurants, theaters, music halls, bandstands, cinemas, exposition structures (fig. 36), and select domestic interiors.[5] European-Americans consistently used it for fantastic and transformative structures—for those venues intended to

FIGURE 35
Richard Morris
Hunt, Scroll
and Key Society,
Yale University,
New Haven, CT,
1869.

transport viewers from quotidian experiences. The Near East struck audiences as an appropriate reference when the activities associated with the spaces provided an escape from the routines of daily life. It suited the sumptuous displays of department stores, the racial exoticism of expositions, and the rule-bending sights of early motion pictures. But Eastern-inspired designs were also deemed appropriate for use by peoples whose customs seemed rooted in distant, exotic cultures. Just as the style offered Christian European-Americans a safe yet exciting escape from everyday life, it seemed to re-create for Jews, and other alien peoples, more natural, native environments.

Given the novelty of Eastern-inspired synagogues in the United States at the close of the 1860s, McKim's assertion that the design of Rodeph Shalom was "of course" Saracenic reflects less on the inevitability of the style's selection than on his understanding of its ideological fitness for a Jewish place of worship,[6] built for a people whom European-Americans thought unable to transcend their alien Eastern character, however long they had lived in the United States.[7] Period guidebooks described the synagogue as both "peculiar" and "novel," because of its "elaborate ornamentation," which "contrast[ed] with the prevailing styles," such contrasts being read by European-Americans as an appropriate expression of Jewish difference.[8] But within the ethnic vocabulary employed by Furness and Hewitt, Moorish designs were also thought suitable for exotic peoples who did not necessarily originate in the Near East. Just as Furness's many commissions for Jewish European-Americans tended to be built in Saracenic forms (for example, the Jewish Hospital of Philadelphia, whose various structures were built between 1871 and 1907), so

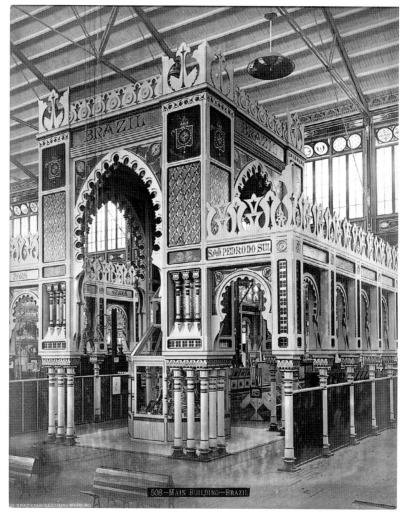

the Brazilian pavilion he designed for the Philadelphia Centennial Exhibition (ca. 1876; see fig. 36) boasted what period commentators knew as a "Moorish style."[9] In determining the appropriateness of Near Eastern forms for particular ethnic or religious groups, European-Americans concerned themselves much less with the people's geographic place of origin than with perceptions of their status as an "other."

Architectural historians typically explain the Rodeph Shalom congregation's embrace of Furness and Hewitt's design with reference to the politics of Rabbi Marcus Jastrow,

who initiated the synagogue's building campaign. A German-born humanist who earned a doctorate in philosophy, Jastrow surprised his congregants by arguing that men and women should be seated together on the main floor of the new synagogue, separated only by an aisle, and by calling for an organ to be located behind the ark. While the changes instituted by Jastrow surely struck more traditional congregants as radical, they represented another step in a century of reform that brought the religious practices of American Jews more in line with Christian conventions. Many Jewish congregations, equating "reform" with Christian norms, adopted such additional changes as the placement of the ark at the far end of the synagogue, addition of a pulpit, establishment of family pews, introduction of sermons, and development of a professional clergy.[10] Whether Jastrow's congregants initially interpreted his reforms in a positive or negative light, few could have missed the pull of Rodeph Shalom toward Christian practices of worship. Because Saracenic design was closely associated with both modernity and Reform Judaism in the Germany of Jastrow's youth, the rabbi's politics encouraged his rejection of the classically inspired synagogues that were then the norm in Philadelphia.[11]

The irony is that the architectural expression of reform offered a visual reminder that synagogues were not churches and, by extension, that Jews were not Christians. In discarding older American prototypes of synagogues that appeared stylistically similar to churches and embracing Orientalist designs, Reform Jews marked their difference from Christians at the precise moment when their practices became more alike. The Jewish embrace of Saracenic design may be interpreted either as a reflection of the growing comfort of Jews in articulating their differences from other Americans in the late 1860s and 1870s or as an expression of their emerging concern to assert religious and cultural distinctions they did not want to erase. In either case, the adoption of a Saracenic style for synagogues undoubtedly helped to distinguish Jewish from gentile European-Americans.[12]

Less than a year after the synagogue's consecration, Furness and Hewitt abandoned their senior partner and formed their own architectural practice, confident that their social connections and growing reputations might sustain a new firm. The new partnership won a number of design competitions, the most lucrative among them the new home of the Pennsylvania Academy of the Fine Arts (1872–76; fig. 37).[13] With its novel design, which bore little stylistic resemblance to that of any previous museum or school of art, the structure brought together a potpourri of architectural styles, including Venetian Gothic, French Néo-Grec, Ruskinian, French Second Empire, and features at least one critic has interpreted as Native American.[14] But as contemporary architectural historians from James O'Gorman to John Sweetman and Zeynep Çelik to Michael Lewis have each observed, the building also made extensive reference to Near Eastern architecture in general, and to Rodeph Shalom in particular: in its brilliant color scheme; interior columns capped with diamond-patterned detailing (figs. 38, 39); decorative floral

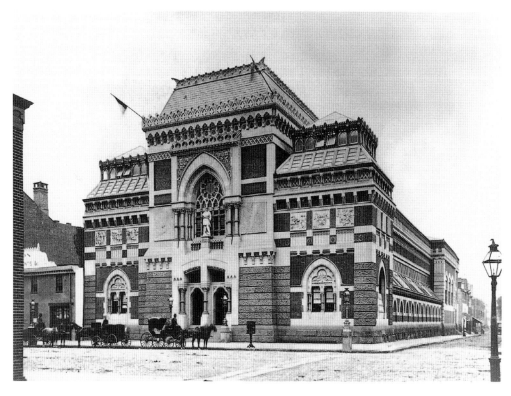

FIGURE 37 Furness and Hewitt, northeast facade of the Pennsylvania Academy of the Fine Arts, Philadelphia, 1872–76. Half of an albumen stereograph print, ca. 1880. Courtesy of the Pennsylvania Academy of the Fine Arts Archives, Philadelphia, PA.

patterns; alternating pink and white voussoirs forming arches above the doors and windows; intricate decorative brickwork; a central Gothic arch supported by short columns, displayed on the buildings' facades but also at the head of the Academy's second-floor landing (fig. 40); and trefoil arches, evident in the Academy over the main entrance and in the borders surrounding the plant motifs in the tympanum of each side-pavilion window (fig. 41), and in the synagogue on its minaret-like tower.[15] While far from carbon copies of one another, the buildings shared obvious Orientalized elements that were all the more noticeable given their proximity on North Broad Street, in a city famously characterized by its unadorned three- to five-story redbrick boxes.

To note the Oriental sources the structures share is not to articulate the ideological work they performed for nineteenth-century audiences. Considerable evidence suggests that while Gilded Age architectural critics saw Near Eastern styles as appropriate for

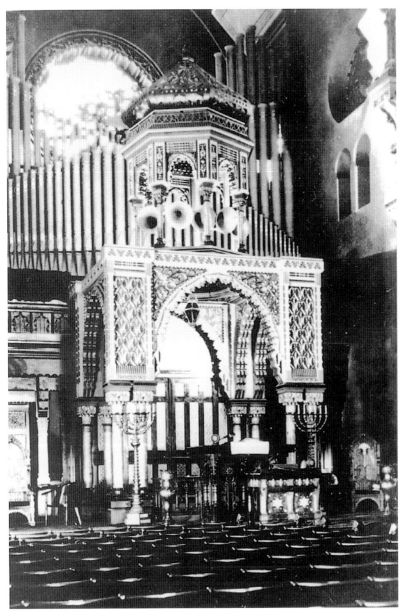

FIGURE 38
Fraser, Furness
and Hewitt,
interior of
Rodeph Shalom
Synagogue,
North Broad
and Mt. Vernon
Streets,
Philadelphia,
1869–70.
Photograph
courtesy of Jack
Quinan with
permission of
Congregation
Rodeph Shalom.

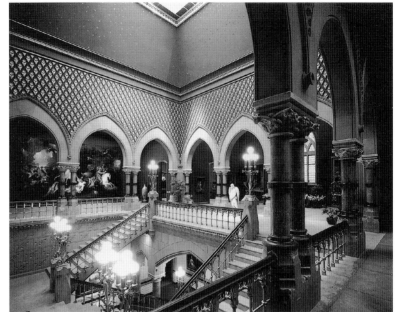

synagogues, they were oftentimes unsettled to find them used for academies of fine arts. One observer, summing up critics' confusion about the Pennsylvania Academy in 1876, claimed that "the style of architecture appears to baffle the critics; one calls it ornamented Gothic; another, modified Gothic; another nearly touches correctness in calling it 'Byzantine or Venetian'; perhaps we may come still nearer the truth in designating it as a combination or patchwork style; we doubt if any known epithet would convey to one who has not seen it a conception of the marvelous incongruities that go to make up the showy exterior of the new Academy of Fine Arts."[16] In the nineteenth century such "bafflement" resulted not from the incoherence of the "combination" or "patchwork" style but from the tendency of old-fashioned architectural critics to interpret eclecticism through the lens of more familiar, yet incompatible, architectural theories.

Confronted with an emergent style that demanded new ways of looking, many critics simply applied the logic of traditional architectural paradigms to eclecticism and misinterpreted the resulting confusion as a failure of the style. This tendency of critics is evident in the controversy surrounding the Academy directors' decision to relocate an ancient Greek statue of Ceres from the front courtyard of their previous building to a pedestal above the front portal of the new edifice (fig. 42).[17] As soon as the plans became known, a commentator warned in the press that the colossal sculpture, placed "in an odd

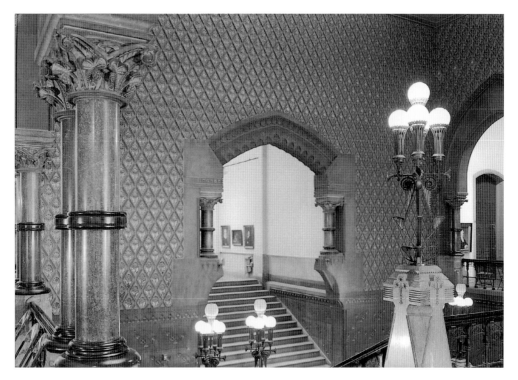

FIGURE 40 Furness and Hewitt, archway leading to the western galleries of the Pennsylvania Academy of the Fine Arts, Philadelphia, 1872–76. Historical American Building Survey, Library of Congress, Washington, DC.

incongruity with their façade, . . . will never be regarded, and will probably soon perish of exposure." The reinstallation prompted a second critic to lament that the statue now stood "in odd contrast with the trim freshness of the surrounding architecture" and was located where "few people will wait to study its beauties, and where it will receive more attention from the weather than from the public."[18]

Each critic linked the reinstallation of the statue to its physical destruction and visual neglect, thus implying that Ceres in its old location had been both safe and studied, though the reality was considerably more complex. Moved from the open courtyard depicted in a mezzotint by John Sartain (fig. 43) to a covered niche at the center of the Academy's Broad Street facade, Ceres was arguably both better protected from the elements and more visible in its more prominent site. No longer relegated to a quiet courtyard, gracing "a silent pale building in the Greek style . . . dedicated to the powers of seclusion and reserve, and only exceptionally approached," the statue was now framed

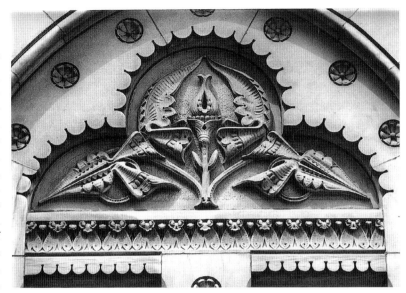

FIGURE 41
Furness and
Hewitt, detail of
tympanum on
northwest facade
pavilions of the
Pennsylvania
Academy of the
Fine Arts,
Philadelphia,
1872–76.
Courtesy of the
Pennsylvania
Academy of
the Fine Arts
Archives,
Philadelphia, PA.

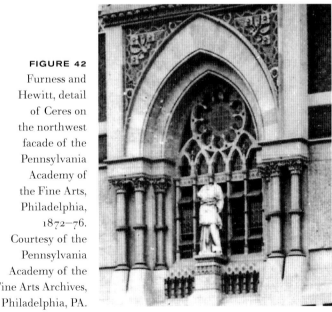

FIGURE 42
Furness and
Hewitt, detail
of Ceres on
the northwest
facade of the
Pennsylvania
Academy of
the Fine Arts,
Philadelphia,
1872–76.
Courtesy of the
Pennsylvania
Academy of the
Fine Arts Archives,
Philadelphia, PA.

FIGURE 43 John Sartain, *Second Building, Pennsylvania Academy of the Fine Arts,* ca. 1860. Mezzotint and stipple, 27.5 × 27.2 cm. Courtesy of the Pennsylvania Academy of the Fine Arts, Philadelphia, PA. Bequest of Dr. Paul J. Sartain.

by a large tracery window and centered on a facade fronting a busy Philadelphia street.[19] Had the sculpture remained cloistered in its neoclassical home, the critics never would have voiced discontent; ironically, only when it became all too visible—by its "incongruous" juxtaposition with disparate architectural traditions—did viewers express concern for what they implicitly understood as its new *kind* of visibility. Some of those who disapproved may have held the emerging view of fine art that championed the display of individual sculptures and paintings; the majority, however, were probably more conservative viewers. Their investment in revivalist architecture had conditioned them to expect that the architectural motifs of a structure be drawn from a single national or cultural tradition.

Difficulties in decoding the eclecticism of the Academy have plagued architectural historians down to the present. As tempting as it is to imagine the assemblage of national motifs on the Academy's exterior as a fitting expression of its institutional mission as a school and museum of art, the Academy's original charter belies such an explanation. Because the Academy focused narrowly on collecting and teaching the artistic traditions of Europe and Euro-America, the wide-ranging eclecticism of the building that housed it cannot be interpreted as a material expression of a charge to collect and display a broad sampling of the world's art.[20] Similarly, the structure, despite evident debts to ecclesiastical architecture, does not reflect how the discourse of art appropriated the language of religion in the final third of the century. True, the Academy was often referred to as a "temple of art," religious leaders were increasingly felt to be appropriate spokesmen for the arts, and art came to be invested with religion's power to elevate the moral sense. But none of these facts shed light on the Academy architects' decision to cite both Jewish and Islamic religious structures.[21] A typical lament on the confusion engendered by the Academy's eclectic styles concludes that "any historical recall in this potpourri aims toward Babel."[22] Contemporary critics are ultimately less comfortable explaining eclecticism in particular buildings than extolling the general resonance of the style. Eclecticism is said to appropriately express Gilded Age culture, given its articulation of "wealth and power," "commercialism," or U.S. "imperialism."[23]

The architectural historian Anne Monahan argues that Victorians, less conscious than we are of the building's Oriental motifs, saw a more consistent architectural message than we are able to appreciate today. She theorizes that Victorians found it "unthinkable" that Islamic forms would be incorporated into "one of the aspiring city's most important buildings," concluding that "most turned a blind eye to the very same patterns they read as 'Moresque' in Rodeph Shalom and the Brazilian Pavilion." That period audiences called the Academy Venetian, Gothic, or frequently even Byzantine rather than Saracenic or Moorish speaks to Monahan of an inability to acknowledge a style that struck them as ideologically incompatible with the mission and importance of an academy of fine arts.[24] But since the building committee of the Academy selected Furness and Hewitt's Orientalized design from a stylistic range of competition entries, and because critics in the 1870s praised the structure consistently, it is more fruitful to see ambivalence than blindness in the Victorian reluctance to label the Academy Near Eastern.[25]

If elite architectural critics articulated no coherent rationale for the Academy's Near Eastern eclecticism, the directors and patrons of the Academy nonetheless self-consciously promoted the structure's Near Eastern associations. The Academy directors fashioned a consecration ceremony for the opening of the building that pointedly connected it to an ancient Jewish past. At noon on April 22, 1876, the Academy staged an elaborately choreographed inauguration that included processions, orchestral music,

speeches by eminent Philadelphians, and displays of select works of art. The keynote address was delivered by the liberal theologian William Henry Furness, the father of the architect, who dedicated the structure with the words of the Old Testament prophet Moses, the "poet of the Hebrews." Then, dramatically unveiling two marble sculptures— G. B. Lombardi's *Deborah* (ca. 1874; fig. 44) and William Wetmore Story's allegory *Jerusalem in Her Desolation* (1873; fig. 45)—the elder Furness declared the building open.[26] Boasting a collection of art whose breadth and quality were then unrivaled in the United States, the institution was consecrated with the presentation of two sculptures that referred explicitly to Old Testament narratives and, so, to an ancient Jewish past.

These sculptures established a transition from opening ceremonies focused on the Academy's architecture to the artworks that the Academy was designed to house. In transferring the attention of the audience from building to holdings, the sculptures established the artistic benchmark for future exhibitions to follow from this first display. *Deborah* and *Jerusalem* served as literal and figurative progenitors of a long line of Academy shows. The two scantily clad female figures, for Gilded Age audiences, alluded to sexuality and to motherhood, but *Deborah*, as the "mother of Israel" in the book of Judges, made the maternal reference explicit. Having prophesied the military victory of the Israelites over King Jabin of Canaan, Deborah was honored by her people as the mother of their national rebirth.

Jerusalem in Her Desolation depicts a brooding figure who sits amid ruins and contemplates her recent destruction at the hands of the Babylonians, but also a maternal figure giving birth to a new institution. Inaugurating a building that was routinely referred to as a "temple of art" with a sculpture that alludes to the destruction of the Temple in Jerusalem, the directors linked their modern temple to the lost glories of the ancient Israelites. With a symbolism lost on few of the assembled guests, the directors consciously invoked the demise of Jerusalem to mark the completion of their Academy, suggesting the cyclical nature of civilizations, the passing of the torch of culture from the Near East to Europe and finally to America, and to the Academy's institutional grounding in the wreckage of an ancient past.

Audiences, who frequently traced their religious heritage to the biblical Israelites, conceived of Jews as the most logical inheritors of the Moorish architectural tradition in the United States and collapsed the distinctions between Israelites and other Near Eastern peoples, found it natural to read in Islamic architectural details and Old Testament subjects an affirmation of the Academy's ties to a mythic Jewish lineage.[27] For Christian European-Americans in the 1870s, the eclectic Academy ultimately fused Jewish (but also Islamic, Catholic, and potentially Native American) sources into a structure that embodied the highest cultural aspirations of Quaker, Unitarian, and Protestant Euro-America. From a twenty-first-century vantage, it seems remarkable that such sources might blend together to express the values of an academy of fine arts, given that they

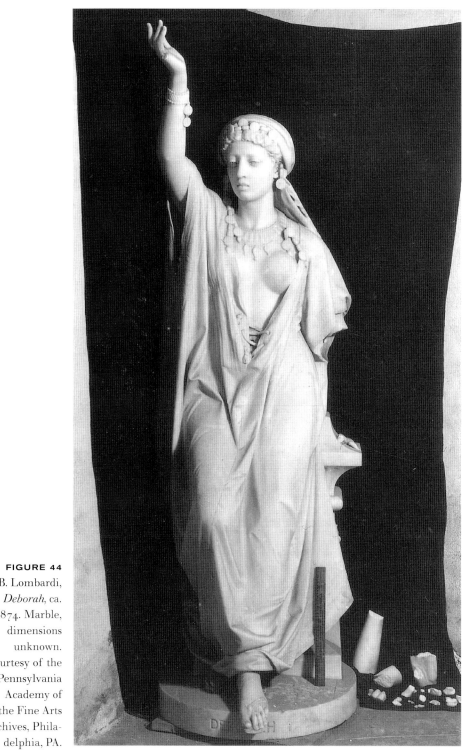

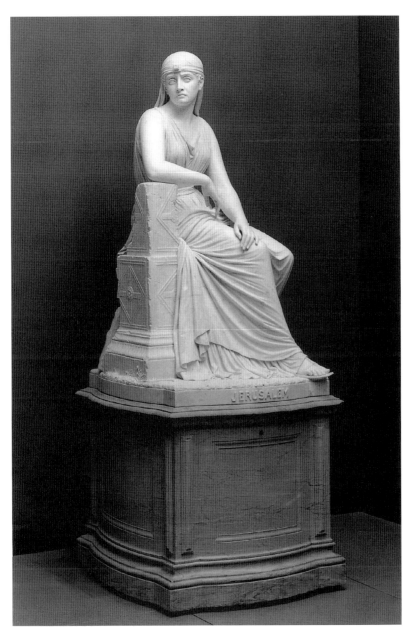

FIGURE 45
William
Wetmore Story,
*Jerusalem in
Her Desolation*,
1873. Marble,
170.2 × 106.7 ×
116.8 cm.
Courtesy of the
Pennsylvania
Academy of
the Fine Arts,
Philadelphia,
PA. Gift of
Mr. and Mrs.
Arthur Klein.

constituted not just foreign but, I will argue, nonwhite motifs and considering that such academies were among the "whitest" institutions in European-American society.

The suggestion that Jewish sources might meaningfully be termed nonwhite may appear to initiate a shift in how the concept of race is deployed in this book. Following the logic of my first two chapters, which contrasted the perspectives and cultures of obviously white and nonwhite groups, readers may question the racial distinction I make between Christian and Jewish European-American peoples. Some scholars, to be sure, have argued for the nonwhite status of Jews in late nineteenth-century America, but others claim that while Jews (and Irish Catholics and Italians, for that matter) were racialized, little evidence supports a claim that they were nonwhite.[28] Protestant European-Americans routinely saw Jews, these scholars argue, as inferior in religion, morals, and even race but never as nonwhite, for unlike Chinese, Japanese, and at times Arab immigrants, they were always granted citizenship based on the understanding that they met the naturalization criterion of being "free white people."[29] To be considered an inferior white is far different from being designated nonwhite.

While I am sympathetic to claims that nineteenth-century American Jews were only "provisional whites," I am not invested in their less-than-white status. Their designation as racial inferiors raises the important question why elite, Christian European-Americans used architectural styles associated with an inferior group.[30] Modern Americans may reflexively assume that one is either white or not, but historians of the nineteenth century generally agree that a European-American Jew ranked lower in the white hierarchy than a Protestant of the same national origin. We also know that being Chinese in Gilded Age America never carried the ideological or material consequences of being African American. Asian immigrants, indisputably subjected to withering discrimination, were accorded better job opportunities and enjoyed greater economic mobility than African Americans. Those designated "nonwhite" in American society were not disadvantaged to precisely the same degree.[31]

The distinctive experiences of immigrant populations suggest a hierarchy between white and nonwhite groups and also within them. The same racial logic that self-evidently separated whites from blacks worked to make fine distinctions about whiteness, about who was closer to or farther from the racial ideal. Just as American society has long ranked empowered white males on the degree to which they epitomize masculine ideals, it judged those legally defined as white on their apparent adherence to racial standards. That is why it matters less that we read the Academy building's sources as definitively Jewish, or even Islamic, than that we appreciate how they would have conjured up peoples who Christian European-Americans believed were subaltern.[32]

Nevertheless, I believe religious and racial forms of otherness were much more closely aligned in the nineteenth century than they appear today. Such alignment stems from the invention of race itself. In his sweeping survey of whiteness in late nineteenth-

century and early twentieth-century American culture, the historian Matthew Frye Jacobson takes the divide between Christian and heathen as foundational both for determining belonging and otherness in Western culture and for laying the conceptual framework for later racial hierarchies.[33] The historian Thomas Holt takes up this point. Noting that all social constructs must build themselves out of existing traditions, he hypothesizes that race owes a developmental debt to the religious hierarchies from which it grew. As I discussed in Chapter 1, the modern concept of race emerged in the late seventeenth and early eighteenth centuries from long-standing conventions for arranging peoples in hierarchies and legitimating those divisions in purportedly objective scientific studies. Most prominently, climatic development theories, predispositions in reading physical appearance, xenophobia, and religious exclusion contributed to the invention of modern race. Holt notes that European religious criteria were instrumental in distinguishing between pure and impure populations, between those who belonged and those who stood in ideological opposition.

To make his case, Holt points to the Spanish expulsion of Jews in 1492 as an expression of protoracial (and protonational) values. Grounded in the rhetoric of "purity of faith," the expulsion was protoracial in the sense that religious prejudices furnished the logic that racial hierarchies would in time adopt. What began as a quest for ideological purity was eventually transformed into a crusade for "purity of blood," as the Inquisition moved to root out biologically inferior Jewish converts who hid their "true" selves behind the mask of Catholicism. Holt argues that prior to its emergence as a coherent category of identity, race took its only possible form (to speak anachronistically, yet historically) in the logic of religious exclusion.[34] Given the ease with which Spanish Catholics transubstantiated ideological distinctions into biological ones, and the impossibility that race could emerge suddenly as a concept unconnected to previous social relations, there is a logic in considering preracial phenomena at least partly in racial terms. But there is even more compelling reason *after* the advent of race to interpret racially the value systems that fed its development, considering their ideological overlap. Racial hierarchies would initially have made sense to Europeans only to the degree that they jibed with preexisting value systems. Protestant, Unitarian, and even Catholic European-Americans who viewed Jews and Jewish-inspired designs were likely to have seen people and products foreign to them in religion and nationality but also alien to them in race.

In nineteenth-century America, religious difference was routinely read through the lens of race. The art historian John Davis has explored how American culture has long been infused with symbols linking the nation to a mythic Holy Land, and Christian European-Americans to the chosen people. Unconcerned with stylistic accuracy or geographic precision, a wide cross section of Americans liberally interpreted a host of Near Eastern references as signs of the link between their cultural and religious heritage and

an ancient Jewish past. While Davis is concerned primarily to illustrate how Christian European-Americans invoked the Holy Land to fashion a usable past, he is sensitive to the anxiety accompanying such associations, offering hints as to its racial grounding. Drawing attention to the European-American desire to downplay the presence of indigenous figures in photographs, paintings, and re-creations of the Holy Land, Davis explains that Near Eastern Arabs and Jews provided useful evidence of scriptural continuity but only to the extent that they were safely distanced in a religious past. Arabs and Jews who were too clearly of the present threatened, in Davis's estimation, the ability of Christian European-Americans to take ideological or material possession of the Holy Land.[35]

In many popular outlets, the articulation of this anxiety was explicitly racial. Consider the reaction of Mark Twain's contemporary and sometime collaborator Charles Dudley Warner to the people of Jerusalem, whom he encountered on an 1875 trip through the Near East. Warner's travelogue, *In the Levant* (1877), records his pleasure in connecting the life of Jesus to the landscape before him but also registers his mounting unease as his contact with indigenous peoples increased. In particular, Warner frets over his difficulties in explaining why most of the Jews he encountered in Jerusalem possess "the hook nose, dark hair and eyes, and not at all the faces of the fair-haired race from which our Saviour is supposed to have sprung." Unable to accept the origin of his God in such "dark" people, Warner solves his "ethnological problem" by hypothesizing that the "real Jews" from whom Jesus descended possessed "fair skin and light hair, with straight nose and regular features," and that those "debased, mis-begotten" Jews characteristic of the West were the corrupted product of an amalgamation with Assyrian conquerors.[36]

Writing three years after *In the Levant* was published, the Reverend William Henry Poole connected contemporary Christian European-Americans more explicitly to ancient Jews by arguing that Anglo-Saxons had descended directly from the lost tribes of Israel. Although Poole's "Anglo-Israel" thesis was never widely embraced, it employed the same defensive gesture evident in more mainstream European-Americans texts—forging a link with a biblical past that avoided tying modern Christian European-Americans to living Jews. Poole based his genealogical argument on tortured philological reasoning, selective scriptural citation, and a series of myths, but it was ultimately grounded in what for him were elemental biological differences. He argued that the ancient Hebrews must have comprised at least two physiognomically distinct groups, for if the lost tribes had had the obvious physical markers of contemporary Jews, they never would have gone missing. Since the bodies of modern Jews were racially marked, it seemed obvious to Poole—from his Christian Eurocentric perspective—that the lost tribes must have been "unmarked," meaning that they looked both Christian and white. For the theologian, God's master plan for losing the tribes was possible only in a context where they had never possessed "the physiognomy of the Jews."[37]

Had Christians coded Jewish difference in religious or cultural terms alone, there would have been little need to distance Christ from the physiognomy of his ancient progenitors.[38] It is telling, then, that Warner and Poole expressed their discomfort with contemporary Western Jews in exclusively physical terms. Rather than object to theological positions or cultural traits of the people who engendered both Christ and modern-day Anglo-Saxons, they worried about the shape of noses and the color of skin, hair, and eyes. Poole's thesis makes explicit Warner's desire to distance Christ from an inferior race to preserve what both men clearly understood as God's Anglo-Saxon stock. This racial sleight of hand performed significant cultural work, allowing Warner and Poole to uphold an image of Christ as white and to root their heritage in the Old Testament yet distance themselves from ancient "dark" Jews and their modern incarnations. The lengths to which European-American commentators went in their efforts to dissociate Christian European-Americans from the Jews of Europe and America suggest the ambivalence of patrons of the Pennsylvania Academy about the building's Jewish and Islamic architectural forms.

I claimed earlier in this chapter that the nonwhite sources used in the Academy were culturally complex because the building was commissioned by Christian European-Americans and because fine arts museums were among the whitest institutions in late nineteenth-century America. The whiteness of institutions dedicated to the fine arts is rooted in the resonance of art, the historical development of museums, the pedagogical role of painting and sculpture in the West, and the ways in which museums increasingly regularized the behavior of their visitors. Of all the factors that racialized late nineteenth-century museums of art, a dedication to the fine arts was doubtless the most significant. The art historian Paul Oskar Kristeller was the first to explore how late eighteenth-century European Enlightenment thought produced our modern concept "fine art." Kristeller acknowledges that each of the arts taken today as fine—painting, sculpture, architecture, music, and poetry—has an ancient history, though he illustrates how they came to be bundled together by modern Europeans in a distinct conceptual category conceived as opposed to craft traditions.[39]

In *The Invention of Art*, the philosopher Larry Shiner builds on Kristeller's work. He traces our modern conception of art back to the eighteenth-century separation of the fine arts from crafts, of artists from artisans, and of aesthetic pleasure from entertainment. These divisions broke a two-thousand-year-old Western convention that art was *any* activity practiced with skill and grace. In the modern West, art came to be defined by the product created, the person making it, and the experience it generated in audiences rather than the quality of what was fashioned. Shiner notes how this new definition of art helped consolidate relations of power: "To elevate some genres to the spiritual status of fine art and their producers to heroic creators while relegating other genres to the status of mere utility and their producers to fabricators is more than a conceptual

transformation." He points out that "the genres and activities chosen for elevation and those chosen for demotion reinforce race, class, and gender lines."[40]

The invention of fine art placed women and minority groups in Europe and America at an obvious disadvantage. Unable, because of biases of sex and race, to produce the most valued art objects, they were further thwarted when what they made was labeled aesthetically inferior art or, worse, craft work. But the implications of Western divisions of art were even more consequential for foreign nonwhite peoples, who possessed no class of purely aesthetic objects. Since cultures outside of the West had never divorced aesthetics from utility, it was easy for European-Americans to devalue even visually alluring objects nonwhite peoples produced, given that such objects always served a practical function. Fine art was a Western test of cultural development that non-Western people had little hope of passing. According to Shiner, Europeans and Americans could not see anything outside of the Euro-American tradition that merited the designation art until they had gained military and economic control over nonwhites. Once they dominated the developing world, Westerners discovered the "primitive" art of the Americas, Oceania, and Africa, which in failing to be fine art reinforced the cultural superiority of whites. For two hundred years now, Europeans and European-Americans have worked to convince themselves and the world that art is a universal concept, when in fact the division of fine arts from crafts actually perpetuates and naturalizes preexisting systems of inequality.[41]

The whiteness of art is more than an ideological opposition between the fine arts and crafts that races are free to adopt or reject at will. It is also a structural reality that rigidly polices access to economic and cultural resources on the basis of race. Up through the close of the nineteenth century, economic barriers precluded a significant percentage of people of color from even attending fine arts museums. The Pennsylvania Academy closed on Sundays during the 1870s, when many nonwhites had their only day off, and a visit during the week was relatively expensive. At a time when admission to the Academy of Natural Sciences was only ten cents, and other cultural attractions in Philadelphia—the Art Gallery at Fairmount Park, the Franklin Institute, the National Museum, the Pennsylvania Historical Society, Independence Hall, and the Eastern Penitentiary—were free, entrance to the galleries at the Academy of the Fine Arts cost twenty-five cents.[42] These barriers were class based, to be sure, but they disproportionately affected people of color, who were subject to profound economic discrimination.

Even if African American, Native American, Asian American, or Latino artists managed to see fine art or to secure rudimentary instruction from skilled artists, they found it nearly impossible to gain admittance to the country's few professional schools of art. The response of the administration and students of the Pennsylvania Academy to the application in 1879 of the young African American artist Henry Ossawa Tanner demonstrates the European-Americans' sense that fine art was a white domain. Following the

Academy's standard application procedure, Tanner had submitted an entrance drawing anonymously, so that the Committee on Instruction might judge whether his artistic skill was sufficient to merit his admission.[43] Initially accepted into the school for the quality of his sketch, Tanner was subjected to a second test: the committee's director, once he had learned of Tanner's race, took the unprecedented step of asking current students to vote on Tanner's suitability for admission. The all-white students voted, not on the applicant's work (which was not presented to them), but on their own willingness to tolerate a black presence in such an obviously white space. The vote offers a clear sign that race—more than either sex or class—reflected the institution's core identity; applications submitted by females or working-class males never precipitated consultation with students. If the Academy had no bylaws barring the admission of blacks, structural impediments made a black applicant—never mind a black enrollee—so unlikely a possibility as to render an official policy superfluous.[44] Most of the time, the structural barriers excluding people of color from artistic training functioned effectively, allowing European-Americans to imagine that the admissions process involved an evenhanded assessment of natural ability and hard work.

A series of subtle cultural impediments reinforcing economic and institutional barriers further complicated the efforts of nonwhites to gain access to the art world. Excluded from clubs, professional associations, and (most significant) schools of art, nonwhites were also hampered in acquiring the "cultural capital" associated with the production, reproduction, and circulation of high art. Pierre Bourdieu defines cultural capital as the knowledge, skills, and values that are socialized into members of a group, serving to determine who does and does not belong. Access to such capital has profound material implications, for it regulates who circulates comfortably in social contexts and who can tap into power by virtue of fluency in specialized languages.[45] One's acceptance into elite art circles has much less to do with affording either admission fees or great works of art than with one's eloquence in various art discourses. By creating paintings that demonstrate an engagement with fashionable techniques, subjects, and issues or by commenting on art in the vocabulary and tropes that reveal an understanding of currently valued trends, individuals signal to other empowered people their membership in the club. The Pennsylvania Academy rose in Philadelphia as a brick-and-mortar embodiment of European-American artistic values, representing a way of thinking and practice largely withheld from nonwhites.

White cultural practices guided the operational logic of museums no less than that of art schools, helping to determine which works were worthy of display, who merited admission, and how students and visitors should act in museum galleries. In the final third of the nineteenth century, high art, which American museums displayed to educate and foster aesthetic experience, was firmly divorced from craft and popular exhibits, which emphasized entertainment. Increasingly, the heterogeneous shows characteristic

of displays at Peale's Museum (see fig. 22) and P. T. Barnum's American Museum gave way to the rarefied purity of fine arts exhibitions at the Pennsylvania Academy; the emergent Museum of Fine Arts, Boston; the Art Institute of Chicago; and the Metropolitan Museum of Art in New York City.[46] These nascent temples of art conceived their missions to be of a higher order. Whether teaching lessons about (white) citizenship and morality in the 1870s or reinforcing a particular visual aesthetic in the 1890s, fine arts museums came increasingly to reflect the evolving values of European-American high culture.

With the development of institutions dedicated to fine arts, wealthy benefactors, elite social critics, and museum administrators imposed new models of behavior on museum visitors. Increasingly in the century's final decades, behavior became as important as admission fees in regulating entrance to fine arts museums. Both Lawrence Levine and John Kasson have explored the new rules of comportment required of visitors to American fine arts museums that were unknown in museums and theatrical halls just a generation earlier.[47] By the 1890s the director of the Metropolitan Museum of Art reported with satisfaction on the improved manners of visitors to his galleries on the recently instituted "free days." The museum's policy of turning away unworthy people at the door and vigorously policing the conduct of those who were admitted explained why "you do not see any more persons in the picture galleries blowing their nose with their fingers; no more dogs brought into the museum openly or concealed in baskets. There is no more spitting tobacco juice on the gallery floors. . . . There are no more nurses taking children to some corner to defile the floors of the Museum. . . . No more whistling, singing, or calling aloud to people from one gallery to another."[48]

The director's report was more than an exaggerated account designed to mock less economically secure patrons; although he makes plain his distaste for working-class people, evidence suggests that the actions of "free-day" attendees he described had only recently lost currency with leisure-class Americans. In the late 1870s, for example, the Pennsylvania Academy actively encouraged visitors to its gallery to spit tobacco juice, providing for that purpose a generous number of spittoons in galleries, stairwells, and hallways of the new building. A series of photographs Frederick Gutekunst took of the Furness and Hewitt structure in 1877 shows spittoons arrayed along walls and in doorways throughout the Academy's public spaces (fig. 46). The director of New York's Metropolitan Museum, in stressing how assiduously he and his staff worked to alter the behavior of those admitted to the museum's free days, illustrated a desire to match the conduct of this audience to that of his paying customers, itself only recently learned.

Historians tend to see this tussle over public behavior as a reflection of emergent tensions over class. The boisterous participatory culture characteristic of all U.S. audiences in the antebellum period was coded as working class after the Civil War, in contrast to the emergent culture of staid rectitude and polite applause (at culturally appropriate

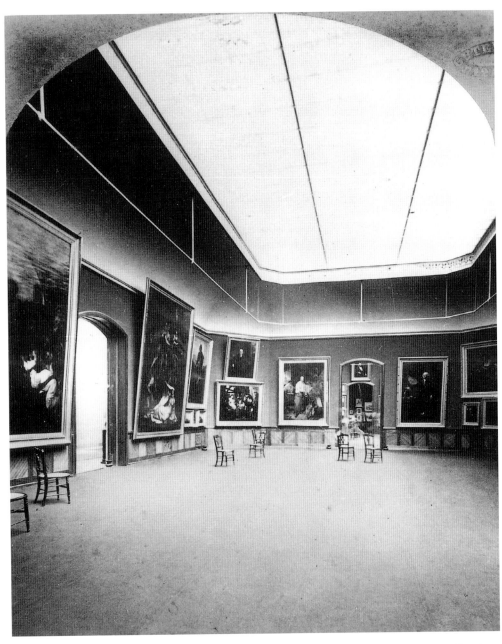

FIGURE 46 Frederick Gutekunst, interior galleries of the Pennsylvania Academy of the Fine Arts, Philadelphia, 1877. Half of an albumen stereograph print, 6.9×15 cm. Courtesy of the Pennsylvania Academy of the Fine Arts Archives, Philadelphia, PA.

moments), seen as characteristic of middle- and leisure-class audiences. As John Kasson writes, "A new bourgeois ideal was inscribed upon the city: orderly, regulated, learned, prosperous, 'civilized.'" Without discounting the class dimensions of the shift, it is important to acknowledge its racial implications, for the older behaviors continued to be associated with immigrant and African American audiences. As Kasson himself notes, old models of comportment remained a feature of Yiddish and Italian theater through the turn of the twentieth century, long after they had lost their class-specific associations for audiences whose cultural roots were in western Europe.[49] Even today it is not unusual to hear whites voice discomfort with the more participatory and vocal culture seen as characterizing African American movie and theater audiences. As Levine explains, in America sizable minority populations, along with perceptions of the darkness of late-century waves of immigration, ensured that working-class culture was necessarily tied to ethnic and racial distinctions.[50]

No doubt the Academy's nonwhite associations complicated nineteenth-century European-Americans' responses to it, but with eclecticism the dominant architectural style during the 1870s, Philadelphia as its American center, and the immensely popular team of Hewitt and Furness among its leading practitioners, the important racial work of the structure more than compensated for its "paradox." Architects, directors, and patrons of the Academy somehow transformed nonwhite elements into the epitome of whiteness. While it is certainly possible that for Americans eclecticism performed symbolic work unrelated to race (and thus helped offset its racial drawbacks), both its popularity and its complexity were firmly rooted in the racial register. To explain how this might be so, I want to turn to the meaning of eclecticism for European-American audiences in the postbellum era.

Before anything approximating a national style developed in the United States, culturally chauvinistic European-American builders turned to Europe for architectural models. As the architectural historian James O'Gorman explains, reliance on European design in antebellum America was largely manifest in historicist styles, but briefly in the 1870s, it found expression in eclectic designs. Historicist building programs reproduced a single architectural style with (supposed) archaeological accuracy; eclectic designs self-consciously assembled motifs from different national and cultural traditions, centuries, and continents.[51] The commingling of styles that Americans had long seen as a sign of architectural ignorance came to represent the height of scholarly practice in the years following the Civil War. Eclectic building design met two important needs of postbellum society: it provided a new national architecture that seemed appropriate to the modern age, and it helped European-Americans to transcend the oppressive cultural and racial weight of European, Near Eastern, and, later, Asian architectural precedents.

Concerned that the roots of European-American culture were shallow, American ar-

chitectural critics in the 1870s worked to turn this newness to advantage by seeing the country's lack of architectural precedents legitimating the selective borrowing from the most valued styles of the past. The prominent architect and critic Henry Van Brunt noted in 1876, "We Americans occupy a new country, having no [European-American] inheritance of ruins and no embarrassments of tradition in matters of architecture." Americans, lacking physical reminders of a cultured past, were free to appreciate how "all the past is ours; books, engravings, photographs, have so multiplied, that at any moment we can turn to and examine the architectural achievements of any age or nations." He concludes that "where architectural monuments and traditions have accumulated to the vast extent that they have in modern times, the question is not whether we shall use them at all, but how we shall choose among them, and to what extent shall such choice be allowed to influence our modern practice."[52] Echoing Van Brunt's assessment, an editorial in the *American Architect* in 1877 claimed that the very profusion of sources available to American architects "seems to lay on us the duty of utilizing them."[53] In 1878 the same editors argued that the selective assemblage of older architectural elements "inevitably gathers to itself more or less modern characteristics; and the results are an eclectic work belonging to the latter half of the nineteenth century, as is proper."[54]

The lack of a European-American architectural tradition, the plethora of available source material, and the heterogeneity of the U.S. population all seemed to justify architectural eclecticism. As Austin Bierbower wrote in the *Penn Monthly*, a literary journal, "we are in a new country, far off from any other, with new resources and new wants, composed of the people of all other countries, so that there is no reason why there should not be, from this fusion of national elements, a new product in [architectural] style superior to any of the others."[55] Scores of architectural critics embraced Bierbower's sentiment. One observer explained "our present conglomerate of architecture" by the "many different nationalities" that make up the population. Another attributed American eclecticism to "the mixed nationalities and sympathies of our people, and our free intercourse with many nations."[56]

None of the authors I quote here was interested in reviving archaeologically accurate historical styles; for each of them, mining past traditions meant selectively recombining older designs into a national architecture appropriate to contemporary America. As Bierbower explains, in an American style "all the [foreign architectural] elements could be used, in small proportions indeed, but in great numbers and variety" to provide an "appearance of richness."[57] Seeing evidence for a national style in eclectic domestic architecture, another critic claimed that "the combination of [styles] . . . makes the distinctiveness, for the features just named are . . . all derived from European sources."[58] Eclecticism borrowed the forms but not the rules of previous architectural systems so that eclectic structures expressed European-American identity in heterogeneity and accumulation rather than in a consistent look. An anonymous critic plead-

ing for eclecticism explicitly addressed its lack of a structuring grammar or vocabulary, noting that "whatever the source from which we borrow our expression, the essential characteristic of our work is modern, and it does not in reality differ so fundamentally from that of our neighbor who selects his form of expression from a precedent as far removed from our own choice as Gothic is removed from Renaissance . . . they both possess all the distinctive characteristics of that first of the great eclectic eras of architecture, the nineteenth century."[59]

Towering over these American proponents of eclecticism was, of course, the English writer and artist John Ruskin, who as early as 1849 championed architectural eclecticism in his *Seven Lamps of Architecture.* Famously opposed to modernism, Ruskin urged a careful study of the ancient world's most august architectural monuments, believing that the past offered all the necessary tools for building the contemporary world. Unsettled by what he interpreted as the modern desire to reinvent architectural styles anew for each successive generation, Ruskin urged architects to hew closely to the principles perfected in ancient systems. Yet once an architect learned to "speak these dead language[s] naturally," Ruskin accorded license "to add to the received forms," noting that "the decorations especially, might be made subjects of variable fancy, and enriched with ideas either original or taken from other schools. And thus in the process of time and by a great national movement . . . a new style should arise."[60] Given that we live today in a world still haunted by modernist concepts of originality, it is difficult to imagine how an eclectic amalgam of sources might signal either nationalism or modernity, but for nineteenth-century American and English audiences, buildings such as Furness and Hewitt's Pennsylvania Academy, William Ware and Henry Van Brunt's Memorial Hall at Harvard University (1865–78; fig. 47), and H. H. Richardson's Trinity Church in Copley Square in Boston (1872–77) did just that.

European-Americans defending eclecticism frequently denigrated what they saw as "creative," or even "original," architectural paradigms. Because eclecticism was understood to draw from a range of "original" styles, its positive qualities were ironically defined in opposition to the secondary styles from which it drew. Van Brunt saw this architectural opposition in decidedly hierarchical terms, writing that "it must not be forgotten that the most essential distinction between the arts of primitive barbarism and those of civilization is that, while the former are original and independent, and consequently simple, the latter must be retrospective, naturally turning to tradition and precedent, and are therefore complex."[61] In 1878 an anonymous architectural critic implicitly expanded on Van Brunt's ideas, claiming that "only two kinds of originality are possible in [architecture]. One is the originality which begins with no acquirement or habit; develops its own forms and methods in native experimental ways. This is the originality of barbarous art . . . it is manifestly impossible in any people which has the appliances of civilized life. . . . The other kind of originality, the only kind which is possible or desirable in a high

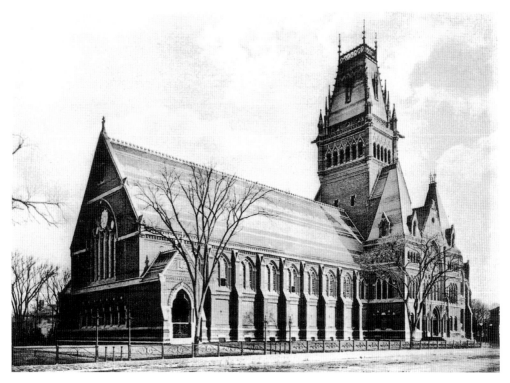

FIGURE 47 William Ware and Henry Van Brunt, Memorial Hall at Harvard University, Cambridge, MA, 1865–78. Photograph courtesy of Jack Quinan.

civilization, is that of thoroughly trained artists, whose skill is cumulative, advancing step by step from the mastery of old forms to the development of new."[62] When European-American viewers stood before the Academy building, they saw a structure whose civilized qualities were signaled by the architects' facility in recombining past architectural precedents *and* by the barbarism resonant in the architectural forms brought together in the structure's design.

The eclecticism of the Academy—its assemblage of elements understood as the products of racially inferior peoples—constructed no new system for imagining European-American identity. Instead, it provided a new outlet for a long-standing impulse. I have already pointed to John Davis's work, which considers how European-American conceptions of Jews and Muslims aided in the construction of American identity, but one might just as fruitfully consider Philip Deloria's analysis of the European-American use of Indian imagery, or Michael Rogin's discussion of the Jewish embrace of blackface, to see the wide-

spread use of racial others in fashioning both American whiteness and nationalism. In architecture, design and arrangement of American expositions increasingly invoked racial others to articulate imperial, national, and racial identity during the time when eclecticism emerged as a dominant style in the United States. Scholars ranging from Robert Rydell to Alan Trachtenberg have detailed the ways in which late-century American fairs articulated a hierarchy of civilizations through the use of particular architectural styles and colors; the arrangement of national displays in racial clusters; the banishment of supposedly inferior cultures to the margins of exhibition halls and fairgrounds; the exclusion of many nonwhite exhibitors, construction workers, and even attendees; and the presentation of nonwhite peoples in ways that confirmed racial stereotypes held by European-Americans.[63] In the words of an 1876 newspaper account of the Centennial Exposition in Philadelphia, such fairs managed "to carry the spectator through the successive steps of human progress," with whites, predictably, epitomizing the ultimate step.[64]

The racial politics of international fairs became more pointed in the final third of the century, according to the historian Curtis Hinsley, when national and international expositions routinely included archaeological and ethnographic displays. Augmenting the standard practice of highlighting national aspirations by exhibiting raw materials extracted from distant colonial possessions, fairs now juxtaposed these resources with the manufactured goods produced from them in the home country. Hinsley notes that in a parallel gesture, European and American fairs that followed the Paris Exposition of 1867 supplemented their displays of colonial resources with exhibits of indigenous peoples themselves to visualize their belief in the linear progression of culture and, hence, the superiority of whites (fig. 48). Not only did black, brown, yellow, and red bodies signal everything that whites were not, but, as Hinsley contends, the "exhibition techniques tended to represent [nonwhite] peoples as raw materials" for the creation of civilized societies.[65] In the logic of the expositions, iron ore was to locomotive engines as Filipinos were to whites. By displaying the products and peoples of their own colonies, Europeans and European-Americans highlighted the distinctions between nonwhite and white identity and discovered new traits from which they could imaginatively refashion whiteness.

The activities of eclectic architects, blackface performers, and fair organizers were based on the assumption that European-Americans could absorb and assimilate racially inferior forms and traits before transforming them into something representative of white culture. A remarkable commencement address delivered by Dexter Hawkins to the graduating class at Syracuse University in 1875 voices the unspoken assumptions of whites. He assured his European-American audience that "political power and the arts of civilization are for the time being intrusted to [our nation]; and while playing its destined *role* in the great epic poem of human life, its sister races struggle in vain to surpass it." He then stated that "the strength of [Anglo-Saxon] blood is manifest in the fact that it crosses with all cognate races, and takes up and absorbs their good qualities without

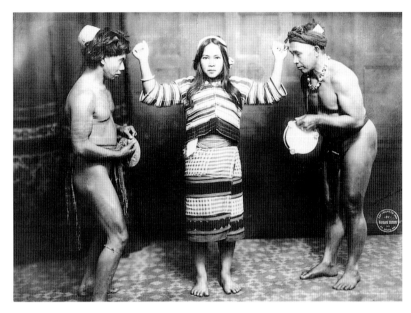

losing its own identity, or failing to manifest or obey its own characteristics." In contrast
to the Jews described by Warner, whites, according to Hawkins, had the capacity to inter-
mingle with other races and emerge enhanced, without their essential nature under-
going change. In both the architectural and the eugenic rhetoric of the era, European-
Americans were racial alchemists whose core nature and cultural creations were
simultaneously transforming and fixed.[66]

A number of scholars in recent years, building on the important work of Edward
Said, have argued that the Western fascination with the East should be read in precisely
these terms—less a foil for defining what the West was not than a means for enlarg-
ing its conceptual boundaries. Taking issue with Said's insistence that Orientalism rep-
resented the Western fantasy of an unchanging East, serving to protect Europeans and
European-Americans from the threat of "contamination brought forward . . . by the very
existence of the other," the historian of imperialism John MacKenzie notes that the West
has never read its "others" in exclusively negative terms; they are interesting for their
blend of feared and desired traits. As MacKenzie contends, the use of Oriental forms il-
lustrates how "the Western arts sought contamination at every turn, restlessly seeking
renewal and reinvigoration through contacts with other traditions" with "both Self and
Other . . . locked into processes of mutual modification."[67] While fashioning a powerful
statement of racial imperialism, the Academy also tied Christian European-Americans
to a prized lineage that stretched back to the founding of monotheism. In so doing, eclec-

ticism communicated the desire of whites to dominate "inferior" foreign races and to share in various traits associated with those groups. The constitutive motifs of eclecticism, instead of defining whiteness through its absence, helped European-Americans imagine identity as an amalgam of difference and affinity.

In the case of the Pennsylvania Academy, this dynamic allowed Christian European-Americans to revel in "contaminations," then strongly associated with Jews and just as forcefully proscribed to proper whites. With the Jews as cultural middlemen, Christian European-Americans could display furtive, taboo traits whose enjoyment would otherwise have cast doubt on a European-American's racial fitness. Much as blacks, historically, have given European-Americans access to sensuality, and Native Americans have showed them a way to the primitive, Jews have served as an excuse for whites to partake in ostentatious and extravagant display. The architecture and ceremonies of the Academy, by invoking Jews—and their attendant stereotypes—could legitimately express an ostentation for which Christian European-Americans had previously found no outlet.

After parsimony, perhaps no stereotype of the Jew was more firmly ingrained in Gilded Age culture than ostentation. When Henry Hilton famously refused to rent a room in his Saratoga hotel to the Jewish, German-born banker Joseph Seligman in the summer of 1877, he defended his action to reporters by pointing to the Jew's "vulgar ostentation" and "overweening display of condition."[68] The *Nation* did not endorse Hilton's policy of exclusion but supported his racial values, finding that the Jewish "tendency to gaudiness in dress or ornament . . . testifies to the purity of the race and the freshness with which its eye still retains the Oriental passion for brilliancy of costume," and concluding that the resultant "effect in our climate is barbaric and coarse."[69] Two years later Austin Corbin echoed Hilton's logic in explaining his determination to bar Jews from his lavish Coney Island resort: Jews were a "pretentious class" and a "vulgar people," and he had known "but one 'white' Jew in [his] life."[70] In response to the controversy Corbin created, the New York–based *Puck* produced, in 1879, an image of the Jewish type shunned by fashionable hoteliers (fig. 49). Nina Morais summed up the late-century attitudes of Christians toward her people, describing in the *North American Review* how "the Jew generically (so runs the ordinary estimate) is an objectionable character, whose shrewdness and questionable dealings in trade enable him to wear large diamonds and flashy clothes. He raises his voice beyond the fashionable key, in a language execrable to the ear of English-speaking people. . . . Mean in pence, he spends his pounds with an ostentation that shocks people."[71]

Several of the most widely reported anti-Semitic incidents in the final quarter of the nineteenth century revolved around admission policies of hotels. During decades when some of the grandest and most opulent structures in the country were built, hotel owners and managers initiated policies to exclude "ostentatious" Jews, who might spoil the pleasure of their white Christian guests.[72] Christian European-Americans maintained

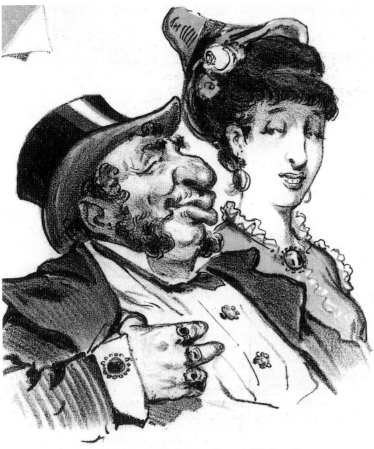

Corbin's " White Jew " and Whiter Jewess.

FIGURE 49
Keppler, *Corbin's
White Jew and
Whiter Jewess,*
detail of *Hints
for the Jews.—
Several Ways of
Getting to Man-
hattan Beach,*
1879. Litho-
graph on paper,
32.8 × 53 cm.
Puck, 1879.
University of
Rochester, Rush
Rhees Library,
Rochester, NY.

the symbolic distance between their favorite vacation spots and what they viewed as a racially inferior group, at the moment when the associations of hotels and Jews began to converge, by deeming the gross display of Jews incompatible with hotel life. This symbolic distancing freed whites to disparage the "vulgar ostentation" and "pretentious" nature of Jews and at the same time admire hotels "built of huge slabs of marble in true Babylonian magnificence," where "everything within it simply drips with gold, silk, and velvet . . . and the opulence spill[s] over the brim like bubbles in a glass of champagne."[73] It is revealing that Corbin restricted admission to his Manhattan Beach Hotel, described by contemporaries as "a monster" resort, "the largest sea-side structure in the world, . . .

[employing] 1,000 servants and attaches" (fig. 50), a place that Theodore Dreiser recalled from his youth as populated by a "prosperous" and "showy" clientele.[74] Not simply lavish, Corbin's hotel exuded a decidedly Oriental flavor because of the architect's decision to place its picnic area in the relocated Moorish fantasy that Furness originally constructed to house the Brazilian Pavilion at the Philadelphia Centennial Exhibition (see fig. 36).[75]

In convincing themselves that the most lavish—and often exotic—hotels were not appropriate for Jews, European-Americans displaced the negative associations of opulence onto a people who were safely excluded, allowing whites to enjoy their ostentatious vacations without the fear of taint. In the case of the Academy as well, Jews offered cultural "cover" for Christians who wanted to break away from the sober simplicity of Philadelphia's architectural heritage and revel in forms that were acceptable largely because they were understood to be other. The often-described "richness" and "enormity" of the Academy, with its "elaborately decorated" and "showy exterior," flowing "with veins of gold," would have been difficult to swallow had it not been safely cloaked in the aura of an Eastern fantasy.[76]

Having considered how eclecticism made use of architectural forms associated with racially inferior and nonwhite peoples to serve the interests of Christian European-Americans, I will now explore why eclecticism became the dominant style through which whiteness was articulated by Philadelphia architects, patrons, and critics during the 1870s and early 1880s, and how it overcame the potentially destabilizing association of whites with inferior peoples. Since European-Americans of the era had recourse to a number of architectural styles that supported their racial interests (even as the racial coding of each was rooted in distinct intellectual contexts), we must consider not simply what made the racial meanings of eclecticism possible but what made them appealing at this particular historical moment. I suspect that the eclecticism of Furness and Hewitt owed its popularity and persistence in Philadelphia to its use of unthreatening national and racial sources. Christian European-Americans regarded the sources as benign either because the peoples with whom the motifs originated were seen as white (or white enough) or because they were largely absent.

In her study of how multiracial environments influence white identity, the ethnographer Pamela Perry found that contemporary European-Americans think through their identities as white using symbols associated with visible minorities, and that use of such symbols is partially guided by the depth and nature of their day-to-day interactions with minority peoples. Perry set out to explore how intimate, routine processes (rather than structural forces) affect the construction of racial self-identification. She pursued her research as a participant observer at two California high schools during the mid-1990s—one suburban and largely white, and the other urban and racially mixed. European-Americans, she found, are much more likely to embrace perceptible signs of black culture,

FIGURE 50
*Manhattan
Beach Hotel,*
ca. 1895. Post-
card, 12.4 ×
8.1 cm. Special
Collections,
Stony Brook
University.

such as hip-hop clothing, rap music, and vernacular speech and manners, when their real-life contacts with African Americans are limited.

For her segregated white subjects, African American styles denoted "toughness" or "coolness" rather than "blackness" per se, and they were adopted with little consideration of their racial implications for minority populations. Most of the white (and non-white) students in the predominantly white school accepted the European-American adoption of attributes associated with minority cultures as little more than a fashion choice. Careful to examine how racial values spoke through such acts of appropriation, regardless of the students' conscious understandings, Perry illustrates how an individual's racial environment alters expressions of whiteness. European-American students in diverse communities appropriated black, Latino, and Asian styles less frequently, but they understood such borrowings as charged with racial overtones—signifying political alliance or sympathetic identification with the minority groups. In settings with significant minority representation, appropriation was a conscious and conspicuous act.[77]

The link Perry discovered between the meaning of appropriated styles and the extent of European-American contact with minority peoples may help to explain the Pennsylvania Academy's appeal for whites in the 1870s. Philadelphia, like every other urban center of the era, required a stream of immigrant (and African American) laborers to sustain its industries. But lacking the scale of industrial production that dominated the economies of its northeastern and midwestern neighbors, Philadelphia attracted the smallest percentage of foreign-born residents of any city in the United States. In 1870, the peak of its immigrant influx, a mere 27 percent of Philadelphia's inhabitants had been born abroad, compared with 48 percent in Chicago, 47 percent in Milwaukee, 44.5 percent in both

New York City and Detroit, 42 percent in Cleveland, 35 percent in Boston, and 32 per-
cent in Pittsburgh.[78] Philadelphia had fewer Irish Catholics, Italians, Poles, Russians, and
Jews than any other metropolitan area, which led European-Americans to refer to it as the
most "American" city—meaning, of course, the most white.[79]

Despite a continuous presence in Philadelphia stretching back to the time of William
Penn, Jews accounted for less than 2 percent of the city's more than eight hundred thou-
sand residents when Furness and Hewitt's Academy opened its doors to the public in
1876.[80] The relative paucity of Jews made the Near Eastern narratives of the Academy
acceptable to Christian European-Americans, for without a significant Jewish presence,
Oriental motifs suggested neither an alliance nor an identification of Christians with
Jews. Christians were free to revel in architectural, ceremonial, and artistic fantasies of
a racial other that expanded whiteness without coupling them to a living people who
were habitually disparaged. Recall that Warner was preoccupied with the racial link of
Jesus to Jews only as his contact with Jews increased in the Holy Land; at his home in
Hartford, symbolic ties to an ancient people surely caused considerably less concern.

Christians may have accepted Saracenic motifs in the Academy more readily because
there were so few Jews in Philadelphia, and because of their relative visibility. This may
sound contradictory. Most scholars of American Jewry have argued that German Jews—
the majority of Philadelphia's Jewish population during the 1870s—assimilated quickly
into American society because their Reform Judaism was palatable to Christians and
they adopted Christian European-American customs in dress, social habits, and business.[81]
Thus one might claim that the subdued profile of Philadelphia's Jews promoted the Chris-
tian European-American embrace of an eclectic design that used Oriental motifs. But
evidence suggests that in some contexts the *invisibility* of Jews concerned Europeans
and European-Americans more than Jewish visibility.

The historian Patrick Girard and the sociologist Zygmunt Bauman have both made
a compelling case for the link between the rise of anti-Semitism in nineteenth-century
Europe and the growing invisibility of Jews over the previous two centuries. Bauman
contends that the historical visibility of Jews was crucial to Christians because the ob-
servable signs of cultural and physiognomic difference stood for millennia as signs of
Jewish estrangement from Christianity, and because such alienation has long been a cen-
tral means by which Christians have imagined who they were. Consequently, anything
that threatened to question Jewish estrangement or reconcile Jews and Christians men-
aced the very core of Christian identity. When in the eighteenth and nineteenth cen-
turies, modernity swept away centuries of legal and social restrictions that had barred
Jews from either religious or cultural assimilation, the outward marks of Jewish differ-
ence began to wane and Christian self-definition became more problematic. Édouard
Drumont, in his two-volume work *Jewish France* (1887), summed up the fear of many
Christians when he explained that "a Mr. Cohen, who goes to synagogue, who keeps kosher

is a respectable person. I don't hold anything against him. I do have it in for the Jew who is not obvious."[82] As Bauman points out, the Christian desire for Jewish visibility reached its tragic apogee in twentieth-century Germany—in a nation long regarded as one of Europe's most tolerant and liberal societies, where Jews had arguably made the greatest inroads at assimilation. According to Girard and Bauman, modern anti-Semitism was born not from difference but from the perceived threat posed by its absence.[83]

Philadelphia's small population of German Jews did not simply blend into Christian American society in the 1870s but embraced Saracenic designs to link themselves to an imagined past and perhaps to distinguish themselves visually from their Christian neighbors at a time when their national, cultural, and theological distinctness was eroding. As an unintended corollary, the Jewish acceptance of Saracenic forms aided Christians by reassuring them of their essential difference and by giving them a new architectural idiom that broadened the socially acceptable range of Christian European-American attributes. Visibility was reassuring only because Philadelphia's Jewish population was small and sufficiently similar to the larger Christian population to appear nonthreatening. In many ways, the visibility of German Jews was appealing because it belied the reality of racial and cultural sameness. When Polish and Russian Jews flooded into American urban centers roughly two decades later, their visibility caused grave concern, for it was understood to reflect significant cultural, religious, and racial differences. In the 1870s, however, German Jews provided an unthreatening source of raw materials for the evolving construct of whiteness.

Because the spatial dimension of buildings complicates the perception of their formal attributes, to make sense of a structure entails considering how viewers experience its exterior and interior spaces. Such spatial issues generated one of the earliest controversies associated with the construction of the new Pennsylvania Academy, for as soon as the directors purchased the lot at the southwest corner of North Broad and Cherry Streets in 1870, a member of the board resigned in protest: the industrialist and inventor Joseph Harrison, who had favored a location on Lemon Hill in Fairmount Park, claimed that "no one would pass the barrier of the public buildings onto North Broad Street."[84] Harrison's objection reflected the popular perception of a European-American elite that the center city region north of Market Street (the main north-south dividing line of Philadelphia) was not an acceptable address for an academy of fine arts. The many tourist guidebooks to the city that described the Academy and its surroundings in the mid-1870s reinforced such a view. One noted in 1876 that moving just a block or two north of Market, one encounters

> an interruption of the usual magnificent display of Broad Street,—a region of warehouses and lumber-yards, which once threatened to be permanent, but to which the removal of

FIGURE 51 *D.P.S. Nichols' Broad Street Horse & Carriage Bazaar*, before 1892. Photographic print, 12.8 × 15.8 cm. Courtesy of the Society Print Collection, Historical Society of Pennsylvania, Philadelphia, PA.

the railroad tracks from Broad Street gave a death blow: so that we may now hope to see their places occupied before long by structures in keeping with the magnificent plan of the street. Nevertheless, it must be confessed that, at the present writing, Broad Street from Arch to Callowhill is *not* a pleasant through fare. The new Academy of Fine Arts, at Broad and Cherry, will do much for this part of the street.[85]

Other guidebooks similarly describe Broad Street north of Market as a crude "industrial" region of "warehouses, shops, lumber yards," claiming that "the only building of note in this part of the street is the new *Academy of Fine Arts*."[86]

FIGURE 52
*H. Muhr's Sons
Watch and Jew-
elry Factory,*
1889. Litho-
graph on paper,
8 × 11 cm.
Courtesy of the
Campbell Collec-
tion, Historical
Society of
Pennsylvania,
Philadelphia, PA.

The late nineteenth-century photographs and prints of North Broad confirm the in-
dustrial character of the region. Like the Academy building itself, D. P. S. Nichols's Broad
Street Horse and Carriage Bazaar (fig. 51) was built in 1876 in anticipation of the crowds
that were to flood Philadelphia for the Centennial celebrations. The stable was located
on North Broad just across Cherry from the Academy, whose northern roofline is visi-
ble at upper left. A block north of the stable, on North Broad, at the intersection of Race,
visitors would have found H. Muhr's Sons watch and jewelry factory (fig. 52). And in-
trepid travelers venturing two blocks farther north would have entered the Bush Hill
district, the industrial heart of Philadelphia near the end of the century. Here was the
massive terminal of the Philadelphia & Reading Railroad; William Seller's and Com-
pany, manufacturer of shafting and large industrial tools; and the Baldwin Locomotive
Works, the city's single largest manufacturer, occupying acres of land.[87]

Harrison clearly believed that the region would drag down the institution, while many guidebook authors imagined that the Academy might improve the street. In both cases, European-Americans perceived a clash between the commercial and industrial identity of the neighborhood and the cultural aspirations of the institution. For the middle- and leisure-class European-Americans whose carriages wended through the commercial region to reach their temple of art, the unavoidable juxtaposition of crass commerce and fine art was surely jarring. Modern readers may well think the juxtaposition fitting: how appropriate that the nearly half-million dollars of capital required to construct the edifice came from commercial and industrial profits that a rising generation of businessmen—such as Harrison himself—donated to the Academy in the late 1860s and 1870s, and that the physical structure rose from a commercial region that emblematized the source of those funds.[88] Gilded Age audiences, of course, could not have perceived this link; for them the disjunction between commercial and artistic culture would be resolved not only by time and the improvement of the street, but also through the design of the building.

Gallery visitors in the 1870s came upon an Academy that towered over a sea of unimposing two-story brick commercial structures. Figure 37 hints at the character of buildings to the south and east (left) and west (right) of the Academy and gives a sense of the institution's scale in relation to surrounding structures. A short flight of steps climbs from the street in front of the massive Academy to its two entrances, on either side of an imposing central column that bisects a shallow arch; nestled on each side of the column are comparatively narrow doorways, each capped with a trefoil arch (fig. 53). Just beyond the doorways is a shallow, dark vestibule that leads, through another bisected arch (fig. 54), to a second shallow archway, which, in turn, leads into the massive central stair hall (see fig. 39), illuminated by a giant skylight. Intriguingly, the sequence of double and single arches through which one enters from the street is repeated (in reverse) as one passes through the interior vestibule: large shallow arch, then two arches nestled within a bisected arch on the exterior, followed by a second set of bisected arches, which precedes another shallow arch on the interior.

Period audiences knew that the sequence of bisected and shallow arches moved them through space in a manner that had a significant influence on their experience of the Academy. After expressing admiration, but also exasperation, with the eclecticism of the building's facade in 1876, one critic concluded that "when we once have passed the impending triple-arch, and gotten within the building we forget and forgive the absurdities of the exterior in admiration of the perfect and exact fitness of every part of the interior."[89] The critic's characterization of the bisected arches nestled within a larger arch (his "triple-arch") as "impending" suggests its menacing quality, probably produced by its unorthodox central column, which hinted at structural instability, and its physical funneling of patrons through a passageway that is surprisingly narrow, off center, and

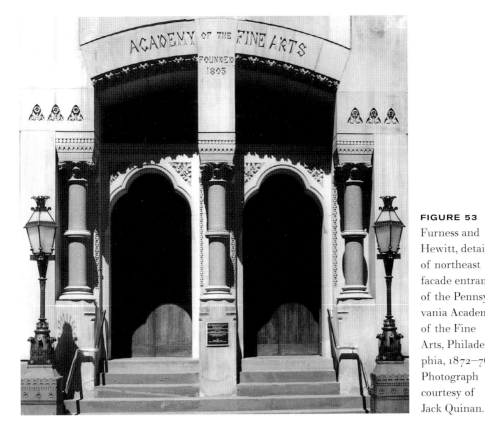

FIGURE 53
Furness and
Hewitt, detail
of northeast
facade entrance
of the Pennsyl-
vania Academy
of the Fine
Arts, Philadel-
phia, 1872–76.
Photograph
courtesy of
Jack Quinan.

dark, in contrast to the size, symmetry, and brightness of the structure's facade. But hav-
ing passed through the arch, the critic finds relief in the "perfection" and "fitness" of
the interior. Writing in the same year, a second critic focused on the sequence of inte-
rior arches: "Once within the vestibule . . . one is seized with a strong desire to knock
away a pier which obstructs, in a most unreasonable manner, the view of a really
magnificent stairway. It is also impossible to get a full view of the grand hall until the
first landing is reached, but, once there, the lofty splendor of the dome and its support-
ing arcade is very impressive."[90] Focusing this time on the effect produced by the inte-
rior arches, this critic also finds both discomfort in the entryway and visual relief in the
passage into the stairway.

Rather than take at face value such assertions that Furness and Hewitt's unusual
entrance formed an impediment to the enjoyment of the "perfect" and "magnificent"
interior, I want to focus on how the awkward entrance contributed to the creation of an

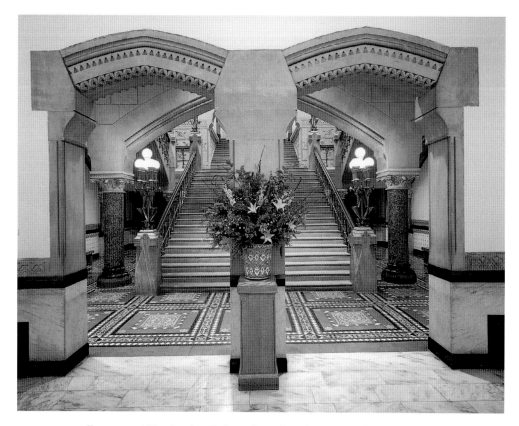

FIGURE 54 Furness and Hewitt, detail of northeast interior passage from vestibule to stair hall of the Pennsylvania Academy of the Fine Arts, Philadelphia, 1872–76. Photograph courtesy of Ralph Lieberman.

admirable interior effect. It seems likely that the discomfort of a dark vestibule, visual obstructions, a hint of structural distress, and the viewer's positioning off the central axis would only have heightened the pleasure of seeing the orderly and brightly lit stairway and galleries beyond. By jarring spectators at the point of entry, Furness and Hewitt made the subsequent "discovery" of the interior space all the more satisfying. But because the interior sequence of arches reverses the order exhibited on the exterior, patrons may have experienced the entrance beyond the once-dim vestibule as an "exit" into another kind of *exterior* space. After passing through a dark foyer, the visitor arrives at an imposing, brightly illuminated stairway, which, as the architects Robert Venturi and Denise Scott Brown observe, "is too big in relation to its immediate surroundings,"

relating instead "to the great scale of Broad Street outside."[91] The grand central stair-way mimicked an exterior space because of its oversized proportions, the inclusion of lamps more suited to an outdoor street setting, and the addition of thousands of tiny silver stars to the deep-blue painted well of the overhead skylight.

The awkward transition from exterior city space to "exterior" Academy space signals the distance museum visitors have traveled: from a street that displays a crude clash of commercial and artistic cultures to a stairwell that offers a refined blend of eclectic architectural forms and painted and sculpted high art; from a street that is dirty, chaotic, and loud to a stairwell that is clean, ordered, and quiet; from a street that teems with nonwhites to a stairwell filled with only the most privileged European-Americans. In providing a strong contrast between the exterior and interior spaces, and by forcing patrons through an entrance that accentuates the border between these two realms, the Academy offers an alternative to the imperfect city beyond its walls. Thus the eclecticism of Furness and Hewitt's Academy is less usefully read as a reflection of the social or racial heterogeneity of Gilded Age America than as a means of exerting symbolic control over such diversity. The great strength of eclecticism was that instead of ignoring unsettling social and racial realities, it acknowledged their existence and used them as the raw materials for both expanding the identities of European-Americans and asserting their cultural and racial dominance. Eclecticism nodded to the reality of late-century America while channeling the perceived dangers of difference for European-Americans into symbolically useful outlets. Before rising waves of eastern European and Asian immigration toward the century's close made the style untenable—by bringing European-Americans into too-close proximity with minorities to allow for the "safe" appropriation of minority symbols—eclecticism harnessed the threatening heterogeneity of the street to serve the interests of European-Americans both inside and out of their Academy.

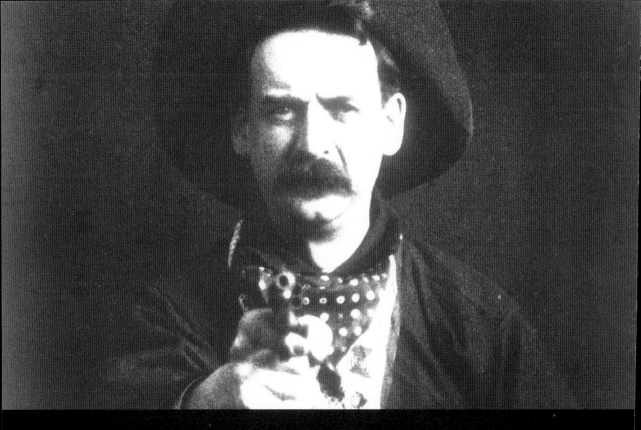

SILENT CINEMA
AND THE GRADATIONS OF WHITENESS

The earliest motion pictures were screened for American audiences in music halls, museums, stage theaters, and vaudeville houses. After the invention of cinema in 1895, a decade passed before venues dedicated exclusively to movie exhibition became commonplace.[1] Vaudeville promoted the new invention most enthusiastically, quickly adding movies to its traditional fare of songs and dances, humorous skits and dialogues, magic, acrobatics, and juggling. Early movies, frequently modeled on the popular entertainments that vaudeville featured, found a congenial setting in vaudeville houses.[2]

The first generation of motion pictures mimicked popular genres of entertainment, much as photography had imitated elite high art genres almost fifty years earlier. In each case, promoters of the new technology struggled for legitimacy by imitating older artistic conventions. Before they learned to appreciate the potential of film for stylistic and narrative innovation, early practitioners copied the form and logic of popular amusements. Vaudeville impresarios, sensing that movies were compatible with their standard offerings, often alternated projected films with stand-alone skits or even the acts of a single performance, thus further blurring the distinctions between their live and recorded entertainments. For early promoters and audiences, the cinema was an extension of long-standing traditions, not an altogether new form of entertainment.[3]

Because motion pictures were shown in venues offering well-established genres of display and because they relied on existing narrative traditions, their meanings were necessarily conditioned by viewers' associations with other cultural forms. As the film

historians Noël Burch and Charles Musser have each pointed out, early cinema drew stories from the common culture that audiences brought with them to the movies.[4] The venues and narratives of the first motion pictures, instead of providing a neutral environment where viewers could experience a new medium, encouraged audiences to interpret movies through a host of discourses, including that of race. Critical responses to a typical vaudeville lineup in the fall of 1896 suggest how racialized viewing practices conditioned the form and reception of early cinema. A theater critic noted in the *Baltimore Sun* that "W. S. Cleveland's 'Greater Massive Minstrelsy' [appeared] last night at Ford's [Opera House] . . . and entertained a large audience with the usual medley of black faces, high collars and songs and jokes. In addition there were several innovations, notably variations of a musical character and more especially 'The Biograph.'"[5] A review in the *Baltimore American* that describes the minstrel performance of Cleveland's troupe also notes that the Biograph films shown at Ford's that evening "were exceedingly good and highly enjoyed," including "a most realistic scene of a reluctant pickaninny taking a forced bath." The reviewer concludes that "the entire show is brisk and entertaining, and the novel effects a pleasing variation on the good old minstrelsy scheme."[6]

The Biograph film the reporter described was probably *Hard Wash*, also known as *The Pickaninny's Bath* (ca. 1896; fig. 55), in which a smiling African American woman vigorously manipulates and scrubs a crying black child in a washtub. This popular movie was designed to amuse white audiences by suggesting that the mother's efforts could never clean the child sufficiently to get him white.[7] That the *Baltimore American* reporter was able to see a consistent theme in an entertainment that incorporated both traditional stage performance and ultramodern film suggests that his concern was with the ideological work of the skits, not their narratives or production techniques. In the critic's estimation the disparate components of the evening came together to constitute an "entire show" that offered a "pleasing variation" on the traditional minstrel theme. Whereas contemporary film historians frequently dwell on the technology of cinema and trumpet its radical nature, many European-Americans at the turn of the twentieth century focused on its atavistic political messages confirming what was taken as the natural hierarchy of the races.

The predisposition of European-Americans to project their racial biases onto both material objects and human beings was sufficiently powerful that films that were formally similar conveyed divergent meanings. In 1898 the Edison Manufacturing Company rushed the producer and cameraman William Paley south to Florida and then on to Cuba to capitalize on the public's desire for scenes relating to the conflict with Spain that would soon escalate into the Spanish-American War. While in Florida, Paley shot several films of troops arriving in the region, including *10th U.S. Infantry, 2nd Battalion Leaving Cars* (1898; fig. 56) and *Colored Troops Disembarking (24th U.S. Infantry)* (1898; fig. 57). Both movies are close to a minute long; are shot from a single, fixed vantage; and display in-

FIGURE 55 *Hard Wash (The Pickaninny's Bath)*, ca. 1896. Film still, Biograph. Motion Picture Division, Library of Congress, Washington, DC.

fantry troops with shaded faces, wearing similar uniforms and full gear. In the *10th U.S. Infantry* soldiers march diagonally in a column past a railroad station and stationary railroad car to the camera's right; in *Colored Troops Disembarking* soldiers, seen in profile, file from left to right down the gangplank of a large moored transport ship. For twenty-first-century viewers, it is difficult to perceive qualitative differences between the colored and noncolored troops, given the obvious similarities in dress and comportment displayed by the men in each film.

The promotional language used by the Edison Manufacturing Company suggests that the shared context of the films' original audiences may have encouraged them to perceive such qualitative differences. Edison's *War Extra* catalogue advertised the *10th U.S. Infantry* as follows: "Hurrah—here they come! Hot, dusty, grim and determined! Real

FIGURE 56 William C. Paley, *10th U.S. Infantry, 2nd Battalion Leaving Cars*, 1898. Film still, Edison. Motion Picture Division, Library of Congress, Washington, DC.

soldiers, every inch of them! No gold lace and chalked belts and shoulder straps, but fully equipped in full marching order: blankets, guns, knapsacks and canteens. Train in the background. Crowds of curious bystanders; comical looking [African American] 'dude' with a sun-umbrella strolls languidly in the foreground, and you almost hear that 'yaller dog' bark." The same catalogue describes *Colored Troops Disembarking* as follows: "The steamer 'Mascotte' has reached her dock at Port Tampa, and the 2nd Battalion of Colored Infantry is going ashore. Tide is very high, and the gang plank is extra steep; and it is laughable to see the extreme caution displayed by the soldiers clambering down. The commanding officer struts on the wharf, urging them to hurry. Two boat stewards in glistening white duck coats, are interested watchers—looking for 'tips' perhaps."[8] Modern audiences will neither hear the barking of the "yaller dog" nor see anything "laughable" in the efforts of the men who descend the gangplank. Such meanings were

FIGURE 57 William C. Paley, *Colored Troops Disembarking (24th U.S. Infantry)*, 1898. Film still, Edison. Motion Picture Division, Library of Congress, Washington, DC.

produced by a racialized value system whose currency is considerably diminished today. Viewers today, lacking sufficiently strong narratives of black cowardice or incompetence to condition their reception of these movies, find the "humor" of the African American characters unsupported by the visual evidence of the films. Paley's pictures fail not only to distinguish the relative abilities of the two infantry units but also, with the dark shadows that fall across the soldiers' heads, to provide the basic physiognomic evidence contemporary viewers need to determine the racial identities of individual men.

It is possible to read the catalogue text as prescriptive rather than as reflecting what period audiences would have seen on their own. Vaudeville theaters and movie houses routinely added live music and commentary when they screened the earliest silent films, and Edison's descriptions helped house managers create appropriate contexts that fos-

tered the films' racialized messages. But even if theater managers could encourage racial readings, I think it unlikely that audiences would have laughed at the colored combat troops had a condescending, even mocking, attitude toward African Americans not already been part of the common culture. Consider how white troops were (and were not) filmed and described for the same *War Extra* catalogue. Paley's recording of white soldiers in *U.S. Calvary Supplies Unloading at Tampa, Florida* (1898), depicts an ambulance that slips away from the men and, in the words of Edison's catalogue, "slides down the inclined planks with a sudden push that makes the men 'hustle' to keep it from falling off." One might expect to find humor in the efforts of the white soldiers, given that black soldiers who struggled against unexpected obstacles were comic. Yet there is no hint of comedy in Edison's descriptive text.[9] The intensely nationalistic and promilitary atmosphere of America's conflict with Spain in 1898 made it impossible for a description or artfully managed music or narration to elicit laughter from European-American audiences at the bearing of the white troops who flitted across the screen.

It is surely not coincidental that still photography was invented and popularized in the West at a moment when racial identity was rooted in physiognomy, or that motion pictures were developed and embraced fifty years later at a time when race was transforming into the performance of approved actions and traits. In each instance, the strengths of the new technology in reproducing the material world dovetailed with dominant views of racial identity. The failure of still photography to capture motion and sound and the inability of early cinema to replicate the detail and shading of objects in motion represented technical limitations that did little to disrupt the racial values that the technologies supported. Without labeling the technologies themselves "white," it seems clear that they were born and embraced, at least in part, because of their facility to confirm racial truths that Europeans and European-Americans "knew."

Readers of this book know by now that European-American films were racialized because they were shot and viewed by people invested in race. The logic of American society necessarily informs the objects and texts it creates and consumes. But as the juxtaposition of Paley's various military films suggests, not all texts are shaped in identical ways, or to the same degree; to contend that all products of European-American society are marked by race is not to claim that each is *equally* enmeshed. The preceding chapters illustrate how invisible discourses residing within members of a culture establish the limits for what texts might mean and how a range of meanings are subsequently focused by more obvious discourses suggested by the artifacts themselves. Having argued generally that racial values condition how texts are read, I want to consider now how confluences of visible discourse intensified the racial charge of certain films. Movies that suggested the hierarchical or stereotypical patterns broadly associated with racial systems heightened the propensity of European-American viewers to read their meanings

through the lens of race. Those films containing narrative or contextual "reminders" of racial tropes encouraged Gilded Age audiences to see race as particularly salient.[10]

The complex racial investment of an anonymous theatrical reviewer for the *Kansas City Star* surveying the new offerings at a local vaudeville house in December 1896 illustrates this abstract claim. He noted that at the Century theater "the real hit with the children was the Biograph pictures. They had already cut loose at yelling with the Brownie fire department, but with the first and second alarm and the thundering of the New York Fire Department through Herald Square the applause grew into a tempest; the bathing of the black baby who kicked and struggled brought the house to a fever pitch."[11] The review focuses on three "acts" that whip the children into ever-greater frenzies: a live libretto, *Palmer Cox's Brownies* (1894); an early Biograph film, *New York Fire Department* (1896); and the aforementioned Biograph film *Hard Wash* (ca. 1896).[12]

The libretto was the creation of Palmer Cox, a cartoonist and comic writer who gained fame for his creation of the Brownie characters—tiny fairylike creatures who roamed after dark, creating inadvertent mischief as they attempted good deeds. Created by Cox to amuse and socialize children, the Brownies rose to national prominence during the late 1880s and 1890s through magazine serials and six successful books, but they gained their largest audiences when the musical adaptation of *Palmer Cox's Brownies* went out on a five-year tour beginning in 1894. The critic refers to the scene at the end of the musical's second act, when the Brownie Fire Department battles an erupting volcano that threatens "the instant destruction of the Brownies."[13]

The film *New York Fire Department* no longer exists, but its general outline can be deduced from the large number and consistency of surviving fire films from the early silent era. During this period, all major production companies offered films catering to the public's interest in fire scenes, with titles such as *The Firebug* (Biograph, 1905), *Stable on Fire* (Biograph, 1896), *Montreal Fire Department on Runners* (Paley, 1901; fig. 58), *Going to the Fire and Rescue* (Lubin, ca. 1901), *Fire Engines at Work* (Selig, 1900), *Man with the Ladder and the Hose* (Vitagraph, 1906), and, most famous, *Life of an American Fireman* (Edison and Porter, 1903; see figs. 67, 68). The earliest of these movies focuses on the firemen's quick response, on the spectacle of their horse-drawn steam engines racing toward the conflagration, and on the fire itself. Fire films created after 1904 adhere to this basic formula, though they also emphasize narrative development and typically culminate in a poignant rescue, often reuniting a mother and child. So popular was the genre that Biograph's first movie catalogue, from 1902, contained a separate section wholly devoted to "Fire and Police" films.[14]

Formal and contextual elements superficially united the live and recorded scenes for the critic (and evidently for the children), given that the two scenes of firemen at work were probably shown back-to-back at the Century theater. Period reviews of *Palmer Cox's*

FIGURE 58 *Montreal Fire Department on Runners*, 1901. Film still, Edison. Motion Picture Division, Library of Congress, Washington, DC.

Brownies mention that Biograph films were projected between the second and third acts of the libretto during the show's 1896 run in both Chicago and Saint Louis.[15] Given the likelihood of a similar presentation format in Kansas City that year, audiences would have viewed the two fire companies one after the other. Oddly enough, the disparate depictions of the Brownie and New York City firemen reinforced these superficial links. The antics of the comical, bumbling Brownies in extinguishing the volcano placed in strong relief what audiences then understood as the competence and abilities of the New York City Fire Department. Although the reputation of firefighters fluctuated wildly over the course of the nineteenth century, at the century's close the public generally admired these men. With the gradual abandonment of urban volunteer fire departments during the second half of the century and the establishment of paid forces in all major

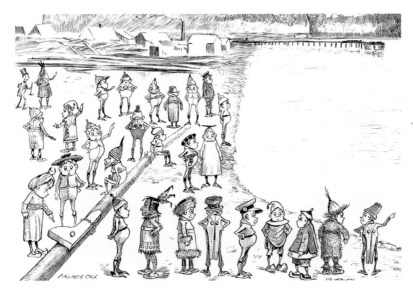

FIGURE 59

Palmer Cox, detail of *Brownies as Tourists from Different Countries at the Rock of Gibraltar*, 1894, from *The Brownies around the World*. Lithograph on paper, 15 × 13.9 cm. Division of Prints and Photographs, Library of Congress, Washington, DC.

cities, firefighters shed their midcentury reputation as hooligans and political lackeys to enjoy Americans' esteem as selfless heroes.[16]

The links established by shared narratives, temporal proximity, and the comic opposition of bumbling and efficient personnel helped fashion what period audiences interpreted as a racial juxtaposition. Because Cox's Brownie characters were drawn from a range of countries that readers would have associated with both white and nonwhite races, the Brownies displayed sufficient physiognomic variety to preclude their designation as racially other based on physical markings alone. They may have been called Brownies because they were "small, brown creatures," but Cox illustrates varying skin pigmentations and physiognomies (fig. 59), and the Brownies come from virtually every racial group.[17] What ultimately branded the Brownies as "other" was their secondary traits, which were closely linked to the purported characteristics of nonwhite peoples.

The Brownies may not have been black, but their bumbling efforts to extinguish the volcano played into dominant stereotypes of the incompetence of nonwhite peoples—particularly, I will argue, the ineptitude of nonwhites in fighting fires—establishing a contrast that encouraged period audiences to map well-worn racial hierarchies onto cultural products with no visible links to race. A critic for the *St. Louis Post-Dispatch* favorably reviewed the 1896 production of Cox's Brownies (along with the Biograph films), noting that the Brownies "capered and danced and sang on the stage as merrily as they do in the book."[18] In using language indistinguishable from that employed in the era to laud minstrel performers, the writer demonstrates how the juxtaposition of the myth-

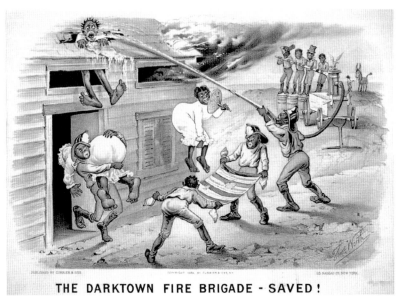

THE DARKTOWN FIRE BRIGADE - SAVED !

FIGURE 60
Thomas Worth,
*The Darktown
Fire Brigade—
Saved!*, 1884.
Vignette on
paper, Currier
& Ives, 25 ×
35 cm. Prints
and Photographs
Division, Library
of Congress,
Washington, DC.

ical and real firemen may well have carried a racial charge. Sensing the existence of an incompetent-competent dynamic between the firemen of stage and cinema, European-American viewers unselfconsciously invoked racialized templates of thought, which encouraged them to respond to the whiteness of the filmed firemen, regardless of their conscious perceptions of the Brownies' racial identity.

A substantial body of stage and print depictions augmented this tendency, making it impossible for Cox (or his audiences) to conceive of comic firefighters without at least unconsciously recalling the stereotype of the bungling black. Currier & Ives, by far the most successful purveyor of lithographs in nineteenth-century America, produced no fewer than seventeen scenes of incompetent black firemen in their virulently dehumanizing *Darktown* series, released between 1884 and 1894.[19] These images attest to the European-American desire to see African Americans as devoid of complex mental, physical, social, or professional skills. Typical lithographs from the series illustrate rescues gone awry (fig. 60), houses inadvertently destroyed by firemen, and many fire trucks hitting pedestrians and crashing into trolleys and other fire engines (fig. 61). The sandwiching of the screening of *New York City Firemen* between the Brownies' musical (which reinforced racial hierarchies without explicitly addressing race) and *Hard Wash* (which overtly drew on racial stereotypes to create its comic effect) and the cultural coupling of both vaudeville and firefighting with racial themes underscored the whiteness of New York City firemen for period audiences.

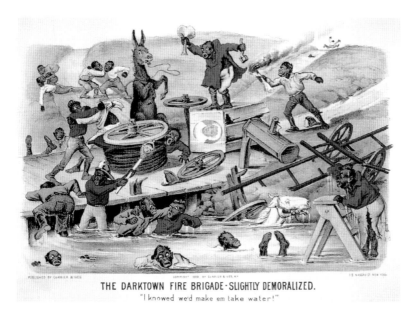

FIGURE 61

The Darktown Fire Brigade— Slightly Demoralized, 1889. Vignette on paper, Currier & Ives, 28 × 35 cm. Prints and Photographs Division, Library of Congress, Washington, DC.

In the introduction to this book I suggested the dangers in European-Americans' making a study of racial others, based on the legacy of well-meaning whites inadvertently using images of blacks to advance their racial self-interest. Such dangers are only compounded when the images reproduced by European-Americans, like those in *Hard Wash* and the *Darktown* series, question the competence and humanity of African Americans. Dehumanizing stereotypes, wherever they are reproduced, argue subtly but persistently to individuals belonging to the dominant culture that certain classes of people differ from themselves and, more ominously, that those people are less than human. The circulation of images that deny or question the humanity of women, racial minorities, gays, lesbians, or politically disempowered groups plays a supporting role in normalizing discriminatory, violent, and potentially even genocidal behavior against individuals from those groups. Interpersonal violence is not guaranteed by a belief that someone else is less than human, but violence and discrimination are much easier to practice when such beliefs exist.[20]

Despite these dangers, the danger of ignoring the historical depiction of blacks ultimately outweighs the risks of reproduction. Having analyzed the visual construction of whiteness without the aid of racial others in earlier chapters, I have selected a number of images depicting African Americans for my analysis of film, knowing that we cannot make sense of whiteness without considering what blackness meant to European-Americans of the Gilded Age. In reproducing these images, I also tacitly acknowledge

the reciprocal danger that some readers today may have only a vague sense of how African Americans have historically been depicted in U.S. culture. For both students and academics, there is something sobering about confronting the ubiquity and perniciousness of images of blacks with which whites promoted (and, in some contexts, continue to promote) their commercial and political interests.

In chapter 1, I discussed the emergence in the 1870s of a racial paradigm that diminished the links between physical appearance and racial identity. I considered how individuals with "white" physical features could be defined as black and how Asians, Native Americans, and Latinos could initiate court challenges based on the theoretical possibility of darker-skinned people being declared legally white. Given the modern academic reflex to see biological definitions of race as more restrictive, and ultimately more repressive, than those based on social or performative criteria, many readers may see the decoupling of race from physiognomy as a positive development. In practice, however, the social construction of race has presented few benefits over a biological model. While it promises more malleable racial definitions that permit individuals a degree of control over identity, the social construction of race has historically left the logic of racial hierarchies intact. Consider the practical implications of the shifts in identity, discussed in Chapter 1, that emerged in the late nineteenth century: more people inscribed as black and stripped of privileges at the same time that people from a growing range of ethnic backgrounds gained citizenship through their classification as white. Even setting aside the material consequences of the emerging paradigm for African Americans, we should hesitate to celebrate the expansion of white identity to include previously disempowered groups when the prerogatives of whites remained predicated on withholding resources from those deemed nonwhite. Expanding the pool of those who benefit from the imbalance of power does not make American society more just.

In many ways the changes in racial definition initiated during the 1870s reached their logical conclusion around 1900, when, as the historian Joel Williamson argues, those born white could be categorized as black based on their actions alone.[21] The abolition of slavery caused conceptual difficulties (not to mention social and economic problems) for white Americans by eliminating their ability to equate blackness unproblematically with servitude. Moreover, in response to a growing mulatto population whose physical whiteness made it difficult to base determinations of race on visual evidence alone, European-Americans increasingly embraced the one-drop rule of black identity, classifying individuals with *any* black progenitors as black. Although the rule had the theoretical advantage of determining racial belonging absolutely, it had the practical disadvantage of proving hard to enforce. Its logic was predicated on immobile populations, which permitted familial genealogies to be part of a community's shared memory, but given the transience prompted by the Civil War and emancipation, and later by World

War I, the rule caused as many metaphysical problems as it solved. Not only could it not erase the specter of invisible blackness, but it also increased the likelihood that blacks would pass as white by defining an increasing number of white-looking people as black. The 1910 census calculated that mulattoes represented 20.9 percent of the U.S. population, which was a significant increase from the 11.2 percent recorded by the 1850 census. It is fairly certain that both percentages reflect an undercounting of mulattoes under the one-drop rule, because determinations were based on white ancestry as it was *visible* to census takers.[22] As the historian John Blassingame notes, by the late nineteenth century, racial intermixing had produced so many light-skinned blacks that it was impossible in some southern states to determine race by sight alone.[23]

Practical difficulties enforcing the one-drop rule led white southerners (and soon thereafter their northern counterparts) to define who was black by traits and actions. Whites desiring at the turn of the century to police the border of whiteness, but often lacking community memory or physical evidence to do so, took an individual's personal morality and public conduct as markers of racial belonging. Not conceived as a means to allow white-acting light-skinned blacks to become white, the shift in racial identification was initially employed to label black those who appeared physiognomically white but who inexplicably aligned themselves with the interests of nonwhites, as well as those one-drop blacks who exhibited no physical signs of their blackness yet retained linguistic, culinary, spiritual, or social characteristics associated with African American culture. For the first time, the conduct alone of those defined as genetically white could redefine them as racially black. As Williamson notes, by the early twentieth century, blackness was conceptually detached from physiognomy.[24]

The process by which race became unglued from external physical features is famously illustrated in Mark Twain's novel *Pudd'nhead Wilson* (1894), which sits uneasily at the cusp of newer and older racial models. The book muses on identity by drawing out the humorous and disturbing repercussions that flow from a switch of two infants—a light-skinned African American child taking the place of his white master in the antebellum South. Terrified that her child might be sold away at her master's whim, the slave Roxy swaps her black baby's clothing—and effectively his identity—for that of her master's white child, who is also in her charge. We first meet Roxy some three months before the switch, when she is introduced as a disembodied voice, overheard trading playful jibes across a field with another slave. The European-American protagonist Pudd'nhead Wilson listens to the exchange as a surrogate for the reader before stepping to his window to see the two speakers. The narrator states that "from Roxy's manner of speech a stranger would have expected her to be black, but she was not. Only one sixteenth of her was black, and that sixteenth did not show."[25] As "strangers" to the town, readers doubtless have come to the same conclusion, for Roxy's language can readily be identified as black vernacular. The narrative, in presenting the evident disjunction between her

white features and black dialect, does not question her identity as black so much as establish the dominant message of the novel: that race, as "a fiction of law and custom" (64), was a powerful social reality.

When Roxy switches her baby with that of her white master, she is reasonably certain that her action will go undetected because both babies appear physiognomically white—with "blue eyes and flaxen curls" (71)—and because clothing, as she has realized, has the power to establish identity. Swapping clothes is more than cosmetic, for it initiates a shift in societal attitudes that profoundly shapes the upbringing of both boys. The first character trait ascribed to either infant comes after the switch, when we learn that Tom, the black baby raised as white, "was a bad baby, from the very beginning of his usurpation" (75). He is "bad" not from the moment of birth but from the time he is marked as white. It is no coincidence that his character and worth are given form by his culture's most significant marker of identity. Even more than their biological sex, the boys' racial designations set the parameters for what they may become.

The switch ensured that "Tom got all the petting, Chambers got none. Tom got all the delicacies, Chambers got mush and milk, and clabber without sugar. In consequence Tom was a sickly child and Chambers wasn't. Tom was 'fractious,' as Roxy called it, and overbearing; Chambers was meek and docile" (77). Later we are told that "Chambers was strong beyond his years, and a good fighter; strong because he was coarsely fed and hard worked about the house, and a good fighter because Tom furnished him with plenty of practice" (78). The child raised as black conforms to all of the accepted stereotypes of blacks—both physical and temperamental—despite the technicality of the child being legally white. The narrator not only lists the developed traits but in nearly every case describes the external pressures that produced them; we learn that coarse food creates a strong constitution, and that practice in scrapping makes one a skilled fighter. It comes as no surprise, then, that the children mirror many of the racial expectations of those around them. Because the boys are "genetically" separated by just one thirty-second of black heritage, their distinguishing secondary traits are all the more compelling, for only socialization can explain how each acquired traits "inappropriate" to his genetic background.

Scholars have long debated the novel's moral and racial economies, uncomfortable with both the resolution of the narrative and the development of Tom's character.[26] Modern liberal readers find it difficult to laud an ending in which the "real" black slave is unmasked and sold downriver, or a story whose sole murder is committed by an African American character who has enjoyed every racial, social, and economic advantage. The novel presents a wealth of evidence suggesting that Tom is significantly shaped by his environment, though his cruelty, greed, cowardice, and prevarication are hard to account for by socialization alone. As Michael Rogin astutely notes, "Although his upbringing as a master in slave society may be responsible for some of his bad qualities, Tom hardly resembles the all-white scions of the First Families of Virginia. He exhibits instead the

stereotypical defects of the slaves."[27] Efforts to trace the root of Tom's negative traits are complicated by Chambers's character, for whereas Tom seems the product of both learned and innate qualities, Chambers is composed wholly by the social realm. Chambers is so completely fashioned by his station in life as stereotypically black that he cannot make the transition back to white when his true mother is revealed. For many scholars, it is difficult *not* to read Tom's failings as a product of the very invisible blackness that turn-of-the-century audiences feared. As a light-skinned black who stabs the novel's purest incarnation of the old white South, Tom embodies the mortal and genetic threats miscegenation poses to the white race.

If the novel leads modern readers to interpret some of Tom's traits as products of biology, this has everything to do with the asymmetrical role of performance that for early twentieth-century European-Americans secured the identities of blacks and whites. Recall that Williamson describes turn-of-the-century racial performance as a process for classifying certain whites and light-skinned blacks as black based on their actions—not a means for nonwhites to become white through theirs. The legal scholar John Tehranian argues that only in the 1920s could nonwhite minorities act openly in a way that would make them white. Reviewing Supreme Court cases of individuals who sought naturalized U.S. citizenship based on their legal designation as white, he observes that only in the third decade of the century did the court base judgments of the whiteness of visible minorities on their performance. According to Tehranian, in these decades "successful litigants demonstrated evidence of whiteness in their character, religious practices and beliefs, class orientation, language, ability to intermarry, and a host of other traits that had nothing to do with intrinsic racial grouping." Early in the twentieth century, the promise held out to various Native American groups since first contact—that they might become white through acculturation—was now legally, if not practically, credible. Race in these decades was linked once more to observable traits, even as its legalized grounding in social rather than biological character transformed racial identities.[28]

Whereas turn-of-the-century Americans could conceive of Chambers's actions making him black, they did not yet have a corresponding conceptual framework to see how Tom's might make him white. Neither Twain nor his readers had the theoretical lens through which to see Tom's character traits rooted fully in the social realm. Considering both the absence of such a lens and the cases examined by Tehranian, which involved nonwhites who were not African American, Tom's depiction in *Pudd'nhead Wilson* is all the more remarkable. Given the racial context of the novel's production, modern readers should be less surprised to see Tom's identity partially rooted in essentialist models of identity than to see how closely it is tied to socialization and the performance of whiteness.

Pudd'nhead Wilson may be seen as one of the cultural works that refined the concept of black performative identity at the close of the nineteenth century. Unable to promise African Americans that they could select alternative racial identifications—a prom-

ise largely unrealized at the start of the twenty-first century—the novel instead sets out an inchoate version of performance's potential. But even as audiences in the 1890s consciously clung to a lingering essentialism, the novel illustrates how they nonetheless responded to race according to more modern racial models. This gap between belief and action is apparent in *Pudd'nhead Wilson* in the scene chronicling the reaction of the townspeople to Tom's homecoming after his brief sojourn at Yale. Returning with a wardrobe and manners reeking of East Coat sophistication, Tom instantly succeeds in irritating his Missouri peers. Because the youths of the town had known a younger Tom who acted and dressed like them, they took offense at what they saw as the clear artificiality of his new bearing. The narrator explains that the young men, having had their fill, "set a tailor to work that night, and when Tom started out on his parade next morning he found the old deformed negro bell-ringer straddling along in his wake tricked out in a flamboyant curtain-calico exaggeration of his finery, and imitating his fancy eastern graces as well as he could" (85). We learn that Tom's response was immediate surrender.

The juxtaposition of two men—one wealthy and white, the other poor and black—parading around town in similar dress and making similar gestures surely occasioned much laughter among the townspeople. The impersonation made explicit what the townspeople perceived as the artificiality of Tom's appearance and heightened the comic nature of his parade for everyone in sight. Whereas previously Tom had enjoyed the "feeling which he was exciting" in town, the parade stripped away his pleasure, forcing him to confront the disjunction the townspeople sensed between who he was and how he acted. Just as the narratives of Currier & Ives's *Darktown* series amused European-Americans by depicting blacks engaged in activities deemed inappropriate for their abilities or station, so Tom's parade was made similarly ridiculous by his juxtaposition with a black. The bell ringer's performance would have proved equally amusing to Americans during the 1850s or the 1890s, though it is uncertain that it would have led the intended victim to abandon his behavior at any time prior to the century's close.

Satirical prints illustrating the supposedly ruinous effects of abolition on the dominant racial order were potent rhetorical weapons in the arsenal of antiabolitionists during the second third of the nineteenth century. They typically illustrate well-dressed and well-mannered African American men suggestively enjoying the company of white women and partaking in cultural offerings that were popularly understood to be beyond their race (fig. 62). The images generated intense interest and excitement among whites, who feared African American gains, social or economic, but their suggestion that blacks could take on white characteristics and activities did not cause European-Americans to question—much less abandon—what were perceived as the natural attributes and activities of whites.

Under controlled conditions, European-Americans of the antebellum era were even known to accept blacks' actual appropriation of their traits. Consider the white recep-

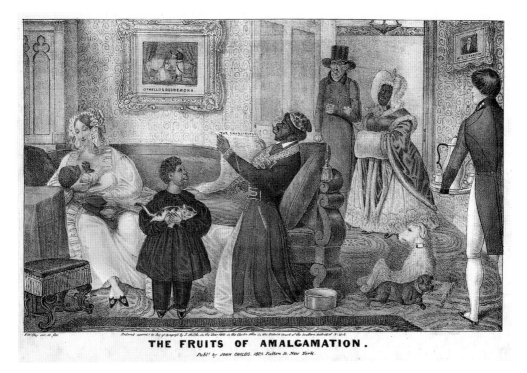

THE FRUITS OF AMALGAMATION.

Publ⁴ by JOHN CHILDS. 160⅓ Fulton St. New York.

FIGURE 62 Edward W. Clay, *The Fruits of Amalgamation*, 1839. Lithograph on paper, 24.5 × 36 cm. Graphic Arts Collection, National Museum of American History, Smithsonian Institution, Washington, DC.

tion of the cakewalk, a dance first performed by African slaves on American plantations for their private entertainment. As the African American musician and freedman Shepard Edmonds recounts, slaves amused themselves on Sundays by dressing up in discarded white finery and performing the cakewalk, an exaggerated dance that spoofed the gait and manners of their white owners. Edmonds claims that white masters naively missed the irony of the dance and took to awarding a cake to the most talented dancing couple, but as the literary historian Eric Sundquist has plausibly argued, it was highly unlikely that white audiences missed so conspicuous a parody. Sundquist contends that more lenient masters might even have acknowledged to their slaves that they saw themselves burlesqued in the dance, given that white manners were only indirectly related to racial identity in the antebellum South.[29] Whether these prints or dances amused or concerned antebellum whites, they could acknowledge blacks' appropriation of their attributes, secure in the knowledge that their own identity as white was not consequently diminished.

Racial values of the 1850s, when the parade in Twain's novel was set, cannot explain Tom's rush to abandon his eastern refinements. The scene makes sense only in the context of the 1890s, when emerging models of identity formation ensured that the parody would reflect on the identity of its intended victim. Tom's reaction demonstrates his practical acceptance of race as a social product, even if he remained unable to articulate it as such. The emerging power of performance makes it unlikely that the townspeople would have found the parade quite so amusing if the bell ringer had worn a precise replica of Tom's outfit rather than an "exaggeration" or if the African American had perfectly reproduced Tom's "eastern graces," instead of simply copying them "as well as he could." Had the mimic proved as convincing as his subject, the parade would probably have disconcerted Tom only slightly more than the youths of the town.

While Twain was evidently comfortable edging toward a model of performative identity for African Americans, most of his European-American contemporaries were not. In European-American literature, painting, and film of the period, African American characters typically had the darkest skin possible and were cast in narratives that rooted them in their self-evident blackness. But instead of offering a return to older, essentialist models, such texts acknowledged the modern shift in identity while attempting to defuse European-American fears of black performance. We appreciate, for example, the comic appeal of *Hard Wash* in the woman's rough manipulation of the screaming child and in her vain efforts to scrub his skin white. The character, unable to appreciate the power of performance to alter *social* markers of identity—and hence affect racial designations—worked ineffectually to alter the baby's *biological* traits. She fails to make him white, according to the logic of the film, because blacks cannot move beyond a belief in skin color as *the* marker of identity—not because performance cannot alter African American identity. The film is concerned to defuse the threat to whites of the new alliance between race and performance by reassuring European-Americans that blacks cannot seize on its potential. At the turn of the century, European-American visual culture routinely presented performance as a dead end for African Americans, cast as buffoonish for their inept mimicking of white attributes (as in *Colored Troops Disembarking* and the *Darktown* series), or as ineffectual for failing to comprehend the process of self-transformation (as in *Hard Wash*). If identity might be performed, then no wonder European-American texts restricted black performance to safely reassuring tropes.

I want now to circle back to *New York Fire Department* to consider how such an identity model affected viewers' perception of the film. Period audiences with even a passing familiarity with New York City would have known that the firemen were not generic whites but Irish Catholics—an ethnic group that occupied a unique racial niche in the minds of period Americans. Before the Civil War, the volunteer fire companies that served New York City rigidly excluded almost all nonwhite people. Because of the perception among Protestant European-Americans that Irish Catholics were inferior, the Irish were

among several groups that were effectively barred from service.[30] Their imperfect whiteness did not marginalize them to the degree of African Americans but nonetheless relegated them to a lower rung on the racial ladder, where they were subjected to overt discrimination in all facets of life. As the historians of race David Roediger and Noel Ignatiev have shown, only in the century's second half did Irish Americans solidify their ties to whiteness by vigorously disavowing their economic and cultural links to blacks.[31]

By the time Biograph filmed *New York Fire Department*, the New York City Fire Department had become an Irish Catholic bastion—because of the substantial increase in the city's Irish population; the legislated dismantling in 1865 of the clubby volunteer companies, which were replaced by a professional department; and, most important, the ascendancy of Tammany Hall, which doled out municipal jobs to the Irish constituents who year after year ensured its electoral success. According to the historian Hasia Diner, by the end of the century so many of New York City's most visible public service jobs were in the hands of the Irish that "teaching, police work and firefighting, had become almost synonymous with being Irish."[32] *New York Fire Department* is intriguing not for its favorable depiction of white people but for its positive representation of a group in the final stage of solidifying its racial identification as white. The Irish, perhaps not yet as white as the descendants of Protestants from western European countries, seemed much closer to the ideal than the eastern European Jews and southern European Italians then flooding into New York City.[33] For Protestant European-Americans, who by century's close feared these newer waves of immigrants much more than the Irish Catholics, the film offered the Irish as a buffer, insulating them from newer, more menacing arrivals. The firemen thus represented a racial bridge between more established, unambiguously white populations and the newer dark immigrant groups.

It may seem maddeningly vague to claim that the firemen of the film were somehow raced by the performance of identity, when it is doubtful that they did much more than speed across the screen with smoking steam engines and perhaps extinguish a fire. Their white identity was nonetheless overdetermined by performance—their own and those of nonwhite characters in period movies, plays, prints, and vaudeville skits, who provided a context for their actions. As apparently minimal as their onscreen performance may have been, their participation in an efficient and professionalized fire department— the type that became the norm in the century's final decades—testified to the self-control the men exercised. By serving in a professional force that was then widely admired, the men demonstrated their ability to regulate their own physical, mental, and emotional impulses and safeguard the interests of whites by protecting their capital, property, and lives. This kind of regulation, valued by European-American audiences, would have contrasted with popular depictions of nonwhites, especially the caricatures of the Irish widely held by Americans just decades earlier. The antebellum stereotypes of the Irish, discussed by David Roediger and others, stress the blackness of the immigrants

by pointing to a lack of self-control. In the popular European-American imagination, the Irish were savage, groveling, bestial, lazy, wild, and simian—neither temperamentally nor racially like the implicitly Irish firefighters in *New York Fire Department*.[34]

Historians have claimed that the Irish were readily transformed, in part, by their physical resemblance to other whites—an ease impossible for darker-skinned groups to copy. According to this argument, the Irish may have worked hard to lose their status as colored, but they did so ultimately because of their physiognomy. In the words of Ignatiev, "White skin made the Irish eligible for membership in the white race."[35] While this argument helps to explain how some waves of comparatively recent immigrants achieved a white status that eluded more established populations (such as blacks, Indians, Latinos, and Asians), it projects backward our current assessments of white identity rather than pointing out the immutable realities inherent in particular concentrations of melanin. After all, during the nineteenth century there was no shortage of European-American viewers who remarked on the physical darkness of Jewish as well as Catholic Irish and Italian immigrants. We may argue that once perceptions of their racial otherness began to dissipate, the "actual" physical whiteness of these groups became apparent, but we would be mistaken to conclude that the physical traits of whiteness are this obvious or fixed. Such presentist thinking reinforces the dangerous, essentialist conclusion that the Jews or Irish were always white and simply needed to be recognized as such. Because the sight of twenty-first-century European-American viewers is no less (if differently) guided by racial discourses than that of viewers in the early years of the last century, pronouncements on the limitations imposed by the perceived pigmentation of this or that ethnic or racial group reflect little more than our current cultural paradigm.

Those deemed white have long exhibited a range of skin colors, and no consistent rule links the lightest skin color to those groups most securely designated as white. My father's olive complexion is certainly darker than that of some African Americans I have met, yet few Americans are likely to question either his whiteness or the blackness of a light-skinned black. Once again, we should appreciate the power of discourses to mold sight, smoothing over the apparent visual contradiction of lighter-skinned groups' being labeled black. Instead of understanding the tendency of present-day European-Americans to see the darker skin of many Asians or Latinos as evidence that these groups are factually too dark to ever be embraced as white, we might more profitably relate their darkness to our ideological belief in their nonwhite status. Given the past perceptions of Irish Catholics as darker than Protestant European-Americans and the obviously unstable border of whiteness, it seems naive to conclude that our twenty-first-century assessments are any more objective. Once the ideological context is in place for absorbing an additional group into the white race, the group's darkness will fade away, allow-

ing its particular coloration to inhabit what we will then see as the natural range of white pigmentation. The logic of whiteness does not rule out *any* group from the designation of white, so long as a nonwhite presence remains visible to secure the identity of whites. As a theoretical matter, even African Americans might be designated as white without necessarily disturbing the underlying logic of the black/white opposition.

There is a limit to what can be said about *New York Fire Department*, given the loss of the film itself. While the *idea* of the film is useful in illustrating how invisible discourses affected the meaning of early cinema, without the benefit of the film itself we can glean only so much of its meaning for turn-of-the-century audiences. Having foregrounded both the racialized contexts in which early films were produced and consumed and the performative model of identity formation then emerging, I turn now to one of the best-known films surviving from the silent era, Thomas Edison and Edwin Porter's *Great Train Robbery* (1903).[36]

The movie opened quietly in a single New York City theater during the Christmas season in December 1903.[37] By the following week, it was showing at eleven locations in the New York area alone and would go on to become the most successful film of cinema's first two decades, to be eclipsed in financial and critical success only by D. W. Griffith's *Birth of a Nation* (1915).[38] *The Great Train Robbery* is a lengthy, multiscene movie, driven by a complex plot that involves the daring efforts of four western bandits to rob a passenger train. The film's fourteen scenes depict a telegraph operator forced at gunpoint to issue false orders for a train to take on water before he is pistol-whipped and tied; four bandits stealing onto the train as it stops for water; a gunfight between two of the robbers and the mail car's clerk, the clerk's death, and the theft of mail bags and the contents of a lockbox; a struggle between two bandits and the train's engineer and fireman that concludes with the fireman's being thrown from the moving train; the engineer uncoupling the locomotive from the passenger cars at gunpoint; passengers being forced off the train and systematically stripped of their valuables, and the shooting of a passenger who attempts an escape; the four robbers making their getaway on the decoupled locomotive; the robbers' descent from the train and flight on foot; the bandits' escape down a hill and across a shallow creek to waiting horses, which they mount and ride offscreen; the telegraph operator's being awakened and untied by his daughter; a dance hall scene illustrating rugged westerners making a city slicker dance as they fire revolvers at his feet, the entrance of the telegraph operator who relays the story of the robbery, and the abandonment of the hall as the men gather their arms and rush off; an exchange of gunfire between the mounted posse and the fleeing robbers; the bandits being surrounded unawares as they examine their haul and an ensuing firefight, which leaves them all dead; and, finally, a close-up of the outlaw gang leader against a black

backdrop, emptying his revolver directly at the audience. According to catalogue copy, this last scene was to be shown at the exhibitor's discretion, as either a prelude or conclusion to the other thirteen scenes. As prerelease advertisements boasted to theater managers, it was a "sensational" film.[39]

Its popularity inspired a host of imitators as it spurred the development of western, robbery, and chase films. Within six months of its release, Siegmund Lubin's distribution company had created a scene-by-scene copy of it, offering its own *Great Train Robbery* (1904) at a price that severely undercut Edison's. Other movies inspired by the original include *The Bold Bank Robbery* (Lubin, 1904), *The Hold-Up of the Leadville Stage* (Selig, 1904), *Rounding Up of the "Yeggmen"* (Edison, 1904), *The Great Jewel Mystery* (Biograph, 1905), *A Daring Hold-Up in Southern California* (Biograph, 1906), *Hold Up of the Rocky Mountain Express* (Biograph, 1906), and even Edison's own *Little Train Robbery* (1905), the last of which offered a humorous adaptation of the original with child actors, candy loot, manic police, and a miniature train.

Film historians have long remarked on the modern qualities of *The Great Train Robbery*, which contains all the essential ingredients of contemporary action films, with its complex narrative, multiple shots, chase scenes, fistfights, gun battles, explosions, and special effects. But in many ways the film lacks the constituent elements of a modern movie for viewers today, who are as likely to register a sense of strangeness as familiarity with the film. They puzzle over *The Great Train Robbery*'s unmodern sense of narrative and its odd depiction of time. Several scenes today seem overly drawn out, even boring, though the film runs for less than twenty minutes. Such scenes include the elaborate tying up of the telegraph clerk, the robbers' waiting for the train at the water tower, the mail clerk's inventory of packages and bags before he is held up, and the emptying of the train and robbery of its passengers.

This last event is captured in scene 6 (fig. 63), in which well-dressed riders file two by two from railroad cars onto the tracks and arrange themselves in orderly rows before the cars with arms raised. Once all the passengers are lined up, a robber moves methodically among them with an open sack, claiming valuables from each displaced passenger. The scene is dull for twenty-first-century audiences because it lasts two or three times longer than we need to glean the narrative information we deem important and because it contains visual information that seems extraneous to the robbery plot. The shot seems useful merely for giving us two pieces of information: that the passengers are forced off the train, and that they are held up. Once we know that much, we wait expectantly for the scene to develop further, or even for the action to move on to another scene. For turn-of-the-century audiences, who enjoyed seemingly mundane films depicting mail processing, soldiers on parade, the transportation of ice by rail, pedestrians on a sidewalk, or even the sorting of trash, movies enthralled by offering naturalistic descriptions of the world in motion. As an early multishot narrative film, *The Great*

FIGURE 63 Edwin S. Porter, *The Great Train Robbery*, scene 6, 1903. Film still, Edison. Motion Picture Division, Library of Congress, Washington, DC.

Train Robbery surely was appreciated for the story it told, but individual scenes could captivate audiences with prosaic detail that for present-day viewers disrupts the film's narrative flow.[40]

Not only are individual scenes drawn out, but narrative and formal links between scenes are frequently obscure. In scene 11 (fig. 64) we watch a dance in a rustic hall filled with couples and a pair of country musicians. A man enters who looks instantly out of place in his city suit and bowler. He is quickly ushered to the center of the dance floor, where he is made to perform an impromptu jig as men fire bullets around his feet. Given that this odd dance sequence immediately follows the scene in which the telegraph operator regains consciousness and that most of the characters we see in it are new to us, it is difficult to imagine its links to the larger narrative. Only at the end of the scene,

FIGURE 64 Edwin S. Porter, *The Great Train Robbery*, scene 11, 1903. Film still, Edison. Motion Picture Division, Library of Congress, Washington, DC.

when the telegraph operator—sporting his distinctive vest set off against his bright white sleeves—bursts into the hall to raise an alarm (fig. 65) do we see the narrative connect to the robbery. As the men from the dance hall grab their weapons and rush out, we understand that they will form a posse. But this is hardly the only narrative or temporal "problem" with the film from a modern vantage. As scholars of film have noted, we can glean from Edison's original catalogue description that scenes 3 and 4, which depict the robbery of the mail car and the fight for control of the engine, occur simultaneously, as do scenes 10 and 2, which depict the freeing of the telegraph operator and the bandits' boarding of the train.[41] It is hard to imagine how audiences unfamiliar with the movie's plot, or lacking a running narration in the theater, might have reached this conclusion on their own.

FIGURE 65 Edwin S. Porter, *The Great Train Robbery,* scene 11, 1903. Film still, Edison. Motion Picture Division, Library of Congress, Washington, DC.

The most obvious explanation for these narrative difficulties would seem to be technical. Directors today show simultaneity with parallel editing—a film cuts back and forth between two or more different shots, representing geographically distinct events that occur simultaneously. Because parallel editing did not exist in 1903, Porter's options in communicating such simultaneity to audiences were restricted.[42] Prior to the advent of parallel editing, filmmakers illustrated simultaneity by selecting from a range of conventions, many of them familiar to us today, including split screens, dream bubbles, or simple intertitles with "Meanwhile . . . " printed across the screen, but they also experimented with a number of largely forgotten approaches, such as that presented in *The Story the Biograph Told* (Biograph, 1903; fig. 66). To provide audiences a view of both sides of a telephone conversation, the filmmaker superimposed a film clip of the wife (seen standing at the left of the frame), who placed the call from home, on a clip of the

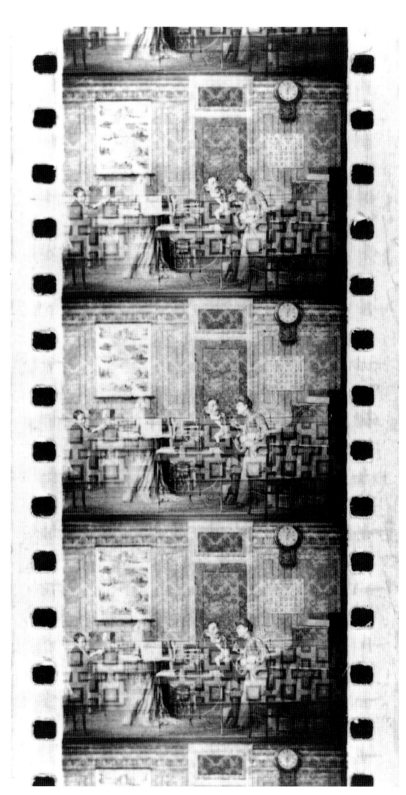

husband (seated at right with his secretary on his lap), who took the call in his office. The resulting double exposure is difficult to decipher, but it offered a novel solution to the problem in its day. Given the tremendous popularity of Porter's films, despite his avoidance of the representational techniques now associated with classic cinema—and embraced by his contemporaries—it is useful to consider what cultural work his particular narrative modes performed for turn of the century audiences. Instead of seeing *The Great Train Robbery* as an imperfect expression of Porter's story that would benefit from modern film conventions, one might profitably see it expressing a different vision of modernity.

As odd as it sounds, there is considerable evidence to suggest that Americans in about 1900 held on to a conception of time largely foreign to us today. Few things seem more natural than time, but only in 1918 did the federal government pass the Standard Time Act, mandating the use of our current time system. Prior to this date, each community maintained what was known as "natural," "solar," or, most commonly, "local" time, based on the daily cycles of the sun. When the sun stood directly overhead, one knew it was noon, which allowed for the setting of watches and clocks based on the cyclical rhythms of the earth. This system ensured that towns at any distance from each other east to west set clocks at different times, based on the apparent movement of the sun from east to west, effectively dividing the country into thousands of zones of time. The historian Stephen Kern points out that a train passenger in 1870 traveling from Washington, D.C., to San Francisco who checked station clocks in every town along the route would have observed more than two hundred different times.[43] This national hodgepodge was no less complicated on the local level, for through the end of the nineteenth century in a single city three distinct times might compete—that of the regional railroad, which generally maintained the time of its home city over the length of its tracks; that of a nearby metropolis to whose economy the town may have been closely tied; and natural time, with all its imprecisions.[44]

Despite the patchwork of time zones blanketing America, the use of local time caused few practical difficulties prior to the nineteenth century. With travel and communication slow and cumbersome, there was little need for distant locales to closely coordinate their activities, and day-to-day problems were rare. New and faster modes of transportation and communication, the spread of national and international business interests, and greater economic and military coordination between nations, however, made a standard system of timekeeping increasingly important. It was essential to establish meaningful arrival and departure times for travel by canal, steamship, and train, just as insurance policies, legal contracts, and business agreements demanded the setting of unambiguous times.[45] In response to the practical inefficiencies of local time, scientists, educators, and eventually railway men pushed for a rationalized model of time—what came to be known as standard time. It derived not from solar variations but from an

average twenty-four-hour day that evened out seasonal irregularities in local time, produced by the earth's elliptical orbit and tilt. Standard time began to replace local time in 1883, when William Frederick Allen successfully guided a national consortium of railroads to base their schedules on this new norm. By imposing times that had no correspondence to the rising and setting of the sun and creating four U.S. time zones, vertical bands of territory that shared the same time and were separated from bordering zones by exactly one hour, standard time eased the challenges of conducting business and travel and of communicating across vast distances.

Standard time, by advancing the interests of capital, encouraged Americans to relate events occurring within and beyond the range of their perceptions in a new way—as simultaneous. Stephen Kern describes how national and, later, international systems of keeping time, along with the telephone and wireless telegraph, helped forge temporal relations between distant geographic locales. Because standard time set the same hour for large areas of the country and because the hours of even remote regions of the nation differed by precisely one, two, or three hours, the new standard combined with instantaneous communications to encourage Americans to think of interconnections in time and space across the continent and the globe. Kern explains how technological changes led to a conceptual shift, which allowed people to see the present as a multiplicity of simultaneous events rather than as a collection of localized occurrences.[46] In contrast to local times, standard times always stood in a meaningful relationship to one another. Gone were the days when a particular time in Washington, D.C., had no discernible relation to the hour in San Francisco.

The benefits to commerce and travel that standard time afforded were tempered by widespread public concern over the abandonment of local time. More than an unease with change, such concern mirrored a political struggle over authority and national character. As the historian Michael O'Malley notes, many Americans, having interpreted local time as natural and God-given, expressing the storied agrarian and individualistic ideals on which they imagined the nation had been founded, resisted efforts to impose standard time, which they saw affirming commerce, trade, and unity.[47] A popular understanding of "artificial" times as serving nothing so much as corporate interests also fostered concern with standard time. The railroads' push to replace natural, solar time struck an anxious chord with workers who had long resisted the imposition of "factory" time by industrialists. Instituted to do away with seasonal variations in the factory day, factory times had been used since the 1830s, often unscrupulously, to wrest ever-longer hours from laborers. Without recourse to the sun as an arbiter of time or to accurate pocket watches, which they could not afford during much of the nineteenth century, industrial workers subjected to factory time were vulnerable to the rigging of clocks to hide a lengthened workday.[48] While the transformation of America into an urban, industrial, and more culturally homogeneous nation had proceeded incrementally, the rail-

roads' dramatic switch to standard time at noon on November 18, 1883, crystallized Americans' fears of various national transformations.

In O'Malley's estimation, the hegemony of standard time was partly turned back by the production and viewing practices of early cinema. O'Malley explains that films resisted standardized time in several ways: by playing continuously in nickelodeons, without set starting or ending times; by offering underdeveloped and not necessarily linear narratives; by using special effects that seemed to slow, speed up, or even reverse the flow of time; and, most significant, by employing cinematic techniques that preserved a sense of local time. O'Malley points to Porter's *Life of an American Fireman* as a paradigmatic example of how specific production techniques maintained older conceptions of time.[49] The central action of the film takes place at a burning home, where a camera placed in a second-floor bedroom allows viewers to follow a fireman's exploits in saving a mother and her child. The fireman bursts through the door, smashes out the bedroom window, and carries first the mother and then the child down a ladder that appears at the window (fig. 67) before finally returning to spray the room with a hose. The film then cuts to the exterior of the burning building (fig. 68) and shows the rescue again, this time from the perspective of onlookers in the street: some firemen raise the ladder to the bedroom window as others play a hose against the wall, and the rescuer descends, first with the mother and then the child, to the safety of the street.

A director today would surely cut rapidly from interior to exterior during the rescue, lending narrative and temporal continuity to events occurring inside and outside the house. Having internalized as normal the convention of omniscient narrative, we are puzzled by a film that portrays the rescue as two self-contained incidents whose distinct perspectives and temporal isolation allowed each to preserve its own local time. The understanding of simultaneity inculcated by standard time makes *Life of an American Fireman* look odd today, even though we appreciate how the film's narrative techniques correspond to the real-life experience of complex events. An omniscient and simultaneous picture of the rescue is possible, after all, only through the assembly of discrete local-time pictures gathered from individuals in multiple locations. If one doubts the artificiality of our current cinematic conventions, one need only consider the criticism of early twentieth-century audiences who called those first films employing parallel editing "jerky" before they learned to assemble a narrative from the interposed scenes.[50] Rather than being unified and regularized by a single temporal or authorial vantage, *Life of an American Fireman* displays a model of time that in 1903 was gradually being eclipsed in American culture.[51]

This observation may help explain the appeal of *The Great Train Robbery* as a modern entertainment whose anachronistic representation of time helped combat some of the more unsettling effects of modernity. As a new technology that preserved older, more reassuring, models of time, the film provided audiences with a framework for imagining

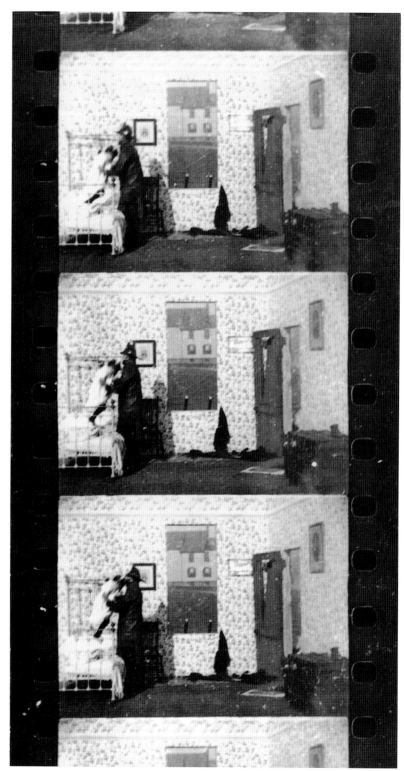

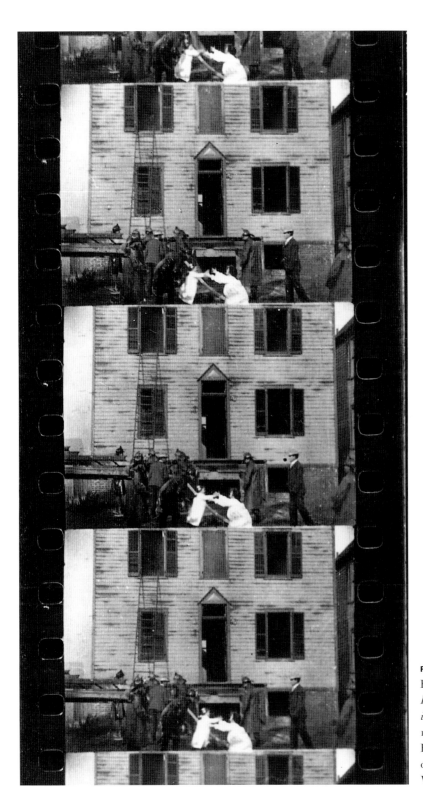

FIGURE 68
Edwin S. Porter,
Life of an American Fireman,
1903. Film still,
Edison. Library
of Congress,
Washington, DC.

emergent technologies, and the future, as benign. There is a certain irony in a film whose plot revolves around a train making use of local time, given the instrumental role of the railroads in supplanting this older convention. As the railroad man William Frederick Allen enthusiastically proclaimed on the eve of the adoption of standard time, "The railroad trains are the great educators and monitors of the people in teaching and maintaining [standard] time."[52] *The Great Train Robbery* does not promote one conception of time over the other but reflects an ambivalence stemming from what may be characterized as cinema's twin instabilities—time and identity.

The producer and film historian Lynne Kirby has explored the ideological and experiential connection between train travel and early cinema, concluding that both embodied perceptual and social instabilities rooted in their technologies. She argues that railroads helped make cinema possible by rationalizing time, thereby increasing the efficiency of labor and expanding the leisure time for viewing, and by promoting efficiencies in transportation that sped the distribution of movies and the travel of patrons to and from the cinema. But more than making cinema a possibility, railroad travel served as a protocinematic experience that helped condition the form and effects of early cinema. As Kirby writes, the railroad provided "early film spectators with a familiar experience and familiar stories, with an established mode of perception that assisted in instituting the new medium in constituting its public and its subjects." She notes that experiences once unique to train travel—of a seated, immobile spectator moved rapidly through time and space; of someone who could be lulled to sleep but also shocked awake; and of heterogeneous bodies closely packed into a confined space where normal social relations frequently broke down—provided a model for creating the cinematic experience. Because train travel provided the conceptual framework for the experience and understanding of film, its inherent instabilities were also central to movies. The compression and expansion of time, the simultaneous sense of immobility and mobility, the capacity to be both lulled and shocked, and the fluidity of social relations all came to characterize the movie experience. Seeing early train films as discursive sites for directors and audiences to negotiate various social identities, Kirby explores how films' tendency to destabilize social relations was both exploited and controlled for the production of gender relations.[53]

The railroad and cinema worked on several levels to destabilize social relations that affected gender dynamics, by opening up socially acceptable public spaces where white women came into contact with crowds of diverse people and by increasing women's economic opportunities. Railroads created new spaces, in trains and stations, where white women circulated with men and women from all social classes, easing their movement from rural communities to urban settings, with their greater economic opportunities; and cinema allowed women to appear onscreen, in the physical space of the theater, and made available to them new jobs in the movie industry. White women began, with the aid of the new technologies, to renegotiate their relation to the masculine world.

The effects of the new technologies on racial relations, however, appear more limited, as blacks experienced trains and cinema in largely segregated environments. The railroads afforded opportunities to blacks for increased travel and menial employment, and the cinema offered entertainment, but unyielding laws and customs continued to restrict contact between the races. The radical potential of the new technologies to increase black-white interactions outside normal hierarchies was defused by the reality of a continuing racial divide. Blacks and whites not only were segregated in theaters but also were kept apart in cinematic depictions. African Americans appeared only rarely in early cinema and were portrayed even less often in those early movies that feature trains.[54] Enforcing in films a version of the Supreme Court's infamous *Plessy v. Ferguson* decision of 1896, which declared it constitutional for states to restrict black riders to separate accommodations, train films relegated characters of color to separate and largely undepicted trains that were doubtless not equal. The symbolic investment of whites in trains was such that they apparently could not tolerate either a literal or a figurative seat for blacks with whites.

The protectiveness with which European-Americans regarded both actual and virtual trains is not surprising, given that during much of the nineteenth century and the early twentieth century perhaps no American material object was more securely tied to whites. The American studies scholar Leo Marx famously explored trains as *the* symbol of American progress and civilization.[55] Implicit in his analysis is the popular conception of civilization by European-Americans as unequivocally white. The historian Gail Bederman has more recently teased out the ways in which turn-of-the-century conceptions of civilization were intertwined with norms of gender and race. Although she is sensitive to distinct groups' recourse to the discourse of civilization to advance their often competing agendas, Bederman contends that most middle- and leisure-class European-Americans saw civilization as the unique purview of whites. Whereas other races could theoretically reach the civilized stage of human development, whites during this period remained convinced that only Anglo-Saxons had attained this pinnacle of racial progress. As she notes, "In colloquial usage, the terms 'civilization' and the 'white man' were almost interchangeable."[56]

Nineteenth-century depictions of trains could scarcely be more obvious in their racial investment, for popular prints and engravings, commercial bank notes, posters, industrial photographs, and high-art oil paintings, along with films, routinely depicted steam engines advancing white civilization while marginalizing racial minorities. Fanny Frances Palmer's lithograph *Across the Continent: "Westward the Course of Empire Takes Its Way"* (1868; fig. 69), reproduced by Currier & Ives, illustrates how train images were coded. The train, packed with passengers, steams from a crowded foreground space toward the flat, open plain, past a rustic village on the left and a pair of mounted Indians on the right. Neat block lettering along the upper portion of the train's cars announces

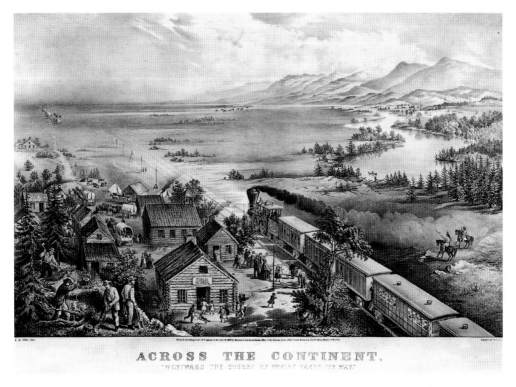

ACROSS THE CONTINENT.

FIGURE 69 Fanny Frances Palmer, *Across the Continent: "Westward the Course of Empire Takes Its Way,"* 1868. Hand-colored lithograph on paper, Currier & Ives, 44.1 × 67.8 cm. Prints and Photographs Division, Library of Congress, Washington, DC.

its westward path, from "New York to San Francisco." We catch the train in midroute, as it passes a tiny village perched at the edge of the frontier, which extols in miniature the civilizing influences that the train brings west. The community boasts a "public school," a church, tidy homes, and industrious inhabitants who clear land to the left and lay additional tracks to the right. The train sends forth a belch of drifting black smoke that is but seconds away from swallowing the scene's only nonwhite presence as it propels its East Coast passengers toward the west.[57]

Despite the racial inscription of trains and their symbolic and physical containment of African American figures, train imagery expressed a unique strain of racial instability. Unlike temporal or gender instability, however, which was created by the clash of older and newer paradigms that trains highlighted, racial instability stemmed from contradictions in whiteness itself that trains made evident. Since blacks' segregation on trains

helped preserve long-standing racial hierarchies—in contrast with women's integration, which destabilized gender norms—train imagery from the early twentieth century drew attention less to black-white or even red-white relations than to relations between whites. Deprived by cinema's segregated policies of an other with which to consolidate white identity, European-American riders and viewers used the logic of race to fashion a hierarchy in their own racial group. Since trains and cinema were culturally overdetermined as sites of imbalance, they served as convenient locations at which Americans worked through racial contradictions that could not otherwise find resolution.[58] Much as the context surrounding vaudeville combined with racial paradigms to structure audiences' experience of *New York Fire Department* and *Palmer Cox's Brownies*, so they conditioned audiences' readings of *The Great Train Robbery*. Although the racial work of cinema only indirectly altered the racial condition of African Americans in U.S. society, it played a significant role in transforming how the borders of whiteness were policed.

Some of the most financially successful early films depicting trains center on robbery, derailment, or high-speed crashes. One can instantly appreciate the appeal of a film such as Edison's *Train Wreckers* (1905), which portrays the heroic efforts of a woman and her lover to save a train from derailment, but the popularity of *The Effects of a Trolley Car Collision* (Lubin, 1903), *Rounding Up of the "Yeggmen"* (Edison, 1904), *Railroad Smashup* (Edison, 1904; fig. 70), *The Wreckers of the Limited Express* (Lubin, 1906), and *Head-On Collision at Brighton Beach Race Track, July 4th, 1906* (Miles Brothers, 1906), all with graphic enactments of railway disasters, is harder to explain.[59] Intuitively, one might expect European-Americans' cultural investment in trains to have precluded audiences' enjoyment of either their robbery or their destruction. Far from destabilizing the power of whiteness, train disasters actually helped European-Americans apply rigid and comforting racial paradigms to cultural texts that appeared superficially removed from issues of race.

In the framework I have developed, readers are unlikely to be shocked by my suggestion that *The Great Train Robbery* codes the bandits as deviant and then reads them through a lens typically reserved for nonwhites. Claiming that they were viewed through a discourse that policed nonwhites is not the same as concluding that European-American audiences would consciously have described them as Native American or African American characters (though it is revealing to note that one of the child robbers is African American in Porter's *Little Train Robbery*, where the cultural stakes of mixing white and black and of plundering a miniature train for a haul of candy were much lower). The bandits of *The Great Train Robbery* were constructed as imperfect whites based on two factors: their character attributes and their disruption of the progress of the quintessentially white train. The bandits demonstrate disrespect for rules of fair play and an inability to regulate their impulses—traits that European-Americans associated with nonwhites. During the robbery, the bandits shoot an unarmed man in the back, an act

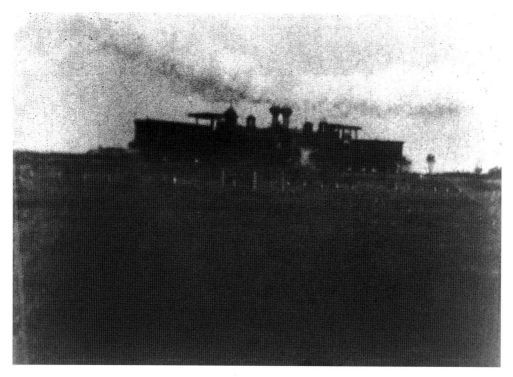

FIGURE 70 *Railroad Smashup,* 1904. Film still, Edison. Motion Picture Division, Library of Congress, Washington, DC.

that would have been seen as barbarous and one that jibed with a dominant strain of Indian identity in the popular imagination of European-Americans.[60] In the movie's final scene, the posse is able to surround and kill them because they cannot delay gratification, taking inventory of their haul before the danger posed by the posse had passed. The film suggests that the bandits' demise is linked to their failure to act like proper whites, given that the delay of gratification and the self-regulation of one's desires were primary attributes of whiteness. But the era's visual and literary construction of those who interfered with the progress of trains sealed their racial identification. Theodor Kaufmann's *Westward the Star of Empire* (1867; fig. 71) shows how train wreckers were coded in the wake of a series of Sioux and Cheyenne attacks on railroads during the late 1860s. The image contrasts the advancing light of white civilization on the distant train and the dark foreground presence who would see it derailed.

Thomas Nast's *Harper's Weekly* caricature of the radical reformer Wendell Phillips suggests how readily European-Americans projected racial otherness onto whites (1869;

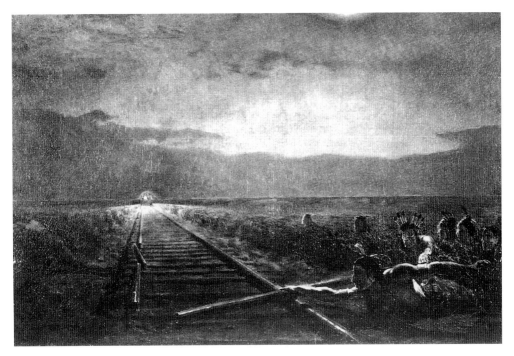

FIGURE 71 Theodor Kaufmann, *Westward the Star of Empire*, 1867. Oil on canvas, 88.8 × 138.8 cm. St. Louis Mercantile Library Association, University of Missouri, St. Louis.

fig. 72). Disgusted with Phillips's support for native rights, especially his endorsement of contemporary Indian efforts to rip up tracks to prevent the completion of the transcontinental railroad, Nast illustrates the reformer as an Indian who himself threatens the progress of a train. Dressed in a buckskin shirt and pants, with a single feather in his hair, Phillips puts his ear to a rail to gauge the approach of a train as he grips a dagger menacingly in his right hand. The proximity of the train that rounds a bend on the left indicates that Nast interpreted Phillips as a significant threat to neither the railroad nor, by extension, white civilization. Viewers appreciate that the locomotive's cowcatcher will soon throw Phillips from the track. Still, we see that his aberrant beliefs allowed *Harper's Weekly* readers to humorously identify Indian supporters with Indians.

In the late 1860s, when the caricature was produced, it was not yet possible for European-Americans whose behavior contradicted their supposed racial character to become nonwhite in any meaningful sense. Nast's print dressed Phillips as an Indian to make fun of his public pronouncements and to suggest his impotence by linking him with what was popularly understood as a "dying race." When *The Great Train Robbery*

"ALL HAIL AND FAREWELL TO THE PACIFIC RAILROAD."
WENDELL PHILLIPS.

FIGURE 72
Thomas Nast,
*All Hail
and Farewell
to the Pacific
Railroad*,
July 10, 1869.
Lithograph on
paper, *Harper's
Weekly*, 15 ×
9.9 cm. Library
of Congress,
Washington, DC.

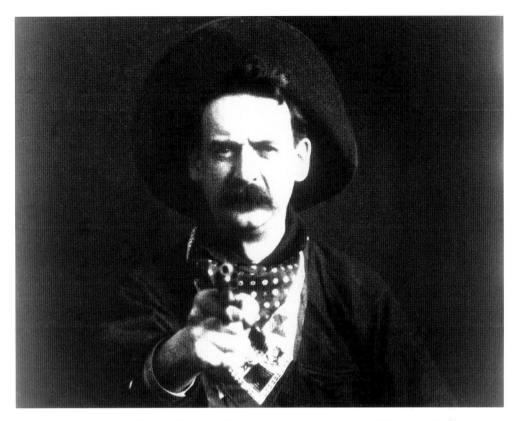

FIGURE 73 Edwin S. Porter, *The Great Train Robbery*, scene 14, 1903. Film still, Edison. Motion Picture Division, Library of Congress, Washington, DC.

was released in 1903, emergent shifts in racial definition presented new consequences to European-Americans who acted or exhibited traits that were coded nonwhite. Recall Williamson's argument that by the turn of the century behavior considered nonwhite could strip a European-American of her whiteness. In contrast to Phillips, whose whiteness was unaffected by his political stance, the robbers were marked by their performance as aberrant whites and their claims to whiteness made tenuous.

Film historians have long remarked that the filming and exhibition of *The Great Train Robbery* heightened viewers' excitement by encouraging them to experience the robbery as if they were among the train's passengers. The starting/ending shot of the gang leader firing toward viewers encourages this reading (fig. 73), as does the film's frequent exhibition after popular panoramic train and trolley films. Panoramic views, typically shot from either the front or the rear of trains, were among the most popular early motion

pictures, replicating for viewers the visual experience of an actual trip through a famous or majestic landscape. We know that *The Great Train Robbery* was also shown to audiences of Hale's Tour, a specialized movie venue franchised by George C. Hale, which seated movie audiences in a simulated railcar and allowed them to watch films of panoramas, famous tourist sites, and trains through the windows. In some cases, the simulated railcar was even rocked to induce in viewers the physical sensations of a passenger en route.[61]

Working-class and immigrant audiences were doubtless encouraged by the film's exhibition venues and narrative to align themselves more closely with the passengers than with the bandits. Such an alliance reassured immigrants by suggesting their ideological affinity with riders who exemplified European-American racial and economic ideals, at the same time that it coded their distance from robbers who embodied deviance from those norms. The movie presented in microcosm the sliding scale of whiteness that was evident each night in vaudeville theaters, where one might view train passengers who epitomize whiteness, firemen who advance toward it, robbers who retreat from theirs, and African Americans who mark its total absence. Given the emphasis in many films on self-transformation, an evening of turn-of-the-century film surely offered a stark lesson in the benefits and drawbacks of contemporary racial choices. From our modern vantage, the redefinition of race at the turn of the twentieth century seems fitting. Support for the dominant tenets of whiteness was now a more important determinant of racial belonging than phenotypical traits. Even without an obvious minority presence, films spoke clearly to viewers about the hierarchy of racial belonging.

Recent scholarship has concluded that working-class and immigrant viewers formed a significant percentage of the audience for cinema only after 1905, with the ascendancy of nickelodeons. Audiences had previously been whiter and more middle-class, for few nonwhites or working-class whites then enjoyed the leisure time and disposable income vaudeville theaters required.[62] The performative model of identity articulated in *The Great Train Robbery* that may well have reassured immigrant audiences is likely to have caused more established whites some concern. After all, the film illustrates that racial identity is a property that can be either lost or gained. Cultural products like films that celebrated the ability of various groups to become white acknowledged, at least tangentially, the possibility of whites' becoming black, though the threat of losing one's whiteness would not have resonated equally for all European-Americans. Rich white heterosexual Christian males were unlikely to lose their racial identity, whatever their actions. Deviance might gain them social disfavor or even, in extreme circumstances, land them in jail, but it could alter their race in little more than theory. Performance was much more an issue for those with marginal identities than for those whose religion, class, gender, political outlook, and sexuality empowered them.

Performance offered a limited range of practical dangers or possibilities for those most securely raced as white, and also for those firmly categorized as black. A dark-skinned

black in late-1890s America who acted white might be killed but would not, by his actions, become white. For those African Americans with the physiognomic traits to pass as white, performance was transformative in the sense that it might make one white. Although it undeniably allowed a select group of blacks to enjoy greater freedom, the performance forced them to abandon black culture and take on a prescriptive white identity. Performance, far from making a person into anything desired, provided the option of being white or not. The shift toward social definitions of race had the collateral result of constricting the roles most blacks were permitted to assume, because taking on any "white" traits was far more threatening to European-Americans once the links between color and race were loosened than when racial identity was conveniently determined by one's skin color. Just as the segregation and political repression of blacks became more urgent to whites *after* abolition, so the circumscription of black roles became more important to whites after physiognomy and race were theoretically decoupled. For all but a select group of liminal Americans, the possibility of assuming a new racial identity held greater symbolic than practical weight. This point is driven home by the weakening of links between European-American audience members and passengers over the course of *The Great Train Robbery*, with white viewers ultimately aligning with the "black" bandits themselves.

Consider the movie's most spectacular and disturbing scenes—those that depict violence. Scene 1, in which the telegraph operator is forced to send a false message to the locomotive's engineer before being knocked out and tied, and scene 3, the robbery and murder of the mail clerk, are set in rectangular, stagelike spaces that position audience members in front of an invisible fourth wall (figs. 74, 75). Each scene, following in the tradition of vaudeville, presents a spare set with action that takes place near the picture plane—we watch events unfold in a shallow space with actors who confine their movements to a horizontal axis. Because the settings seem so obviously self-contained, these scenes offer no *visual* cues to encourage audience identification with either the bandits or their victims. Audiences may well sympathize with depicted characters based on narrative development, the exhibition venue, and their own subject positions, but the arrangement of the sets, placement of actors, and handling of camera shots do nothing to advance such identification. The neutral framing of violence in the film's first scenes turns out to be a transitional aesthetic—marking the shift from stage to filmic performance—replaced in subsequent shots by a radically different vantage that aligns viewers visually with the criminals of the film.

In scene 4, when two bandits take over control of the locomotive and throw the fireman from the train, the camera, placed on the tender, aims forward (fig. 76). From this position we see the robbers advance, with their backs to us, toward the engineer and his fireman. The significant narrative events now progress from front to back, rather than play out along the width of the set with spectators located in the symbolic space from

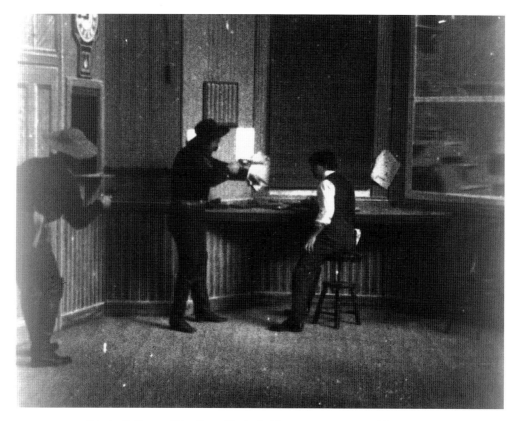

FIGURE 74 Edwin S. Porter, *The Great Train Robbery*, scene 1, 1903. Film still, Edison. Motion Picture Division, Library of Congress, Washington, DC.

which the bad guys entered the shot. Every scene that follows in which a violent confrontation occurs—scene 6, with the shooting of the escaping passenger; scene 12, showing the exchange of gunfire between posse members and gang (fig. 77); and scene 13, illustrating the ultimate shoot-out to the death (fig. 78)—replicates the visual setup of scene 4 and symbolically aligns movie audiences with the bandits through shared space and joint confrontation of railway men, passengers, and posse.

This effect is particularly dramatic in the final shoot-out, where the posse appears to surround both the gang and the movie audience. When the shooting begins, we find ourselves in the posse's direct line of fire. As with Winslow Homer's nearly contemporaneous painting *Right and Left* (1909; fig. 79), spectators enter the scene from an unusual viewing angle, which aligns them with the victims of a shooting who would ordinarily

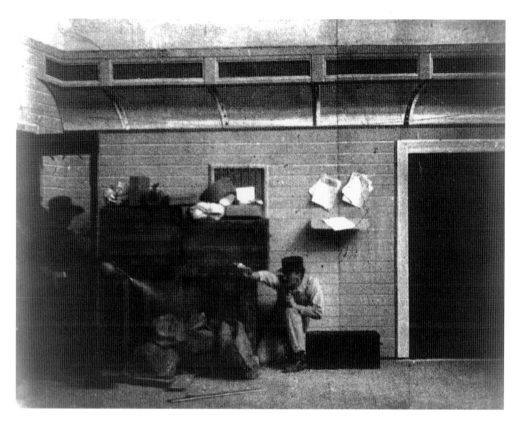

FIGURE 75 Edwin S. Porter, *The Great Train Robbery*, scene 3, 1903. Film still, Edison. Motion Picture Division, Library of Congress, Washington, DC.

not arouse the sympathy of period audiences. In Homer's image, we glimpse the tiny hunter in a distant boat as, rising with a wave, he peeks over a swell to release a double-barreled shotgun blast at a pair of goldeneye ducks. With the red muzzle flash and smoke puff of the weapon still visible, the birds contort grotesquely as they are pierced by buckshot that races into the viewer's space. If film historians are correct in claiming that the movable fourteenth scene of a bandit shooting in our direction encourages us to feel like victimized passengers, how can the final battle, which finds us in the line of the posse's fire, not cast us as predacious bandits?[63]

The Great Train Robbery may forge a strong visual link between viewers and robbers, but the evidence for reading such a link as racial is circumstantial. It rests primarily on readers' willingness to recognize the predisposition of turn-of-the-century viewers to map

FIGURE 76 Edwin S. Porter, *The Great Train Robbery*, scene 4, 1903. Film still, Edison. Motion Picture Division, Library of Congress, Washington, DC.

racialized meanings onto texts that suggested the logic of race. Moviegoers were aligned with a nonwhite presence through their visual identification with outlaws who, while apparently of European extraction, deviated from accepted racial norms. But this racial link is given added weight through reference to another prominent representation of a train heist, namely, Paul Leicester Ford's popular novel *The Great K. & A. Train-Robbery*. Serialized in *Lippincott's Monthly Magazine* in 1896 and published in book form in 1897 (and made into a feature film by Lewis Seiler and the Fox Film Corporation in 1921), it recounts the frontier adventures of Dick Gordon, a recent Yale graduate and collegiate football player, who is the superintendent of the Kansas and Arizona Railroad.

The novel opens with Gordon assigned to escort the wealthy investor Albert Cullen and his well-heeled party on their western journey to the annual stockholders' meeting

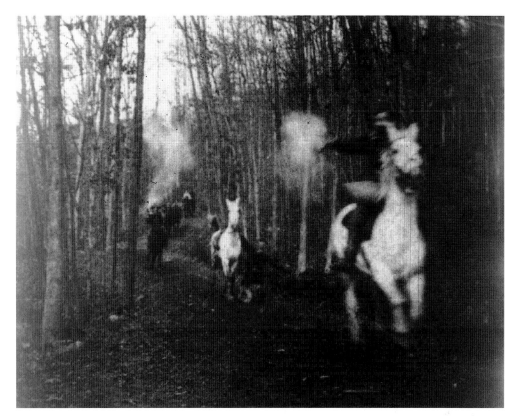

FIGURE 77 Edwin S. Porter, *The Great Train Robbery*, scene 12, 1903. Film still, Edison. Motion Picture Division, Library of Congress, Washington, DC.

of the K. & A. Railroad in Arizona. From the moment the travelers board Gordon's train, robberies are much on their minds. Cullen's daughter Madge peppers Gordon with questions about holdups, expressing on more than one occasion her desire to experience one firsthand.[64] Readers do not wait long for the anticipated robbery but are as surprised as Gordon to discover that the robbery was engineered by Mr. Cullen and his party. Having stolen from the mail car shareholder proxy votes that were destined to bankrupt him, Mr. Cullen conceals them on his daughter's person. Miss Cullen does not merely experience the robbery she so eagerly sought; she experiences it as a bandit.

White privilege ensures that neither Madge Cullen nor any European-American of her party will go to jail for the crime. When the motive for the robbery is laid before him, Gordon nods, "seeing it all as clear as day, and hardly blaming the Cullens for what

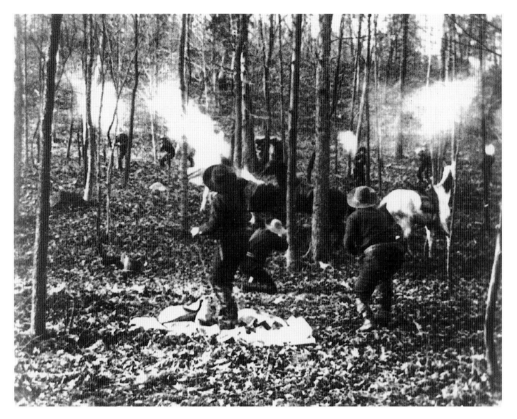

FIGURE 78 Edwin S. Porter, *The Great Train Robbery*, scene 13, 1903. Film still, Edison. Motion Picture Division, Library of Congress, Washington, DC.

they had done; for any one who has had dealings with the G.S. [railroad] is driven to pretty desperate methods to keep from being crushed, and when one is fighting an antagonist that won't regard the law, or rather one that, through control of legislatures and judges, makes the law to suit its needs, the temptation is strong to use the same weapons one's self" (76). Gordon's rationalization of the Cullens' actions and his subsequent efforts to keep the Cullens out of jail and bankruptcy make perfect sense, given his investment in the privilege of whites. The novel opens with Gordon's admission that he "should have got the sack" at Yale "had it not been for [playing] half-back on the team," and it closes with his acknowledgment that his recent promotion to head "one of the largest railroad systems in the world" came about through "pure favoritism," due to Albert Cullen's gratitude for his aid (1, 188).

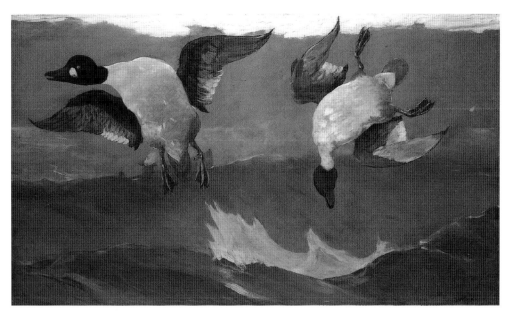

FIGURE 79 Winslow Homer, *Right and Left,* 1909. Oil on canvas, 71.8 × 122.9 cm. National Gallery of Art, Washington, DC. Gift of the Avalon Foundation Image © 2004 Board of Trustees, National Gallery of Art, Washington, DC.

More revealing than Gordon's willingness to readjust his moral compass to the actions of self-evidently white protagonists is Madge Cullen's subtle appreciation for the link between her deviant actions and race. In the novel's most puzzling scene, Gordon describes for Miss Cullen an "angel" with whom he has fallen in love. With a flippancy that seems grossly out of keeping with her character, Miss Cullen takes pleasure in feigning confusion when both she and readers understand that Gordon describes her. Twisting Gordon's words, she asks if he meant "light brown" to describe not her hair but her complexion, wondering if his angel might be "mulatto" (115). Miss Cullen's odd out-of-character joke about racial designation comes soon after her role in the robbery is exposed. Her jest about a "mulatto" identity surely springs from the same anxiety that leads her to feel humiliated by her participation in the heist. Having played a key role in the train's robbery—and in her father's larger plan to thwart the consolidation of a railroad line—she takes on, however briefly, the guise of a racially liminal character. Miss Cullen's transitory blackness is perfectly in keeping with the literary and legal characterization of European-Americans who disrupted or robbed late-century trains. At the end of the century, white strikers who sought to cut off rail traffic were described

as Indians who threatened to "scalp" locomotive engineers, and train robbers were "dark men" or those willing to shoot their victims "with the unerring aim of an Indian."[65]

In encouraging European-Americans to identify with deviant characters who disrupt the progress of trains, both novel and film allowed audiences to slum without requiring them to escape symbolically or physically to the company of African Americans in the clubs of Harlem, to that of Native Americans in the pueblos of New Mexico, or to that of Asian Americans in the opium dens of San Francisco. Whites derived much the same psychic reward from experiencing the exploits of train robbers and from enjoying the exotic lives of uncivilized races. They could experience vicariously seemingly *extra*white activities proscribed in proper white society, just as they could enjoy entertainments performed by an other against whom their identity as white was defined. Rather than expand or dismantle the conception of whiteness, the nonwhite activities that whites enjoyed in the novel and film helped maintain a turn-of-the-century racial system in which whiteness was paramount. While the apparent transgressions of the texts were made more titillating by the shift toward performative identity, they posed no real threat to the whiteness of middle-class Christian European-American audiences. If Miss Cullen could retain her racial identification even after robbing a train, European-American viewers of *The Great Train Robbery* had little to fear from the comparatively minor infraction of identifying with the robbers on-screen. Even with no racial minorities on the scene, novel and film facilitate what James Baldwin memorably described as the white need to visit black America, which "he now watches wistfully from the heights of his lonely power and, armed with spiritual traveller's checks, visits surreptitiously after dark."[66]

THE TRIUMPH OF RACIALIZED THOUGHT

Race emerged in early modern Europe to mark an imagined divide between Christian Europeans and the Jewish and African populations in their midst. It ensured that peoples who were religiously, ideologically, or geographically removed from Christian European norms were defined as other based on purported differences in physiognomy and then subjected to a series of racially discriminatory attitudes and policies. In its first few centuries of life, racial thought remained tied inextricably to the presence of nonwhites. By the later nineteenth century, however, the exclusive links between race and nonwhites had been conceptually dissolved, allowing European-Americans to think "racially" without needing a nonwhite presence to activate such patterns of thought.

As we have seen in some detail, racial values helped guide the understanding of a diverse array of subjects—ranging from natural conservation to armed robbery. It was not that European-Americans consciously perceived race as an issue in the texts I have considered but that they consistently *responded* to them in ways that betrayed their investment in whiteness. Having internalized discourses that supported their self-interest as whites, European-Americans unselfconsciously impressed their values onto the visual products around them. Thus images silently reinforced ideological systems that benefited whites, disadvantaged nonwhites, ensured that certain deviant and marginal European-Americans suffered materially for their outsider status, and prompted those seeking acceptance as white to trade elements of their human nature and ethnic identities for a privileged race.

The decoupling of race from the presence of nonwhites allowed the logic of race to seep into all spheres of American culture and newer, more insidious discrimination to take root. People of color today continue to experience race-based discrimination that hinges on perceptions of their physiognomic difference, but they also confront graver threats posed by the institutionalization of whiteness. As the racial values of European-Americans were embedded into society's dominant discourses and structures, nonwhites found themselves increasingly out of step with America's most entrenched values and institutions. With "normative" standards of thought and action those espoused by whites, people of color were always marked as deviant. Educational, corporate, judicial, and governmental systems that increasingly expressed the values of whiteness necessarily failed to accommodate the interests of nonwhites. In the past minorities suffered only to the extent that individuals judged them as other and then imposed discriminatory penalties; now systemic inequities were hardwired into the nation's core institutions. The racial values of Euro-America, once expressed primarily in the violent acts of individuals and groups, now found outlet in anonymous structures perfectly tailored to meet the imagined needs and desires of whites.

Americans invested in whiteness today frequently point to the lessening of individual bias, the declining significance attached to physiology, and the waning of legislated discrimination, as well as to the rise of nonwhite participation in business, politics, entertainment, and sports and to the entrenchment of affirmative action programs as proof that minorities who fall behind European-Americans are culturally (or even biologically) predisposed to fail. Because most European-Americans do not see the biases of whiteness, they read nonwhite failure reassuringly, as a product of minority deficiencies, and not as a predictable result of the clash between unyielding white structures and the values of nonwhites. Yet neither the decline in racial bias expressed by individual European-Americans nor the rise of successful people of color means that racial hierarchies have become obsolete. Instead, it testifies to the triumph of a racialized system wherein such individual attitudes and successes are merely incidental to advancing the interests of whites. Nonwhites today fail and succeed largely in white terms. Although that is arguably an advance over an era when physiognomy determined success, it is hardly the outcome we would expect from a system that is racially just.

NOTES

INTRODUCTION

1 For a devastatingly comprehensive analysis of secondary source material outlining the impact of whiteness and racism on people of color, see George Lipsitz, *The Possessive Investment in Whiteness: How White People Profit from Identity Politics* (Philadelphia: Temple University Press, 1998), 1–23. Also see David Cole, *No Equal Justice: Race and Class in the American Criminal Justice System* (New York: New Press, 1999); Ian F. Haney López, *White by Law: The Legal Construction of Race* (New York: New York University Press, 1996); Lani Guiner and Gerald Torres, *The Miner's Canary: Enlisting Race, Resisting Power, Transforming Democracy* (Cambridge, MA: Harvard University Press, 2002); Ashley W. Doane and Eduardo Bonilla-Silva, eds., *White Out: The Continuing Significance of Racism* (New York: Routledge, 2003); Eduardo Bonilla-Silva, *Racism without Racists: Color-Blind Racism and the Persistence of Racial Inequality in the United States* (New York: Rowman and Littlefield, 2003). While the costs of whiteness are of course disproportionately borne by nonwhite peoples, this book will also consider its negative impact on whites. For an early discussion of such costs for European-Americans, see W. E. B. DuBois, *The World and Africa: An Inquiry into the Part Which Africa Has Played in World History* (New York: International Publishers, 1965), 18–21. Also see James Baldwin, *The Fire Next Time* (New York: Vintage Books, 1991); Joe R. Feagin, Hernán Vera, and Pinar Batur, *White Racism: The Basics*, 2nd ed. (New York: Routledge, 2001).

2 For a useful introduction to the centrality of race to American culture, see Michael Omi and Howard Winant, *Racial Formation in the United States: From the 1960s to the 1990s* (New York: Routledge, 1994); for an argument on how our modern concept of culture is itself an exten-

sion of racial thought, see Walter Benn Michaels, *Our America: Nativism, Modernism, and Pluralism* (Durham, NC: Duke University Press, 1995), 135–42. For the pioneering work on whiteness to outline dangers inherent in seeing race at issue only in those images depicting nonwhites, see Richard Dyer, *White* (New York: Routledge, 1997), 13.

3 For the political dangers springing from whites' associating their feelings of oppression with the discrimination experienced by racial minorities, see Trina Grillo and Stephanie M. Wildman, "Obscuring the Importance of Race: The Implications of Making Comparisons between Racism and Sexism (or Other Isms)," in *Critical White Studies: Looking behind the Mirror*, ed. Richard Delgado and Jean Stefancic (Philadelphia: Temple University Press, 1997), 619–26.

4 For discussions on the historical "whiteness" of Catholics and Jews, see Noel Ignatiev, *How the Irish Became White* (New York: Routledge, 1995); Thomas A. Guglielmo, *White on Arrival: Italians, Race, Color, and Power in Chicago, 1890–1945* (New York: Oxford University Press, 2003); James Baldwin, "Negroes Are Anti-Semitic Because They're Anti-White," in *The Price of the Ticket: Collected Nonfiction, 1948–1985* (New York: St. Martin's Press, 1985), 425–33; Karen Brodkin, *How Jews Became White Folks and What That Says about Race in America* (New Brunswick, NJ: Rutgers University Press, 1998); Sarah Banet-Weiser, *The Most Beautiful Girl in the World: Beauty Pageants and National Identity* (Berkeley and Los Angeles: University of California Press, 1999), 123–80; Matthew Frye Jacobson, *Whiteness of a Different Color: European Immigrants and the Alchemy of Race* (Cambridge, MA: Harvard University Press, 1998); Sander Gilman, *The Jew's Body* (New York: Routledge, 1991).

5 Conscious that some readers may interpret the inclusion of biographical details in a scholarly study as tangential or even self-indulgent, I am nonetheless convinced of the need to acknowledge my subject position as someone who enjoys unearned benefits. This book would surely have taken another form had I been born to African American parents, so it seems prudent and academically honest to let readers consider my subject position as they evaluate the ideological tenor of my project. For politically astute reflections on an author's whiteness, see Jane Lazarre, *Beyond the Whiteness of Whiteness: Memoir of a White Mother of Black Sons* (Durham, NC: Duke University Press, 1996); Maurice Berger, *White Lies: Race and the Myths of Whiteness* (New York: Farrar, Straus and Giroux, 1999); and the introductory chapters to David Roediger, *The Wages of Whiteness: Race and the Making of the American Working Class* (New York: Verso, 1991), 3–17; Dyer, *White*, 1–18.

6 Michael Rogin makes a similar point throughout his tightly argued *Blackface, White Noise: Jewish Immigrants in the Hollywood Melting Pot* (Berkeley and London: University of California Press, 1996).

7 Eric Lott, *Love and Theft: Blackface Minstrelsy and the American Working Class* (New York: Oxford University Press, 1993), 4, 8; Rogin *Blackface, White Noise*, 27–30. See also Roediger, *Wages of Whiteness;* and Alexander Saxton, *The Rise and Fall of the White Republic: Class Politics and Mass Culture in Nineteenth-Century America* (New York: Verso, 1990).

8 bell hooks, *Killing Rage: Ending Racism* (New York: Henry Holt, 1995), 188.

9 While virtually all whiteness studies interpret the construct as an effect, a series of traits, and an entity, studies tend to emphasize one of the three elements over the other two. For a range of approaches to defining and studying whiteness, see the essays in Birgit Brander Rasmussen, Eric Klinenberg, Irene J. Nexica, and Matt Wray, eds., *The Making and Unmaking of Whiteness* (Durham, NC: Duke University Press, 2001); Mike Hill, ed., *Whiteness: A Critical Reader* (New York: New York University Press, 1997); Delgado and Stefancic, *Critical White Studies;* Richard Delgado and Jean Stefancic, eds., *Critical Race Theory: The Cutting Edge* (Philadelphia: Temple University Press, 2000); and Michael S. Kimmel and Abby L. Ferber, eds., *Privilege: A Reader* (Boulder, CO: Westview Press, 2003).

10 Some of the most frequently quoted scientific studies questioning a genetic basis for race include Alexander Alland, *Human Diversity* (New York: Columbia University Press, 1971); Richard C. Lewontin, "The Apportionment of Human Diversity," *Evolutionary Biology* 25 (1972): 276–80; B. D. H. Latter, "Genetic Differences within and between Populations of the Major Human Subgroups," *American Naturalist* 116:2 (1980): 220–37; M. Nei and A. Roychoudhury, "Genetic Relationship and Evolution of the Human Races," *Evolutionary Biology* 14 (1983): 1–59; Guido Barbujani, Arianna Magagni, and Eric Minch, "An Apportionment of Human DNA Diversity," *Proceedings of the National Academy of Sciences of the United States of America* 94 (April 29, 1997): 4516–19.

11 Baldwin, *Fire Next Time,* 104.

12 John Boswell has argued that debates on the origin of sexuality have long revolved around a social constructivist/biological determinist axis, with the biological determinist position being a straw man created by self-proclaimed social constructivists. In John Boswell, "Categories, Experience and Sexuality," in *Forms of Desire: Sexual Orientation and the Social Constructionist Controversy,* ed. Edward Stein (New York: Routledge, 1992), 133–73. A similar argument may be made for racial debates, given the paucity of academics today who argue for the biological reality of race.

13 Noah A. Rosenberg et al., "Genetic Structure of Human Populations," *Science* 298 (December 2002): 2381–85. Given the inconsistent definitions of race in Western countries, those test subjects determined to be of "African" or "Eurasian" heritage did not necessarily occupy the socially produced racial designation their societies assigned them.

14 Richard J. Hernstein and Charles Murray, *The Bell Curve: Intelligence and Class Structure in American Life* (New York: Simon and Schuster, 1996).

15 Steven Pinker, *The Blank Slate: The Modern Denial of Human Nature* (New York: Viking, 2002), 142–49.

16 Ibid., 145.

17 Ignatiev, *How the Irish Became White;* Brodkin, *How Jews Became White Folks;* Banet-Weiser, *The Most Beautiful Girl in the World;* Jacobson, *Whiteness of a Different Color;* Gilman, *The Jew's Body.*

18 López, *White by Law.* Although the United States dropped racial criteria for citizenship in 1952, it did not abandon its byzantine immigration quota systems, criteria for asylum, work visa requirements, and policies for registering aliens, all of which tend to discourage nonwhite immigration.

CHAPTER 1

1 Alfred Jones, "A Sketch of the Life and Character of William S. Mount," *American Whig Review* 14:80 (August 1851): 125.

2 As the legal theorist Barbara Flagg has articulated, whites rarely think of race until they are confronted with a nonwhite presence, and even then are led to think less about their own whiteness than about the blackness or "otherness" of nonwhites. It is not that whites are blind to whiteness, as some scholars of race have claimed, for few groups are as conscious of the racial identities of those around them; rather, whites are blind to the significance of their racial designation (unless confronted with a nonwhite presence) and to the cultural work that whiteness performs for them each day. Barbara J. Flagg, "The Transparency Phenomenon, Race-Neutral Decision-making, and Discriminatory Intent," in *Critical White Studies: Looking behind the Mirror,* ed. Richard Delgado and Jean Stefancic (Philadelphia: Temple University Press, 1997), 220–21.

3 "The Fine Arts," *Literary World* 3:69 (March 27, 1848): 328; quoted in Elizabeth Johns, "'Boys Will Be Boys': Notes on William Sidney Mount's Visions of Childhood," in *William Sidney Mount: Painter of American Life,* ed. Deborah J. Johnson (New York: New York Federation of Arts, 1998), 14. The theme of white boys shirking their duties was a popular one for Mount, variations of which were requested by a number of patrons. Related commissions include *The Truant Gamblers* or *Undutiful Boys* (1835), and *Boys Hustling Coppers* or *The Disagreeable Surprise* (1843).

4 Despite the attention paid to whiteness by scholars of American literature, history, and film, few art historians have devoted sustained attention to whiteness in nineteenth-century American visual culture. For a sophisticated exception, see Bruce Robertson, "Who's Sitting at the Table? William Sidney Mount's *After Dinner* (1834)," *Yale Journal of Criticism* 11:1 (Spring 1998): 103–7. For an exhibition catalogue addressing whiteness in twentieth-century art, see Tyler Stallings, ed., *Whiteness: A Wayward Construction* (Laguna Beach, CA: Laguna Art Museum and Fellows of Contemporary Art, 2003). For a fascinating collection of essays that illustrate how long African Americans have been thinking and writing about whiteness, see David Roediger, ed., *Black on White: Black Writers on What It Means to Be White* (New York: Schocken Books, 1998); also see Langston Hughes, *The Ways of White Folks* (New York: Vintage Books, 1990), first published in 1933.

5 For the foundational art historical study, see Ernst Gombrich, *Art and Illusion: A Study of the Psychology of Pictorial Representation* (New York: Pantheon Books, 1961); for more recent analyses, see Jonathan Crary, *Techniques of the Observer: On Vision and Modernity in the Nineteenth Century* (Cambridge, MA: MIT Press, 1990), and Geoffrey Batchen, *Burning with De-*

sire: The Conception of Photography (Cambridge, MA: MIT Press, 1997); for a scientific study, see Dale Purvis and R. Beau Lotto, *Why We See What We Do: An Empirical Theory of Vision* (Sunderland, MA: Sinauer Associates, 2003).

6 Wen C. Fong and James C. Y. Watt, *Possessing the Past: Treasures from the National Palace Museum, Taipei* (New York: Abrams, 1996), 125–27.

7 Philip Fisher, *Hard Facts: Setting and Form in the American Novel* (New York: Oxford University Press, 1985).

8 For a contemporary reading of the work as a statement on environmental degradation, see Amy Pastan, *Young America: Treasures from the Smithsonian American Art Museum* (New York: Watson-Guptill, 2000), 70.

9 Nicolai Cikovsky Jr., "George Inness and the Hudson River School: *The Lackwanna Valley*," *American Art* 2:2 (Fall 1970): 36–57.

10 John C. Van Dyke, *American Painting and Its Tradition* (New York: Scribner's Sons, 1919), 84–86.

11 Joseph B. Hudson Jr., "Banks, Politics, Hard Cider, and Paint: The Political Origins of William Sidney Mount's *Cider Making*," *Metropolitan Museum Journal* 10 (1975): 107–18; Elizabeth Johns, *American Genre Painting: The Politics of Everyday Life* (New Haven, CT: Yale University Press, 1991), 33–38; see also Johnson, *William Sidney Mount*.

12 The basic example cited here illustrates what Michel Foucault termed the disciplinary procedure of ordering discourse. In his description of discourse, Foucault notes that its form is conditioned by internal limits (such as disciplinary procedures), by external limits that operate through various processes of exclusion, and by procedures governing the conditions of communication. Taken together, these constraints form a web of protocols that conditions what gets said. For more on Foucault's analysis of discourse, see "The Discourse on Language," in *The Archaeology of Knowledge and the Discourse on Language* (New York: Pantheon Books, 1972), 215–37.

13 Charles Colbert, "*Fair Exchange, No Robbery:* William Sidney Mount's Commentary on Modern Times," *American Art* 8:3–4 (Summer/Fall 1994): 34.

14 "Fine Arts. The Mount Collection," *New York Herald*, April 10, 1871, 7.

15 Ronald Sanders, *Lost Tribes and Promised Lands: The Origins of American Racism* (Boston: Little, Brown, 1978), 95–123; Francis Jennings, *The Invasion of America: Indians, Colonialism, and the Cant of Conquest* (New York: Norton, 1976), 15, 71. Also see Gustav Jahoda, *Images of Savages: Ancient Roots of Modern Prejudice in Western Culture* (New York: Routledge, 1999).

16 John Winthrop, *Winthrop Papers, 1623–1630*, vol. 2 (Boston: Massachusetts Historical Society, 1929), 140–41.

17 Theodore Roosevelt, *The Winning of the West*, vol. 1. (New York: Putnam's, 1889), 90; quoted in Wilcomb E. Washburn, *Red Man's Land/White Man's Law: A Case Study of the Past and*

Present Status of the American Indian (New York: Scribner's, 1971), 38. For additional quotations outlining the belief that whites were entitled to native lands based on period understandings of whites' abilities to make more productive use of them, see Thomas F. Gossett, *Race: The History of an Idea in America* (New York: Oxford University Press, 1997), 228–52; Alexander Saxton, *The Rise and Fall of the White Republic: Class Politics and Mass Culture in Nineteenth-Century America* (New York: Verso, 1996), 36–38.

18 Senator Theodore Frelinghuysen, Senate speech, April 9, 1830, quoted in Francis Paul Prucha, ed., *Documents of United States Indian Policy*, 2nd ed. (Lincoln: University of Nebraska Press, 1990), 49.

19 Cheryl L. Harris, "Whiteness as Property," *Harvard Law Review* 106:8 (June 1993): 1716.

20 "Fine Arts," 7. "Feathertop: A Moralized Legend" was written in 1851 and published serially in February and March 1852 in the *International Monthly Magazine*. It then appeared in the second edition of *Mosses from an Old Manse* (1854). Subsequent references appear in parentheses. *Nathaniel Hawthorne's Tales*, ed. James McIntosh (New York: Norton, 1987).

21 Allegory is by no means a straightforward category to be easily separated out from other kinds of fiction. For a discussion of how all writing is necessarily allegorical, see Sharon Cameron, *The Allegorical Self: Allegories of the Body in Melville and Hawthorne* (Baltimore: Johns Hopkins University Press, 1981). Nonetheless, Hawthorne's penchant for allegory has long been assumed. In reviewing *Mosses from an Old Manse* (the second edition of which contained the "Feathertop" tale), Henry James gave detailed consideration to Hawthorne's "original" stories of "fantasy and allegory." In Henry James Jr., *Hawthorne* (London: Macmillan, 1879), 56; see also 62–63, 114, 117.

22 For more on the complicated nature of appearances in Hawthorne's work, see Aladár Sarbu, *The Reality of Appearances: Vision and Representation in Emerson, Hawthorne, and Melville* (Budapest: Akadémiai Kiadó, 1996).

23 Baum's *Wizard of Oz* delivers much the same message on the scarecrow's identity, even as he allows his straw man to meet a happier end.

24 For a discussion of Mount's investment in the positivistic science of phrenology, see Charles Colbert, *A Message of Perfections: Phrenology and the Fine Arts in America* (Chapel Hill: University of North Carolina Press, 1996), 33–37, 254–57.

25 Johnson, *William Sidney Mount*, 83–86; Colbert, "*Fair Exchange, No Robbery*," 29.

26 In an often-cited article on Locke and American politics, John Dunn argues that scholars had exaggerated the philosopher's influence on the thinking of the founding fathers. See John H. Dunn, "The Politics of Locke in England and America in the Eighteenth Century," in *John Locke: Problems and Perspectives*, ed. John W. Yolton (Cambridge: Cambridge University Press, 1969), 45–80. More recent studies, however, have reestablished the considerable influence of Locke's ideas on the American revolutionaries. See Thomas L. Pangle, *The Spirit of Modern*

Republicanism: The Moral Vision of the Founding Fathers and the Philosophy of Locke (Chicago: University of Chicago Press, 1988); Steven Dworetz, *The Unvarnished Doctrine: Locke, Liberalism, and the American Revolution* (Durham, NC: Duke University Press, 1990); Hans Aarsleff, "Locke's Influence," in *The Cambridge Companion to Locke,* ed. Vere Chappell (Cambridge: Cambridge University Press, 1994), 252–89.

27 Winthrop Jordan, *White over Black* (New York: Norton, 1977), 287–88, 441; Audrey Smedley, *Race in North America: Origin and Evolution of a Worldview* (Boulder, CO: Westview Press, 1993), 211–16; Joanne Pope Melish, *Disowning Slavery: Gradual Emancipation and "Race" in New England, 1780–1860* (Ithaca, NY: Cornell University Press, 1998), 56; Steven Pinker, *The Blank Slate: The Modern Denial of Human Nature* (New York: Viking, 2002), 5–6.

28 Both Harry Bracken and Noam Chomsky have made note of how Locke is invoked by liberal critics. Harry M. Bracken, "Philosophy and Racism," *Philosophia* 8:2–3 (November 1978): 251–52; Noam Chomsky, *Language and Responsibility* (New York: Pantheon Books, 1977), 92–93.

29 Kay Squadrito, "Innate Ideas, Blank Tablets and Ideologies of Oppression," *Dialectics and Humanism* 11:4 (Autumn 1984): 544, 545; also see her articles "Racism and Empiricism," *Behaviorism* 7:1 (Spring 1979): 105–15; "Locke's View of Essence and Its Relation to Racism: A Reply to Professor Bracken," *Locke Newsletter* 6 (1975): 109; also see Thomas G. West, *Vindicating the Fathers: Race, Sex, Class, and Justice in the Origins of America* (New York: Rowman and Littlefield, 1997), 6–7.

30 David Brion Davis, *The Problem of Slavery in Western Culture* (New York: Oxford University Press, 1988), 118; Robert A. Williams Jr., "Documents of Barbarism: The Contemporary Legacy of European Racism and Colonialism in Narrative Traditions of Federal Indian Law," in *Critical Race Theory: The Cutting Edge,* ed. Richard Delgado (Philadelphia: Temple University Press, 1995), 98–109.

31 Wayne Glausser, "Three Approaches to Locke and the Slave Trade," *Journal of the History of Ideas* 51:2 (April–June 1990): 199–216.

32 Harry M. Bracken, "Essence, Accident and Race," *Hermathena* 116 (1973): 81–96; Bracken, "Philosophy and Racism," 241–60. For broader arguments on how slavery was a constitutive part of American freedom, democracy, and progress, see Edmund Morgan, *American Slavery, American Freedom: The Ordeal of Colonial Virginia* (New York: Norton, 1975); David Brion Davis, *Slavery and Human Progress* (New York: Oxford University Press, 1984); Eugene D. Genovese, *The Slaveholders' Dilemma: Freedom and Progress in Southern Conservative Thought, 1820–1860* (Columbia: University of South Carolina Press, 1995).

33 Bracken, "Philosophy and Racism," 250. Building on the work of Bracken and Chomsky, the historian David Theo Goldberg pushes the argument, claiming that "empiricism encouraged the tabulation of perceivable differences between peoples and from this deduced their natural differences," and that "the concept of race has served, and silently continues to serve, as a boundary constraint upon the applicability of moral principle." In *Racist Culture: Philosophy and the Pol-*

itics of Meaning (Cambridge, MA: Blackwell, 1993), 28; for Goldberg's analysis of Locke and racism, see 27–30.

34 Albert Memmi, *Racism*, trans. and ed. Steve Martinot (Minneapolis: University of Minnesota Press, 2000), 169. While holding that race is a social product, Memmi argues that thinking about race—and not race itself—is made possible by our biological predispositions. For a quantitative study that offers support for Memmi's claims, see Lawrence A. Hirschfeld, *Race in the Making: Cognition, Culture, and the Child's Construction of Human Kinds* (Cambridge, MA: MIT Press, 1998); for support from a psychologist of language, see Pinker, *Blank Slate*.

35 Memmi, *Racism*, 21–23.

36 Dinesh D'Souza, *The End of Racism* (New York: Free Press, 1995); H. F. Augstein, ed., *Race: The Origins of an Idea, 1760–1850* (Bristol, UK: Thoemmes Press, 1996), x.

37 In an 1842 address, Ralph Waldo Emerson noted that "what is popularly called Transcendentalism among us, is Idealism." Emerson went on to explain that "as thinkers, mankind have ever been divided into two sets, Materialists and Idealists; the first class founded on experience, the second on consciousness; the first class beginning to think from the data of the senses, the second class perceive that the senses are not final." See "The Transcendentalist," in *The Complete Works of Ralph Waldo Emerson*, vol. 1, ed. Edward Waldo Emerson (Boston: Houghton Mifflin, 1903), 329. For more on idealism, see Paul Coates and Daniel D. Hutto, eds., *Current Issues in Idealism* (Bristol, UK: Thoemmes Press, 1996); W. J. Mander, "Royce's Argument for the Absolute," *Journal of the History of Philosophy* 36:3 (July 1998): 443–57; W. J. Mander, ed., *Anglo-American Idealism, 1865–1927* (Westport, CT: Greenwood Press, 2000); A. M. Quinton, "Absolute Idealism," in *Rationalism, Empiricism, and Idealism: British Academy Lectures on the History of Philosophy*, ed. Anthony Kenny (New York: Oxford University Press, 1986), 124–50.

38 Josiah Royce, *Religious Aspect of Philosophy: A Critique of the Bases of Conduct and of Faith* (Boston: Houghton Mifflin, 1885), 423.

39 Mander, *Anglo-American Idealism*, 3–4.

40 F. James Davis, *Who Is Black? One Nation's Definition* (University Park: Pennsylvania State University Press, 1991), 42–47; Joel Williamson, *New People: Miscegenation and Mulattoes in the United States* (New York: Free Press, 1980), 61–109.

41 That the rule caused anxiety among whites is testament to the ways in which European-Americans still desired the reassurance proffered by an experiential system that made sight the arbiter of racial categorization. To claim that idealism was dominant at the close of the nineteenth century is not to say that it wiped out all competing belief systems.

42 Ian F. Haney López, *White by Law: The Legal Construction of Race* (New York: New York University Press, 1996), 49–50.

43 Philip Dole, "The Picket Fence at Home," in *Between Fences*, ed. George K. Dreicer (New York:

Princeton Architectural Press, 1996), 32–33. Also see Philip Dole, *The Picket Fence in Oregon: An American Vernacular Comes West* (Eugene: University of Oregon Press, 1986).

CHAPTER 2

1 Watkins's testimony is quoted in Peter E. Palmquist, *Carleton Watkins: Photographer of the American West* (Albuquerque: University of New Mexico Press, 1983), 9; also see Douglas R. Nickel, *Carleton Watkins: The Art of Perception* (New York: Abrams, 1999), 21, 216.

2 Abigail Solomon-Godeau, *Photography at the Dock: Essays on Photographic History, Institutions, and Practices* (Minneapolis: University of Minnesota Press, 1991), 169–83.

3 F. V. Hayden, *Sun Pictures of Rocky Mountain Scenery* (New York: J. Bien, 1870), quoted in Alan Trachtenberg, *Reading American Photographs: Images as History, Mathew Brady to Walker Evans* (New York: Hill and Wang, 1989), 131. Miles Orvell points to the Victorian understanding of the existence of multiple truths and notes that in the late nineteenth century it was often more important that a photograph be "convincing rather than true." In *The Real Thing: Imitation and Authenticity in American Culture, 1880–1940* (Chapel Hill: University of North Carolina Press, 1989), 85–86.

4 Josiah Dwight Whitney to William Henry Brewer, 5 July 1866, Brewer-Whitney Correspondence, Bancroft Library, University of California, Berkeley, quoted in Palmquist, *Carleton E. Watkins*, 27.

5 During the 1860s and 1870s, Watkins's images of the West competed against those produced by a number of talented photographers of local and national fame, including Charles Leander Weed, Nathan M. Klain, John James Riley, Thomas C. Roche, Alexander Gardner, Timothy O'Sullivan, Mathew Brady, and even Eadweard Muybridge. In Palmquist, *Carleton E. Watkins*, 23–24, 53.

6 For a discussion of how Europeans during the Enlightenment came to prize those natural formations deemed singular, see Barbara Maria Stafford, *Voyage into Substance: Art, Science, Nature, and the Illustrated Travel Account, 1760–1840* (Cambridge, MA: MIT Press, 1984).

7 *Report of the Commissioners to Manage the Yosemite Valley and the Mariposa Big Tree Grove for the Years 1866–7* (San Francisco: Towne and Bacon, 1868), 12.

8 Amy Rule outlines Watkins's preference for installing his photographs in dense hangings whenever possible in *Carleton Watkins: Selected Texts and Bibliography* (Boston: G. K. Hall, 1993), 22.

9 James Mason Hutchings, "California for Waterfalls!" *Mariposa Gazette*, August 16, 1855, reprinted in David Robertson, *Yosemite as We Saw It: A Centennial Collection of Early Writings and Art* (Yosemite National Park, CA: Yosemite Association, 1990), 213, emphasis in original; J. H. Beadle, *The Undeveloped West; or Five Years in the Territories* (Philadelphia: National Publishing Company, 1873), 278; John S. Hittell, *Yosemite: Its Wonders and Its Beauties* (San Francisco: H. H. Bancroft, 1868), 10.

10 For a list of the disparate groups that left names for Yosemite's natural features, as well as a detailed etymological discussion of European-American names, see Peter Browning, *Yosemite Place Names: The Historic Background of Geographic Names in Yosemite National Park* (Lafayette, CA: Great Western Books, 1988).

11 For the whiteness of landscape conventions in the West, see Kevin DeLuca, "In the Shadow of Whiteness: The Consequences of Constructions of Nature in Environmental Politics," in *Whiteness: The Communication of Social Identity*, ed. Thomas K. Nakayama and Judith N. Martin (Thousand Oaks, CA: Sage, 1999), 217–46.

12 Despite the efforts of federal troops, there was a nearly continuous native presence in the valley from the 1850s until the late 1990s. Robert H. Keller and Michael F. Turek provide one of the few accounts of the relationship between Native Americans and the U.S. National Park system, noting that Yosemite "provided the worst possible scenario for Indian/white relations." In *American Indians and National Parks* (Tucson: University of Arizona Press, 1998), 20–22. For more on the valley's original inhabitants and their culture, see Mark David Spence, *Dispossessing the Wilderness: Indian Removal and the Making of the National Parks* (New York: Oxford University Press, 1999), 101–32; Margaret Sanborn, *Yosemite: Its Discovery, Its Wonders, and Its People* (New York: Random House, 1981); Kat Anderson, "We Are Still Here," *Yosemite* 53 (1991): 1–5.

13 Stephen Powers, "Tribes of California," in *Contributions to North American Ethnology*, vol. 3, ed. J. W. Powell (Washington, DC: Government Printing Office, 1877), 361–68. For additional examples of the difficulty experienced by European Americans in translating Native American names for Yosemite's features, see J. D. Whitney, *Geological Survey of California* (New York: Julius Bien, 1868), 16–17; S. A. Barrett, "Myths of the Southern Sierra Miwok," *American Archaeology and Ethnology* 16:1 (March 27, 1919): 26–27. For a discussion of Native American language systems, see Shirley Silver and Wick R. Miller, *American Indian Languages: Cultural and Social Contexts* (Tucson: University of Arizona Press, 1997), esp. 238–41; for a related discussion of Apache language and naming practices, see Keith H. Brasso, *Wisdom Sits in Places: Landscape and Language among the Western Apache* (Albuquerque: University of New Mexico Press, 1996).

14 Mark Warhus, *Another America: Native American Maps and the History of Our Land* (New York: St. Martin's Press, 1997), 11.

15 Ibid., 16.

16 Ibid., 3–11.

17 For more on the subjective nature of maps, see Denis Wood, *The Power of Maps* (New York: Guilford Press, 1992); Norman J. W. Thrower, *Maps and Civilization: Cartography in Culture and Society* (Chicago: University of Chicago Press, 1999); Jeremy Black, *Maps and History: Constructing Images of the Past* (New Haven, CT: Yale University Press, 2000).

18 E. R. Wallace, *Descriptive Guide to the Adirondacks and Handbook of Travel* (New York: Amer-

ican News Company, 1875), 132; see also *The Tourist's Guide Book to the United States and Canada* (New York: Putnam's, 1883), 79, 198. For similar descriptions of the Catskills, see S. S. Colt, *The Tourist's Guide through the Empire State* (Albany, NY: privately printed, 1871), 160, 162.

19 Browning, *Yosemite Place Names*, xi.

20 For the intersection of "male" and "imperial" gazes, see E. Ann Kaplan, *Looking for the Other: Feminism, Film, and the Imperial Gaze* (New York: Routledge, 1997).

21 For a nineteenth-century European-American account of the supposed indifference of Native Americans toward Yosemite's grandeur, see Frederick Law Olmsted, "The Yosemite Valley and the Mariposa Big Trees: A Preliminary Report," ed. Laura Wood Roper, *Landscape Architecture* 43 (1952): 22. For more on the myth of Indians' fear of nature, see Keller and Turek, *American Indians and National Parks*, 24, 94, 236.

22 For the complex interrelation of late-century norms of gender and race, see Gail Bederman, *Manliness and Civilization: A Cultural History of Gender and Race in the United States, 1880–1917* (Chicago: University of Chicago Press, 1995).

23 Hittell, *Yosemite*, 10.

24 Chris J. Magoc, *Yellowstone: The Creation and Selling of an American Landscape, 1870–1903* (Albuquerque: University of New Mexico Press, 1999), 13. Perhaps the ultimate expression of nature as a sign for European-American power is provided by Mount Rushmore, which was carved by Gutzon Borglum, a white supremacist and Ku Klux Klan supporter. See John Taliaferro, *Great White Fathers: The Story of the Obsessive Quest to Create Mt. Rushmore* (New York: Public Affairs, 2002), 56, 185–95.

25 Rebecca Bedell, *The Anatomy of Nature: Geology and American Landscape Painting, 1825–1875* (Princeton, NJ: Princeton University Press, 2001), 125.

26 James O'Gorman, *H. H. Richardson: Architectural Forms for an American Society* (Chicago: University of Chicago Press, 1987), 94; also see 91–111.

27 Margaret Sanborn notes the nineteenth-century story that Lincoln reviewed Watkins's photographs of Yosemite prior to signing the bill to preserve the region. In Sanborn, *Yosemite*, 99. For a perceptive discussion of the links between Watkins's photographs and commerce, see George Dimock, *Exploiting the View: Photographs of Yosemite and Mariposa by Carleton Watkins* (North Bennington, VT: Park-McCullough House, 1984), 10.

28 In A. L. Bancroft, *Bancroft's Tourist's Guide: Yosemite, San Francisco, and Around the Bay (South)* (San Francisco: A. L. Bancroft, 1871), xiii.

29 For essays noting the photographer's contradictory mixing of nature and industry, see Maria Morris Hambourg, "Carleton Watkins: An Introduction," and Douglas R. Nickel, "An Art of Perception" in Nickel, *Carleton Watkins*, 13, 27; Weston Naef and James N. Wood, *Era of Exploration: The Rise of Landscape Photography in the American West, 1860–1885* (Buffalo and New

York: Albright-Knox Art Gallery and the Metropolitan Museum of Art, 1975), 85. For sophisticated discussions of how Watkins's images are wedded to an ideology of development, see Martha Sandweiss's foreword in Palmquist, *Carleton E. Watkins;* and Rule, *Carleton Watkins.*

30 Alfred Runte, *National Parks: The American Experience* (Lincoln: University of Nebraska Press, 1979), 63–64; see also 31. See also Richard West Sellars, *Preserving Nature in the National Parks: A History* (New Haven, CT: Yale University Press, 1997), 22–27.

31 John S. Hittell, *The Resources of California Comprising Agriculture, Mining, Geography, Climate, Commerce* (San Francisco: A. Roman, 1863), 72.

32 Ibid., vi.

33 Joseph Weed, *A View of California as It Is* (San Francisco: Bynon and Wright, 1874), 122.

34 See Lafayette Houghton Bunnell, *Discovery of the Yosemite, and the Indian War of 1851, Which Led to That Event* (Chicago: Fleming H. Revell, 1880), 53–62; John Muir, *Our National Parks* (Boston: Houghton Mifflin, 1901), 78; Nathaniel Pitt Langford, *The Discovery of Yellowstone Park: Journal of the Washburn Expedition to the Yellowstone and Firehole Rivers in the Year 1870* (Lincoln: University of Nebraska Press, 1972 [1905]), 58–59; Horace Greeley, *An Overland Journey from New York to San Francisco in the Summer of 1859* (New York: C. M. Saxton, Barker, 1860), 300; "The Backbone of America," *Penn Monthly* 1:6 (June 1870): 232. For additional examples of how nineteenth-century Americans saw links between mining and civilization, see Frank Fossett, *Colorado: Its Gold and Silver Mines, Farms and Stock Ranges, and Health and Pleasure Resorts* (New York: C. G. Crawford, 1879), 197, 368.

35 Langford, *Discovery of Yellowstone Park*, 34, 96–97; see also 37.

36 For Langford's description of the region as "desolate and impassable and barren of resources," see Langford, *Discovery of Yellowstone Park*, 80.

37 Sellars, *Preserving Nature in the National Parks*, 18, 62–63. Despite Albright's efforts, the 1932 Olympics went to Lake Placid, New York, and not Yosemite. Having previously dismissed President George W. Bush's approach to natural resources as one that transparently catered to the interests of energy, mineral, hunting, and livestock concerns, I have come to appreciate how his destructive policies neatly reflect an old-fashioned, nineteenth-century view of the natural world.

38 Frederick Law Olmsted, "Governmental Preservation of Natural Scenery," March 8, 1890, printed circular, U.S. Library of Congress, Washington, D.C., Olmsted Papers, box 32; Olmsted, "Yosemite Valley and the Mariposa Big Trees," 16–17.

39 Frederick Law Olmsted, *A Journey through Texas; or a Saddle-Trip on the Southwestern Frontier* (New York: Dix, Edwards, 1857), 289; Frederick Law Olmsted, *A Journey in the Back Country* (New York: Mason Brothers, 1860), 287–88.

40 For the European-American tendency to confuse Native American ecology with environmentalism, see Shepard Krech III, *The Ecological Indian: Myth and History* (New York: Norton, 1999).

41 David C. Huntington, *The Landscapes of Frederic Edwin Church: Vision of an American Era* (New York: George Braziller, 1966), 61–62; William H. Truettner, "Genesis of Frederic Edwin Church's *Aurora Borealis*," *Art Quarterly* 31:3 (Autumn 1968): 280; Franklin Kelly, *Frederic Edwin Church* (Washington, DC: National Gallery of Art, 1989), 62.

42 "Conflict of Northern and Southern Races," *DeBow's Review* 31 (October–November 1861): 394; quoted in Drew Gilpin Faust, *The Creation of Confederate Nationalism: Ideology and Identity in the Civil War South* (Baton Rouge: Louisiana State University Press, 1988), 10.

43 "The Difference of Race between the Northern and Southern People," *Southern Literary Messenger: A Magazine Devoted to Literature, Science and Art* 30:26 (June 1860): 407.

44 Maria Morris Hambourg, "Carleton Watkins: An Introduction," in Nickel, *Carleton Watkins*, 10–11.

45 Charles Roscoe Savage, "A Photographic Tour of Nearly 9000 Miles," *Philadelphia Photographer* 4:45 (September 1867): 289; Oliver Wendell Holmes, "Doings of the Sunbeam" *Atlantic Monthly* 12:69 (July 1863): 1–15. Ralph Waldo Emerson, quoted in Maria Morris Hambourg, "Carleton Watkins: An Introduction," in Nickel, *Carleton Watkins*, 10. For additional examples of critics' enthusiasm for Watkins's work during the 1860s, see "California Scenery in New York," *North Pacific Review* 2:7 (February 1863): 208; "California Photographs," *Journal of Photography and the Allied Arts and Sciences* 18:2 (May 15, 1866): 21; H. J. Morton, "Yosemite Valley," *Philadelphia Photographer* 3:36 (December 1866): 376–79; and G. Wharton Simpson, "Photography at the International Exhibition at Paris," *Philadelphia Photographer* 4:43 (July 1867): 201–4.

46 Fitz Hugh Ludlow, *The Heart of the Continent: A Record of Travel across the Plains and in Oregon, with an Examination of the Mormon Principle* (New York: Hurd and Houghton, 1870), 412, 428.

47 Not only does the missing branch on the foreground pine's trunk in *The Yosemite Valley from the Best General View* suggest that Watkins followed Weed, but comments made by Josiah Dwight Whitney during the summer of 1866 clarify that Watkins's overviews of the valley were taken both from "Inspiration point" and "from Weed's point of view." Quoted in Palmquist, *Carleton E. Watkins*, 27. For more on Weed, see Peter Palmquist, "California's Peripatetic Photographer: Charles Leander Weed," *California History* 58:3 (Fall 1979): 194–219; Mary V. Hood, "Charles L. Weed, Yosemite's First Photographer," *Yosemite Nature Notes* 38:6 (June 1959): 76–87.

48 Morton, "Yosemite Valley," 377.

49 Albert Boime, *The Magisterial Gaze: Manifest Destiny and American Landscape Painting, c. 1830–1865* (Washington, DC: Smithsonian Institution Press, 1991), 21, 1. Also see Alan Wallach, "Making a Picture of the View from Mount Holyoke," in *American Iconology: New Approaches to Nineteenth-Century Art and Literature*, ed. David C. Miller (New Haven, CT: Yale University Press, 1993), 80–91. In stressing how art historians have read the inclusion of figures in landscapes as a sign of viewers' power, I do not wish to imply that scholars are unified in the belief that the absence of figures necessarily diminishes the symbolic or narrative power of viewers.

For an account of how the apparent lack of a human presence communicates another kind of power, see Angela Miller, *The Empire of the Eye: Landscape Representation and American Cultural Politics, 1825–1875* (Ithaca, NY: Cornell University Press, 1993), 41, 110.

50 Boime, *Magisterial Gaze*, 151.

51 "Views in the Yosemite Valley," *Philadelphia Photographer* 3:28 (April 1866): 107.

52 Quoting from the work of the sociologists Peter Berger and Thomas Luckmann, the art historian Norman Bryson notes that "the social world is typically and habitually experienced by its inhabitants 'in the sense of a comprehensive and given reality confronting the individual in a manner analogous to the natural world.'" Bryson goes on to claim that the "historical determined nature of [an image's verisimilitude] must be concealed if the image is to be accepted as a reflection of a preexisting real: its success lies in the degree to which the specificity of its historical location remains hidden; which is to say that the success of the image in naturalising the visual beliefs of a given community depends on the degree to which the image remains unknown as an *independent* form." In *Vision and Painting: The Logic of the Gaze* (New Haven, CT: Yale University Press, 1983), 14; Peter L. Berger and Thomas Luckmann, *The Social Construction of Reality: A Treatise in the Sociology of Knowledge* (Garden City, NY: Doubleday, 1966), 65–70.

CHAPTER 3

1 Letter from J. Miller McKim to Charles McKim, August 2, 1869, Charles Follen McKim Collection, Manuscript Division, Library of Congress, microfilm reel 10, frame 657. For other references to the "Saracenic" character of the synagogue, see James D. McCabe, *Illustrated History of the Centennial Exhibition* (Philadelphia: National Publishing Company, 1975 [1876]), 29; *Stranger's Illustrated Pocket Guide to Philadelphia* (Philadelphia: Lippincott, 1876), 44; William Syckelmoore, *Syckelmoore's Illustrated Handbook of Philadelphia* (Philadelphia: William Syckelmoore, 1874), 21. While few architectural historians have dealt with the links between architecture and whiteness—or even architecture and race—some suggestive studies include Bernard Tschumi, *Architecture and Disjunction* (Cambridge, MA: MIT Press, 1994); Lesley Naa Norle Lokko, ed., *White Paper, Black Marks: Architecture, Race, Culture* (Minneapolis: University of Minnesota Press, 2000); Craig Evan Barton, ed., *Sites of Memory: Perspectives on Architecture and Race* (New York: Princeton Architectural Press, 2001). For the most compelling discussion of which I am aware, see Leland T. Saito, *Race and Politics: Asian Americans, Latinos, and Whites in a Los Angeles Suburb* (Urbana: University of Illinois Press, 1998), 39–54.

2 In nineteenth-century America, the terms "Saracenic," "Moorish," and "Mohammedan" were used interchangeably to signify a style of architecture at least loosely inspired by Near Eastern prototypes that were primarily Islamic. Up until the very end of the century, when Americans invoked the Orient, they referred to the peoples, buildings, and cultures of the Near East, and not those of the Far East, with which many Americans associate the term today.

3 For an architectural survey of Orientalism, see John Sweetman, *The Oriental Obsession: Islamic Inspiration in British and American Art and Architecture, 1500–1920* (Cambridge: Cambridge University Press, 1988); for discussion of Oriental-inspired design in the early part of the nineteenth century, see David Van Zanten, *The Architectural Polychromy of the 1830's* (New York: Garland, 1977).

4 "Progress of Architecture in the United States," *American Architect and Building News,* October 1868, 278.

5 While the earliest Saracenic building in the United States was a private home, Iranistan (1848–65; Bridgeport, CT), built by the German-Jewish architect Leopold Eidlitz for P. T. Barnum, the style was usually reserved for commercial and religious structures. On those occasions when it was introduced into domestic architecture, it was typically confined to a smoking or billiard room or to an artist's studio.

6 Rachel Wischnitzer, *Synagogue Architecture in the United States: History and Interpretation* (Philadelphia: Jewish Publication Society of America, 1955), 77. Wischnitzer credits Keneseth Israel (1864) at Sixth and Brown Streets, Philadelphia, with igniting the Saracenic trend for synagogue design in the United States (67).

7 For references to Jews as perpetually alien and outside of historical developments, see Joseph Henry Allen, *Hebrew Men and Times from the Patriarchs to the Messiah* (Boston: Roberts Brothers, 1879), 425; Anna L. Dawes, *The Modern Jew: His Present and Future* (Boston: D. Lothrop, 1886), 41; David A. Gerber, ed., *Anti-Semitism in American History* (Urbana: University of Illinois Press, 1986), 103–28.

8 *Stranger's Illustrated Pocket Guide,* 98; *Magee's Centennial Guide of Philadelphia* (Philadelphia: R. Magee & Son, 1876), 29.

9 McCabe, *Illustrated History of the Centennial Exhibition,* 152.

10 Wischnitzer, *Synagogue Architecture,* 60–61; for more on the reforms at Rodeph Shalom, see Malcolm H. Stern, "National Leaders of Their Time: Philadelphia's Reform Rabbis," in *Jewish Life in Philadelphia, 1830–1940,* ed. Murray Friedman (Philadelphia: Ishi Publications, 1983), 179–97.

11 Michael J. Lewis, *Frank Furness: Architecture and the Violent Mind* (New York: Norton, 2001), 77–78; James O'Gorman, *The Architecture of Frank Furness* (Philadelphia: Philadelphia Museum of Art, 1973), 32; George E. Thomas, Michael J. Lewis, and Jeffrey A. Cohen, *Frank Furness: The Complete Works* (New York: Princeton Architectural Press, 1991), 68. Because the commission for the synagogue is likely to have resulted through the familial connections of Frank Furness—not only was his German-speaking brother, Horace, on good terms with the synagogue's new German-born rabbi, but his father was a close friend of Rebecca Gratz, a long-time congregant—it is generally assumed that the firm's senior partner, John Fraser, left the design of the structure to his two junior partners. In Lewis, *Frank Furness,* 77; Thomas, Lewis, and Cohen, *Frank Furness,* 68. John Sweetman takes the use of Orientalist forms by European

Jews as a statement of pride in a Near Eastern origin and as a means to distance themselves from European traditions. In Sweetman, *Oriental Obsession*, 287, 252–53.

12 In a lecture delivered to the Latrobe Chapter of the Society for Architectural Historians in Washington, D.C., entitled "Discourse of Civilizations: 'Islamic' Architectural Forms and Concepts in Western Architecture and Decoration, 1800–1950" (February 12, 2003), the architectural historian Mehrangiz Nikou postulated eight factors that influenced the Jewish embrace of what she termed "neo-Islamic" architecture during the nineteenth century: the strong associations of both Gothic and Romanesque architecture with Christianity; the abstract decorative program of Saracenic design, which met the Jewish prohibition of graven images; the perception of the medieval Spanish era as a golden age for Jews; the desire for a strong architectural expression as the first synagogues were built outside of ghettos; the tendency of nineteenth-century audiences to see architecture as an expression of race; the style's appropriateness based on the shared Semitic heritage of Jews and Arabs; the desire for a spiritual connection to the Holy Land through geographically appropriate architectural forms; and the association of the style with a neo-national Jewish identity.

13 Furness and Hewitt's building became the third home of the Academy, replacing Richard Gilpin's building (1846–47; fig. 43), which itself had replaced the original structure designed by John Dorsey (1805–6).

14 For reference to Native American rug patterns incorporated into the decorative program of the Academy's facade, see Hyman Myers, "Three Buildings of the Pennsylvania Academy," *Antiques* 121:3 (March 1982): 682.

15 O'Gorman, *Architecture of Frank Furness*, 35; Myers, "Three Buildings," 682; Zeynep Çelik, *Displaying the Orient: Architecture of Islam at Nineteenth-Century World's Fairs* (Berkeley and Los Angeles: University of California Press, 1992), 168; Lewis, *Frank Furness*, 95; Sweetman, *Oriental Obsession*, 238. For the most comprehensive consideration of the Academy's links to Islamic architecture, see Anne Monahan, "'Of a Doubtful Gothic': Islamic Sources for the Pennsylvania Academy of the Fine Arts," *Nineteenth Century* 18:2 (Fall 1998): 28–36.

16 "Centennial Exposition Memoranda," *Potter's American Monthly* 7 (November 1876): 316.

17 Helen Henderson, *The Pennsylvania Academy of the Fine Arts and Other Collections of Philadelphia* (Boston: L. C. Page, 1911), 10; see also "History of the Pennsylvania Academy to 1876" in the "Pennsylvania Academy of the Fine Arts Records, 1805–1976," Archives of American Art, microfilm reel P50, frame 743.

18 *American Architect and Building News*, March 4, 1876, 80; *American Architect and Building News*, May 6, 1876, 145.

19 "The First American Art Academy: First Paper," *Lippincott's Magazine*, February 1872, 143; also see Fannie Warner Bicknell, "Pennsylvania Academy of the Fine Arts," *Evening Star*, April 14, 1876, in the clipping file on the Furness and Hewitt building in Pennsylvania Academy of the Fine Arts Archives, Philadelphia.

20 For a listing of the Academy's European- and Euro-American-focused collections during this
 period, see the *Catalogue of the Property and Loan Exhibition of the Pennsylvania Academy
 of the Fine Arts* (Philadelphia: Collins Printer, 1876); *Catalogue of the Forty-seventh Annual
 Exhibition of the Pennsylvania Academy of the Fine Arts* (Philadelphia: Collins Printer, 1876),
 10–26.

21 For reference to the Academy as a "temple of art," see *Exercises at the Laying of the Corner
 Stone of the New Building for the Pennsylvania Academy of the Fine Arts, December 7, 1872*
 (Philadelphia: Collins Printer, 1872), 4; *Inauguration of the New Building of the Pennsylvania
 Academy of the Fine Arts, 22 April, 1876* (Philadelphia: Pennsylvania Academy of the Fine
 Arts, 1876), 10; *Magee's Centennial Guide*, 28–29. For reference to both the religious power
 of art and the role of religious leaders as artistic spokesmen, see Henry Adams, *Esther* (New
 York: Prometheus Books, 1997 [1884]), esp. 21; Neil Harris, *The Artist in American Society: The
 Formative Years* (New York: George Braziller, 1966), 307–9. The most sustained analysis of the
 cultural function of the Academy's decorative program is offered by George Thomas, who de-
 scribes the building's extensive use of red brick as an effort to forge a link with Philadelphia's
 Quaker roots. While acknowledging the novel and eclectic design of the Academy, Thomas reads
 the building primarily in terms of its continuity with Philadelphia's past. In making exten-
 sive use of red brick at the very moment when the corrupt Republican machine that ruled city
 government favored white marble—and faux marble finishes—exemplified most famously
 by John McArthur's City Hall (1871–94) and, earlier, by Thomas U. Walter's Girard College
 (1833), the Academy offered reassuring reference to the founding fathers. In Thomas, Lewis,
 and Cohen, *Frank Furness*, 57–62. I find Thomas's argument compelling, but I am more in-
 terested in the ways in which this radical building *departs* from period conventions.

22 James F. O'Gorman, *H. H. Richardson: Architectural Forms for an American Society* (Chicago:
 University of Chicago Press, 1987), 63. Also see Walter C. Kidney, *The Architecture of Choice:
 Eclecticism in America, 1880–1930* (New York: Braziller, 1974), 1.

23 Damie Stillman, *Architecture and Ornament in Late-Nineteenth-Century America* (Pennsau-
 ken, NJ: National Designers, 1981), 12; Kidney, *Architecture of Choice*, 5; George L. Hersey, *High
 Victorian Gothic: A Study in Associationism* (Baltimore: Johns Hopkins University Press, 1972),
 48.

24 Monahan, "'Of a Doubtful Gothic,'" 33.

25 Although only one of the competition sketches for the Academy survives, it seems certain that
 the building committee reviewed a broad array of styles, given that the architects invited to
 submit designs were known for their distinctive work. In addition to Furness and Hewitt, the
 competing architects were Henry Sims, Thomas Richards, Addison Hutton, and James Win-
 drim. Variety was also introduced by the "Invitation for Proposals," which requested prospec-
 tive designs in "dark stone dressings" and "white marble" from each competitor. "Invitation
 for Proposals to Erect a Building for the Pennsylvania Academy of the Fine Arts," June 20, 1871,
 Archives of the Pennsylvania Academy of the Fine Arts, Philadelphia.

26 For the context of Reverend Furness's citation, "Let the Beauty of the Lord our God be upon
 us," see *Inauguration of the New Building*, 18. Reporters following the opening ceremonies showed
 an invariable interest in the unveiling. The editors of the *American Architect and Building News*,
 May 6, 1876, 145, wrote, "An exhibition of more than usual interest signalizes the opening of
 the building, of which the most interesting feature is the unveiling of Story's statue of Jeru-
 salem, that has just been presented to the Academy." The *Philadelphia Inquirer*, April 24, 1876,
 2, commented that after a speech by Frank's father, the Reverend William Henry Furness, "two
 magnificent statues, that of 'Jerusalem' by Story, and 'Deborah,' by Lombardi, were unveiled."
 And according to the *Art Journal* 2:18 (June 1876), 192, "at the conclusion of the address Story's
 statue of 'Jerusalem,' and Lombardi's statue of 'Deborah,' were unveiled . . . *[Deborah]* is a beau-
 tiful figure, in pearly-white marble, and attracted much attention." See also "The Philadel-
 phia Academy Exhibition," *Art Journal* 2:19 (July 1876): 222–23. The illustration of *Deborah*
 is the only known photographic image of this currently unlocated work, taken in 1937 after
 the sculpture was damaged by a hammer-wielding assailant.

27 For the importance of the ancient Israelites to nineteenth-century Americans, see John Davis,
 *The Landscape of Belief: Encountering the Holy Land in Nineteenth-Century American Art and
 Culture* (Princeton, NJ: Princeton University Press, 1996), esp. 13–26. During the 1870s, an ar-
 ticle appearing in the *Saturday Evening Post* claimed that Moroccan Jews "are the descendants
 of those Moors whose labors and success . . . are still visible round Grenada"; another noted that
 the Jews of Syria are "Arabs in language, habits, and occupations, in so far at least as religion
 will permit." In "Return of the Jews," *Saturday Evening Post* 57:23 (December 29, 1877): 8;
 "The Jews," *Saturday Evening Post* 55:15 (November 6, 1875): 7.

28 For studies that discuss the nonwhite status of Jews, see Karen Brodkin, *How Jews Became White
 Folks and What That Says about Race in America* (New Brunswick, NJ: Rutgers University Press,
 1998); and Matthew Frye Jacobson, *Whiteness of a Different Color: European Immigrants and
 the Alchemy of Race* (Cambridge, MA: Harvard University Press, 1998). For arguments
 disputing the idea that Jews ever occupied a nonwhite identity in American society, see the
 journal *International Labor and Working-Class History* 60 (Fall 2001), which is dedicated to a
 critical reassessment of whiteness studies, especially Eric Arnesen, "Whiteness and the Histo-
 rians' Imagination," 3–32; and Eric Foner, "Response to Eric Arnesen," 57–60.

29 For more on the shifting whiteness of Arabs in United States immigration law, see Ian F. Haney
 López, *White by Law: The Legal Construction of Race* (New York: New York University Press,
 1996), 76, 106, 204–5, 212–13. Although they were granted citizenship, Jews were not neces-
 sarily accorded all the rights of citizens. Leonard Dinnerstein notes that a number of eastern
 states required oaths acknowledging the divinity of Christ for voting up into the nineteenth
 century. In Leonard Dinnerstein, "Antisemitism in Crisis Times in the United States: The 1920s
 and 1930s," in *Anti-Semitism in Times of Crisis*, ed. Sander L. Gilman and Steven Katz (New
 York: New York University Press, 1991), 213. For a discussion of how Jews were perceived in
 early Philadelphia, see William Pencak, "Jews and Anti-Semitism in Early Pennsylvania,"
 Pennsylvania Magazine of History and Biography 126:3 (July 2002): 365–408.

30 The phrase "provisional whites" is taken from Jacobson, *Whiteness of a Different Color*. Also see James R. Barrett and David Roediger, "Inbetween Peoples: Race, Nationality and the 'New Immigrant' Working Class," *Journal of American Ethnic History* 16:3 (Spring 1997): 3–44.

31 See Ronald Takaki, *Iron Cages: Race and Culture in Nineteenth-Century America* (New York: Oxford University Press, 1990), 219–20.

32 Diane Johnson notes the range of peoples that reference to an "Islamic" style conjured up for Europeans and European-Americans, writing that "in the nineteenth century the term 'Islamic' included a remarkable variety of styles, from Mogul tombs in India to Moorish palaces in Spain, and it could refer to 'Arabic, Mohammedan, Turkish, Moorish, Persian, Saracenic, or Hindoo'" forms. In Diane Chalmers Johnson, *American Art Nouveau* (New York: Abrams, 1979), 131.

33 Jacobson, *Whiteness of a Different Color*, 23–24. For specific reference to how this dynamic affected Jews, see 172.

34 Thomas C. Holt, *The Problem of Race in the Twenty-first Century* (Cambridge, MA: Harvard University Press, 2000), 37–67. Also see Ronald Sanders, *Lost Tribes and Promised Lands: The Origins of American Racism* (Boston: Little, Brown, 1978), 65–73; Craig R. Prentiss, ed., *Religion and the Creation of Race and Ethnicity: An Introduction* (New York: New York University Press, 2003).

35 Davis, *Landscape of Belief*, 83; see also 84–88. Also see "A Photographer in Jerusalem, 1855: Auguste Salzmann and His Times," in Abigail Solomon-Godeau, *Photography at the Dock: Essays on Photographic History, Institutions, and Practices* (Minneapolis: University of Minnesota Press, 1991), 150–68.

36 Charles Dudley Warner, *In the Levant* (Boston: James R. Osgood, 1877), 42–43; also see 44–46. Warner is best known today as Mark Twain's collaborator on *The Gilded Age* (1873).

37 William Henry Poole, *Anglo-Israel or the Saxon Race Proved to Be the Lost Tribes of Israel* (Toronto: William Briggs, 1889 [1880]), 16–17, 673. Also see Edward H. Rogers, *Law and Love, or, The Resemblance and the Difference between Moses and Christ with a Prophetic Supplement Concerning Anglo-Israel* (Chelsea, MA: E. H. Rogers, 1897); Edward Hine, *Forty-seven Identifications of the British Nation with the Lost Ten Tribes of Israel: Founded upon Five Hundred Scripture Proofs* (London: W. H. Guest, 1874); Edward Hine, *Forty-seven Identifications of the British Nation and the United States with the Lost Ten Tribes of Israel* (London: W. H. Guest, 1879). For the nineteenth-century tradition of reading Christian, western Europeans as the lost tribes of Israel, see Douglas E. Cowan, "Theologizing Race: The Construction of Christian Identity," in *Religion and the Creation of Race and Ethnicity: An Introduction*, ed. Craig R. Prentis (New York: New York University Press, 2003), 113–16. For a complementary discussion of how late nineteenth-century Jews understood their identity as racialized and attempted to abandon their "Jewish" bodies, see Sander Gilman, *The Jew's Body* (New York: Routledge, 1991), 169–93.

38 For more on how Christian European-Americans conceived of the theological roots of Christian-

ity in Judaism, see Sally Promey's discussion of the controversy engendered by the installation of John Singer Sargent's *Synagogue* (1919) in the Boston Public Library. In *Painting Religion in Public: John Singer Sargent's Triumph of Religion at the Boston Public Library* (Princeton, NJ: Princeton University Press, 1999), 174–225.

39 Paul Oskar Kristeller, *Renaissance Thought and the Arts: Collected Essays* (Princeton, NJ: Princeton University Press, 1990), 163–227.

40 Larry Shiner, *The Invention of Art: A Cultural History* (Chicago: University of Chicago Press, 2001), 4, 7.

41 Ibid., 3.

42 For the admission fees of Philadelphia's various attractions in the 1870s, see Thompson Westcott, *The Official Guide Book to Philadelphia* (Philadelphia: Porter and Coates, 1875), v–xi; *Magee's Centennial Guide*, 178–86. The Pennsylvania Academy instituted a "free day" only in the 1880s. See "An Example of Munificence," *North American*, February 25, 1880, n.p. Clipping reproduced in the Archives of American Art, Pennsylvania Academy of the Fine Arts Records, microfilm roll 53, frame 253; and "A Philadelphia Art Gallery on Sunday," *Harper's Weekly*, June 11, 1887, 419.

43 For more on the admission requirements and procedures of the Academy during the 1870s, see *American Architect and Building News*, May 6, 1876, 145.

44 Joseph Pennell, *The Adventures of an Illustrator: Mostly Following His Authors in America and Europe* (Boston: Little, Brown, 1925), 53. Although Tanner was admitted to the Academy—becoming just the second African American to study there since the institution's founding in 1805—he faced considerable hostility from students. One frequently recounted anecdote describes him being tied to his easel in a "crucifixion" and left in Broad Street in the middle of the night. In Pennell, *Adventures of an Illustrator*, 54. For discussions illustrating the structural impediments faced by nineteenth-century African American artists, see Naurice Frank Woods Jr., "Insuperable Obstacles: The Impact of Racism on the Creative and Personal Development of Four Nineteenth-Century African American Artists" (Ph.D. diss., Union Institute Graduate School, 1993). Also see Alain LeRoy Locke, *Negro Art: Past and Present* (Washington, DC: Associates in Negro Folk Education, 1936); Richard Powell, *Black Art: A Cultural History* (New York: Thames and Hudson, 2002); Michael D. Harris, *Colored Pictures: Race and Visual Representation* (Chapel Hill: University of North Carolina Press, 2003).

45 Pierre Bourdieu, *Distinction: A Social Critique of the Judgement of Taste* (Cambridge, MA: Harvard University Press, 1984), 387; for the importance of cultural capital in art education, see Pierre Bourdieu, "The School as a Conservative Force: Scholastic and Cultural Inequities," in *Contemporary Research in the Sociology of Education*, ed. John Eggleston (New York: Methuen, 1974), 42.

46 For more on the institutional development of the fine arts museum, see Paul DiMaggio, "Cultural Entrepreneurship in Nineteenth-Century Boston: The Creation of an Organizational Base

for High Culture in America," in *Media, Culture and Society: A Critical Reader*, ed. Richard Collins (Beverly Hills: Sage, 1986), 194–211; Tony Bennett, *The Birth of the Museum: History, Theory, Politics* (New York: Routledge, 1995); Daniel J. Sherman and Irit Rogoff, eds., *Museum Culture: Histories, Discourses, Spectacles* (Minneapolis: University of Minnesota Press, 1994); Steven Conn, *Museums and American Intellectual Life, 1876–1926* (Chicago: University of Chicago Press, 1998); Alan Wallach, *Exhibiting Contradiction: Essays on the Art Museum in the United States* (Amherst: University of Massachusetts Press, 1998). For an exhibition addressing the whiteness of European-American museum display, see Lisa G. Corrin, ed., *Mining the Museum: An Installation by Fred Wilson* (Baltimore: New Press, 1994).

47 Lawrence Levine, *Highbrow/Lowbrow: The Emergence of Cultural Hierarchy in America* (Cambridge, MA: Harvard University Press, 1988), 186; see also John Kasson, *Rudeness and Civility: Manners in Nineteenth-Century Urban America* (New York: Hill and Wang, 1990), 217–24.

48 Calvin Tomkins, *Merchants and Masterpieces: The Story of the Metropolitan Museum of Art* (New York: Holt, 1989), 84–85. Since few museums arranged for a free day prior to the 1890s, and because museums were generally closed on Sunday, there were limited opportunities for working-class whites and nonwhites to attend fine arts museums during these decades. Tony Bennett notes that nineteenth-century British "advocates of public museums had to fight hard against a tide of influential opinion which feared that, should museums be opened to the public, they would fall victim to the disorderliness of the crowd." In *Birth of the Museum*, 99.

49 Kasson, *Rudeness and Civility*, 252.

50 Levine, *Highbrow/Lowbrow*, 272.

51 O'Gorman, *H. H. Richardson*, 62.

52 Eugène Emmanuel Viollet-le-Duc, *Discourses on Architecture*, translated with an introductory essay by Henry Van Brunt (Boston: James R. Osgood, 1875), x.

53 "Eclecticism in Architecture," *American Architect and Building News*, January 15, 1876, 18.

54 *American Architect and Building News*, August 4, 1877, 262.

55 Austin Bierbower, "American Architecture," *Penn Monthly* 8:1 (December 1877): 937.

56 "Architecture in America: Naissant and Renaissant," *Sloan's Architectural Review and American Building Journal* (April 1869), 613; "Eclecticism in Architecture," 18; also see Samuel J. Burr, *Four Thousand Years of the World's Progress from the Early Ages to the Present Time* (Hartford, CT: L. Stebbins, 1878), 710.

57 Bierbower, "American Architecture," 939.

58 "An American Style," *Sloan's Architect and Building Journal*, November 1868, 336.

59 *American Architect and Building News*, August 1877, 262.

60 John Ruskin, *The Seven Lamps of Architecture* (New York: Wiley, 1887), 192.

61 Viollet-le-Duc, *Discourses on Architecture*, x. I do not wish to assert that "creative" and "replicative" practices were firmly linked to inferior and superior racial groups, respectively, but rather that this strain of thought could be found in the period discourse. If anything, the *dominant* view linked replicative arts and architecture to female and nonwhite groups. After viewing the Chinese and Japanese displays at the Centennial Exhibition, a Congregational minister voiced the standard European-American view in claiming that "Christian nations were 'largely inventive,' whereas Asian nations were 'essentially and laboriously *imitative*.'" Quoted in Robert W. Rydell, *All the World's a Fair: Visions of Empire at American International Expositions, 1876–1916* (Chicago: University of Chicago Press, 1984), 31. For the gendering of this equation, see Rozsika Parker and Griselda Pollock, *Old Mistresses: Women, Art and Ideology* (London: Pandora Press, 1989).

62 *American Architect and Building News*, August 1877, 262. For an additional reference to the gradual, evolutionary nature of "proper" architectural development, see James Ferguson, *A History of Architecture in All Countries from the Earliest Times to the Present Day*, vol. 1 (New York: Dodd, Mead, 1874), 45.

63 Rydell, *All the World's a Fair*; Alan Trachtenberg, *The Incorporation of America: Culture and Society in the Gilded Age* (New York: Hill and Wang, 1982). For a fascinating contemporary example of how European-Americans make use of nonwhite architectural forms to signal whiteness, see Saito, *Race and Politics*, 39–54.

64 Rydell, *All the World's a Fair*, 20.

65 Curtis M. Hinsley, "The World as Marketplace: Commodification of the Exotic at the World's Columbian Exposition, Chicago, 1893," in *Exhibiting Cultures: The Poetics and Politics of Museum Display*, ed. Ivan Karp and Steven D. Levine (Washington, DC: Smithsonian Institution Press, 1991), 345.

66 Dexter A. Hawkins, *The Anglo-Saxon Race: Its History, Character, and Destiny: An Address before the Syracuse University, at Commencement, June 21, 1875* (New York: Nelson and Phillips, 1875), 3, 26. For a related discussion of how Victorians juggled both "civilized" and "barbaric" traits, see Matthew Frye Jacobson, *Barbarian Virtues: The United States Encounters Foreign Peoples at Home and Abroad, 1876–1917* (New York: Hill and Wang, 2000).

67 Edward Said, *Orientalism* (New York: Vintage Books, 1978); Edward Said, *Musical Elaborations* (New York: Columbia University Press, 1991), 52, quoted in John M. MacKenzie, *Orientalism: History, Theory and the Arts* (Manchester: Manchester University Press, 1995), 209. For critiques of Said's work that stress the changing nature and valences of the Orient for the West, see MacKenzie, *Orientalism*, 76–77, 78, 101, 208–15; James Clifford, *The Predicament of Culture* (Cambridge, MA: Harvard University Press, 1988), 258, 263–64; and Malini Johar Schueller, *U.S. Orientalism: Race, Nation, and Gender in Literature, 1790–1890* (Ann Arbor: University of Michigan Press, 1998).

68 *New York Tribune*, June 20, 1877, 4.

69 *Nation*, June 28, 1877, 378, quoted in Jacobson, *Whiteness of a Different Color*, 164.

70　Stanley McKenna, "Reviving a Prejudice," *New York Herald*, July 22, 1879, 5; also see *Coney Island and the Jews: A History of the Development and Success of This Famous Seaside Resort Together with a Full Account of the Recent Jewish Controversy* (New York: C. W. Carleton, 1879). In June 1879, Hilton and Corbin came together to found the American Society for the Suppression of Jews. In Leonard Dinnerstein, *Antisemitism in America* (New York: Oxford University Press, 1994), 40.

71　Nina Morais, "Jewish Ostracism in America," *North American Review* 133:298 (September 1881): 269.

72　David Watkin et al., *Grand Hotel: The Golden Age of Palace Hotels, An Architectural and Social History* (New York: Vendome Press, 1984), 13–18; Nikolaus Pevsner, *A History of Building Types* (Princeton, NJ: Princeton University Press, 1976), 176, 182.

73　This is an 1876 description of the Palmer House hotel in Chicago provided by a European visitor in Henry Sienkiewicz, *Portrait of America: Letters of Henry Sienkiewicz*, ed. and trans. Charles Morley (New York: Columbia University Press, 1959), 50.

74　*Coney Island and the Jews*, 11, 17–18; Theodore Dreiser, *The Color of a Great City* (New York: Boni and Liveright, 1923), 121.

75　Michael Immerso, *Coney Island: The People's Playground* (New Brunswick, NJ: Rutgers University Press, 2002), 25.

76　*Magee's Centennial Guide*, 29; Westcott, *Official Guide Book to Philadelphia*, 192; *American Architect and Building News*, May 6, 1876, 145; "Fine Arts: The Pennsylvania Academy," *Nation*, May 4, 1876, 297–98; "Centennial Exposition Memoranda," 316; McCabe, *Illustrated History of the Centennial Exhibition*, 86–87.

77　Pamela Perry, *Shades of White: White Kids and Racial Identities in High School* (Durham, NC: Duke University Press, 2002).

78　Caroline Golab, "The Immigrant and the City: Poles, Italians, and Jews in Philadelphia, 1870–1920," in *The Peoples of Philadelphia: A History of Ethnic Groups, and Lower-Class Life, 1790–1940*, ed. Allen F. Davis and Mark H. Haller (Philadelphia: Temple University Press, 1998), 204.

79　"Philadelphia: Corrupt and Contented," *McClure's*, July 1903, quoted in Golab, "Immigrant and the City," 203.

80　Friedman, *Jewish Life in Philadelphia*, 7, 48; Davis and Haller, *Peoples of Philadelphia*, 9. Philadelphia's population stood at 817,448 in 1876, according to the city census (conducted to correct undercounting in the national census of 1870), as reported in the *Philadelphia Inquirer*, April 3, 1876, 2.

81　Dinnerstein, *Antisemitism in America*, 39; Friedman, *Jewish Life in Philadelphia*, 6; Louise A. Mayo, *The Ambivalent Image: Nineteenth-Century America's Perception of the Jew* (Toronto: Associated University Presses, 1988), 13–14.

82 Édouard Drumont, *La France Juive: Essai d'histoire contemporaine,* 2 vols. (Paris: C. Marpon & E. Flammarion, 1887), quoted in Patrick Girard, "Historical Foundations of Anti-Semitism," in *Survivors, Victims, and Perpetrators: Essays on the Nazi Holocaust,* ed. Joel E. Dimsdale (New York: Hemisphere, 1980), 71; also see 55–77.

83 Zygmunt Bauman, *Modernity and the Holocaust* (Ithaca, NY: Cornell University Press, 1989), 34–66.

84 "History of the Pennsylvania Academy of the Fine Arts to 1876," typescript in the Archives of American Art, Pennsylvania Academy of the Fine Arts Records, microfilm roll 50, frame 512. For a brief sketch of Harrison's career in locomotive and boiler production, and in iron smelting, see his obituary in *Scientific America* 30:16 (November 1, 1874): 248.

85 *Stranger's Illustrated Pocket Guide,* 98.

86 Syckelmoore, *Syckelmoore's Illustrated Handbook,* 20; McCabe, *Illustrated History of the Centennial Exhibition,* 29.

87 John K. Brown, *The Baldwin Locomotive Works, 1831–1915* (Baltimore: Johns Hopkins University Press, 1995); Domenic Vitiello, "Engineering the Metropolis: William Sellers, Joseph M. Wilson, and Industrial Philadelphia," *Pennsylvania Magazine of History and Biography* 126:2 (July 2002): 273–303.

88 *Inauguration of the New Building,* 20.

89 "Centennial Exposition Memoranda," 316.

90 "Academy of the Fine Arts, Philadelphia," *Art Journal* 2:19 (July 1876): 202.

91 Robert Venturi, *Complexity and Contradiction in Architecture* (New York: Museum of Modern Art, 1966), 25.

CHAPTER 4

1 Charles Musser, *The Emergence of Cinema: The American Screen to 1907,* vol. 1 (Berkeley and Los Angeles: University of California Press, 1990), 417–18. Musser also indicates that nickelodeons came late to New York City.

2 Ibid., 2–3. The first movie catalogue produced by the American Mutoscope & Biograph Company in 1902 contains an entire section of "Vaudeville" offerings. In *Picture Catalogue: American Mutoscope & Biograph Company* (New York: American Mutoscope & Biograph Company, 1902), 7; reproduced in *Thomas A. Edison Papers: A Guide to Motion Picture Catalogs by American Producers and Distributors, 1894–1908: A Microfilm Edition* (Frederick, MD: University Publications of America, 1985), reel 2, H-006.

3 The practice of inserting unrelated entertainments between the acts of a performance has a long

tradition. As Lawrence Levine has explained, this custom was a staple of operatic and theater performances throughout the nineteenth century. In *Highbrow/Lowbrow: The Emergence of Cultural Hierarchy in America* (Cambridge, MA: Harvard University Press, 1988). The seamless border between live and recorded performances is suggested also by the decline of stage vaudeville in the late 1920s and early 1930s and its replacement by film. Having initially been introduced as a complement to live vaudeville performances, movies were part of the complex cultural shift that edged vaudeville out of theaters while providing what became a more satisfying, and less costly, entertainment.

4 Noël Burch, "Porter, or Ambivalence," *Screen* 19 (Winter 1978/1979): 91–105; Musser, *Emergence of Cinema*, 4–5. Early cinema, typically defined as that produced before 1907, is characterized by production techniques that might be termed pre-Griffith. Michael Rogin notes that "minstrelsy's successors, vaudeville, Tin Pan Alley, motion pictures, and radio, did not so much displace as incorporate blackface." In *BlackFace, White Noise: Jewish Immigrants in the Hollywood Melting Pot* (Berkeley and Los Angeles: University of California Press, 1996), 29.

5 *Baltimore Sun*, November 3, 1896, n.p. The article was reprinted in a promotional pamphlet published prior to 1897 by the American Mutoscope Company and quoted in *Biograph Bulletins 1896–1908*, compiled with an introduction and notes by Kemp R. Niver (Los Angeles: Artisan Press, 1971), 16. Charles Musser notes that in 1896 an American Mutoscope projector toured with Cleveland's minstrels; in Musser, *Emergence of Cinema*, 155.

6 *Baltimore American*, November 3, 1896, n.p., quoted in Niver, *Biograph Bulletins*, 15.

7 Musser, *Emergence of Cinema*, 148. Biograph's 1902 catalogue lists *Hard Wash* along with *A Watermelon Feast* and *Dancing Darkies*. Its description reads: "A colored woman washing a little pickaninny. Very funny, and especially pleasing to children." In *Picture Catalogue*, 9; reproduced in *Edison Papers*, reel 2, H-007.

8 *Edison Films War Extra Catalogue*, May 10, 1898, supplement no. 4, 3–4, 6; reproduced in *Edison Papers*, reel 1, G-015.

9 *War Extra*, 3; reproduced in *Edison Papers*, reel 1, G-014.

10 In a very different but related context, the ethnographer Pamela Perry discovered that late twentieth-century high school students in homogeneously white schools tend to maintain racial hierarchies by mapping stereotypical "black" traits onto groups of white students who display deviance from the norm. Without conscious awareness, the students demonstrate the power of racial thinking even when minorities are largely absent. For her revealing study, see Pamela Perry, *Shades of White: White Kids and Racial Identities in High School* (Durham, NC: Duke University Press, 2002), esp. 25–43.

11 *Kansas City Star*, December 2, 1896, n.p., quoted in Niver, *Biograph Bulletins*, 20.

12 We can be fairly certain that the fire film shown at the Century was *New York Fire Department*,

given that a review of *Palmer Cox's Brownies* appearing the previous month during its Chicago run mentions this film by name. In *Chicago Chronicle*, November 17, 1896, n.p., quoted in Niver, *Biograph Bulletins*, 18.

13 For the most comprehensive discussion of Cox's life and work, see Roger W. Cummins, *Humorous but Wholesome: A History of Palmer Cox and the Brownies* (Watkins Glenn, NY: Century House Americana Publishers, 1973); *Libretto of Palmer Cox's Brownies*, words by Palmer Cox and music by Malcolm Douglas (New York: T. B. Harris, 1894), 20.

14 *Picture Catalogue*, 7; reproduced in *Edison Papers*, reel 2, H-006.

15 See *Chicago Chronicle*, November 17, 1896; *St. Louis Post Dispatch*, November 23, 1896, n.p., quoted in Niver, *Biograph Bulletins*, 18, 19.

16 For a sophisticated discussion of how this fluctuating reputation had more to do with the psychic needs of the public than with changes in the actions of firemen, see Amy Greenberg, *Cause for Alarm: The Volunteer Fire Department in the Nineteenth-Century City* (Princeton, NJ: Princeton University Press, 1998).

17 Cummins, *Humorous but Wholesome*, 70; Cox, *Brownies*, iv.

18 *St. Louis Post-Dispatch*, November 23, 1896, n.p., quoted in Niver, *Biograph Bulletins*, 19.

19 For prints in the *Darktown* series, see *Currier & Ives: A Catalogue Raisonné*, compiled by Gale Research Company, with an introduction by Bernard F. Reilly (Detroit: Gale Research Company, 1984), 149–65. Those that depict black firemen are numbered 1511–23, 1527–29, and 1560.

20 The concerns outlined here were refined through a conversation with Michael Harris, a former colleague at the University of North Carolina at Chapel Hill who specializes in African and African American art. Although he will not agree with my ultimate decision to reproduce these images, I hope he will appreciate my acknowledgment of the dangers they pose.

21 Joel Williamson, *New People: Miscegenation and Mulattoes in the United States* (New York: Free Press, 1980), 108

22 F. James Davis, *Who Is Black? One Nation's Definition* (University Park: Pennsylvania State University Press, 1991), 54.

23 John Blassingame, *Black New Orleans* (Chicago: University of Chicago Press, 1973), 201; quoted in Davis, *Who Is Black?* 98.

24 Williamson, *New People*, 108; see also 98–109.

25 Mark Twain, *Pudd'nhead Wilson and Those Extraordinary Twins*, edited with an introduction by Malcolm Bradbury (New York: Penguin Books, 1986), 63. Subsequent page references to *Pudd'nhead Wilson* appear in parentheses in the text.

26 See, for example, the essays by John H. Schaar, Michael Rogin, and Myra Jehlen in Susan Gillman and Forrest G. Robinson, eds., *Mark Twain's Pudd'nhead Wilson: Race, Conflict, and Cul-*

ture (Durham, NC: Duke University Press, 1990). For other sophisticated discussions of Twain's novel, see Susan Gillman, *Dark Twins: Imposture and Identity in Mark Twain's America* (Chicago: University of Chicago Press, 1989), and Eric J. Sundquist, *To Wake the Nations: Race in the Making of American Literature* (Cambridge, MA: Harvard University Press, 1993).

27 Michael Rogin, "Francis Galton and Mark Twain: The Natal Autograph in *Pudd'nhead Wilson*," in Gillman and Robinson, *Mark Twain's Pudd'nhead Wilson*, 73. Tom's "negative" traits may also be explained without acknowledging the "confusing" articulation of his character. He may not act in the manner of his white father or uncle, but he exhibits a middle range of white cruelty that locates his moral position between the selfish indifference exhibited by the aristocratic First Families of Virginia and the inhumanity of the Yankee plantation owner's wife who attempts to engineer Roxy's painful death. If not the best white person in the novel, Tom is probably not the worst. Or we might argue that modern readers make unreasonable demands of the novel in expecting all of Tom's negative qualities to be readily traced to a social source. Not only is it unrealistic to imagine a character who is wholly formed by socialization; it is simplistic to assume that all biologically rooted characteristics are also racial. Tom's genetics may have played a role in his cruelty without the "black" thirty-second of him having anything to do with the development of his character.

28 John Tehranian, "Performing Whiteness: Naturalization Litigation and the Construction of Racial Identity in America," *Yale Law Journal* 109:14 (January 2000): 820–21.

29 Sundquist, *To Wake the Nations*, 278. European-Americans also tolerated parodies of their actions by blacks on Election Day, an African American celebration dating to the 1750s, which saw slaves electing their own government officials, appropriating their masters' clothing, mounting their horses, and at times even forming army platoons. See Eric Lott, *Love and Theft: Blackface Minstrelsy and the American Working Class* (New York: Oxford University Press, 1993), 46–47.

30 Ronald H. Bayor and Timothy J. Meagher, eds., *New York Irish* (Baltimore: Johns Hopkins University Press, 1996), 26; for discussions of how other American populations negotiated the white-black divide, see Neil Foley, *The White Scourge: Mexicans, Blacks, and Poor Whites in Texas Cotton Culture* (Berkeley and Los Angeles: University of California Press, 1997).

31 David Roediger, *The Wages of Whiteness: Race and the Making of the American Working Class* (New York: Verso, 1991); Noel Ignatiev, *How the Irish Became White* (New York: Routledge, 1995).

32 Hasia R. Diner, "The Most Irish City in the Union," in Bayor and Meagher, *New York Irish*, 105.

33 Chris McNickle, "When New York Was Irish, and After," in Bayor and Meagher, *New York Irish*, 341–42.

34 Roediger, *Wages of Whiteness*, 133.

35 Ignatiev, *How the Irish Became White*, 59. Also see Sarah Banet-Weiser, *The Most Beautiful Girl in the World: Beauty Pageants and National Identity* (Berkeley and Los Angeles: University of California Press, 1999), 161–62.

36 Interested readers may view the film at the Web page for the Library of Congress's Motion
 Picture and Television Reading Room. The film is available at <http://memory.loc.gov/cgi-bin/
 query/D?papr:2:./temp/~ammem_axcy::>.

37 See the large advertisements featuring the film in the *New York Clipper*, November 4, 1903, 920;
 December 12, 1903, 1016.

38 While I do not wish to belabor the point about how early films were raced by context, neither
 do I wish to leave readers with the impression that *The Great Train Robbery* may have been
 less closely tied to racialized themes than the previous films discussed. First, it is worth noting
 that *The Great Train Robbery* was produced in a trilogy by Porter with *The Life of an Amer-
 ican Fireman* (1902–3) and *Uncle Tom's Cabin* (1903). Consider also that during the same week
 in which the film premiered at Huber's Museum in New York City, the amusement hall ad-
 vertised the season's first view of "Krao, 'the missing link,' who is considered one of the great-
 est living freaks, especially with those who hold to Darwinian theory." In the *New York Clipper*,
 December 19, 1903, 1029. Also bear in mind that of the eleven theaters showing *The Great
 Train Robbery* during its second week in New York (Hurtig & Seamon's; Circle Theatre; Proc-
 tor's 125th Street; Keith's 14th Street; Harlem Opera House; Tony Pastor's; Eden Musee; Hu-
 ber's Museum; Orpheum, Brooklyn; Comedy Theatre; and the Orpheum Music Hall), at least
 ten routinely featured acts of whites impersonating African Americans, Jews, Asians, and Na-
 tive Americans. While I suspect that *all* of these theaters featured racial transvestism, I have
 been unable to document any of the performances for the Comedy Theatre. What follows is a
 listing of the ten theaters, along with a sampling of the racialized acts they advertised around
 the time *The Great Train Robbery* was first exhibited. Hurtig & Seamon's: "Ned Wayburn's
 Minstrel Misses," *New York Clipper*, December 12, 1903, 1005. Circle Theatre: "Ned Wayburn's
 Minstrel Misses, composed of seventeen young women, who . . . black up in full view of the
 audience," *New York Clipper*, December 26, 1903, 1052; "Hebrew Parodies," *New York Clip-
 per*, January 16, 1904, 1128; "Geo. W. Day in black face monologue," *New York Clipper*, No-
 vember 7, 1903; "Lew Hawkins, one of the really few clever burnt cork comedians," *New York
 Clipper*, December 12, 1903, 1005. Proctor's: "Howe and Scott, Hebrew comedians," *New York
 Clipper*, November 7, 1903, 885. Keith's: "Harry and Sadie Fields . . . [in] Hebrew Cake Walk,"
 New York Clipper, December 26, 1903. Harlem Opera House: "Four Cohans," *New York Clip-
 per*, November 7, 1903, 884; "Sultan of Sulu," *New York Clipper*, November 14, 1903, 910; "A
 Chinese Honeymoon," *New York Clipper*, January 16, 1904, 1128. Tony Pastor's: "Adamind
 and Taylor in . . . 'The Wandering Minstrels,'" *New York Clipper*, December 5, 1903, 981; "Ray-
 mond Teal, black face songs and stories . . . [and] Seeker, Wilkes and Co., Cute, Comical, Cun-
 ning Coons," *New York Clipper*, December 19, 1903. Eden Musee: "Wonita and Hiawata, In-
 dian basket makers," *New York Clipper*, November 7, 1903, 885. Huber's Museum: "A
 convention of Barnum Freaks . . . [and] Moore's New Orleans Minstrels," *New York Clipper*,
 December 5, 1903, 980; "Indian Tableaux," *New York Clipper*, November 14, 1903, 909. Or-
 pheum, Brooklyn: "George Walton, minstrel comedian," *New York Clipper*, December 26, 1903,
 1061; "George Thatcher, the Minstrel," *New York Clipper*, November 7, 1903, 885; "Minstrel
 Lew Hawkins," *New York Clipper*, December 19, 1903, 1029. Orpheum Music Hall: "McIntyre

and Heath . . . America's representative black face comedians," *New York Clipper*, December 26, 1903, 1072.

39 *New York Clipper*, December 5, 1903, 1016.

40 The film historian Eileen Bowser points out that even after the ascendancy of feature films in the second decade of the twentieth century, viewers clung to their habit of entering the theater whenever they wished rather than at published starting times. In *The Transformation of Cinema: 1907–1915*, vol. 2 (Berkeley and Los Angeles: University of California Press, 1990), 192. Not only did individual shots of multiscene films often have a stand-alone quality, but as Tom Gunning points out, their creators typically copyrighted each scene instead of the film as a whole. In Tom Gunning, "The Non-continuous Style of Early Film, 1900–1906," in *Cinema 1900–1906: An Analytical Study by the National Film Archive (London) and the International Federation of Film Archives*, vol. 1, comp. Roger Holman (Brussels: Fédération Internationale des Archives du Film, 1982), 220.

41 André Gaudreault, "Detours in Film Narrative: The Development of Cross-Cutting," in *Cinema 1900–1906*, 188–89; and Charles Musser, *Before the Nickelodeon: Edwin S. Porter and the Edison Manufacturing Company* (Berkeley and Los Angeles: University of California Press, 1991), 254–56.

42 For the absence of parallel editing during this period, see Gunning, "Non-continuous Style of Early Film," 219–29; Musser claims that the problem of temporality in early cinema "can be explained in large part by the severe limitations on temporal specificity in traditional lantern shows," which laid the earliest conceptual framework for moving picture shows. In Musser, *Before the Nickelodeon*, 153; also see 207. Musser dates parallel editing to 1909, with the creation of Griffith's *Lonely Villa*, in Musser, *Before the Nickelodeon*, 226.

43 Stephen Kern, *The Culture of Time and Space, 1880–1918* (Cambridge, MA: Harvard University Press, 1983), 12. Also see "Standard Time," *Harper's Weekly*, December 29, 1883, 843; Carlene E. Stephens, *On Time: How America Has Learned to Live by the Clock* (Boston: Little, Brown, 2002).

44 Michael O'Malley, *Keeping Watch: A History of American Time* (Washington, DC: Smithsonian Institution Press, 1990), 63, 80, 137.

45 Ibid., 60; Kern, *Culture of Time and Space*, 12–13.

46 Kern, *Culture of Time and Space*, 67–68.

47 O'Malley, *Keeping Watch*, 140, 143.

48 Ibid., 30–40; also see Mark M. Smith, *Mastered by the Clock: Time, Slavery, and Freedom in the American South* (Chapel Hill: University of North Carolina Press, 1997).

49 O'Malley, *Keeping Watch*, 215–17. Stephen Kern makes a similar point, noting that time conventions were challenged both by early cinema and by the electric light. In Kern, *Culture of Time and Space*, 29. While appreciating the novel temporal qualities of early cinema, Lynne Kirby

believes that both Porter's *Life of an American Fireman* and *The Great Train Robbery* express the new simultaneity promoted by standard time. In Lynne Kirby, *Parallel Tracks: The Railroad and Silent Cinema* (Durham, NC: Duke University Press, 1997), 53–55.

50 Kern, *Culture of Time and Space*, 71.

51 For how belief in older conceptions of time lingered at the close of the century, see ibid., 140.

52 O'Malley, *Keeping Watch*, 115–16.

53 Kirby, *Parallel Tracks*, 7; also see 1–73.

54 Ibid., 10.

55 Marx is careful to contrast the dominant, popularly embraced reading of the train as a symbol of civilization with competing, elite views that see it as its antithesis. In Leo Marx, *The Machine in the Garden: Technology and the Pastoral Ideal in America* (New York: Oxford University Press, 2000), 383. For the conflicted resonances of technologies for European-Americans, see David E. Nye, *America as Second Creation: Technology and Narratives of New Beginnings* (Cambridge, MA: MIT Press, 2003).

56 Gail Bederman, *Manliness and Civilization: A Cultural History of Gender and Race in the United States, 1880–1917* (Chicago: University of Chicago Press, 1995), 23, 50.

57 For more on the cultural resonances of the train for European-Americans, see Susan Danly and Leo Marx, eds., *The Railroad in American Art: Representations of Technological Change* (Cambridge, MA: MIT Press, 1988).

58 Such instability may have been encouraged in the case of the railroad by European-Americans understanding that this stereotypically white symbol was constructed by nonwhite and "deviant" laborers, including Irish Catholic and Chinese immigrants, as well as defeated Confederate soldiers. See Stephen E. Ambrose, *Nothing Like It in the World: The Men Who Built the Transcontinental Railroad, 1863–1869* (New York: Simon and Schuster, 2000).

59 For Kirby's thesis on "train travel as a paradigm for cinematic spectatorship based on shock," see *Parallel Tracks*, 57–72.

60 John M. Coward notes the regularity with which newspaper reports characterize Indians as prone to senseless violence, savagery, barbarity, treachery, and attacks on unarmed civilians in *The Newspaper Indian: Native American Identity in the Press, 1820–1890* (Urbana: University of Illinois Press, 1999), 105–6, 198–99, 230–31. For more on the complex ways in which the idea of Indians has been used by European-Americans, see Philip J. Deloria, *Playing Indian* (New Haven, CT: Yale University Press, 1998).

61 Musser, *Emergence of Cinema*, 429–30.

62 Ibid., 10–11.

63 In her discussion of gender and horror movies, Carol Clover notes how the common cinematic convention of forcing audiences to look through the eyes of a killer as he stalks his victim aligns viewer and murderer. In her analysis, it is "the subjective camera [that] makes killers . . . of us all." In *Men, Women, and Chain Saws: Gender in the Modern Horror Film* (Princeton, NJ: Princeton University Press, 1992), 186.

64 Paul Leicester Ford, *The Great K. & A. Train-Robbery* (New York: Dodd, Mead, 1897), 7, 11. Subsequent page references to *The Great K. & A. Train-Robbery* appear in parentheses in the text.

65 Frank H. Spearman, *The Nerve of Foley and Other Railroad Stories* (New York: Harper and Brothers, 1900), 142; Cy Warman, *The Express Messenger and Other Tales of the Rail* (New York: Scribner's, 1897), 14; John Finis Philips, *Speeches of Judge John F. Philips and Wm. H. Wallace, Prosecuting Attorney of Jackson County, Missouri: In the Trial of Frank James at Gallatin, Missouri, for Murder Committed While Engaged in Train Robbery* (Kansas City: s.n., 1898), 208.

66 James Baldwin, *The Fire Next Time* (New York: Vintage Books, 1991), 96. *The Great K. & A. Train-Robbery*, unlike *The Great Train Robbery*, contains passing references to African Americans. On three separate occasions, Gordon refers to his train porters as "darkies."

BIBLIOGRAPHY

Aarsleff, Hans. "Locke's Influence." In *The Cambridge Companion to Locke*, edited by Vere Chappell, 252–89. Cambridge: Cambridge University Press, 1994.

"Academy of the Fine Arts, Philadelphia." *Art Journal* 2:19 (July 1876): 202.

Adams, Henry. *Esther*. New York: Prometheus Books, 1997 [1884].

Alland, Alexander. *Human Diversity*. New York: Columbia University Press, 1971.

Allen, James. *Without Sanctuary: Lynching Photography in America*. Santa Fe, NM: Twin Palms, 2000.

Allen, Joseph Henry. *Hebrew Men and Times from the Patriarchs to the Messiah*. Boston: Roberts Brothers, 1879.

Allen, Theodore W. *The Invention of the White Race*. 2 vols. New York: Verso, 1997.

Ambrose, Stephen E. *Nothing Like It in the World: The Men Who Built the Transcontinental Railroad, 1863–1869*. New York: Simon and Schuster, 2000.

"An American Style." *Sloan's Architect and Building Journal*, November 1868, 334–36.

Anderson, Kat. "We Are Still Here." *Yosemite* 53 (1991): 1–5.

"Architecture in America: Naissant and Renaissant." *Architectural Review and American Building Journal* (April 1869): 609–13.

Arnesen, Eric. "Assessing Whiteness Scholarship: A Response to James Barrett, David Brody, Barbara Fields, Eric Foner, Victoria Hattam, and Adolph Reed." *International Labor and Working-Class History* 60 (Fall 2001): 81–92.

―――. "Whiteness and the Historians' Imagination." *International Labor and Working-Class History* 60 (Fall 2001): 3–32.

Augstein, H. F., ed. *Race: The Origins of an Idea, 1760–1850.* Bristol, UK: Thoemmes Press, 1996.

"The Backbone of America." *Penn Monthly* 1:6 (June 1870): 226–40.

Baldwin, James. *The Fire Next Time.* New York: Vintage Books, 1991.

―――. *The Price of the Ticket: Collected Nonfiction, 1948–1985.* New York: St. Martin's Press, 1985.

Balibar, Etienne, and Immanuel Wallerstein. *Race, Nation, Class: Ambiguous Identities.* New York: Verso, 1991.

Bancroft, A. L. *Bancroft's Tourist's Guide: Yosemite, San Francisco, and Around the Bay (South).* San Francisco: A. L. Bancroft, 1871.

Banet-Weiser, Sarah. *The Most Beautiful Girl in the World: Beauty Pageants and National Identity.* Berkeley and Los Angeles: University of California Press, 1999.

Barrett, James R. "Whiteness Studies: Anything Here for Historians of the Working Class?" *International Labor and Working-Class History* 60 (Fall 2001): 33–42.

Barrett, James R., and David Roediger. "Inbetween Peoples: Race, Nationality and the 'New Immigrant' Working Class." *Journal of American Ethnic History* 16:3 (Spring 1997): 3–44.

Barrett, S. A. "Myths of the Southern Sierra Miwok." *American Archaeology and Ethnography* 16:1 (March 27, 1919): 26–27.

Barton, Craig Evan, ed. *Sites of Memory: Perspectives on Architecture and Race.* New York: Princeton Architectural Press, 2001.

Batchen, Geoffrey. *Burning with Desire: The Conception of Photography.* Cambridge, MA: MIT Press, 1997.

Bauman, Zygmunt. *Modernity and the Holocaust.* Ithaca, NY: Cornell University Press, 1989.

Bayor, Ronald H., and Timothy J. Meagher, eds. *New York Irish.* Baltimore: Johns Hopkins University Press, 1996.

Beadle, J. H. *The Undeveloped West; or Five Years in the Territories.* Philadelphia: National Publishing Company, 1873.

Bedell, Rebecca. *The Anatomy of Nature: Geology and American Landscape Painting, 1825–1875.* Princeton, NJ: Princeton University Press, 2001.

Bederman, Gail. *Manliness and Civilization: A Cultural History of Gender and Race in the United States, 1880–1917.* Chicago: University of Chicago Press, 1995.

Bennett, Tony. *The Birth of the Museum: History, Theory, Politics.* New York: Routledge, 1995.

Berger, Maurice. *White Lies: Race and the Myth of Whiteness.* New York: Farrar, Straus and Giroux, 1999.

Berger, Peter L., and Thomas Luckmann. *The Social Construction of Reality: A Treatise in the Sociology of Knowledge.* Garden City, NY: Doubleday, 1966.

Bernardi, Daniel, ed. *The Birth of Whiteness: Race and the Emergence of U.S. Cinema*. New Brunswick, NJ: Rutgers University Press, 1996.

Bierbower, Austin. "American Architecture." *Penn Monthly* 8:1 (December 1877): 936–44.

Black, Jeremy. *Maps and History: Constructing Images of the Past*. New Haven, CT: Yale University Press, 2000.

Blassigame, John. *Black New Orleans*. Chicago: University of Chicago Press, 1973.

Boime, Albert. *The Magisterial Gaze: Manifest Destiny and American Landscape Painting, c. 1830–1865*. Washington, DC: Smithsonian Institution Press, 1991.

Bonilla-Silva, Eduardo. *Racism without Racists: Color-Blind Racism and the Persistence of Racial Inequality in the United States*. New York: Rowman and Littlefield, 2003.

Boswell, John. "Categories, Experience and Sexuality." In *Forms of Desire: Sexual Orientation and the Social Constructionist Controversy*, edited by Edward Stein, 133–73. New York: Routledge, 1992.

Bourdieu, Pierre. *Distinction: A Social Critique of the Judgement of Taste*. Cambridge, MA: Harvard University Press, 1984.

———. "The School as a Conservative Force: Scholastic and Cultural Inequalities." In *Contemporary Research in the Sociology of Education*, edited by John Eggleston, 32–46. New York: Methuen, 1974.

Bowser, Eileen. *The Transformation of Cinema: 1907–1915*. Vol. 2. Berkeley and Los Angeles: University of California Press, 1990.

Bracken, Harry M. "Essence, Accident and Race." *Hermathena* 116 (1973): 81–96.

———. "Philosophy and Racism." *Philosophia* 8:2–3 (November 1978): 241–60.

Brander Rasmussen, Birgit, Eric Klinenberg, Irene J. Nexica, and Matt Wray, eds. *The Making and Unmaking of Whiteness*. Durham, NC: Duke University Press, 2001.

Brasso, Keith H. *Wisdom Sits in Places: Landscape and Language among the Western Apache*. Albuquerque: University of New Mexico Press, 1996.

Brodkin, Karen. *How Jews Became White Folks and What That Says about Race in America*. New Brunswick, NJ: Rutgers University Press, 1998.

Brown, John K. *The Baldwin Locomotive Works, 1831–1915*. Baltimore: Johns Hopkins University Press, 1995.

Browning, Peter. *Yosemite Place Names: The Historic Background of Geographic Names in Yosemite National Park*. Lafayette, CA: Great Western Books, 1988.

Bryson, Norman. *Vision and Painting: The Logic of the Gaze*. New Haven, CT: Yale University Press, 1983.

Bunnell, Lafayette Houghton. *Discovery of the Yosemite, and the Indian War of 1851, Which Led to That Event*. Chicago: Fleming H. Revell, 1880.

Burch, Noël. "Porter, or Ambivalence." *Screen* 19 (Winter 1978/1979): 91–105.

Burr, Samuel J. *Four Thousand Years of the World's Progress from the Early Ages to the Present Time.* Hartford, CT: L. Stebbins, 1878.

"California Photographs." *Journal of Photography and the Allied Arts and Sciences* 18:2 (May 15, 1866): 21.

"California Scenery in New York." *North Pacific Review* 2:7 (February 1863): 208.

Cameron, Sharon. *The Allegorical Self: Allegories of the Body in Melville and Hawthorne.* Baltimore: Johns Hopkins University Press, 1981.

Catalogue of the Forty-seventh Annual Exhibition of the Pennsylvania Academy of the Fine Arts. Philadelphia: Collins Printer, 1876.

Catalogue of the Property and Loan Exhibition of the Pennsylvania Academy of the Fine Arts. Philadelphia: Collins Printer, 1876.

Çelik, Zeynep. *Displaying the Orient: Architecture of Islam at Nineteenth-Century World's Fairs.* Berkeley and Los Angeles: University of California Press, 1992.

"Centennial Exposition Memoranda." *Potter's American Monthly* 7 (November 1876): 316.

Chomsky, Noam. *Language and Responsibility.* New York: Pantheon Books, 1977.

Cikovsky, Nicolai, Jr. "George Inness and the Hudson River School: *The Lackawanna Valley.*" *American Art* 2:2 (Fall 1970): 36–57.

Clifford, James. *The Predicament of Culture.* Cambridge, MA: Harvard University Press, 1988.

Clover, Carol J. *Men, Women, and Chain Saws: Gender in the Modern Horror Film.* Princeton, NJ: Princeton University Press, 1992.

Coates, Paul, and Daniel D. Hutto, eds. *Current Issues in Idealism.* Bristol, UK: Thoemmes Press, 1996.

Colbert, Charles. "*Fair Exchange, No Robbery:* William Sidney Mount's Commentary on Modern Times." *American Art* 8:3–4 (Summer/Fall 1994): 34.

———. *A Message of Perfection: Phrenology and the Fine Arts in America.* Chapel Hill: University of North Carolina Press, 1996.

Cole, David. *No Equal Justice: Race and Class in the American Criminal Justice System.* New York: New Press, 1999.

Colt, S. S. *The Tourist's Guide through the Empire State.* Albany, NY: privately printed, 1871.

Coney Island and the Jews: A History of the Development and Success of This Famous Seaside Resort Together with a Full Account of the Recent Jewish Controversy. New York: C. W. Carleton, 1879.

Conn, Steven. *Museums and American Intellectual Life, 1876–1926.* Chicago: University of Chicago Press, 1998.

Corrin, Lisa G., ed. *Mining the Museum: An Installation by Fred Wilson.* Baltimore: New Press, 1994.

Cowan, Douglas E. "Theologizing Race: The Construction of Christian Identity." In *Religion and the Creation of Race and Ethnicity: An Introduction,* edited by Craig R. Prentis, 112–23. New York: New York University Press, 2003.

Coward, John M. *The Newspaper Indian: Native American Identity in the Press, 1820–1890.* Urbana: University of Illinois Press, 1999.

Cox, Palmer. *The Brownies Abroad.* New York: Century, 1899.

———. *The Brownies around the World.* New York: Century, 1894.

———. *The Brownies in the Philippines.* New York: Century, 1904.

———. *The Brownies, Their Book.* New York: Century, 1887.

Cox, Palmer, and Malcolm Douglas. *Libretto of Palmer Cox's Brownies.* New York: T. B. Harris, 1894.

Crary, Jonathan. *Techniques of the Observer: On Vision and Modernity in the Nineteenth Century.* Cambridge, MA: MIT Press, 1990.

Cummins, Roger W. *Humorous but Wholesome: A History of Palmer Cox and the Brownies.* Watkins Glenn, NY: Century House Americana Publishers, 1973.

Danly, Susan, and Leo Marx, eds. *The Railroad in American Art: Representations of Technological Change.* Cambridge, MA: MIT Press, 1988.

Davis, David Brion. *The Problem of Slavery in Western Culture.* New York: Oxford University Press, 1988.

———. *Slavery and Human Progress* New York: Oxford University Press, 1984.

Davis, Edward. *The History of Rodeph Shalom Congregation, Philadelphia, 1820–1926.* Philadelphia: Edward Stern, 1926.

Davis, F. James. *Who Is Black? One Nation's Definition.* University Park: Pennsylvania State University Press, 1991.

Davis, John. *The Landscape of Belief: Encountering the Holy Land in Nineteenth-Century American Art and Culture.* Princeton, NJ: Princeton University Press, 1996.

Dawes, Anna L. *The Modern Jew: His Present and Future.* Boston: D. Lothrop, 1886.

Deloria, Philip J. *Playing Indian.* New Haven, CT: Yale University Press, 1998.

DeLuca, Kevin. "In the Shadow of Whiteness: The Consequences of Constructions of Nature in Environmental Politics." In *Whiteness: The Communication of Social Identity,* edited by Thomas K. Nakayama and Judith N. Martin, 217–46. Thousand Oaks, CA: Sage, 1999.

"The Difference of Race between the Northern and Southern People." *Southern Literary Messenger* 30:26 (June 1860): 401–9.

DiMaggio, Paul. "Cultural Entrepreneurship in Nineteenth-Century Boston: The Creation of an Organizational Base for High Culture in America." In *Media, Culture, and Society: A Critical Reader,* edited by Richard Collins, 217–24. Beverly Hills, CA: Sage, 1986.

Dimock, George. *Exploiting the View: Photographs of Yosemite and Mariposa by Carleton Watkins.* North Bennington, VT: Park-McCullough House, 1984.

Diner, Hasia R. "The Most Irish City in the Union." In *New York Irish,* edited by Ronald H. Bayor and Timothy J. Meagher, 87–106. Baltimore: Johns Hopkins University Press, 1996.

Dinnerstein, Leonard. *Antisemitism in America.* New York: Oxford University Press, 1994.

———. "Antisemitism in Crisis Times in the United States: The 1920s and 1930s." In *Anti- Semitism in Times of Crisis*, edited by Sander L. Gilman and Steven Katz, 212–26. New York: New York University Press, 1991.

Doane, Ashley W., and Eduardo Bonilla-Silva, eds. *White Out: The Continuing Significance of Racism*. New York: Routledge, 2003.

Dole, Philip. "The Picket Fence at Home." In *Between Fences*, edited by George K. Dreicer, 26–35. New York: Princeton Architectural Press, 1996.

———. *The Picket Fence in Oregon: An American Vernacular Comes West*. Eugene: University of Oregon Press, 1986.

Dreiser, Theodore. *The Color of a Great City*. New York: Boni and Liveright, 1923.

Drumont, Édouard. *La France Juive: Essai d'histoire contemporaine*. 2 vols. Paris: C. Marpon & E. Flammarion, 1887.

D'Souza, Dinesh. *The End of Racism*. New York: Free Press, 1995.

DuBois, W. E. B. *The World and Africa: An Inquiry into the Part Which Africa Has Played in World History*. New York: International Publishers, 1965.

Dunn, John H. "The Politics of Locke in England and America in the Eighteenth Century." In *John Locke: Problems and Perspectives*, edited by John W. Yolton, 45–80. Cambridge: Cambridge University Press, 1969.

Dworetz, Steven. *The Unvarnished Doctrine: Locke, Liberalism, and the American Revolution*. Durham, NC: Duke University Press, 1990.

Dyer, Richard. *White*. New York: Routledge, 1997.

"Eclecticism in Architecture." *American Architect and Building News*, January 15, 1876, 18–19.

"Eclecticism in Architecture." *American Architect and Building News*, March 4, 1876, 80.

Exercises at the Laying of the Corner-Stone of the New Building of the Pennsylvania Academy of the Fine Arts, December 7, 1872. Philadelphia: Collins Printer, 1872.

Faust, Drew Gilpin. *The Creation of Confederate Nationalism: Ideology and Identity in the Civil War South*. Baton Rouge: Louisiana State University Press, 1988.

Feagin, Joe R., Hernán Vera and Pinar Batur. *White Racism: The Basics*. 2nd ed. New York: Routledge, 2001.

Ferguson, James. *A History of Architecture in All Countries from the Earliest Times to the Present Day*. New York: Dodd, Mead, 1874.

"Fine Arts. The Mount Collection." *New York Herald*, April 10, 1871, 7.

"Fine Arts: The Pennsylvania Academy." *Nation*, May 4, 1876, 297–98.

"The First American Art Academy: First Paper." *Lippincott's Magazine*, February 1872, 143–53.

Fisher, Philip. *Hard Facts: Setting and Form in the American Novel*. New York: Oxford University Press, 1985.

Flagg, Barbara J. "The Transparency Phenomenon, Race-Neutral Decisionmaking, and Discrimina-

tory Intent." In *Critical White Studies: Looking behind the Mirror,* edited by Richard Delgado and Jean Stefancic, 220–26. Philadelphia: Temple University Press, 1997.

Foley, Neil. *The White Scourge: Mexicans, Blacks, and Poor Whites in Texas Cotton Culture.* Berkeley and Los Angeles: University of California Press, 1997.

Foner, Eric. "Response to Eric Arnesen." *International Labor and Working-Class History* 60 (Fall 2001): 57 60.

Fong, Wen C., and James C. Y. Watt. *Possessing the Past: Treasures from the National Palace Museum, Taipei.* New York: Abrams, 1996.

Ford, Paul Leicester. *The Great K. & A. Train Robbery.* New York: Dodd, Mead, 1897.

Fossett, Frank. *Colorado: Its Gold and Silver Mines, Farms and Stock Ranges, and Health and Pleasure Resorts.* New York: C. G. Crawford, 1879.

Frankenberg, Ruth, ed. *Displacing Whiteness: Essays in Social and Cultural Criticism.* Durham, NC: Duke University Press, 1997.

———. "The Mirage of Unmarked Whiteness." In *The Making and Unmaking of Whiteness,* edited by Birgit Brander Rasmussen, Eric Klinenberg, Irene J. Nexia, and Matt Wray, 72–96. Durham, NC: Duke University Press, 2001.

———. *White Women, Race Matters: The Social Construction of Whiteness.* Minneapolis: University of Minnesota Press, 1993.

Gaudreault, André. "Detours in Film Narrative: The Development of Cross-Cutting." In *Cinema 1900–1906: An Analytical Study by the National Film Archive (London) and the International Federation of Film Archives,* vol. 1, compiled by Roger Holman, 254–56. Brussels: Fédération Internationale des Archives du Film, 1982.

Genovese, Eugene D. *The Slaveholders' Dilemma: Freedom and Progress in Southern Conservative Thought, 1820–1860.* Columbia: University of South Carolina Press, 1995.

Gerber, David A., ed. *Anti-Semitism in American History.* Urbana: University of Illinois Press, 1986.

Gillman, Susan. *Dark Twins: Imposture and Identity in Mark Twain's America.* Chicago: University of Chicago Press, 1989.

Gillman, Susan, and Forrest G. Robinson, eds. *Mark Twain's Pudd'nhead Wilson: Race, Conflict, and Culture.* Durham, NC: Duke University Press, 1990.

Gilman, Sander. *The Jew's Body.* New York: Routledge, 1991.

Girard, Patrick. "Historical Foundations of Anti-Semitism." In *Survivors, Victims, and Perpetrators: Essays on the Nazi Holocaust,* edited by Joel E. Dimsdale, 55–77. New York: Hemisphere Publishing, 1980.

Giroux, Henry A. *Disturbing Pleasures: Learning Popular Culture.* New York: Routledge, 1994.

Glausser, Wayne. "Three Approaches to Locke and the Slave Trade." *Journal of the History of Ideas* 51:2 (April–June 1990): 199–216.

Golab, Caroline. "The Immigrant and the City: Poles, Italians, and Jews in Philadelphia, 1870–1920."

In *The Peoples of Philadelphia: A History of Ethnic Groups, and Lower-Class Life, 1790–1940*, edited by Allen F. Davis and Mark H. Haller, 203–30. Philadelphia: Temple University Press, 1998.

Goldberg, Theo David. *Racist Culture: Philosophy and the Politics of Meaning*. Cambridge, MA: Blackwell, 1993.

Gombrich, Ernst. *Art and Illusion: A Study of the Psychology of Pictorial Representation*. New York: Pantheon Books, 1961.

Gossett, Thomas F. *Race: The History of an Idea in America*. New York: Oxford University Press, 1997.

Greeley, Horace. *An Overland Journey from New York to San Francisco in the Summer of 1859*. New York: C. M. Saxton, Baker, 1860.

Greenberg, Amy. *Cause for Alarm: The Volunteer Fire Department in the Nineteenth-Century City*. Princeton, NJ: Princeton University Press, 1998.

Grillo, Trina, and Stephanie M. Wildman. "Obscuring the Importance of Race: The Implications of Making Comparisons between Racism and Sexism (or Other Isms)." In *Critical White Studies: Looking behind the Mirror*, edited by Richard Delgado and Jean Stefancic, 619–26. Philadelphia: Temple University Press, 1997.

Guglielmo, Thomas A. *White on Arrival: Italians, Race, Color, and Power in Chicago, 1890–1945*. New York: Oxford University Press, 2003.

Guiner, Lani, and Gerald Torres. *The Miner's Canary: Enlisting Race, Resisting Power, Transforming Democracy*. Cambridge, MA: Harvard University Press, 2002.

Gunning, Thomas. "Non-continuity, Continuity, Discontinuity: A Theory of Genres in Early Film." *Iris* 2:1 (1984): 101–12.

———. "The Non-continuous Style of Early Film, 1900–1906." In *Cinema 1900–1906: An Analytical Study by the National Film Archive (London) and the International Federation of Film Archives*, vol. 1, compiled by Roger Holman, 219–30. Brussels: Fédération Internationale des Archives du Film, 1982.

Hale, Grace Elizabeth. *Making Whiteness: The Culture of Segregation in the South, 1890–1940*. New York: Vintage Books, 1999.

Hambourg, Maria Morris. "Carleton Watkins: An Introduction." In *Carleton Watkins: The Art of Perception*, edited by Douglas R. Nickel, 8–17. New York: Abrams, 1999.

Harris, Cheryl. "Whiteness as Property." *Harvard Law Review* 106:8 (June 1993): 1709–91.

Harris, Michael D. *Colored Pictures: Race and Visual Representation*. Chapel Hill: University of North Carolina Press, 2003.

Harris, Neil. *The Artist in American Society: The Formative Years*. New York: George Braziller, 1966.

Hawkins, Dexter A. *The Anglo-Saxon Race: Its History, Character, and Destiny: An Address before the Syracuse University, at Commencement, June 21, 1875*. New York: Nelson and Phillips, 1875.

Henderson, Helen. *The Pennsylvania Academy of the Fine Arts and Other Collections of Philadelphia*. Boston: L. C. Page, 1911.

Hernstein, Richard J., and Charles Murray. *The Bell Curve: Intelligence and Class Structure in American Life*. New York: Simon and Schuster, 1996.

Hersey, George L. *High Victorian Gothic: A Study in Associationism*. Baltimore: Johns Hopkins University Press, 1972.

Hill, Mike. *After Whiteness: Unmaking an American Majority*. New York: New York University Press, 2004.

———, ed. *Whiteness: A Critical Reader*. New York: New York University Press, 1997.

Hine, Edward. *Forty-seven Identifications of the British Nation and the United States with the Lost Ten Tribes of Israel*. London: W. H. Guest, 1879.

———. *Forty-seven Identifications of the British Nation with the Lost Ten Tribes of Israel: Founded upon Five Hundred Scripture Proofs*. London: W. H. Guest, 1874.

Hinsley, Curtis M. "The World as Marketplace: Commodification of the Exotic at the World's Columbian Exposition, Chicago, 1893." In *Exhibiting Cultures: The Poetics and Politics of Museum Display*, edited by Ivan Karp and Steven D. Levine, 344–65. Washington, DC: Smithsonian Institution Press, 1991.

Hirschfeld, Lawrence A. *Race in the Making: Cognition, Culture, and the Child's Construction of Human Kinds*. Cambridge, MA: MIT Press, 1998.

Hittell, John S. *The Resources of California Comprising Agriculture, Mining, Geography, Climate, Commerce*. San Francisco: A. Roman, 1863.

———. *Yosemite: Its Wonders and Its Beauties*. San Francisco: H. H. Bancroft, 1868.

Holmes, Oliver Wendell. "Doings of the Sunbeam." *Atlantic Monthly* 12:69 (July 1863): 1–15.

Holt, Thomas. *The Problem of Race in the Twenty-first Century*. Cambridge, MA: Harvard University Press, 2000.

Hood, Mary V. "Charles L. Weed, Yosemite's First Photographer." *Yosemite Nature Notes* 38:6 (June 1959): 76–87.

hooks, bell. *Black Looks: Race and Representation*. Boston: South End Press, 1992.

———. *Killing Rage: Ending Racism*. New York: Holt, 1995.

Horsman, Reginald. *Race and Manifest Destiny: The Origins of American Racial Anglo-Saxonism*. Cambridge, MA: Harvard University Press, 1981.

Hudson, Joseph, Jr. "Banks, Politics, Hard Cider, and Paint: The Political Origins of William Sidney Mount's *Cider Making*." *Metropolitan Museum Journal* 10 (1975): 107–18.

Hughes, Langston. *The Ways of White Folks*. New York: Vintage Books, 1990.

Huntington, David C. *The Landscapes of Frederic Edwin Church: Vision of an American Era*. New York: George Braziller, 1966.

Ignatiev, Noel. *How the Irish Became White*. New York: Routledge, 1995.

Ignatiev, Noel, and John Garvey, eds. *Race Traitor*. New York: Routledge, 1996.

Immerso, Michael. *Coney Island: The People's Playground.* New Brunswick, NJ: Rutgers University Press, 2002.

Inauguration of the New Building of the Pennsylvania Academy of the Fine Arts, 22 April, 1876. Philadelphia: Pennsylvania Academy of the Fine Arts, 1876.

Jacobson, Matthew Frye. *Barbarian Virtues: The United States Encounters Foreign Peoples at Home and Abroad, 1876–1917.* New York: Hill and Wang, 2000.

———. *Whiteness of a Different Color: European Immigrants and the Alchemy of Race.* Cambridge, MA: Harvard University Press, 1998.

Jahoda, Gustav. *Images of Savages: Ancient Roots of Modern Prejudice in Western Culture.* New York: Routledge, 1999.

James, Henry, Jr. *Hawthorne.* London: Macmillan, 1879.

Jennings, Francis. *The Invasion of America: Indians, Colonialism, and the Cant of Conquest.* New York: Norton, 1976.

"The Jews." *Saturday Evening Post* 55:15 (November 6, 1875): 7.

Johns, Elizabeth. *American Genre Painting: The Politics of Everyday Life.* New Haven, CT: Yale University Press, 1991.

Johnson, Deborah J., ed. *William Sidney Mount: Painter of American Life.* New York: New York Federation of Arts, 1998.

Johnson, Diane Chalmers. *American Art Nouveau.* New York: Abrams, 1979.

Jones, Alfred. "A Sketch of the Life and Character of William Sidney Mount." *American Whig Review* 14:80 (August 1851): 122–27.

Jordan, Winthrop. *White over Black.* New York: Norton, 1977.

Kaplan, E. Ann. *Looking for the Other: Feminism, Film, and the Imperial Gaze.* New York: Routledge, 1997.

Kasson, John. *Rudeness and Civility: Manners in Nineteenth-Century Urban America.* New York: Hill and Wang, 1990.

Keller, Robert H., and Michael F. Turek. *American Indians and National Parks.* Tucson: University of Arizona Press, 1998.

Kelly, Franklin. *Frederic Edwin Church.* Washington, DC: National Gallery of Art, 1989.

Kern, Stephen. *The Culture of Time and Space, 1880–1918.* Cambridge, MA: Harvard University Press, 1983.

Kidney, Walter C. *The Architecture of Choice: Eclecticism in America, 1880–1930.* New York: George Braziller, 1974.

Kimmel, Michael S., and Amy L. Ferber, eds. *Privilege: A Reader.* Boulder, CO: Westview Press, 2003.

Kincheloe, Joe L., Shirley R. Steinberg, Nelson M. Rodriguez, and Ronald E. Chennault, eds. *White Reign: Deploying Whiteness in America.* New York: St. Martin's Griffin, 1998.

King, Desmond. *Making Americans: Immigration, Race, and the Origins of the Diverse Democracy.* Cambridge, MA: Harvard University Press, 2000.

Kirby, Lynne. *Parallel Tracks: The Railroad and Silent Cinema.* Durham, NC: Duke University Press, 1997.

Kolchin, Peter. "Whiteness Studies: The New History of Race in America." *Journal of American History* 89 (June 2002): 154–73.

Krech, Shepard, III. *The Ecological Indian: Myth and History.* New York: Norton, 1999.

Kristeller, Paul Oskar. *Renaissance Thought and the Arts: Collected Essays.* Princeton, NJ: Princeton University Press, 1990.

Langford, Nathaniel Pitt. *The Discovery of Yellowstone Park: Journal of the Washburn Expedition to the Yellowstone and Firehole Rivers in the Year 1870.* Lincoln: University of Nebraska Press, 1972.

Lazarre, Jane. *Beyond the Whiteness of Whiteness: Memoirs of a White Mother of Black Sons.* Durham, NC: Duke University Press, 1996.

Levine, Lawrence. *Highbrow/Lowbrow: The Emergence of Cultural Hierarchy in America.* Cambridge, MA: Harvard University Press, 1988.

Levine-Rasky, Cynthia, ed. *Working through Whiteness: International Perspectives.* Albany: State University of New York Press, 2002.

Lewis, Michael J. *Frank Furness: Architecture and the Violent Mind.* New York: Norton, 2001.

Lewontin, Richard C. "The Apportionment of Human Diversity." *Evolutionary Biology* 25 (1972): 276–80.

Lipsitz, George. *The Possessive Investment in Whiteness: How White People Profit from Identity Politics.* Philadelphia: Temple University Press, 1998.

Locke, Alain LeRoy. *Negro Art: Past and Present.* Washington, DC: Associates in Negro Folk Education, 1936.

Lokko, Lesley Naa Norle, ed. *White Paper, Black Marks: Architecture, Race, Culture.* Minneapolis: University of Minnesota Press, 2000.

López, Ian F. Haney. *White by Law: The Legal Construction of Race.* New York: New York University Press, 1996.

Lott, Eric. *Love and Theft: Blackface Minstrelsy and the American Working Class.* New York: Oxford University Press, 1993.

Ludlow, Fitz Hugh. *The Heart of the Continent: A Record of Travel across the Plains and in Oregon, with an Examination of Mormon Principle.* New York: Hurd and Houghton, 1870.

MacKenzie, John M. *Orientalism: History, Theory and the Arts.* Manchester: Manchester University Press, 1995.

Magee's Centennial Guide of Philadelphia. Philadelphia: R. Magee & Son, 1876.

Magoc, Chris J. *Yellowstone: The Creation and Selling of an American Landscape, 1870–1903.* Albuquerque: University of New Mexico Press, 1999.

Mander, W. J., ed. *Anglo-American Idealism, 1865–1927*. Westport, CT: Greenwood Press, 2000.

———. "Royce's Argument for the Absolute." *Journal of the History of Philosophy* 36:3 (July 1998): 443–57.

Marx, Leo. *The Machine in the Garden: Technology and the Pastoral Ideal in America*. New York: Oxford University Press, 2000.

Mayo, Louise A. *The Ambivalent Image: Nineteenth-Century America's Perception of the Jew*. Toronto: Associated University Presses, 1988.

McCabe, James D. *Illustrated History of the Centennial Exhibition*. Philadelphia: National Publishing Company, 1975.

McIntosh, James. *Nathaniel Hawthorne's Tales*. New York: Norton, 1987.

McIntosh, Peggy. "White Privilege and Male Privilege: A Personal Account of Coming to See Correspondences through Work in Women's Studies." In *Critical White Studies: Looking Behind the Mirror*, edited by Richard Delgado and Jean Stefancic, 291–99. Philadelphia: Temple University Press, 1997.

McKenna, Stanley. "Reviving a Prejudice." *New York Herald*, July 22, 1879, 5.

McNickle, Chris. "When New York Was Irish, and After." In *New York Irish*, edited by Ronald H. Bayor and Timothy J. Meagher, 337–56. Baltimore: Johns Hopkins University Press, 1996.

Melish, Joanne Pope. *Disowning Slavery: Gradual Emancipation and "Race" in New England, 1780–1860*. Ithaca, NY: Cornell University Press, 1998.

Memmi, Albert. *Racism*. Translated and edited by Steve Martinot. Minneapolis: University of Minnesota Press, 2000.

Michaels, Walter Benn. *Our America: Nativism, Modernism, and Pluralism*. Durham, NC: Duke University Press, 1995.

Miller, Angela. *The Empire of the Eye: Landscape Representation and American Cultural Politics, 1825–1875*. Ithaca, NY: Cornell University Press, 1993.

Monahan, Anne. "'Of a Doubtful Gothic': Islamic Sources for the Pennsylvania Academy of the Fine Arts." *Nineteenth Century* 18:2 (Fall 1998): 28–36.

Morais, Nina. "Jewish Ostracism in America." *North American Review* 133:298 (September 1881): 256–75.

Morgan, Edmund. *American Slavery, American Freedom: The Ordeal of Colonial Virginia*. New York: Norton, 1975.

Morrison, Toni. *Playing in the Dark: Whiteness and the Literary Imagination*. Cambridge, MA: Harvard University Press, 1992.

Morton, H. J. "Yosemite Valley." *Philadelphia Photographer* 3:36 (December 1866): 376–79.

Muir, John. *The Mountains of California*. New York: Century, 1894.

———. *Our National Parks*. Boston: Houghton Mifflin, 1901.

———. *The Story of My Boyhood and Youth*. Boston: Houghton Mifflin, 1913.

———. *The Yosemite*. New York: Century, 1912.

Musser, Charles. *Before the Nickelodeon: Edwin S. Porter and the Edison Manufacturing Company*. Berkeley and Los Angeles: University of California Press, 1991.

———. *The Emergence of Cinema: The American Screen to 1907*. Vol. 1. Berkeley and Los Angeles: University of California Press, 1990.

Myers, Hyman. "Three Buildings of the Pennsylvania Academy." *Antiques* 121:3 (March 1982): 679–89.

Naef, Weston, and James N. Wood. *Era of Exploration: The Rise of Landscape Photography in the American West, 1860–1885*. Buffalo and New York: Albright-Knox Art Gallery and the Metropolitan Museum of Art, 1975.

Nickel, Douglas R. *Carleton Watkins: The Art of Perception*. New York: Abrams, 1999.

Niver, Kemp R. *Biograph Bulletins, 1896–1908*. Los Angeles: Artisan Press, 1971.

Nye, David E. *America as Second Creation: Technology and Narratives of New Beginnings*. Cambridge, MA: MIT Press, 2003.

O'Gorman, James. *The Architecture of Frank Furness*. Philadelphia: Philadelphia Museum of Art, 1973.

———. *H. H. Richardson: Architectural Forms for an American Society*. Chicago: University of Chicago Press, 1987.

Olmsted, Frederick Law. "Governmental Preservation of Natural Scenery." Printed circular, March 8, 1890. Washington, DC: U.S. Library of Congress, Olmsted Papers, Box 32.

———. *A Journey in the Back Country*. New York: Mason Brothers, 1860.

———. *A Journey through Texas; or a Saddle-Trip on the Southwestern Frontier*. New York: Dix, Edwards, 1857.

———. "The Yosemite Valley and the Mariposa Big Trees: A Preliminary Report." Edited by Laura Wood Roper. *Landscape Architecture* 43 (1952): 16–17.

O'Malley, Michael. *Keeping Watch: A History of American Time*. Washington, DC: Smithsonian Institution Press, 1990.

Omi, Michael, and Howard Winant. *Racial Formation in the United States: From the 1960s to the 1990s*. 2nd ed. New York: Routledge, 1994.

Orvell, Miles. *The Real Thing: Imitation and Authenticity in American Culture, 1880–1940*. Chapel Hill: University of North Carolina Press, 1989.

Palmquist, Peter E. "California's Peripatetic Photographer: Charles Leander Weed." *California History* 58:3 (Fall 1979): 194–219.

———. *Carleton E. Watkins: Photographer of the American West*. Foreword by Martha Sandweiss. Albuquerque: University of New Mexico Press, 1983.

Pangle, Thomas L. *The Spirit of Modern Republicanism: The Moral Vision of the Founding Fathers and the Philosophy of Locke*. Chicago: University of Chicago Press, 1988.

Parker, Rozsika, and Griselda Pollock. *Old Mistresses: Women, Art and Ideology*. London: Pandora Press, 1989.

Pastan, Amy. *Young America: Treasures from the Smithsonian American Art Museum.* New York: Watson-Guptill, 2000.

Pencak, William. "Jews and Anti-Semitism in Early Pennsylvania." *Pennsylvania Magazine of History and Biography* 126:3 (July 2002): 365–408.

Pennell, Joseph. *The Adventures of an Illustrator: Mostly Following His Authors in America and Europe.* Boston: Little, Brown, 1925.

Perry, Pamela. *Shades of White: White Kids and Racial Identities in High School.* Durham, NC: Duke University Press, 2002.

Pevsner, Nikolaus. *A History of Building Types.* Princeton, NJ: Princeton University Press, 1976.

"The Philadelphia Academy Exhibition." *Art Journal* 2:19 (July 1876): 222–23.

"A Philadelphia Art Gallery on Sunday." *Harper's Weekly*, June 11, 1887, 419.

Philips, John Finis. *Speeches of Judge John F. Philips and Wm. H. Wallace, Prosecuting Attorney of Jackson County, Missouri: In the Trial of Frank James at Gallatin, Missouri, for Murder Committed While Engaged in Train Robbery.* Kansas City: s.n., 1898.

Picture Catalogue: American Mutoscope & Biograph Company. New York: American Mutoscope & Biograph Company, 1902.

Pinker, Steven. *The Blank Slate: The Modern Denial of Human Nature.* New York: Viking, 2002.

Poole, William Henry. *Anglo-Israel or the Saxon Race Proved to Be the Lost Tribes of Israel.* Toronto: William Briggs, 1889 [1880].

Powell, Richard. *Black Art: A Cultural History.* New York: Thames and Hudson, 2002.

Powers, Stephen. "Tribes of California." In *Contributions to North American Ethnology*, vol. 3, edited by J. W. Powell. Washington, DC: Government Printing Office, 1877.

Prentiss, Craig R., ed. *Religion and the Creation of Race and Ethnicity: An Introduction.* New York: New York University Press, 2003.

"Progress of Architecture in the United States." *American Architect and Building News*, October 1868, 278.

Promey, Sally M. *Painting Religion in Public: John Singer Sargent's Triumph of Religion at the Boston Public Library.* Princeton, NJ: Princeton University Press, 1999.

Prucha, Francis Paul. *Documents of United States Indian Policy.* 2nd ed. Lincoln: University of Nebraska Press, 1990.

Purvis, Dale, and R. Beau Lotto. *Why We See What We Do: An Empirical Theory of Vision.* Sunderland, MA: Sinauer Associates, 2003.

Quinton, A. M. "Absolute Idealism." In *Rationalism, Empiricism, and Idealism: British Academy Lectures on the History of Philosophy*, edited by Anthony Kenny, 124–50. New York: Oxford University Press, 1986.

Reilly, Bernard F. *Currier & Ives: A Catalogue Raisonné.* Detroit: Gale, 1984.

Report of the Commissioners to Manage the Yosemite Valley and the Mariposa Big Tree Grove for the Years 1866–7. San Francisco: Towne and Bacon, 1868.

"Return of the Jews." *Saturday Evening Post* 57:23 (December 29, 1877): 8.

Robertson, Bruce. "Who's Sitting at the Table? William Sidney Mount's *After Dinner* (1834)." *Yale Journal of Criticism* 11:1 (Spring 1998): 103–7.

Robertson, David. *Yosemite as We Saw It: A Centennial Collection of Early Writings and Art.* Yosemite National Park, CA: Yosemite Association, 1990.

Roediger, David, ed. *Black on White: Black Writers on What It Means to Be White.* New York: Schocken Books, 1998.

———. *Toward the Abolition of Whiteness: Essays on Race, Politics, and Working Class History.* New York: Verso, 1994.

———. *The Wages of Whiteness: Race and the Making of the American Working Class.* New York, Verso, 1991.

Rogers, Edward H. *Law and Love, or, The Resemblance and the Difference between Moses and Christ with a Prophetic Supplement Concerning Anglo-Israel.* Chelsea, MA: E. H. Rogers, 1897.

Rogin, Michael. *Blackface, White Noise: Jewish Immigrants in the Hollywood Melting Pot.* Berkeley and Los Angeles, University of California Press, 1996.

———. "Francis Galton and Mark Twain: The Natal Autograph in *Pudd'nhead Wilson*." In *Mark Twain's Pudd'nhead Wilson: Race, Conflict, and Culture,* edited by Susan Gilman and Forrest G. Robinson, 73–85. Durham, NC: Duke University Press, 1990.

Roosevelt, Theodore. *The Winning of the West.* Vol. 1. New York: Putnam's, 1889.

Rosenberg, Noah, J. K. Pritchard, J. L. Weber, H. M. Cann, K. K. Kidd, L. A. Zhivotovsky, and M. W. Feldman. "Genetic Structure of Human Populations." *Science* 298 (December 2002): 2381–85.

Royce, Josiah. *Religious Aspect of Philosophy: A Critique of the Bases of Conduct and of Faith.* Boston: Houghton Mifflin, 1885.

Rule, Amy. *Carleton Watkins: Selected Texts and Bibliography.* Boston: Hall, 1993.

Runte, Alfred. *National Parks: The American Experience.* Lincoln: University of Nebraska Press, 1979.

Ruskin, John. *The Seven Lamps of Architecture.* New York: Wiley, 1887.

Rydell, Robert W. *All the World's a Fair: Visions of Empire at American International Expositions, 1876–1916.* Chicago: University of Chicago Press, 1984.

Said, Edward. *Musical Elaborations.* New York: Columbia University Press, 1991.

———. *Orientalism.* New York: Vintage Books, 1978.

Saito, Leland T. *Race and Politics: Asian Americans, Latinos, and Whites in a Los Angeles Suburb.* Urbana: University of Illinois Press, 1998.

Sanborn, Margaret. *Yosemite: Its Discovery, Its Wonders, and Its People.* New York: Random House, 1981.

Sanders, Ronald. *Lost Tribes and Promised Lands: The Origins of American Racism.* Boston: Little, Brown, 1978.

Sarbu, Aladár. *The Reality of Appearances: Vision and Representation in Emerson, Hawthorne, and Melville.* Budapest: Akadémiai Kiadó, 1996.

Savage, Charles Roscoe. "A Photographic Tour of Nearly 9000 Miles." *Philadelphia Photographer* 4:45 (September 1867): 287–89, 313–16.

Saxton, Alexander. *The Rise and Fall of the White Republic: Class Politics and Mass Culture in Nineteenth-Century America.* New York: Verso, 1990.

Schueller, Malini Johar. *U.S. Orientalism: Race, Nation, and Gender in Literature, 1790–1890.* Ann Arbor: University of Michigan Press, 1998.

Schwalbe, Michael, Sandra Goodwin, Daphne Holden, Douglas Schrock, Shealy Thompson, and Michelle Wolkomir. "Generic Processes in the Reproduction of Inequality: An Interactionist Analysis." *Social Forces* 79:2 (December 2000): 419–52.

Sellars, Richard West. *Preserving Nature in the National Parks: A History.* New Haven, CT: Yale University Press, 1997.

Sherman, Daniel J., and Irit Rogoff, eds. *Museum Culture: Histories, Discourses, Spectacles.* Minneapolis: University of Minnesota Press, 1994.

Shiner, Larry. *The Invention of Art: A Cultural History.* Chicago: University of Chicago Press, 2001.

Sienkiewicz, Henry. *Portrait of America: Letters of Henry Sienkiewicz.* Edited and translated by Charles Morley. New York: Columbia University Press, 1959.

Silver, Shirley, and Wick R. Miller. *American Indian Languages: Cultural and Social Contexts.* Tucson: University of Arizona Press, 1997.

Simpson, G. Wharton. "Photography at the International Exhibition at Paris." *Philadelphia Photographer* 4:43 (July 1867): 201–4.

Smedley, Audrey. *Race in North America: Origin and Evolution of a Worldview.* Boulder, CO: Westview Press, 1993.

Smith, Mark M. *Mastered by the Clock: Time, Slavery, and Freedom in the American South.* Chapel Hill: University of North Carolina Press, 1997.

Solomon-Godeau, Abigail. *Photography at the Dock: Essays on Photographic History, Institutions, and Practices.* Minneapolis: University of Minnesota Press, 1991.

Spearman, Frank H. *The Nerve of Foley and Other Railroad Stories.* New York: Harper and Brothers, 1900.

Spence, Mark David. *Dispossessing the Wilderness: Indian Removal and the Making of the National Parks.* New York: Oxford University Press, 1999.

Squadrito, Kay. "Innate Ideas, Blank Tablets and Ideologies of Oppression." *Dialectics and Humanism* 11:4 (Autumn 1984): 537–45.

————. "Locke's View of Essence and Its Relation to Racism: A Reply to Professor Bracken." *Locke Newsletter* 6 (1975): 41–54.

————. "Racism and Empiricism." *Behaviorism* 7:1 (Spring 1979): 105–15.

Stafford, Barbara Maria. *Voyage into Substance: Art, Science, Nature, and the Illustrated Travel Account, 1760–1840.* Cambridge, MA: MIT Press, 1984.

Stallings, Tyler, ed. *Whiteness: A Wayward Construction.* Laguna Beach, CA: Laguna Art Museum and Fellows of Contemporary Art, 2003.

Stephens, Carlene E. *On Time: How America Has Learned to Live by the Clock.* Boston: Little, Brown, 2002.

Stern, Malcolm H. "National Leaders of Their Time: Philadelphia's Reform Rabbis." In *Jewish Life in Philadelphia, 1830–1940,* edited by Murray Friedman, 179–97. Philadelphia: Ishi Publications, 1983.

Stillman, Damie. *Architecture and Ornament in Late-Nineteenth-Century America.* Pennsauken, NJ: National Designers, 1981.

Stranger's Illustrated Pocket Guide to Philadelphia. Philadelphia: Lippincott, 1876.

Sundquist, Eric J. *To Wake the Nations: Race in the Making of American Literature.* Cambridge, MA: Harvard University Press, 1993.

Sweetman, John. *The Oriental Obsession: Islamic Inspiration in British and American Art and Architecture, 1500–1920.* Cambridge: Cambridge University Press, 1988.

Syckelmoore, William. *Syckelmoore's Illustrated Handbook of Philadelphia.* Philadelphia: William Syckelmoore, 1874.

Takaki, Ronald. *A Different Mirror: A History of Multicultural America.* New York: Little Brown, 1993.

————. *Iron Cages: Race and Culture in Nineteenth-Century America.* New York: Oxford University Press, 1990.

Taliaferro, John. *Great White Fathers: The Story of the Obsessive Quest to Create Mt. Rushmore.* New York: Public Affairs, 2002.

Tehranian, John. "Performing Whiteness: Naturalization Litigation and the Construction of Racial Identity in America." *Yale Law Journal* 109:14 (January 2000): 820–21.

Thomas, George E., Michael J. Lewis, and Jeffrey A. Cohen. *Frank Furness: The Complete Works.* New York: Princeton Architectural Press, 1991.

Thomas A. Edison Papers: A Guide to Motion Picture Catalogs by American Producers and Distributors, 1894–1908: A Microfilm Edition. Frederick, MD: University Publications of America, 1985.

Thrower, Norman J. W. *Maps and Civilization: Cartography in Culture and Society.* Chicago: University of Chicago Press, 1999.

Tomkins, Calvin. *Merchants and Masterpieces: The Story of the Metropolitan Museum of Art.* New York: Holt, 1989.

Tourist's Guide Book to the United States and Canada. New York: Putnam's, 1883.

Trachtenberg, Alan. *The Incorporation of America: Culture and Society in the Gilded Age.* New York: Hill and Wang, 1982.

———. *Reading American Photographs: Images as History, Mathew Brady to Walker Evans.* New York: Hill and Wang, 1989.

Truettner, William. "Genesis of Frederic Edwin Church's *Aurora Borealis.*" *Art Quarterly* 31:3 (Autumn 1968): 267–83.

Tschumi, Bernard. *Architecture and Disjunction.* Cambridge, MA: MIT Press, 1994.

Twain, Mark. *Puddn'head Wilson and Those Extraordinary Twins.* Edited with an introduction by Malcolm Bradbury. New York: Penguin Books, 1986.

Van Dyke, John C. *American Painting and Its Tradition.* New York: Scribner's, 1919.

Van Zanten, David. *The Architectural Polychromy of the 1830's.* New York: Garland, 1977.

Venturi, Robert. *Complexity and Contradiction in Architecture.* New York: Museum of Modern Art, 1966.

"Views in the Yosemite Valley." *Philadelphia Photographer* 3:28 (April 1866): 106–7.

Viollet-le-Duc, Eugène Emmanuel. *Discourses on Architecture.* Translated with an introductory essay by Henry Van Brunt. Boston: James R. Osgood, 1875.

Vitiello, Domenic. "Engineering the Metropolis: William Sellers, Joseph M. Wilson, and Industrial Philadelphia." *Pennsylvania Magazine of History and Biography* 126:2 (July 2002): 273–303.

Wallace, E. R. *Descriptive Guide to the Adirondacks and Handbook of Travel.* New York: American News Company, 1875.

Wallach, Alan. *Exhibiting Contradiction: Essays on the Art Museum in the United States.* Amherst: University of Massachusetts Press, 1998.

———. "Making a Picture of the View from Mount Holyoke." In *American Iconology: New Approaches to Nineteenth-Century Art and Literature,* edited by David C. Miller, 80–91. New Haven, CT: Yale University Press, 1993.

Ware, Vron, and Les Back, *Out of Whiteness: Color, Politics, and Culture.* Chicago: University of Chicago Press, 2002.

Warhus, Mark. *Another America: Native American Maps and the History of Our Land.* New York: St. Martin's Press, 1997.

Warman, Cy. *The Express Messenger and Other Tales of the Rail.* New York: Scribner's, 1897.

Warner, Charles Dudley. *In the Levant.* Boston: James R. Osgood, 1877.

Washburn, Wilcomb E. *Red Man's Land/White Man's Law: A Case Study of the Past and Present Status of the American Indian.* New York: Scribner's, 1971.

Waters, Mary C. *Ethnic Options: Choosing Identities in America.* Berkeley and Los Angeles: University of California Press, 1990.

Watkin, David, Daniel Wheeler, Marc Walter, and Jean D'Ormesson. *Grand Hotel: The Golden Age of Palace Hotels, an Architectural and Social History.* New York: Vendome Press, 1984.

Weed, Joseph. *A View of California as It Is.* San Francisco: Bynon and Wright, 1874.

West, Thomas G. *Vindicating the Fathers: Race, Sex, Class, and Justice in the Origins of America.* New York: Rowman and Littlefield, 1997.

Westcott, Thompson. *The Official Guide Book to Philadelphia.* Philadelphia: Porter and Coates, 1875.

Whitney, J. D. *Geological Survey of California.* New York: Julius Bien, 1868.

Wiegman, Robyn. "Whiteness Studies and the Paradox of Particularity." *Boundary 2* 26:3 (Autumn 1999): 115–50.

Williams, Linda. *Playing the Race Card: Melodramas of Black and White from Uncle Tom to O. J. Simpson.* Princeton, NJ: Princeton University Press, 2001.

Williams, Robert A., Jr. "Documents of Barbarism: The Contemporary Legacy of European Racism and Colonialism in Narrative Traditions of Federal Indian Law." In *Critical Race Theory: The Cutting Edge,* edited by Richard Delgado, 98–109. Philadelphia: Temple University Press, 1995.

Williamson, Joel. *New People: Miscegenation and Mulattoes in the United States.* New York: Free Press, 1980.

Winthrop, John. *Winthrop Papers, 1623–1630.* Vol. 2. Boston: Massachusetts Historical Society, 1929.

Wischnitzer, Rachel. *Synagogue Architecture in the United States: History and Interpretation.* Philadelphia: Jewish Publication Society of America, 1955.

Wood, Denis. *The Power of Maps.* New York: Guilford Press, 1992.

Woods, Naurice Frank, Jr. "Insuperable Obstacles: The Impact of Racism on the Creative and Personal Development of Four Nineteenth-Century African American Artists." Ph.D. diss., Union Institute Graduate School, 1993.

INDEX

Note: Page numbers in italics refer to illustrations.

EDITOR

STEPHANIE FAY

ASSISTANT ACQUISITIONS EDITORS

ERIN MARIETTA, SIGI NACSON

COPYEDITOR

SUSAN ECKLUND

INDEXER

ANDY JORON

DESIGNER

JESSICA GRUNWALD

PRODUCTION COORDINATOR

JOHN CRONIN

TEXT

11/13 WALBAUM

DISPLAY

AKZIDENZ GROTESK EXTENDED

COMPOSITOR

INTEGRATED COMPOSITION SYSTEMS

PRINTER AND BINDER

FRIESENS